WRITING MATTER

WRITING MATTER:
FROM THE HANDS OF THE
ENGLISH RENAISSANCE

Jonathan Goldberg

STANFORD UNIVERSITY PRESS Stanford, California

Stanford University Press
Stanford, California
© 1990 by the Board of Trustees of the
Leland Stanford Junior University
Printed in the United States of America
Original printing 1990
Last figure below indicates year of this printing:
00 99 98 97 96 95 94 93 92 91
CIP data appear at the end of the book

In small proportions, we just beauties see:
And in short measures, life may perfect be.

ACKNOWLEDGMENTS

RITING MATTER, as my Introduction indicates,
has a number of debts to the work of others; it also follows
from *Voice Terminal Echo*, and most directly from my reading
of the human/scriptive character in Shakespeare there; indeed,
in its earliest draft, this project was defined in those terms, and
traces of that design remain in epigraphs as well as in several
essays on Shakespeare written concurrently. (Had this trajec-
tory been followed, this book would have resembled Marjorie
Garber's *Shakespeare's Ghost Writers*.) It soon became clear to
me, however, that an investigation of the conditions in which
script was produced in Renaissance England was the subject
for a book in itself, and that the path from letters to literature,
a project yet to be undertaken in English Renaissance studies,
could not be traced without it. Indeed I believe that this study
opens a number of itineraries, not only to a comprehension
of the place of the literary, but, in its linking of writing to the
hand, to Renaissance conceptions of the body (for example,
the joining of literariness to the gendered body in the *blason,*
which the forthcoming book of Nancy J. Vickers will enable
us to read) or to the place of the signature in late Renaissance
works of art.

As "Hamlet's Hand" (now in *Shakespeare Quarterly*) some of

the earliest formulations of the argument of this book were tried out on a number of audiences—at Bard College, Connecticut College, the Folger Shakespeare Library, the Getty Center for the History of Art and the Humanities, Harvard University, Stanford University, and at several campuses of the University of California—Riverside, San Diego, Santa Barbara. I am grateful to those who invited me to speak— among them, John Bender, Kenneth Bleeth, Elizabeth Frank, Marjorie Garber, George Haggerty, Louis Montrose, Barbara Mowat, David Riggs, Don Wayne—for much hospitality, and for a number of highly informative and stimulating discussions that convinced me that I had a topic worth pursuing and helped me towards this final draft. As "On the one hand . . . ," an initial version of "The Hand in Theory" was first presented as a lecture, thanks to Michael Silverman and the Semiotics program at Brown University, and it gives me pleasure to recall here those former colleagues and students (above all, friends) present at that occasion: Robert Mandelbaum, Almon Grimsted, John Murchek, Karen Newman and Tom Brooks, C. D. Wright and Forrest Gander, Mary Jo and Steven Foley, and Kaja Silverman. Four wonderful Johns Hopkins students in a seminar on Elizabethan pedagogy taught me more than I can say: to Michael Dee, Natasha Korda, Sharon Marcus, and Jennifer Summit I owe some of my best ideas. Among my colleagues at Hopkins, I have had before me the model of Michael Fried's work; Walter Melion kindly allowed me to see some of his manuscript on Goltzius and print culture in the Netherlands; John Guillory gave important intellectual support, Jerome Christensen inspiration, Sharon Cameron and Mary Poovey all that and more.

A pair of anonymous readers alerted me to some potential problems in my manuscript; I am grateful to them, but above all to Michael Warner, who read the initial draft and whose comments have guided me ever since; to Jonathan Crewe, for a reading as exacting as it was generous; to Steven Mullaney,

for encouragement about a particularly recalcitrant passage; to Michael Moon and Stephen Orgel, who have been my best readers, and a great deal more. It gives me pleasure to wonder what Julia and Abigail Goldberg will make of this book.

Writing Matter is dedicated to the memory of Richard C. Newton, who died of an AIDS-related illness on Thanksgiving Day, 1986. The profession has lost one of its most astute readers of Ben Jonson; Temple University has lost a brilliant and kind colleague. To his friends, the loss is bearable only because Dick taught us how to accept it, a final act of generosity from someone always generous. What he gave us we still have, and that cannot be lost.

CONTENTS

FIGURES

WRITING MATTER

Write.　OE. *writan,* = O Fris. *writa* to score, write (Fris. *write* to score by rubbing, etc.), OS. *writan* to cut, write (MLG. *writen*), OHG *rigan* to tear, draw (MHG. rizen, G. reissen), ON. *rita* to score, write (Norw. *rita, vrita,* Sw. *rita* to draw); cf. ON. and Icel. *rita,* to write.

Letter.　I. An alphabetic character. II. Something written. 4. A missive communication in writing, addressed to a person or body of persons; an epistle [f. ἐπί on the occasion of + στέλλειν to send]. 5. The precise terms of a statement. 6. pl. Literature in general; hence, acquaintance with it, learning, study, erudition.

Signature.　1. *Sc. Law.* A writing prepared and presented to the Baron of Exchequer by a writer to the signet, as the ground of a royal grant to the person in whose name it is presented. 2. The name (or a special mark) of a person written in his or her own hand as an authentication of some document or writing. 3. The act of impressing or stamping. 4. A distinctive mark, a peculiarity in form or colouring, etc. 5. An image; a figure; an imitative mark. 6. *Printing.* A letter or figure, a set or combination of letters or figures, etc., placed by the printer at the foot of the first page (and frequently on one or more of the succeeding pages) of every sheet in a book, for the purpose of showing the order in which these are to be placed or bound.

—Oxford English Dictionary

Literatus.　I. Lettered, inscribed with letters; *servus,* branded [the mark of a slave]. . . . II. Learned, liberally educated [the mark of a citizen]. . . .

—Cassell's Latin Dictionary

A.　Sometime a lettre, sometyme a word, whych was in the old tyme taken amongest the Romaynes for a note, or marke of aequitayle, as it is now here in Englande, that abiured parsons bene bronded therewyth, whych is called of Cicero the lettre of Saulfgarde.

—Richard Huloet, *Abcedarium Anglico Latinum,* 1552

Say what you will, sir, but I know what I know;
That you beat me at the mart, I have your hand to show.
If the skin were parchment and the blows you gave were ink,
Your own handwriting would tell you what I think.

—*Comedy of Errors,* 3.1.11–14

WRITING MATTER is a study of handwriting in the Renaissance; its focus is on manuals of instruction, the materials and the materiality of a practice that extends from the manuals to the hand of the writer, and on the social and historical positions that these instructions and those instructed come to occupy. Multiple institutional sites of a practice that is itself hardly uniform, questions of their historicity, and the parameters of their ideological effects and aims are engaged in the pages that follow. Although a description of the field of handwriting entails a range of texts and questions that extend well beyond the immediate practices examined, I have directed my attention to Renaissance England as a way of delimiting the issues. This circumscription is not merely an arbitrary choice, nor one dictated solely by my own interests in the period; for within a history of handwriting, most narrowly defined, England is one site for a momentous shift in the history of handwriting. The handwriting manuals, which exemplify and attempt to regulate a multiplicity of hands—suited for specific institutional sites or social circumstances—also introduce into England (and on a large scale, thanks to printing) the italic hand, an Italian import, which came, in the course of the sixteenth century, to signify socially as the mark

of high literariness and a full literacy. It is from the italic that our handwriting descends, and it is from the social work performed by this new hand that a new subject of writing comes to be formed. This historic shift, then, which is assumed (not documented) in the pages that follow, guides my discussion. Our place within it is the topic of my final chapter.

This discussion, however much indebted to the work of paleographers and historians of handwriting, does not operate within their usual descriptive, documentary mode, nor does it subscribe to the narratives that have governed them.[1] It depends rather upon the critique of such terms and assumptions as are articulated by Jacques Derrida in *Of Grammatology* and upon the theory of writing offered in their place. *Writing Matter* takes its cue from a "cultural graphology," the possibility of which Derrida gestures towards in broad terms near the end of the first part of that book:

the articulation of an individual and a collective *graphie*, of the graphic "discourse"—so to speak—and the graphic "code" . . . ; problems of the articulation of graphic forms and of diverse substances, of the diverse forms of graphic substances (materials: wood, wax, skin, stone, ink, metal, vegetable) or instruments (point, brush, etc., etc.); as to the articulation of the technical, economic, or historical levels . . . ; as to the limit and the sense of variations in style within the system; as to all the investitures to which a *graphie*, in form and substance, is submitted. (*Gram*, 87)

This is a vast field, as is a similar outline offered in the final pages of "Freud and the Scene of Writing," which opens upon investigations into "a *psychopathology of everyday life*"; "a *history of writing*"; "a *becoming literary of the literal*"; and "a new *psychoanalytic graphology*" (230–31). As Gayatri Chakravorty Spivak remarks in her introduction to *Grammatology*, these statements seem to represent a plan for future work, for Derrida to become "the authorized grammatological historian of writing in the narrow sense" which he "quietly drops" in the pursuit of the continuing theoretical project that follows from "the

grammatological opening" upon "the structure of writing" in the wider sense that the term has for Derrida (*Gram*, lxxx). My aim, in the pages that follow, is to keep in sight writing in both of these senses of the term, and thus to pursue a path that is historical as well as theoretical.

"Writing Lessons" opens by attempting to read out of a passage from *Grammatology* how such a double enterprise may be pursued. But its title also alludes to the chapter from Lévi-Strauss's *Tristes Tropiques* that is read at the opening of the second part of *Grammatology*. This is such a well-known episode that it scarcely needs to be retold. Suffice to recall that in it Lévi-Strauss describes how a Nambikwara chief, having seen the ethnographer employing the tools of his trade—writing implements—seizes upon the power of writing in an attempt to mystify his fellow Indians. Lévi-Strauss uses the occasion to meditate upon writing, finding the episode exemplary since it reveals that writing (supposedly the crucial differential marker distinguishing "primitives" from their "civilized" observers) is not inherently a tool of civilized knowledge but of ideological imposition, a violence not merely visited upon the Indians, but one that also marks the history of the West. "Although writing may not have been enough to consolidate knowledge," Lévi-Strauss writes, "it was perhaps indispensable for the strengthening of dominion," and not only in the imperialistic designs that accompany the emergence of writing among the Sumerians or the Egyptians:

The systematic development of compulsory education in the European countries goes hand in hand with the extension of military service and proletarianization. The fight against illiteracy is therefore connected with an increase in governmental authority over the citizens. Everyone must be able to read, so that the government can say: Ignorance of the law is no excuse. (300)

Derrida's intervention in this episode is equally well known; he demonstrates that Lévi-Strauss's attempt to escape the ethnocentricity that structures the opposition between

people without and people with writing is reinscribed in the episode, as the native population is granted an innocence denied the West, one that seems allied to their lack of writing. Derrida is equally severe about the Marxist analysis that Lévi-Strauss offers; although granting that "it has long been known that the power of writing in the hands of a small number, caste, or class, is always contemporaneous with hierarchization, let us say with political differance" (*Gram*, 130), he cautions against the various collapses performed in Lévi-Strauss's analysis: in which law becomes oppression, in which difference becomes domination, in which knowledge is always and only in the service of power. Derrida insists that those who do not write cannot be sheltered from such violence (writing, in the extended sense, is complicit with a founding violence, in which the human and the social emerge); but, on the other hand, whatever there may be of law, liberty, or knowledge can only be preserved in a more differentiated reading than the one Lévi-Strauss performs: "Access to writing is the constitution of a free subject in the violent movement of its own effacement and of its own bondage. A movement unthinkable within the classical concepts of ethics, psychology, political philosophy, and metaphysics" (*Gram*, 132).

Derrida's reading of Lévi-Strauss attempts to resituate the discussion beyond and before the anthropologist's oppositional analysis; it insists upon interrupting the easy allegorization that Lévi-Strauss performs as he moves from the empirical observation of the episode with the Nambikwara chief to its universalization as a scene of oppression. Rigorous as a theoretical gesture, Derrida's reading is also troubling as a political and historical one. François Furet and Jacques Ozouf have been the historians of literacy most attendant to Lévi-Strauss's coupling of literacy to state apparatuses of control, and I have followed a similar agenda. Hence, in the pages that follow, although I have attempted to respect Derrida's philosophical gesture (it has guided me, for instance, in under-

standing the conceptual failings in much theoretical work that has been done around the question of literacy by such practitioners as Jack Goody or Walter Ong), I have also wanted to respect the powerful critique that Lévi-Strauss offers, for there is in Derrida's intervention (as much as in Lévi-Strauss's analysis) the danger of a foreclosing collapse. To resituate Lévi-Strauss as another instance of logocentrism can deny the painful acuity of Lévi-Strauss's reading, which is of a scene of colonizing and imperialist imposition, and one in which the anthropologist is unwittingly and unwillingly complicit (it is just such complicities that are scrutinized in many of the essays gathered by James Clifford and George Marcus in *Writing Culture*). But it is to Lévi-Strauss's credit that he so summarily dismisses the ideological supposition (that continues to function in the work of Goody or Ong) that writing is *tout court* the mark of civilization and knowledge. His brilliant paragraph is worth citing:

Writing is a strange invention. One might suppose that its emergence would not fail to bring about profound changes in the conditions of human existence, and that these transformations must of necessity be of an intellectual nature. The possession of writing vastly increases man's ability to preserve knowledge. It can be thought of as an artificial memory, the development of which ought to lead to a clearer awareness of the past, and hence to a greater ability to organize both the present and the future. After eliminating all other criteria which have been put forward to distinguish between barbarism and civilization, it is tempting to retain this one at least: there are people with, or without, writing; the former are able to store up their past achievements and to move with ever-increasing rapidity towards the goal they have set themselves, whereas the latter, being incapable of remembering the past beyond the narrow margin of individual memory, seem bound to remain imprisoned in a fluctuating history which will always lack both a beginning and any lasting awareness of an aim. (298)

"Yet nothing we know about writing and the part it has played in man's evolution," Lévi-Strauss continues, "justifies

this view." It is, however, within just such assumptions, as Brian Street demonstrates in his important study, *Literacy in Theory and Practice*, that most work has been undertaken in the field. Building upon what Street calls "the autonomous model," social scientists and anthropologists (Jack Goody's work is examined at length by Street)[2] have supposed an equation between writing, rational knowledge, and democracy. Derrida would obviously not subscribe to such suppositions (he is as wary of the idealizing reversal of Lévi-Strauss as he is of its Marxist critique), but his analysis, while admirably leaving open the possibility for such values, would seem to foreclose a political and historical critique.

This is certainly not his aim, as he makes clear in the afterword to *Limited Inc*, or as is apparent in "Racism's Last Word," yet the philosophical scrupulousness of Derrida's political arguments have allowed him only gestures towards possibilities that appear to be stymied by the impasse that logocentrism represents. For, as he understands it, "the axiomatics of numerous (and perhaps even all) politics in the West, whether of the right or of the left," share a common code, and "deconstruction . . . if it also has a political dimension, is engaged in the writing (or if you prefer, in the future production) of a language and of a political practice that can no longer be comprehended, judged, deciphered by these codes" (*Limited Inc*, 139). This is the double writing that would entail recognizing the complicity of enslavement and freedom and that dreams of a movement beyond that binarism. But, as in "Racism's Last Word," that beyond can only be voiced in and towards a futurity that it awaits. "The opposition conservative/revolutionary is no longer pertinent," Derrida writes. "That is precisely what gets on everyone's nerves" (*Limited Inc*, 141). On my nerves, too.

Street proposes, in place of the "autonomous model," an ideological analysis, one that insists upon recognizing the social and historical imbeddedness of literacy—of what is

variously defined as literacy, of the institutions that promulgate and regulate its social instantiation and dispersion. Derrida's work has been vital to me in performing such analyses,
for the shorthand name for the ideological project represented
by the texts studied in this book is logocentrism. Yet, as
the program for a "cultural graphology" outlined above also
suggests (however much it represents the path not taken by
Derrida), logocentrism can be delimited in descriptions that
attend to the historic specificity of the regulation of writing
in the narrow sense. In the pages that follow, I attempt to
do so. The double gesture that guides me here I continue to
recognize as Derridean, even as it leads me towards historicopolitical work of a kind not practiced by him.

"Writing Lessons" works this out in more detail by juxtaposing its reading of a historical program from Derrida with a
reading of a sixteenth-century pedagogic text, Richard Mulcaster's *Elementarie*. That suggestively named book is pertinent to my purposes since it means to lay out the course of
education at its most elementary level, and yet is unable to
do so because of the troubling place that writing occupies in
its program. A Derridean analysis of that text clarifies how
Mulcaster's project (which also entails a relationship between
writing in its narrow and broader senses) falters in its logocentric designs. A critique of that ideological project, undertaken through a Derridean analysis, allows me to proceed
in "Writing Lessons" to sketch the historic situation of Mulcaster's pedagogic project, and with it, the sites upon which
and through which script was produced in Renaissance England and the place of pedagogy and of the pedagogue, issues
that remain with us today.

The three chapters that follow are organized through the
model of a typical Renaissance manual teaching handwriting.
Jean de Beau Chesne and John Baildon's *A Booke Containing
Divers Sortes of Hands*, which appeared in 1570—the first English manual, reprinted in 1571, 1602, and 1611—could serve

as an example to introduce what is found in many of these books. It opens with a set of verses, "Rules Made by E. B. For Children to write by" (A2), that takes the form of instructions—how to make ink, how to make and hold a pen, how to write. "The Violence of the Letter" pursues these regimes, looking particularly at the instruments of writing and the ways in which penhold takes hold of the hand. To be read in the relationship between the hand and the hand writing is a discourse—an anatomy—that shapes the body as well, and that generates a certain way of viewing the world through the prospect of script. The practice of script, which informs "Copies," cannot be read without some sense of the social settings, and their implications for writing, as they extend beyond the pedagogical scene imagined in E. B.'s verses for children, for the Elizabethan world is not one in which instruction in writing is extended to all, or available to every child. Social and gender economies are thus read against the scripts for reproduction that the writing manuals provide, and I examine closely some of the work of Esther Inglis, the sole female calligrapher of the period whose work survives.

In Beau Chesne and Baildon's manual, social economies are apparent in the hands that are displayed to be copied. These (the first 24 examples, at any rate) are arranged alphabetically. These hands bespeak (and would install) social differences, an idealizing and theoretical project that functions as an ideological manifesto, but which also alludes to particular institutional sites. Thus, samples of specialized court hands (stabilized much earlier, in the fifteenth century, and, according to John H. Fisher, the scriptive basis for the notion of the King's English) are displayed, as well as several types of the secretarial hand to be found on Elizabethan documents of various kinds. But also offered are examples of the italic hand, whose ascendence in England in the sixteenth century goes hand in hand with the production of what comes to count as "high" literacy, as well as literariness. It is the hand that English mon-

archs wrote in the sixteenth century, the hand an aristocrat (or a humanist, or an author like Sidney or Spenser) would use to sign a letter.

Beau Chesne and Baildon's book structures its examples through alphabetical order, and it is the alphabet, both in contemporary literacy studies, as well as in Renaissance manuals, through which the most exalted and mystified ideologies of the hand are offered. In "Letters Themselves," these are examined, along with a discussion of the vexed question of orthography, which is one place in which Elizabethans confront the relationship between speaking and writing. In "Signatures, Letters, Secretaries," the effects of the hand in advancing notions of the individual (as the owner of a proper name and signature) are my subject. Here, too, the social reproduction of individuality is involved—through regimes of copy (as exemplified by letter-writing manuals) and through socially prescribed sites for the production of signatures (in documents and letters, by secretaries, and in the bureaucratic machinery that developed with the office of the principal secretary in sixteenth-century England). Although the secretary's closet may seem to mark the arrival of this study in a highly straitened domain, it is the argument throughout that it represents the locus through which a modern individuality emerges, with extensions to all who write.

By the end of that chapter, then, some of the fields mapped in a Derridean cultural graphology have been explored within several socially differentiated terrains of sixteenth-century England. Centered as it is on the formations of a new "high" literacy, and on the manuals directed at this ideological project, this book hardly pretends to be a complete account of English Renaissance handwriting. I can only glance at the alternative sites that these books preclude, sites that vitally contradict their regulatory aims. Although I occasionally summon up examples of actual rather than prescribed practice, that field (all that remains produced by Elizabethan hands) is yet to be

explored through the kind of analysis opened here (the work of Christian Bec and Armando Petrucci, on Italy, provides pertinent models); it is by no means my supposition—virtually the opposite—that practices would simply exemplify the distinctions the manuals are bent on producing (as is well known, even Ben Jonson, whose literary ambitions were extraordinary in the period, copied out his masques for royal presentation in a hand that mixed secretary and italic letter forms). Moreover, although this book traces the emergence of the modern hand, it does not pursue that history through the eighteenth and nineteenth centuries, an important project that remains to be done (and has been in part, with Italy as the focus, in Petrucci's *La Scrittura*, while Jean-Luc Nancy has written an extraordinary set of pages analyzing Descartes watching his hand producing script).

While I have suggested the paths from letters and literacy to literature (or to the visual arts), this, too, is work that lies ahead (though there are in Michael Fried's *Realism, Writing, Disfiguration* and Derrida's *Signsponge* formidable contributions along these lines). The texts that situate the Renaissance hand need to be complemented too with what Stephanie Jed has called in the final paragraph of *Chaste Thinking: The Rape of Lucretia and the Birth of Humanism* a "new paleography," which her examination of the relationships between the humanist and mercantile hands in Renaissance Italy, and the ideological work they perform, exemplifies. We need for England similar studies, which would read documents and texts with attention to the material forms of letters (whether written or printed). Such histories would also rewrite history. (Michael Warner's forthcoming book on the relationships between printing and American ideology will write an important chapter in this work.)

All this remains to be done. This book ends instead by examining some texts by Barthes, Heidegger, Freud, and Engels, and through them glances at the close of the his-

tory of the hand, as natural, human, and individual, and the opening of the discourses that re-mark the human hand in the direction that the Derridean perspective of this book embraces and seeks to further. "Deconstruction," Derrida writes in the afterword to *Limited Inc*, risking a definition, is "destabilization on the move," and is to be distinguished from destruction: "Destabilization is required for 'progress' as well. And the 'de-' of *de*construction signifies not the demolition of what is constructing itself, but rather what remains to be thought beyond the constructivist or deconstructivist scheme" (147). However much, as Derrida formulates it, that "beyond" seems to be a utopian and entirely a mental, theoretical, and philosophical project (one that stays within the safe terrains of the academy), it need not be. At least I would want to read it in the light of the postmodern, postmarxist Marxism of Ernesto Laclau and Chantal Mouffe's *Hegemony and Socialist Strategy*, as opening up the possibilities for political action, contingent alliances at the nodal points of the social— one of which is the university—even when political agendas (whether they take the form of essentialist humanism or of classical Marxism) are suspect. I see this book as moving in that direction, or the one espoused by Donna Haraway, in her wonderfully outrageous "A Manifesto for Cyborgs," an essay written from a feminist socialist position: "We are cyborgs," Haraway writes, chancing an alliance with technology and destruction. Unlike Heidegger, however, who, in "The Question Concerning Technology," can only pluck safety from danger by retreating to poetry and a refound originary humanity, Haraway recasts the human through the machine to open upon a de-essentialized being. "The cyborg gives us our ontology; it gives us our politics," she writes (66). Haraway's "we" includes as its exemplary instance "women of color"; it speaks too to the political urgency of "people living with AIDS."

Breaking down the humanist categories that have secured

such oppositions as human versus animal, human versus machine, the physical versus the non-physical, cyborgs in Haraway's argument no longer allow the agendas of totalization or sentimental recall to essentialist positions. They represent the most radical attempt at delegitimization. They are resolutely anti-totalitarian. If they are the products of postmodern technologies, they are the illegitimate offspring that call all legitimacies into question. For the technologies of destruction are complicit with humanism, as anyone knows who has attended to the twin rhetorics of star wars and the sanctity of the nuclear family, and with them the virtual disenfranchisement of huge sectors of the population. It is from the perspective of the politics of the cyborg that *Writing Matter* has been written, and the final chapter of this book, especially, seeks to enlarge upon this claim: to read, from this vantage point, a construction of the so-called human (gendered, classed, socialized, "individualized," and, as Francis Barker would say, lethal), and to challenge it.

WRITING LESSONS: INSTRUCTIONS OF THE HAND

The introduction of writing, and all the subsequent stages of its development, are intrinsically new forms of social relationship. There has been great variation in making these skills available, and this has had major effects on the relationships embodied in writing in diverse historical and cultural conditions.

—Raymond Williams,
Writing in Society

N THE FINAL pages of "On Ethnographic Allegory" (an essay in *Writing Culture*), James Clifford pauses over the "subversive challenge" that Derridean grammatology poses to the work of ethnographers and to their allegorical project, which Clifford describes as a version of pastoral in which the Western observer speaks for—by inscribing—the "primitive," whose timeless, unlettered world can be "saved" (redeemed, made permanent) only by the ethnographer—a salvaging that is also, in several senses of the word, a savaging. In contradistinction, Clifford writes:

What matters for ethnography is the claim that *all* human groups write—if they articulate, classify, possess an "oral-literature," or inscribe their world in ritual acts. They repeatedly "textualize" meanings. Thus, in Derrida's epistemology, the writing of ethnography cannot be seen as a drastically new form of cultural inscription, as an exterior imposition on a "pure," unwritten oral/aural universe. The logos is not primary and the *gramme* its mere secondary representation. (117–18)

Clifford's critique (from within) of anthropological practice (a writing practice) is equally pertinent to anthropological theoreticians of literacy like Jack Goody, whose several books

on the subject suppose the ethnocentric value of writing that Clifford quickly dismantles. Clifford has in mind even more explicitly Walter Ong, whose name soon appears in his discussion and whose arguments (also found in a number of books) are most readily available in his "New Accents" volume, *Orality and Literacy*. Its title summons up the motivating opposition that governs Ong's discussion as it pursues its version of what Brian Street would call the "autonomous model" of literacy. Ong's work is representative; he has read widely, and he proceeds under the aegis of many social scientists, psychologists, anthropologists, and historians of writing who subscribe to and, in one way or another, reinscribe Clifford's ethnographic allegory.

"The notion that writing is a corruption, that something irretrievably pure is lost when a cultural world is textualized is, after Derrida, seen to be a pervasive, contestable, Western allegory," Clifford writes (call it the Fall). "Walter Ong and others," he continues, "have shown that something is, indeed, lost with the generalization of writing. But authentic culture is not that something" (119). Rather, Clifford's argument implies, what is lost is a powerful tool of ethnocentricity. Lost, too, is a basic model for historical criticism which, at least in literacy studies, organizes its narrative as a movement from the oral to the literate (and not only at the supposed beginning of history; it is regularly invoked as one way of marking moments of historical transition, as for instance in Eric Havelock's studies in ancient Greek literacy).

What remains problematic is the question of what is gained, how ethnography is to proceed when it can no longer tell its contestable story, or how the recognition that "all human groups write" can be mobilized for work—including this book—that seeks to register (in Raymond Williams's phrase) "diverse historical and cultural conditions" (3), here specifically the promulgation of writing in Renaissance England. How is writing in its narrow sense (and the particular forma-

tions that mark it, the institutions that regulate and dissemi-
nate it) to be distinguished from and situated within writing
in its broader frame? If a Derridean analysis denies the preju-
dicial markers of those with versus those without writing,
what terms for difference are offered instead?

These are, of course, the disturbing questions raised by
Derrida's reading of the writing lesson in Lévi-Strauss, for
Derrida's own allegorization of Lévi-Strauss, made in the
name of philosophical rigor, also violently imposes its over-
arching categories upon the scene that the anthropologist wit-
nessed and precipitated. If it is illegitimate for Lévi-Strauss
to read the Nambikwara writing lesson as an exemplary mo-
ment in the history of the west, it is equally illegitimate for
Derrida to do so, especially when his generalization dispels
the particulars. Granted, writing, in its broadest sense, cannot
be viewed as the imposition of the outside upon the inside, as
a violence done upon the innocent; nonetheless the scene that
Lévi-Strauss describes is one of violent imposition. It is just
such complicities between anthropology and colonialism that
trouble *Writing Culture* as well; the recognition that everyone
writes, that there is no culture without violence, cannot efface
the historicity of the discipline or the specifics of the scene
among the Nambikwara, differences in the extent and kinds
of violence that attend upon all historico-cultural formations.

Nonetheless, more differentiated terms than the ones used
by theoreticians like Ong or Goody are needed, for theirs drop
away in a Derridean analysis: on the one hand, they wish to
preserve the pristine oral culture as the place of face-to-face
encounters, an unalienated and virtually Edenic embodiment;
on the other hand, however wary they are of writing (in Ong's
subtitle literacy is called "The Technologizing of the Word"),
they also see it as the instrument of rationality, science, ob-
jectivity, subjectivity, history—in short, as the bringer of cul-
ture and civilization. These are the two sides of logocentrism,
easily recognized as the plot of Clifford's ethnographic alle-

gory. Nevertheless they do raise a question that needs to be asked; as Clifford indicates, Ong questions whether calling everything writing is not itself a further act of violent encroachment, an imposition of the terms of modern civilization upon all cultures and all moments in history. Ong in fact writes that Derridean deconstruction is guilty of "historically unreflective, uncritical literacy"; "the most text-bound of all ideologies, . . . it plays with the paradoxes of textuality alone and in historical isolation, as though the text were a closed system" (168–69).

Although this charge seems to me to rest on a misunderstanding of the much misunderstood statement in *Grammatology* that *"there is nothing outside of the text"* (158) (*"il n'y a pas de hors-texte,"* 227), it still raises questions that need to be asked. How can the relationship between writing in its extended and in its narrower senses be articulated? How can the globalizing and universalizing of the term "writing" also be used to re-mark historic and cultural difference? How, to come closer to answering the questions, can "writing" (as employed by Derrida, in its widest sense) be recognized not as a term of self-identity (not, that is, as a term that makes all texts one text, all textuality an instance of self-sameness) but as itself a term for difference, a term that means to mean difference? Asked that way, one can at least begin to situate what kind of work the Derridean term might be set to do; it allows one, too, to see that the risk, acknowledged in *Grammatology* (and not least by its very use of the term "writing"), of a complicity between deconstruction and that which it seeks to deconstruct is a real one.

These questions are, in a variety of ways, at the heart of many current debates about deconstruction; Derrida's answer (as in the afterword to *Limited Inc*) has been to insist that his work has not been read. As I have indicated already, that does not seem to me to be enough of an answer, yet it does at least offer a first step. However broadly it is outlined, there is a

"cultural graphology" projected in *Grammatology*, and there is an attempt to articulate through the problematic of writing (again, in very broad terms) questions of history and difference (the two are entwined in the term "differ*a*nce"). "Of Grammatology as a Positive Science," the concluding section of the first part of *Grammatology*, is the locus for these concerns, opening with a recognition of "writing being thoroughly historical" (75) and closing with a breathtaking paragraph on writing in the narrow sense that has at least as much bite as Lévi-Strauss:

The fact that access to the written sign assures the sacred power of keeping existence operative within the trace and of knowing the general structure of the universe; that all clergies, exercising political power or not, were constituted at the same time as writing and by the disposition of graphic power; that strategy, ballistics, diplomacy, agriculture, fiscality, and penal law are linked in their history and in their structure to the constitution of writing; that the origin assigned to writing had been—according to the chains and mythemes—always analogous in the most diverse cultures and that it communicated in a complex but regulated manner with the distribution of political power as with familial structure; that the possibility of capitalization and of politico-administrative organization had always passed through the hands of scribes who laid down the terms of many wars and whose function was always irreducible, whoever the contending parties might be; that through discrepancies, inequalities of development, the play of permanencies, of delays, of diffusions, etc., the solidarity among ideological, religious, scientific-technical systems, and the systems of writing which were therefore more and other than "means of communication" or vehicles of the signified, remains indestructible; that the very sense of power and effectiveness in general, which could appear as such, as meaning and mastery (by idealization), only with so-called "symbolic" power, was always linked with the disposition of writing; that economy, monetary or pre-monetary, and graphic calculation were co-originary, that there could be no law without the possibility of trace (if not, as H. Lévy-Bruhl shows, of notation

in the narrow sense), all this refers to a common and radical possibility that no determined science, no abstract discipline, can think as such. (*Gram*, 92–93)

"It is not enough to denounce ethnocentrism" (84), Derrida opens a particularly dense paragraph in the course of his discussion. I would like to read this passage attentively, to see how in it the Derridean categories of trace and differance, and with them the concept of an *arche*-writing (writing in the broad sense), also offer terms for a relationship to writing in the narrow sense. Derrida's terms are often understood merely as semiotic markers that call into question determinate differences (since differance differs and defers); that rob the sign of substance (since the trace is both the "originary" mark and its erasure); that seemingly render all linguistic signs the same, catching up all moments (even including an originary moment) in his *arche*-writing. Such a way of reading Derrida sees his project as destructive, not as deconstructive, I would argue; moreover, it negatively retranscendentalizes his critique. Looked at closely (and that will not be a simple or straightforward task), this passage may suggest some of the ways in which deconstruction engages (and resituates) history and materiality.

Reading the passage will also help to answer the questions I have been asking: How then to avoid the danger that particular forms of social and historical violence will be regarded as simply one more instance of the undifferentiated field of writing? How might a new historical practice take its cue from the non-originary origin that Derrida calls writing? How might that term, rather than acting to efface difference, be mobilized towards the recognition and registration of difference? What history of writing would follow from grammatology, and how might the equation of history and writing that opens the third part of *Grammatology* be situated in relation to history, as the term is ordinarily understood, or to economics

or ideology, as it is in the sweeping paragraph that ends the section? What new understanding of history is implicated in its equation with writing?

Relying upon the anthropologist Leroi-Gourhan, Derrida sketches some answers as he redefines history, from the start, in a non-originary origin. I will attempt to read these difficult sentences, beginning with "the history of life—of what I have called differance—as the history of the *gramme*" (84). Genetic programming, Derrida argues, is the first inscription, and life develops in the movement from being written to writing being. Being written might be termed the first metaphor, but it is also literality: what is, what existence is, literally, is writing. A retroactive textuality will rename this origin, calling it nature, the oral, shielding it from writing and shielding life, too, from a program—a technologizing, from the start—that troubles the distinction between human life and the machine, between life and death, which are, in this Derridean paradigm of originary inscription, born together. Mortality is the relationship between inscription and effacement, an ineluctable pair. The Derridean origin-in-writing is as much life as it is death, a finite system of infinite indetermination (this is the mathematical logic of the computer, and that writing communicates essentially with the Derridean trace, just as all mathematical notation argues against the logocentric bias of the alphabet).

It is perfectly clear why such a version of the origin would trouble Ong's theologism, for it denies the word and the logos, troubles the category of the human and of divine creation. There is, in Derrida's argument, no origin, and no possibility of writing history as a movement that commences in an undifferentiated origin (the pristine world of orality). Yet the doubled origin offered instead does not install a textuality once and for all in place. Life, rather, is differance, the *movement* of the trace, of "the trace as the unity of a double movement of protention and retention" (*Gram*, 84). The con-

cept of this movement is difficult to think because it abandons the "vulgar" concept of time aligned to the conception of writing as linearization. It says that at any moment (but the concept of the moment also must be written under erasure, since it implies a succession of bounded temporal units each of which can be imagined as saturated and self-present) the moment is not full of and in itself but *is* rather only insofar as it is a relationship between past and future. The past is only retroactively determinate in terms of the future possibilities that coexist in any moment; thus even the "original" trace has a past, a past made in the very structure of the trace as an entirely differential structure. Hence no historical moment can be seen as fully self-saturated, self-identical, and present in itself; but this does not mean that all moments, because they are differential, are one and the same. Rather, it is that differential structure that defines the historical movement of the trace.

The trace as differ*a*nce differs and defers. This well-known redefinition of the Saussurian sign also describes the twin and intertwined movements of history. Time cannot be stopped if what the trace holds is a reserve; this is the protentive side of its retentiveness. "It is an emergence that makes the *gramme* appear *as such* (that is to say according to a new structure of nonpresence) and undoubtedly makes possible the emergence of the systems of writing in the narrow sense" (*Gram*, 84). The *gramme as such*: this is another way of describing the originary trace from which writing in the narrow sense is a derivative effect, not, it should be added, as a determinate or necessary effect, but as the possibility that is written into the trace structure and its differ*a*ntial reserve. Unlike theoreticians of literacy, Derrida is not positing a technology of the intellect; this structural possibility is entirely mindless. Nor is he arguing that writing has determinate consequences (that it entails rationality, a historical sense, and so on). Rather, possibilities, which will always involve (non)relationships between differential pairs, are implied in the differential structure of

protention and retention, the movement of the trace, which is not an unfolding towards a predeterminate end nor an infinite expansion; it is, rather, an indeterminate expansion within a definite (retroactively defined) end.

Difficult and abstruse as this argument is, it has immediate and recognizable consequences. From the amoeba to *homo sapiens* one follows a trail from one writing to another: "The possibility of the *gramme* structures the movement of its history according to rigorously original levels, types, and rhythms" (84). History is within the *gramme*, but since the *gramme* is not self-identical, its movement opens (has always already opened) the possibilities of definable differences of "levels, types, and rhythms." These broad categories are terms of difference, and they open the historical field, although not in a completely familiar fashion. This history is multiple, never fully determinable (a complete determination would stop history, make change impossible), but not indeterminable. History may be read as texts are.

What this means is suggested by Derrida's painstaking reading of Rousseau in *Grammatology*. Deconstruction attends to textual movements—to what sustains them unsustainably. It attends to what regulates the text, but also to what exceeds it, both "a determined textual system" (*Gram*, 160) and its exorbitance. This doubleness also marks the historical, for any differential system is sustained by that which also fails to sustain it; were that not the case, there would be no history. If, for Derrida, the large name for the sustaining principle is logocentrism, the equally large name for that which is within and yet exceeds it is writing. History, in the broadest sense, can be understood as the relationship between these terms (it is not simply a dialectic since the terms are not merely oppositional). History is capable of being understood more specifically as well.

The movement of history/writing is summarized by Derrida in the paragraph I have been unfolding: "from the ele-

mentary programs of so-called 'instinctive' behavior up to the constitution of electronic card-indexes and reading machines" (*Gram*, 84); from being written to being writing, once again. Still relying on Leroi-Gourhan, Derrida rephrases the history of writing, from the general to the particular meanings of the word: "The history of writing is erected on the base of the history of the *gramme* as an adventure of relationships between the face and the hand. . . . Leroi-Gourhan describes the slow transformation of manual motricity which frees the audio-phonic system for speech, and the glance and the hand for writing" (84). Oral and written are derivative, then, from the handedness of the human. As Raymond Williams says, there are "relationships embodied in writing" (3). For Derrida, that is literally true; the writing being is also being written, whether at the instinctive level or while writing at the computer. In the relationship between writing in the general and in the specific senses—in relationships which are not merely at the order of conceptuality, but which are also social and historical—the field of a differential inscription of human being comes into view. In the chapters that follow, I pursue these relationships between the hand writing and handwriting.

There is then a history of technology that is also the history of "man," the programmed/programming machine: the human written. The human cannot simply be returned to the divine/oral origin; the hand is there from the start, as the locus of retroactive redetermination. Thus, from the start, the written being and the writing being are coincident and differential, opening and enclosing at one and the same time interiority and exteriority, the human and the technological, the mind and the body, speech and writing in their narrow sense; from the start, the relationships between these and all other differential terms exist within the possibility of protention and retention and the differential possibilities of rhythms of emergence. Because the opening is not foreclosed, because

the system is not static and at rest but in movement from the start, these relaying structures are not "there" all at once except within the possibility of a structure that is never there all at once. That possibility is the structure of the trace as reserve and remainder; that structure is history, the enlarging of "differance and the possibility of putting in reserve" (*Gram*, 84).

If a deconstructive reading attempts to return to this non-unified unity and this non-originary origin, it attempts then to read historically, albeit at "another level of historical experience" (*Gram*, 85), not that recognized in the "vulgar" concept of history as the line (history as alphabetic script). The relationships between these two histories can be likened to the psychoanalytic paradigm, for the patient discovers that the biography that might be told consciously is not the story of the unconscious; hence, Derrida describes the deconstructive history as the repressed, and linearization as suppression of that other history. The relationships between these two histories can also be likened to the Marxist paradigm, for linearization is also "capitalization" (*Gram*, 85) with its reserve structure (there is a surplus at the start) and its unveiling of hierarchization. The Derridean paradigm differs from these models: the unconscious is not timeless or universal, but historical; capitalization is always already "present" (which does not mean that all historical eras are the same). This paradigm, however, does not deny the most radical aspects of Freud or Marx; it wants to think them insofar as possible outside of the metaphysical tradition, outside of the logocentrism which supports those interpretive systems, and which they nonetheless also disturb.

Thus to read deconstructively/historically on the line can be to practice an ideological reading, for the possibility of linearization (read, within literacy studies as the telos of script, the realization of rationality, the apex of civilization, and so on) "has been structurally bound up with that of economy,

of technics, and of ideology. This solidarity appears in the process of thesaurization, capitalization, sedentarization, hierarchization, of the formation of ideology by the class that writes or rather commands the scribes" (*Gram*, 86). That statement (perhaps one of those that Derrida claims have not been read) provides the program for *Writing Matter* as much as the long passage cited above that closes the first part of *Grammatology*. Granted, then, such an ideological reading, attending to historically differentiated "rhythms, levels, and types," is only gestured towards in these sweeping statements. But if Derrida problematizes history in the ordinary sense, and goes no further than announcing the problematic, that does not incapacitate practice; if he is wary of histories that tell a single and determinate story (the story of oppression, for instance, or the story of the Fall, for another, not unrelated narrative), he offers the possibility of other ways of telling history, ones that could be as attentive to oppression and closures, to institutional determinations and acts of violence, but that would also see these as never entirely closing off the structures that exceed them.

To write an episode in the history of writing that also attends to the *gramme as such* is the grammatological task of *Writing Matter*. (This is also Derrida's aim in *Grammatology*— "we wish to identify a decisive articulation of the logocentric epoch," he writes on page 162—although his analysis is conducted at a level of interpretation that attends to writing in its broadest sense.) It is, as I understand it, only possible to avoid writing a positivistic history by not losing sight of the problematic of writing/history in the broadest sense, yet my aim in the pages that follow is also to consider writing as a material practice, and one that writes materiality and the hand in its writing lessons. The "decisive articulation" I wish to investigate thus involves the materials of and the material production of the hand/writing within the politico-social spheres of power and institutions of writing in the English Renais-

sance. Attending to "a determined textual system," I wish to read the ideology of mastery and idealization of the hand/ writing and to deconstruct these texts, for my reading seeks to function as a political intervention in a scene of writing that we still inhabit (as teachers, as humanists, as literate, or —even—as signers of our names). My choice of Renaissance England as a locus of investigation does not mean to posit it as the singular origin of modernity for the English speaking world; it is not the place of the first signature or the origin of writing. As mentioned earlier, it holds a particular place in the history of handwriting; moreover, sixteenth-century England is often regarded as a site of educational expansion, of unprecedented extensions of literacy. What this newly extended written literacy entails is one of my concerns. The fact that it could be extended, even beyond the institutional sites meant to regulate it, is another. That the manuals I will be reading were printed and disseminated means that I read the technological situation not in the manner of Elizabeth Eisenstein (as one more episode in how we all became more rational, scientific, individualized, and democratic) but as a technology that goes hand-in-hand with the ideological formations of the Elizabethan hand.

I will return to these larger concerns at the close of this chapter. What I wish to offer now is a representative example of a deconstructive reading of a pedagogic text and of the site of writing within a programmatic, regularizing pedagogy. Ong's objections, I recognize, have not been fully dealt with by a reading of Derrida, or by announcing the possibility of pursuing a program implicated in but not undertaken in his work. I want to turn to Richard Mulcaster's *Elementarie*, for it, I believe, does answer Ong's charge. It writes writing, or wishes to, as an imperializing gesture. A deconstructive reading of that text will show, then, both its attempts and its failures, will show, in a word, why there can be a world of difference between the Derridean insistence that there is noth-

ing outside of the text and Mulcaster's intonation of rather similar-seeming notions albeit in a quite different register. The reading that follows is governed by deconstructive protocols, and it reads and unravels Mulcaster's text slowly; in the final section of this chapter, I will turn to the broader historical consequences that situate this reading. Some readers may prefer to skip ahead.

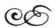

Richard Mulcaster, headmaster of the Merchant Taylors' School from its founding in 1561, had promised in his 1581 pedagogic treatise, *Positions*, to provide a detailed educational curriculum. *The First Part of the Elementarie* (1582) is proffered in partial fulfillment of that promise: "this Elementarie institution, wherein I entend to handle all those things which young children are to learn of right *reading, writing, drawing, singing,* and *playing*" (5). The elementary or petty school was where a child's education began, installing the fundamentals of a literacy assumed when the child passed on to a grammar school like the one Mulcaster ran. As Mulcaster frames it, the elementary is a social institution for literacy, and its curricular program means to assure a definition of a minimal literacy recognized within these social and institutional sites. To assume that there is a place in which literacy is offered, however, and that there is such a minimal requirement, entails other and opposing assumptions: that no other place could install literacy, and that nothing before or outside of such an institution could count as literacy. The *Elementarie*, thus, within its particular terms, faces a question of origin— of the instituted origin of literacy—and would mark that determinate point and place of origin as entirely differentiated from a prior (non)place of illiteracy. It draws the place of difference much as historians of writing do when they decide that only an alphabetic script counts as true writing.

Mulcaster's book is remarkable because it is unable to accomplish what it sets out to do; one imagines that Mulcaster will simply proceed to describe the curriculum of the elementary school. That is not, however, the way that the *Elementarie* proceeds, which is why it is worth examining in some detail. Except in forecasts or foreshortened summaries, Mulcaster never delivers the five stages promised; he is, in fact, in the closing sentences of the last chapter of the book, "*Of the natur of an Elementarie institution*" (ch. 27), still attempting to begin: "I will streight waie in hand with my first principle, which is that of *Reading*" (229). The book never begins within the terms of its own founding intention—it can never get it "in hand"; it is forestalled at instituting its elementary (and elemental, originary) institution. It is forestalled "in hand," that is, within a non-originary origin which makes it impossible for the book ever (within its intentional structure) to begin. Writing is the troubling element in the elementary.

The elements of the "Elementarie institution" that Mulcaster intends "to handle" (5) are in fact named in that opening description: the problems of institution, elements, and the hand, what the child is to learn of "right," hinge on the problem of what the child is to learn to write. Facing a problem of origin, of describing the institution of literacy as a break (with non-literacy) that would be foundational, a manual textuality insists upon itself to the virtual ruin of that intention, for Mulcaster would install writing, "the right writing of our English tung," as the title page puts it, at the origin, and this turns out to be impossible. Most immediately, for Mulcaster, there is no right writing because there is no uniform orthography (a topic to which I will return in "Letters Themselves"), but the orthographic dilemma ramifies to the larger question of writing (the Derridean problematic of writing) as Mulcaster's instituting gesture looks backward for an original guarantee, and forward to a schooled and literate society.

Writing and "righting" are the coincident aims of the trea-

tise, an attempt to install right writing from the start—before the elementary begins, so that its progression from reading to writing will guarantee the submission of the tongue to script (reading is the reading aloud of a script that the child cannot write). The proposed five-part schema is thus forever interrupted by the attempt to found it within a principle that is, within the curriculum, secondary (the child proceeds to writing only after learning to read). Right writing is Mulcaster's *arche*-writing, and it needs to be installed before vulgar writing can assume its secondary position. Secondarity and doubling trouble the *arche* from the start, however, as the double right/write might almost of itself suggest. Writing can never be right: Mulcaster's *arche* right writing is exploded by the Derridean *arche*-writing—writing in its broad sense.

Mulcaster's *arche*-writing is not Derrida's, therefore, and it is through a Derridean analysis of the ruin of his *arche* by its secondariness and doubleness that one can read Mulcaster's *arche* as an ideological gesture (for making writing right at the start would institute at the origin an ideological foundation; "right" ramifies in all sorts of directions—social, moral —installing and meaning to stabilize hierarchies of value and class at the beginning) and see its impossibility. One can read Mulcaster's *arche* through Derrida's *arche*-writing because of Mulcaster's attempt to transfer an originary value from a secondary place; so doing, his institutional gesture is seen to be unsupportable (cannot be supported by the origin it wishes to found), as is evident more simply by the fact that Mulcaster cannot fulfill his elementary designs; the intention to describe the five-part elementary is baffled conceptually (by the broad field that goes under the Derridean name of writing). The sign of that bafflement inheres in the duplicities of right writing. Submitted to a deconstructive reading, Mulcaster's *arche* reveals the social, historical, and ideological work that is involved in the attempt to found an origin. And here, since that origin is inscribed within a pedagogical apparatus and

structure, that institution's *arche* is (un)founded. Not merely a philosophical dilemma is involved.

The elementary problem in instituting the elements of education lies in the letter; "element," the word for an indivisible natural, material foundation, is from the Greek word for "letter." This problematic duplicity in literality, which undoes the origin, is nonetheless, for Mulcaster, the resource of language: "The number of things, whereof we write and speak is infinite, the words wherewith we write and speak, be definite and within number. Whereupon we ar driven to use one, and the same word in verie manie, naie somtime in verie contrarie senses . . . as letters, wherewith we write, & letters which hinder" (92). It is "letters" which "let" Mulcaster's treatise proliferate within the simulacrum of right and write (as identifications) and which "lets" (prevents) the *Elementarie* from ever proceeding beyond its elementary duplicity. One value of English, Mulcaster contends in his closing peroration, is that *"it doth admit such daliance, with the letter, as I know not anie"* (268). English alliteration is a great pedagogical tool, for it is through reiterations of the letter that the pedagogic subject is inscribed. Thus, as these citations begin to suggest, Mulcaster's desire for the origin and the definitive institution of the elements is itself split by the letter. Why this should be so, ideologically and politically, we will soon see. But, for the moment, let us turn to the origin itself—how the duplicating letter writes the elements, nature, and human nature.

Summarily put, inscription must already have occurred for the subject to be (re)inscribed within the pedagogic scheme. "The beginning of everie thing is of most moment, chefelie to him, that is young and tender, bycause the stamp is then best fashioned, and entreth deepest, wherewith ye mean to mark him, and the sequele will be such, as the foretrain shall lead, whether soever you march, bycause naturallie the like still draweth on the like" (23). Mulcaster is here translating Plato; he continues by transferring the textual inscription of

the child to his own reading of Plato and to the pedagogic function of his text: "These words, as theie ar wiselie uttered by the grave philosopher, so ought theie to engraf both in parents and masters a depe impression to observe them as carefullie, as theie be spoken trewlie" (23).

If, within educational progress (from reading to writing and beyond), the first step is overtaken by the second one, foreclosing the possibility of arriving at the first step, that is also the case in this originary elementary inscription of the child; it is within nature, Mulcaster says, that like draws upon like. So, in the sentences cited above, the pedagogic relationship reads nature. The inscribed nature so delineated is that of right and write, playing on the letter; the pedagogic "sequele" marks the natural "foretrain"—the text that "engrafts" (grafts and engraves) parents and masters (that is, teachers) must be marked by them and must re-mark them (with "a depe impression") to re-mark the child (stamped "deepest . . . to mark him") within a secondary scheme of duplication in which the child is to be written—at first—to receive the human mark.

In other words, there can be no "right" nature for Mulcaster except that which is written. He provides terms for this duplicity in the distinction between "mere being onelie" and "well being" (30). Only the latter is genuine human being, a secondary institution that re-marks "mere being" as human through a retrodetermination (returning the elementary to the elements). That is, as Mulcaster writes, it is only by "wiselie marking, whereunto natur is either evidentlie given, or secretlie affectionat" (28) that nature is realized and brought "to artificiall perfection." Mulcaster's elementary is grounded in this re-marked nature: "I ground my argument that this must nedes be a verie good Elementarie" (29), grounded, that is, in the re-marking, perfecting, and making-artificial of nature, reading it as already written towards the rewriting of the initial human stamp and impression. "Where natur hir

self offereth verie good hold, there art must be at hand and redie to take it" (29); nature lends a hand to the hand/writing nature.

What nature offers in its "mere being" includes "in the hand an abilitie to catch and hold . . . in our minde an abilitie to forese" (29). Thus, what Mulcaster re-marks is also what he foresees (this also describes the structure of the pedagogical scheme), and conceptual grasping (retrodeterminative foreseeing) is one with the grasping of the hand (writing rightly). Nature, at the first, follows this seconding: "Natur sheweth hir self to be verie well willing to follow the hand of anie such a trainer" (30). Nature here is the pedagogic subject, or remarked as such. The "as such" of nature is its inscription as the *gramme*, or here, in the trained hand of the grammarian, who writes the elementary "foretrain" retrospectively. Through the "handling" (30) of nature, mere being is made right; if in "his mere being . . . he be but half a beast" (31), in his humanity, being is "fined, to the most civill use" to arrive at "his well being, whereby he is likest him" (31). Best being, right being, is the being written, identical to itself in its resemblance: the structure of the written simulacrum that defines the protention and retention in which written being is written from the beginning and the end.

We can begin to see what kind of ideological and political work this inscription of the pedagogic subject serves when we recognize that it also describes the position in which and from which Mulcaster writes, not only in the retroactivity of the secondary grounding of the elementary sequence of his pedagogy, but also of himself, the self-remarking of the writer. Mulcaster writes towards "redresse" (3), towards the re-marking of the subject by an authoritative other whose existence is postulated as a future possibility (a future made possible by the retroactive re-marking of his writing). Only at that time, and for such authoritative readers, will his book

be legible; since it writes as the elementary, it can only be read within re-marking. "At which time my labour shall find frute, tho my self be not found: and my wish shall take effect, tho my self be no partaker" (3). Mulcaster writes himself within the always deferred structure of his *Elementarie* and within its rewriting of nature and its elements.

Writing thus has the status of a reserve, the structure of protention and retention. This can be mobilized towards ideological work (this is, in a variety of ways, why Mulcaster needs the duplicities that undo his scheme), but it is also what overcomes the possibility of the stabilization of an ideological and political program. The politics of this pedagogy, then, coincides with the textual effects that I have been describing. They are, to summarize: the impossibility of describing "mere" nature without having already assumed "perfect" nature; the impossibility of outlining the sequence of elementary topics without having already transposed the second element (writing) to a primary position; the impossibility of Mulcaster's presence in his text, which awaits a future reception that will find the writer dead and absent. In its grounding assumptions, in its institutional aims, in its structure of the writing subject, then, the *Elementarie* defines its element in the duplicities of the letter.

The word in Mulcaster's text that covers all these issues is "fining," refining, defining, finishing, a word that attempts to draw the boundary between nature and art, past and future, mere animal being and human being. The word attempts to structure the right writing that would need to be in place before the system could work, but were it in place, it would foreclose—finish—the entire system. For fining is also an apparatus of censorship and stoppage, attempting to fix and stay what is always on the move, language itself, which is, for Mulcaster, written language; another name for it is grammar, and once again one encounters a retrospectivity that operates from the first:

Grammer travelleth first to have the naturall tung of ech cuntrie fined to that best As how to reduce our English tung to som certain rule, for writing and reading, for words and speaking, for sentence and ornament, that men maie know, when theie write or speak right To fine our own tung, or to learn a foren, we ar much bound to grammer. (49–50)

Grammar is here the secondary school that marks the elementary; it is Mulcaster's institutional re-marking; and it is the national language which, like nature itself, submits to "certain rule."

The artifice of grammar is positioned as a transcendental ruling principle, but, in fact, this is not the case: the ruling principle of language is, Mulcaster insists, custom and prerogative. This latter—as the term "prerogative" makes absolutely clear, although tied to the monarchy (as custom is tied to the common law)—also submits to the Derridean *gramme*, in its prerogatives forever violating the borders that must be maintained. Mulcaster's extraordinary myth of the origin of writing (ch. 12 of the *Elementarie*; I will return to it in "Letters Themselves"), in which script, at first subservient to the tyranny of sound, finally refuses to serve sound alone and subscribes to custom and reason, offers the most extended narrative of origins. In Mulcaster's myth of the origin of writing, each stage in it is ratified by writing; there is writing before writing. (For example, agreeing at first to the sway of sound, the deliberation ends: "Whereunto theie subscribed their names, and set to their seals the daie and year, when their consent past," 65.) The pen comes to rule, as in this summarizing—and circular—formulation:

In this writing *prerogative*, the verie pen it self is a great doer and of marvellous autoritie, which bycause it is the secretarie alone, and executeth all, that the wit can deliver, presumeth therefor much, & will venter as far, as anie counseller else, of what soever calling, tho never against *reason*, whose instrument it is to satisfie the sight, as

the tung doth the ear. *Custom*, (whose charge *prerogative* is, as the pen is his conveier) favoreth the pen excedinglie much. (160–61)

The secretary and the pen seem to pre-exist the founding of the institution of writing. The prerogative of the pen exceeds the borders, and it is unclear who is in charge, as the meaning of "let" coincides with its opposite: the instrument and conveyer conveys what would limit it, custom and reason, founded in the prerogative of the writing instrument, that elementary institution.

Here, rather than about Derrida, Ong's charges are true. There is for Mulcaster nothing but writing, and the writing he would institute is ideally fixed; in its rule and prerogative it is the hand of power. Yet, as the deconstructive reading I have been attempting also suggests, that hand is undermined by the structure of writing as Derrida describes it, even, despite his aims, as Mulcaster describes it. It is writing in Derrida's generalized sense of that term that impedes the generalization of writing that Mulcaster attempts in founding a right writing, a determinate textuality that would bind past and present in a single script. Mulcaster's text, then, is written, as it were, with two hands (*gramme* and grammar), within the duplicities of the letter. If this means that there can never be a firm foundation for Mulcaster's *Elementarie*, it also means that that lack serves a more divided power, for putting into reserve, defining limits, righting writing, is also a stratagem of power. However, it, too, is written with two hands. It is time to consider the broad political and ideological purposes of Mulcaster's divided elementary.

On the one hand, Mulcaster writes his *Elementarie* for anyone, anyone human, that is; the extension of literacy to all serves the needs of state, reading and writing being the modes of inscribing subjects within structures of belief and obedience. Reading "shall catechise him in relligion trewlie, frame him in opinion rightlie, fashion him in behavior civillie, and

withall contain in som few leaves the greatest varietie of most syllabs" (21–22), thus alphabetizing the subject. Writing is copying; "the direction of his hand, whereby he learns to write shalbe answerable to his reading" (22). The educational apparatus is only for those who are "allyed naturallie to learning" (12), which means those who agree with Mulcaster's tenet that "the common weall is the measur of everie mans being" (ibid.), another transformation of mere being into its fined and final form; education is to make subjects "able to serve that publik turn, whereunto theie ar destinate" (14). An elementary education is for those who "chuse the pen & pencil to live by" (58), grammar school for those who will serve as lawyers and magistrates. The system maintains place and hierarchies of order. Pedagogy serves the state, just as Mulcaster is, he writes, "*bond to my cuntrie*" (272).

If the educational system is bound to the state (and thus to the staying powers that Mulcaster attempts in his project of right writing), however, Mulcaster is himself part of the pedagogic apparatus, attempting to further it within those designs. He is, at best, a notary, a secretary of state, not directly in the state's employ except insofar as the entire educational apparatus is an apparatus of the state:

It is an honorable conceit besides the incredible good, for a learned vertewous prince by the assistence of a like counsell, to reduce the professours of learning, by choice in everie kinde to a certain number, to make choice in points of learning necessarie for the state, to appoint out books for learning, both in multitude not to manie, and in method of the best. (251–52)

The process of selection starts with the ABC. The pedagogue is thus himself in a secondary position, and if he writes as subject to the state, and for the state, he does not write as the state.

Mulcaster's conceptual difficulty (of describing the whole elementary apparatus through the part, of installing a begin-

ning in an apparatus whose fining—whose end—remains un-
definable since the prerogative of language, the prerogative
of the prince, *is not in his hands* is thus not merely a fact about
(Derridean) writing itself. It is also, and fundamentally (ruin-
ing all foundational attempts), a fact about the educational
apparatus and its relationship to the state.

Thus, when Mulcaster offers his book to the Earl of Leices-
ter in the dedicatory epistle, he worries whether the mas-
ter of the queen's horse will be willing to receive the book.
Leicester's support of education, his patronage of Mulcaster's
school is duly noted. But Leicester is finally an apt recipi-
ent of Mulcaster's book on right writing, "pertinent to my
profession, tho seming not so proper to your estate" (*ir),
because "your honor both handle the pen your self excedinglie
well" (ibid.). Mulcaster negotiates the impropriety of what he
would put into Leicester's hand (right writing) by deriving his
own profession from what is proper to the noble hand. Leices-
ter's hand serves here as nature does in the treatise, to offer
the hand to the hand that then re-marks the originary hand
within its secondary apparatus. The structure of re-marking
thus serves also to mark places and limits, to assure that Mul-
caster's educational scheme has its place within the customary
and reasonable prerogatives of power and that his book will
fall only into the right hands (those who can read it already
or who can learn to read it, thereby being those whom the
state has marked out for an education). It will fall into those
"right" hands that have already been written and who there-
fore subscribe to (and thereby institute) the apparatuses that
have already written them.

Mulcaster writes his book to promote English, and En-
gland; right writing is needed in a country that is expanding
its bounds, trading abroad, involved in diplomacy. The lan-
guage needs not merely the grammatical prestige of Latin;
it must also displace that grammatical tongue, enfranchising,
as Mulcaster calls it (ch. 22), the foreign words and making

them English. This "enfranchisment" is akin to the "*libertie and fredom*" (254) that Mulcaster proclaims for English: "*I love* Rome, *but* London *better, I favor* Italie, *but* England *more, I honor the* Latin, *but I worship the* English" (ibid.). This is the liberty of a written language that follows its grammatical rules while ever heeding the prerogatives of a *gramme* that is cast by the ruling hand, a ruling hand, however, that is re-marked by the educational apparatuses which it maintains.

On the other hand, there are slippages in these "fined" designs, slippages of the ruling writing hand, hence Mulcaster's insistence on the role of reason and custom and of royal prerogative. The entire structure of secondariness writes the state apparatuses within the pedagogic scheme, *maintains* them quite literally, holding them in hand. "*Learned maintenance*" (248) is the function of a pedagogy that recognizes and re-marks that "*at the Princes hand, it standeth all them in hand*" (252), a recognition that it is also the function of the hand of the pedagogue to reinscribe from the start, as the elementary institution. Such is the "weight" of Mulcaster's style: "*everie word bearing weight, & everie sentence being well, & even that well well weighed, where both time doth lend weing, and the matter deserves weing*" (267). Thus will it "*print depe*" (266), giving "*time the turn*" (265), allowing for, making for, future legibility, a writing beforehand, in another hand, that assures weight as it waits forever, weighing well, storing in reserve.

The place of education is therefore the place of the doubly instituted elementary, and the conceptual aporias that (un)-found Mulcaster's treatise are also what insures that pedagogy maintains the state, subscribes to its demands, hierarchies, and exclusions, furthers its designs, *and yet* also and at the same time promotes the aims of the state within a script whose very functions of reserve (fining) are, by definition, incapable of definition and limitation. The quintessence of written language for Mulcaster is its prerogative. Mulcaster mobilizes an apparatus of power that at once puts in reserve and destines

towards a future whose final fining cannot be determined: "*First & last, . . . fal not in view togither at one time*" (232). The institutional gesture attempts to bind first and last together in a maintenance that is always on the move. That movement at once secures power but *also hands over power*; it entwines (as inextricably as etymology does) grammar and the *gramme*.

The aporetic structure of Mulcaster's *Elementarie* ramifies beyond its immediate textual site, perhaps as far as Derrida suggests in "The Principle of Reason: The University in the Eyes of Its Pupils," in which the "double basis" of the educational apparatus is summarized as its "representative" function: "The university has *reflected* society only in giving it the chance for reflection, that is, also, for *dissociation*" (19), a dissociation that can be mystified (and perhaps is even in Derrida's formulation) when, as Antonio Gramsci puts it, "intellectuals think of themselves as 'independent,' autonomous, endowed with a character of their own, etc." (8). Mulcaster's text faces the crucial question of the place of the educational apparatus within a series of different domains: state power, the development of the (pedagogic) subject, the role of the teacher (the intellectual), domains that involve questions of the articulation of state power through the educational apparatus, family structures, class, and gender. The structure of re-marking in Mulcaster's text is this "double basis" within the larger social and historically differentiated spheres in which the educational apparatuses have their places in Elizabethan society. The always foreclosed and forecasted attempt to situate the elementary reads that site forwards and backwards: back from the grammatical and forward towards a social situation in which the educational apparatus has been institutionalized as the arm of a state power without limit, and yet one in which its encroachments also insist upon limits: the subjects of such a state have

been re-marked within (or excluded from) the pedagogical apparatuses.

Mulcaster's text can be read within the historical problematic named by Norbert Elias as the "civilizing process." Within the emerging national states of the Renaissance and the formation of what Elias terms the "royal mechanism" (2: 161), there arises a new class of secular intellectuals, as much the products of the social differentiation, centralization, and bureaucratization that marks that historical situation as the producers of it —through texts that delineate the differentiated, hierarchical structures that come to count as "civilization": structures of social and psychological management and control, a stylistic decorum that ramifies from textual purity to decorous behavior. The humanistic programs of education, which, of course, cannot be reduced to a single program and which need to be read differently in their various locales—from the "universalist" aspirations of Erasmus, citizen of the world, writer in Latin, whose work was textually reproduced through the apparatus of print, to the nationalist, Protestant, and vernacular culture of Mulcaster—are part of this civilizing process. It does not take place all at once or uniformly from state to state, but its aim, variously realized, is the production of the pedagogic subject, the installation of the pedagogic apparatus as the arm of an increasingly centralized and bureaucratized power, and the securement of a place for the intellectual within the bureaucratic operations of the state, opening a space for this emerging class through systems of restraint and decorum even as those values come to inscribe the ruling class as their ideology.

Some surveying the English scene, like Lawrence Stone, have regarded the situation as revolutionary: an extension of literacy on a scale hitherto unimagined and to classes before

then excluded from higher education; others (including Rose-
mary O'Day) have doubted Stone's statistics and the progres-
sive Whig bias in his account of this so-called revolution. But
what seems undeniable is the conclusion that Keith Thomas
reaches in "The Meaning of Literacy in Early Modern En-
gland," perhaps the best treatment of the subject: "The in-
equal spread of literacy thus gave a new cultural dimension to
social differences previously founded on wealth and power.
It reinforced the existing social hierarchy by enabling the
upper classes to despise their inferiors" (117). Consequently,
as Thomas states later, "What it did was to consolidate the
authority of the educated classes over their inferiors and to
impoverish and disparage other forms of expression" (121).
The educational texts of the sixteenth century are intent upon
a series of strategies that face in these multiple directions: to
secure the place of educational privilege (which means both
extensions and exclusions), to establish, that is, what Thomas
calls "a new cultural dimension," the dimension of culture and
civilization as Elias would describe them. This involves both
the formation of a new class of secular intellectuals (furthered,
of course, in England by the Reformation) and the reshaping
of the ruling class through these ideals, which serve to legiti-
mate new forms of wealth and power through the educational
apparatus and what Pierre Bourdieu and Jean-Claude Passeron
would term its "cultural capital." Mulcaster's difficulties in
situating the elementary play off the problems involved in the
formation of this new social elite, of carving out its territory
and spheres of influence.

At the center of humanistic programs was grammar, the in-
culcation of skills of translation, from Latin to the vernacular
and from the vernacular back to Latin. The pedagogic sub-
ject is established within a bilingualism that re-marks nature
and the native, mother tongue, within a paternal, foreign lan-
guage. Translation extends well beyond the writing exercises
that filled the notebooks of grammar school children, for the

proprieties that mark the hand are also behavioral paradigms for structures of decorous and refined behavior, techniques of denaturalized imitation that open, on a social scale, the pedagogic sphere of reflection: the civilized subject not only reflects the structures of power but also turns that reflection back as a mirror for those in power.

Such, for example, is the aim of Elyot's *The Governor*, a book which attempts to write the formation of a newly educated ruling class and which, at the same time, also serves as a mirror for the monarch written by one of his disaffected servants. Elyot wrote the book in retirement from court service; he had served, thanks to Wolsey, as Chief Clerk of the King's Council, a member of the secretariat in other words, an employed hand who turned his hand, employed for the state, to the double writing of his pedagogic text after his dismissal in 1530, trying, that is, to assert the value of humanist pedagogy for the governing class, and attempting to situate himself within the structures of power by asserting the value of the pedagogic sphere.

The place of the pedagogue within such higher reaches (where the texts of pedagogy and its ideological apparatuses did penetrate) was, as Mulcaster's dedicatory remarks suggest, insecure. Sir John Cheke, for instance, who tutored Edward VI in a program that might be taken as an exemplary scheme of humanistic education and its realization— the monarch submits to his tutor—was admitted to the Privy Chamber but was never a member of that inner council of power. Such, too, is the situation depicted by Ascham in the opening pages of *The Schoolmaster*, as he sits on the sidelines as members of the Privy Council meet after dinner. Ascham, of course, had served as his monarch's tutor (and claimed to have had a hand in Edward's education as well), and he was Elizabeth's Latin Secretary. The text of *The Schoolmaster* could be read as a depiction of the place of the schoolmaster, in relation to the court, but also to the aristocratic and gentle families

from which Ascham culled his pupils, a marginal position, like the one Ascham depicts himself in at the opening dinner party, which becomes a central one, as the party turns to questions of educational discipline and the formation of the "civility" of the ruling class. That civility is in fact represented by the kindly paternalistic figure of the pedagogue who serves in loco parentis, opposing the rod for the sake of a loving indoctrination into civilized and courtly values that seem more realized in the schoolmaster than, say, in the cruel parents of Lady Jane Grey. Ascham's text fosters double translation, and its rhetoric is also a modus vivendi, attempting to negotiate the position of a pedagogic class within the reformed courtly/ gentle society which the pedagogue claimed to form. Yet the pedagogue himself remains marginal, his text, as Ascham repeatedly registers, digressive: its style opens the sphere of the pedagogue, and it is a sphere of writing, a copious elaboration that exceeds the designs of Ascham's unfinished text. Ascham did not keep school; he wrote *The Schoolmaster*, attempting from the margins to rewrite the center of his society, the court as the apex of pedagogic culture. With Elizabeth on the throne, the project had some credibility.

A schooled society ruled by a monarch with impeccable humanist credentials: under such an aegis the claim that literacy is schooling could be maintained and furthered—that is, to return to Thomas's remark—the claim that certain forms of literacy count and that others are to be excluded. Stone's revolution is true in only this sense: that it represents the historic moment within English culture of the formulation of the values and claims still to be found in the work of modern historians of literacy, the movement charted by Anthony Grafton and Lisa Jardine in *From Humanism to the Humanities* (or dictating the work of David Cressy, measuring literacy through signatures and thereby deciding in advance what counts as literacy). Their account, scarcely laudatory, traces the formations of education towards state service like the secretariat-

ships we have noted in the careers of Elyot and Ascham, the ideological functions of an educational apparatus bent on the formation of a class of intellectuals with power (in the court or in the schools), thereby also depriving women and the lower classes such access in the name of "humanity." In the Elizabethan period, that value cannot be separated from hierarchies of class and power; pedagogy represents and reproduces the state in its differentiated and bureaucratized forms, and attempts to secure for itself a sphere of power as the place from which and within which the state is reproduced.

If this entails problems of the place of the pedagogue, not himself after all a member of the nobility or the ruling class, never holding a position of power within the inner domains of the Privy Council, tutoring the sons (and occasionally the daughters) of the nobility and gentry, it also means that pedagogic texts are bent, at one and the same time, at extensions that secure a place for pedagogy and subaltern classes (insofar, that is, as classes below the aristocracy are the classes producing humanists), and that yet keeps that sphere exclusive by not extending the apparatus too far. (On the whole, the English pedagogues who wrote educational treatises came from landed families, and while they promote an extension of the gentry to extend its bounds, that is as far as they go; to be educated is to be a member of the gentry, and education thus comes to confer class status.) Thus, Francis Clement's *The Petie Schole* (1587) or William Kempe's *The Education of Children in Learning* (1588), books written for lower-class audiences, hold out the value of education (often in transcendental and mystified ways as a treasure past all value) even as they maintain class differences and limits. Clement's book, offering, as its title says, "a method to enable both a childe to reade perfectly within one moneth, & also the unperfect to write English aright," aims at a "perfecting," a "finishing" like Mulcaster's, that also insures that its readers will pass no further than the elementary skills of reading, writing, and arithmetic.

"Teach a childe in the trade of his way and when he is old he shall not depart from it" is the biblical text (Proverbs 22) on the title page. Nonetheless, Clement also includes quotations in Latin (a letter of Cicero's most notably, in which the value of translation is the subject) as the grammatical forecast from which the elementary subject is barred and to which he is yet lured. To attain to the status of the educated petty is thus to have secured a place within the regimes that continue beyond the petty school—to the grammar school and the university. That beyond is, in Kempe's book, also a before, and the values of education are placed within the posthumous text of King Alfred, who lives on in (Kempe's) writing to offer the promise of heavenly reward for subjects who submit to their pedagogic translation. Kempe, in fact, offers a history of civilization which is the history of schooling, translations between Greco-Roman culture and Christian-English culture, a history, in fact, of writing in which the place of the pedagogic subject is written.

For Clement, this means taking children out of *"the worst handes"* (4), those of *"men or women altogether rude"*—weavers or seamstresses who set up to teach; he urges children to "the parish Clarke" to "Learne A,B" (9). At such a moment, Clement's text opens on the scenes of alternative literacies, other pedagogic sites beyond the regulated sequence of elementary, grammar school, and university that a text like Mulcaster's *Positions* attempts to prescribe as part of a regulated, uniformly directed apparatus. That is to say, Clement's book, proscribing such formations, glances at the channels of literacy that the new "humanistic" apparatuses would foreclose; his book, which scarcely would hold the door open to many to advance beyond elementary education, nonetheless would regulate the type and locale of education that will count as elementary. Like Mulcaster's *Elementarie*, the *gramme* communicates with grammar, through principles of exclusion and inclusion. It is within the virtually forbidden forecasted form

of additional education that the petty is foreclosed within the
elementary, learning to read and to write "A,B" and written
as an element within grammatical designs that would rewrite
the entire social sphere as an extended pedagogic apparatus.
Such, too, is the aim of Mulcaster's *Positions*, which wishes to
extend elementary schooling to all ("To write and read wel
. . . is a pretty stocke for a poore boye to begin the world
withall," 34; Mulcaster even suggests that tradesmen might
learn some Latin [245], and he favors education for women
—since it will make them better wives) and yet insists that
"there must be a *restraint* . . . all may not passe on to learning"
(141). The numbers of the class of intellectuals and state ser-
vants must be limited, ideally, if they would, to the nobility,
but in practice to those of the "middle" sort, with occasional
poor boys who show educational promise—a meritocracy of
those found "fittest," which means, Mulcaster insists, those
who display obedience to their masters. Favoring, beyond the
already prescribed catechism or the grammar of Colet and
Lily, set texts throughout the curriculum, separate colleges
for specializations (law, medicine, even teaching), Mulcaster
offers his book as an instance of the extension of state power,
aligning bureaucratized pedagogic apparatuses with the regu-
latory functions of those in power. "If that wit fall to preach,
which were fitter for the plough, and he clime a pulpit, which
is made to scale a wall, is not a good *carter* ill lost, and a good
souldier ill placed?" (137). The book bids for power by submit-
ting to power, reproducing the hierarchies of authority as the
"position" of its *Positions*.

The success of such designs is marked in Brian Street's *Lit-
eracy in Theory and Practice*, when he argues that what historians
of literacy regularly claim for literate skills are in fact skills in-
culcated by schools. This is explored brilliantly in an essay by
John Guillory on canon formation, which traces the history of
exclusions that have always operated to make sure that an ever
widening educational apparatus has always secured power and

privilege for a small number to the exclusion of many. Guillory's argument correlates with the thesis of François Furet and Jacques Ozouf in *Reading and Writing: Literacy in France from Calvin to Jules Ferry*. It is their contention that the history of literacy in France represents an uneven and multiple development, striated by social, geographical, class, and sexual divisions, which are maintained early on, for example, by keeping reading in the religious (and female) domain—inscribing passivity—and making writing a skill for those who keep accounts. Rather than seeing the school as the instrument of literacy, or the state and church as its promoters, Furet and Ozouf argue that literacy must be recognized as a culturally generated need, one that is met in ways that maintain social hierarchies and divisions, so that the extension of literacy is not automatically the opening of new domains of freedom or of political representation. Hence, the spread of literacy always correlates with social and economic inequalities. Literacy, they conclude, "represented the key to entry to the cultural model of the upper classes. Wherever we look, in every period, social stratification presides over the history of literacy" (303). Increasing literacy means the increasing inscription of subjects. Extensions of literacy redefine, but do not abolish, structures of class.

Such, too, is the case with the educational revolution initiated in sixteenth-century England, and if, by the close of the early modern period, literacy had spread on a scale hitherto unrealized, we cannot read that event as a sign of straightforward progress or democratization, but within the shifts of power and emergence of classes that secured their power and prestige through the values of "civilization" to the exclusion of those whose literate skills nonetheless kept them in their places. It is undoubtedly the case that from the sixteenth century on, there was an increasing need for literate skills (Peter Burke summarizes the situation in Renaissance Italy), but also a need to maintain these skills within the limits of an

increasingly differentiated educational apparatus. These needs are not merely or purely economic (Cressy's explanation for the spread of literacy); they are, as Furet and Ozouf insist, socially generated. Thus, even as more and more members of the lower classes gained literate skills and were indoctrinated into the belief that such skills carry with them social advancement, only a few (those who went to the "right" schools or had gained other forms of social certification, like money) attained to culturally prestigious literacy. This is true still, of course; these pages, written in a society that declares itself committed to universal literacy, will claim few readers. It would be naive to assume, as Derrida argues, that the modern pedagogic apparatus, with its ever more specialized and differentiated structure, serves no place in the larger social spheres; late twentieth-century humanists, no more than their sixteenth-century counterparts, do not operate in entirely dissociated positions; ours, like theirs, is a social dissociation.

It would be possible, and undoubtedly valuable, to continue this discussion of Elizabethan pedagogy, to specify the multiple and differentiated structures that have been glanced at in the preceding pages. Perhaps, however, enough has been said to suggest the choice of terrain for the chapters that follow and their particular concern, the formations of the Elizabethan hand. While it is true that there were multiple literacies in the period, what this book attempts to do is to explore the "foundations" of that highly valued literacy that comes to count as the only true literacy. The grammar school, the center of humanistic education, was a site of translation; Erasmus and Vives prescribed methods of notetaking, the storing up of copies, and the pedagogues instructed their students in the arts of translation that began in their hands and aimed at their arrival into the places that pedagogy promised and controlled. This is a course from the letter to literature and a reinscription of the pedagogic subject shaped by exemplary texts. It all starts, as Mulcaster's text suggests, in the hand; reading may

come first in the ideal course of study, but there must first be texts to read—texts chosen for their grammatical purity of matter and style. The style communicates from the first with the stylus, and that propriety of hand and text is re-marked within the elementary scene of the teaching of writing. It is to such scenes that I turn in the pages that follow.

For if the grammar school offered a double translation as its civilizing technique, it was to those who, ideally, wrote with two hands. As is well known to historians of handwriting, England in the sixteenth century arrived belatedly at the hand that marked "civilization" among continental humanists, the italic hand that had been developed by humanists (in fact from Carolingian script, not from genuine Roman examples) as an authentic antique hand. Armando Petrucci is the paleographer who has most thoroughly studied the phenomenon in Renaissance Italy, as the hand adopted by the Papal Chancery in 1431 (and thus known as *cancellaresca corsiva*) attained cultural dominance. Originally a humanistic hand, but also the hand of the papal secretariat, it became the hand that marked culture and class. Alongside it, and gradually replaced by the italic, was a mercantile hand, and Petrucci has examined the production of script, the teaching of writing in Italy, to see how class remained in the hand and how class mobility was negotiated through the hands. "Every epoch and every society can be better understood and evaluated by the use made of writing instruments, by the way in which they provide for the social distribution of the capacity to write and read, by the functions which they attribute from era to era to scripted products and their diverse types," Petrucci writes (*Scrittura e Popolo*, 9), in a programmatic statement that also underwrites *Writing Matter*. "In the course of the fifteenth century," Petrucci summarizes (*Letteratura Italiana*, 2: 520), "one sees in a more evident and crude manner a kind of graphic bipolarism of literate Italy, by which those who study and know Latin adopt the new humanistic script or its cursive varieties, while those limited

to a knowledge of the vulgar write in a mercantile script."
Some twenty years into the sixteenth century, Italians began
to publish books teaching the varieties of handwriting, pro-
moting the italic hand.

It is to these books that I will turn frequently in the pages
that follow since they are the models for the English hand-
writing manuals produced later in the sixteenth century. In
Italy, they come late in the history of a transformation in script
that had begun as early as Petrarch; in England they arrive
only a short time after the introduction of italic—by, as the
story goes, Petrus Carmelianus, Latin Secretary to Henry VII.
In the opening years of the sixteenth century, one can count,
almost on the fingers of one hand, those Englishmen who
wrote the italic script (Alfred Fairbank and Bruce Dickins
offer a list). By the close of the century, those with claims to
high literacy could manage at least to produce their signatures
in this culturally prestigious hand. In early modern England,
as Keith Thomas argues, multiple literacies can be aligned to
multiple scripts and typefaces:

Black-letter literacy [the typeface that corresponds to the secretary
hand] . . . was a more basic skill than roman-type literacy; and it
did not follow that the reader fluent in one was equally at home in
the other. And even if he could manage both forms of type, it did
not mean that he could decipher a written document. . . . The only
people who could easily read script were the privileged minority
who had themselves learned to write it. (99–100)

Or, rather, to write "them," for scriptive literacy was also
doubly marked.

I take that historical transformation in handwriting as the
guarantee of the study that follows. In the course of the six-
teenth century, when at least a dozen distinctly different hands
were written—varieties of secretary, the ordinary hand that
developed from earlier "gothic" scripts, as well as a number of
fixed hands used in the keeping of records of various branches

of the government and law—a new hand, imported from Italy, superseded the native types, not initially as the usual documentary hand, but as the hand in which to write private correspondence. It is the hand of the humanist pedagogues, and in England, unlike Italy, it is the hand of a centralized monarchy. Edward's exemplary humanistic education began in his hand; Ascham taught the queen to produce a handsome italic script. Alongside the centralization of the state in England went this monarchical subscription to the humanist hand, granting it a cultural prestige on a scale beyond that of any other European nation. Thus, as Joan Simon reports, "the first thing the master of Wolsey's school at Ipswich thought to send its patron in 1529 was specimens of the boys' handwriting" (109n). In 1554, according to Fairbank and Dickins, the first italic signature appears in the Common Paper of the Scriveners' Company, a guild whose membership swelled in the course of the sixteenth century as their services were in increasing demand in a culture more and more transacting its business in writing. (For statistics see the essays on the teaching of handwriting by Hilary Jenkinson and Herbert Schulz.) Copybooks produced in England taught both hands to those who could afford the price of purchase; even a text like *The Petie Schole* gives instructions in the production of both secretary and the italic hand. For if the hand was meant to secure class, it was also necessary for the scribes and secretaries being trained to take their place within the bureaucracies of the state. These books are part of an educational apparatus that functions alongside the sort that Mulcaster dreamed of in *Positions*, for there remained throughout the sixteenth century a distrust of handwriting, associated as it was with monkly scribes and seen as a mechanical and manual task unworthy of an aristocrat. Many young men arrived at grammar school or at the university unable to write, and itinerant writing masters or scriveners usually provided instruction in handwriting.

Those conclaves of weavers and seamstresses, too, were sites of instruction in the hand.

All of this is implied in the prolix title to William Panke's short 1591 tract:

A Most breefe, easie and plaine receite for faire writing. Wherein the Author being well acquainted with the causes, which in these daies hinder it, hath for the good of his Cuntrie, so distinguished and broken every particular letter for the true making thereof, and so perfectly and plainely shewed the ready way of true ioyning the same. Both for the Roman and Secretary handes, as any one of ordinarye yeres and capacity, not hindring any other busines, may at his idle times by his own private practices, in short time attaine to write, to serve very good uses either in office or otherwise.

Panke was a chancery clerk at the time of writing, and his manual is for those who have been excluded from the regular pedagogical apparatuses. The book promises an entree into a high literate world. Thus, when Martin Billingsley, in his 1618 manual, *The Pens Excellencie*, described the secretary hand as the usual English hand, he was almost out of date. Describing the italic as a university hand—but one also apt for women, since Billingsley claims that it is easier to write—it was fast becoming the ordinary hand (our modern hand descends from the seventeenth-century round hand that succeeded the italic). The differences maintained by the sixteenth-century hands were on the verge of disappearance, to be replaced by distinctions within the round hand of ruliness and of "individuality." The hand of power extends beyond its sixteenth-century confines and into a different system of re-marking, culminating this "revolution" in script (from the highly differentiated and multiple hands of the sixteenth century to the single hand of modernity) that goes hand-in-hand with the regulated extensions of literacy.

That sixteenth-century revolution is, literally, a revolution of the signifier. To learn to write italic is to confront a new

alphabet and new techniques of making script. It is, as much as learning Latin, the production of a divided, denaturalized pedagogic subject. The relation of signifier to signified undergoes a crisis of referentiality; the relationship between script and the writer is also disturbed. The production of the well-ruled subject takes place on the line. In the analyses that follow, I will pursue these various regimes, examining both how script was produced and what it aimed at in terms of social reproduction, and the duplicities, splits, and aporias that go hand-in-hand with such double-handedness.

In chapter 11 of the *Elementarie*, forecasting a scheme never realized in the book, Mulcaster delineates the subject matter of an elementary education. We might read his pages on the teaching of handwriting as a forecast of what lies ahead. Here, as throughout the book, the curriculum is offered in strategies of promise and deferral, strategic reserves like those Mulcaster found in extending writing to all, an investment for the future. As I have suggested, that future (the movement towards "full" literacy) can be marked through the divided practices of the Elizabethan hand. Mulcaster proposes that the elementary pupil, tutored by "the writing master" (that peripheral and marginal figure whom Mulcaster would write into the regularized course of training), should learn "both the English and the latin letter" (56). Once again, education begins through a structure of reserve that has forecast itself backwards; the protention and retention of the mark is this elementary re-marking within the hand. As Mulcaster makes explicit: "I ioyn the latin letter with the English, bycause the time to learn the latin tung is next in order after the Elementarie, and the childes hand is then to be acquainted with the latin charact, which is nothing so combersom as the English charact is, if it be not far more easie" (56). What will happen

then, afterwards, happens before; the Latin tongue will come after the Latin hand has been written. Although Mulcaster writes out of a strong commitment to vernacular culture, English must be re-marked from the start with the Latin hand. The word for the letter is character, and this is the beginning of a scriptive reformation of the pedagogic subject, and a beginning, too, of an ideological re-marking of nature: the Latin character, we are told here, as in Billingsley afterward, is easier to produce. Easiness, rather, is produced, as is the child's hand within this double marking.

"To frame the childes hand right" (56) is Mulcaster's explicit aim, framed in this double script with its economies of reserve, storing up a futurity in the present of its double marking. The "direction of the hand" (57) Mulcaster proposes should be undertaken within a more limited regime of copying than that normally prescribed. As he would have limited the texts of higher education to set, state-prescribed books, so he would have the pupil's hand submit to "one perpetuall copie" (57), "a few lines, which must plant an habit." This planting is the denaturalized renaturalization of the pedagogic subject, conformed to script. Habits of behavior begin with the control of the hand, with the formations of the hand. The one copy is two, English and italic, and the child must learn to "write & resemble those two copies" (57). The child's script is the mirror for a social reproduction that may exceed by perpetuation that which Mulcaster would control as the regulatory frame. The dream of a single script, like the dream of the apparatus of pedagogy, is shattered by this glass of reproduction, which opens (even as it wishes to foreclose) onto the ever increasing stockpiling of cultural capital. For the hand is introduced into an order of being that is that of resemblance, reassembling itself, making itself within the self-simulation that defines a being-in-the-hand stripped of ontological security. Within such writing matter, matter is written, the scriptive being of a newly literate subjectivity.

THE VIOLENCE OF THE LETTER: INSTRUMENTS OF THE HAND

I will speak daggers to her, but use none.

—*Hamlet*, 3.2.381

NSTRUCTION in handwriting begins with an en-
tangled scene of constraints and appropriation: placing the
instruments of writing in the hand, instruments conceived of
as tools of violence, the hand is also thereby placed within a
regulated scriptive domain—such, at any rate, is the claim.
But even as the manuals instruct their readers in the knowl-
edge necessary for the writer—how to make a quill, first of
all—more than a manual practice is involved, for what the
hand is instructed to do to the quill also reflects upon the
hand; an order of simulation opens that exceeds the regulated
circulation between hand and instrument by enfolding both
hand and quill within a secondary instrumentality that defines
the sociality and materiality of the practice of writing from
the start. Rather than the closed circulation that such instruc-
tion aims at, divided practices are implicated in the folds of
the movement from hand to quill. Rather than offering mere
description of techniques of preparing the quill, a technology
implicates itself into the descriptions, writing them along the
paths of social prescriptions. Both hand and quill are instru-
ments. The writer's hand emerges as that which is produced
by and that which exceeds these prescriptions: the hand as an
instrument of violence in which what also has been violated is

any notion of the human hand outside of the scriptive order, any notion of materiality outside of writing matter.

Close to the end of his life, Juan Luis Vives, the Spanish humanist who had tutored Mary Tudor, the future queen, and whose career at Oxford and at the court of Henry VIII had ended when he supported Katherine of Aragon, wrote *Linguae Latinae Exercitatio* (1538). A set of dialogues, *Tudor School-Boy Life*, as Foster Watson titles his translation, is "a first book of practice in speaking the Latin language as suitable as possible, I trust, to boys" (xxi), as Vives puts it in his dedicatory epistle to the future Philip II (future husband, too, of his former pupil). Ten dialogues depict the everyday life of the schoolboy: getting up, getting dressed, learning his ABCs; these dialogues write such scenes as grammar lessons. The book participates in what Elias calls the civilizing process, for these scenes of everyday life construct the everyday through grammatical and pedagogic proprieties, and doubly so, since the book was composed as a school text; it was required at Eton in 1561 and reprinted frequently (into the eighteenth century) to reproduce the everyday within its pedagogic inscription, "as suitable as possible . . . to boys." The book presents an elementary vocabulary for social life, for ordinary objects, within its exclusive all-male, socially elite domain. Everyday life is offered in Latin; schoolboys are to find themselves and their daily practices in that rewriting.

In 1583, another version of Vives's book appeared as *Campo di Fior* by Claudius Desainliens. Dedicated to Lucy Harington, the text offers selections from the dialogues in four languages: Latin, Italian, French, and English. The text has not, at least in its dedication, left the world of the elite, although a woman of the gentry, not a prince, is its recipient. Available in four languages, it is legible to all who can read, and translation

need not work only in one direction. In such a form, the text enters into a circulation that exceeds the apparent limits of the Latin version, widening the field of rhetorical flowers; in such a form, it extends those limits beyond the all-male preserve of an Eton, but Eton had *already* extended the scene of the humanist and the prince implicated in the original dedication. The printed book is not just in the prince's hand.

What is being extended? The ninth dialogue, *Scriptio* ("Writing"), suggests some answers. Two noble youths, Manricus and Mendoza, falteringly attempt to recall a lecture about handwriting, and then receive instructions from a writing master. They can remember almost nothing. "Why didn't you take notes?" (67), Manricus asks. "Cur non excipiebas penna?" ("Why diddest not write it: Why didest not use th'office of the penne? Why diddest not gather it together with a penne?" Desainliens translates on page 322.) Desainliens copiously extends *"excipiebas"* (to receive, capture, take hold), widening the scriptive domain. Although the youths can recall almost nothing from the lecture, they remember an elementary definition, that writing makes absence present, and they recall too an originary ethnographic and ethnocentric scene often recounted thereafter, the orator telling how the American Indians were amazed by Spanish script:

He added that nothing seemed more marvellous in these islands recently discovered by the munificence of our kings, whence indeed gold is brought, than that men should be able to open up to one another what they think from a long distance by a piece of paper being sent with black stains marked on it. For the question was asked, Whether paper knew how to speak? (66)

The lack of a pen to record the oration in praise of handwriting has left little more than this remembrance of the "civilizing" function of the hand and little more, too, than the recognition that the nobility do not usually write well and that they must, "to vindicate ourselves from the charge of vulgar ignorance"

(68)—to vindicate the nobility from their own hands, for the "common run of people" (68) are learning to write well:

Manr. I don't know how it is inborn in me to plough out my letters so distortedly, so unequally and confusedly.

Mend. You have this tendency from your noble birth. Practise yourself—habit will change even what you think to be inborn in you. (68)

And thus the young noblemen approach the writing master.

What has been extended—as in Desainliens's copious translation of Vives—is to be regathered in the hand ("why diddest not gather it together with a penne?"), a regathering like the colonial activity in which royal "munificence" is repaid in gold. The pen opens a social space even as it fills the mind, for had they had their pens to hand they would have remembered the oration on the dignity of handwriting: memory lies in the hand. But the structuring principles of handwriting, shaping both exteriority and interiority, have been remembered already in the question "Cur non excipiebas penna?" Asking the question, the youths have been re-marked within the proprieties of the hand. They desire to reinscribe in their hands what has been extended beyond their class; they wish to regather by the pen what was spoken, to make absence present, to close up the distance opened by writing. Desainliens's extensions are implicated already in Vives's Latin dialogue—or in the career of Vives, an international humanist like Erasmus, born in Spain, educated at Louvain, attending the court of Henry VIII, and attempting to rewrite society along the lines of humanist prescriptions. In the dialogue, the noble youths, aware that the civilizing process has been extended through the bureaucratic apparatus of a writing class—extended to the lower classes and across the seas to the newly discovered islands—claim for themselves something against their noble natures, and yet as "noble" as the oration on handwriting had proclaimed that manual skill to be.

Thus, the master asks the boys: "But have you come here armed?"

Manr. Not at all, good teacher, we should have been beaten by our teachers if we had dared to merely look at arms, at our age, let alone touch them.

Teacher. Ah, ah! I don't speak of the arms of blood-shedding, but of writing-weapons, which are necessary for our purpose. Have you a quill-sheath together with quills in it? (70)

"Venistis huc armati": "Have you brought your weapons? Have you brought your tooles?" (Desainliens, 331). The "civilized" young men have been properly schooled, open violence restrained and resituated (the great shift charted by Elias as the civilizing process), as when they recast colonizing as kingly "munificence," or when they recognize the proper tools necessary for the tasks of civilization—the writers' weapons of quill and quillcase (replacing arrows and sheaths). These weapons they have to hand.

Such a conception of the tools—and with it the corollary social scenes of class negotiations and imperialistic ventures—is not unique to Vives. "What is a scholar without his pen and ink?" asks a speaker in another school text, Erasmus's *Colloquia Familiaria* (1522); he is answered, "Like a soldier without his shield and spear" (*S&S*, 28). "The pen-knife is one of your chief instruments," interlocutor G in the Plantin *Dialogues Francois, Pour Les Jeunes Enfans* (1567) opines, continuing, "to put it neatly, it is like your pens' schoolmaster since it often loosens their tongue" (Nash, 25), "a parler plus proprement, c'est comme l'instructeur de vos plumes, puis que si souvent il leur fait le bec" (124). The pen is mightier than the sword.

The two young men in Vives's dialogue have been schooled, yet they require the additional, extracurricular schooling of the writing master. His social dislocation (they are pleased to find, however, that he lives in their neighbor-

hood) parallels Desainliens's text with its extension beyond
the confines of Eton. The planting of the habit against their
noble nature "to plough out my letters so distortedly" is a
self-colonization along the lines of Spanish imperialism. The
writing master in Vives functions as the knife in the Plantin
dialogue for the young; the nobles are to be taught to produce
script, to be able to write "properly"—to make voice present
in the sharpened tips of their quills. "For the question was
asked, Whether paper knew how to speak?" The answer to the
question is the reappropriation of presence in absence through
writing, and with it those scenes of violence, beginning with
the writing weapons in hand, that extend in the directions
we have been tracing, those that Derrida lists at the close of
the first part of *Grammatology*, a stockpiling of the reserves in
writing that goes hand in hand with the widening of power,
extending the *gramme* and grammar.

G puts it as "neatly" ("*proprement*") as Vives does by writ-
ing in a manner "as suitable as possible." What is suitable
and proper are these literal metaphors in which writing en-
croaches upon questions of class and gender, nations and colo-
nies, schoolrooms and courts, a field of violence and vio-
lent displacements along the paths of a proper displacement
and dissociation (not swords but quills; not pens that write
but those that speak). The "proper" metaphor of the knife
as schoolmaster gathers the pen within the violence of the
script even as it effaces writing, producing it as speech—over-
coming distance, making absence present. These texts, gath-
ered together, offer a familiar Derridean plot of logocentric
idealization, inflected here in the particular social and historic
formations that characterize Renaissance literacy and its place
within the civilizing process.

The scene of violence can be specified even more immedi-
ately, for it is not merely a metaphoric power of the pen that
circulates in these texts. Quills are made into writing instru-
ments by knives; writers are made in the process. In his meta-

phor of the speaking pen, speaker G produces the logocentric illusion of immediacy, but only as a secondary effect; secondary because it follows upon the activity of the knife; secondary because it is metaphorical speech that the pen produces; secondary because it is the writing master (or the humanist) that produces the pedagogic (and noble) subject—both the "speakers" in these grammatically inscribed dialogues and the readers of Desainliens's extended text.

The "literal" scene of the knife can be found in many writing manuals, often as they open with instructions in the making of the quill. Peter Bales begins *The Key of Calygraphie: that is, of faire writing* (Q2r), the third part of his *Writing Schoolemaster* (1590), with such instructions in a chapter on "the choyce of your penknife":

As in all kinde of Artes and Sciences, the most exquisite workmen have alwaies desired and sought the best instruments, for the better perfecting of their worke intended: so, for the more speedie and sure atteining to the Arte and knowledge of faire writing, the best things for that purpose are to be provided. (Q2r)

The first of these "instruments" for "perfecting" the art of writing is the knife, and Bales closes the chapter with a verse summary of his prescriptions: "*Provide a good knife; right* Sheffeild *is best. / A razer is next, excelling the rest*" (Q2r). What such a text offers is a material and "everyday" practice, and Bales also tells his reader how to sharpen the knife and, in the next chapter, how to use it to make the quill. Yet these instructions are legible beyond their mundane inscription. Calligraphy (last in Bales's three-part book, after *The Arte of Brachygraphie*, a book on ciphers and shorthand, and after an orthography) represents the "perfecting" of manual skills, a "fining" as in Mulcaster that also extends to the hand domains of art and knowledge. The speed and sureness of the practiced hand is deployed from the mundane to the world, grasping it within a scriptive domain. The violence of such a scene is there from

the start, in the knife that must be to hand and sharp if script is to be produced, if the writer is to write, and in the appropriation of the claims to art and knowledge for a manual skill.

In his preface, Bales identifies himself as a writer; in the section on calligraphy, he promises, *"through my long practize, to be able to say something more than ordinarie"* (B3v). The "more than ordinary" is the extraordinary and excessive orbit that the scene of writing implicates from the start. It enfolds the writer's life, "the course wherein I have travailed all my life time," as Bales puts it in the dedicatory letter to Sir Christopher Hatton, Lord Chancellor of England (A2r). *The Writing Schoolemaster* extends that path to its readers. It is not a school text, but legible in the world, imparting skills—beginning with the handling of the knife—skills that mark out the writer's domain that we have begun to read in Vives.

Bales's life is not the same as the humanist's; as recorded in such sources as the DNB or Chalmers, William Massey's *The Origin and Progress of Letters* or Ambrose Heal's *The English Writing-Masters*, it suggests the exorbitancy of the writer's domain (as does the position of the writing master in Vives), a life that does not cohere around the institutions that mark the life of Vives (court and university), but further extends (as does Vives's printed book or its translation) the complicated processes of a violent (dis)appropriation. Bales's life is best summarized in a series of scenes, some of which may overlap in time, some of which contradict others. He was, for example, at Oxford, "but there is no evidence whether he was at the university as a scholar or as a professor of his art" (DNB), which included, the DNB continues, "microscopic penmanship," shorthand, and "dextrous copying." The Oxford information comes from Anthony a Wood, who remarks that "that study which he used for diversion only, proved at length an imployment of profit" (Chalmers, "Bales"). Wood appears somewhat diverted, perhaps by the spectacle of the

writing master of uncertain origins teaching boys who ar-
rived at Oxford unable to write, noble youths like those in
Vives, perhaps by the claims to "art" in Bales's manual skills.
Sometime thereafter—in the 1570's and 1580's—Bales was at
the court of Queen Elizabeth but never to be granted a secure
position (as is suggested by the 1590 letter to Hatton, offer-
ing the text as a "small mite . . . which if it might have
stood in such ripening and fruitefull soyles, as others have
obteined, would have presented a farre welthier oblation").
He was hounded by "reproovers" (at Oxford, in London), as
he calls the detractors of his skills (and their claims to confer
value upon the writer) in the preface to *The Writing Schoolemas-
ter* (B3r), yet celebrated in a commendatory verse by Thomas
Lodge:

> Then gentle *Bales,* despise the scoffing brood;
> Thy Booke hath past the eyes of learned men,
> And shall supplie this Soyle with sweete availe. (B1v)

Bales was a deviser of codes and ciphers, and not merely
in *The Arte of Brachygraphie*, since his court employment by
Walsingham and Hatton was in their spy service in the 1580's
(covert employment that led to no further, more legitimate
patronage?—yet in the 1590's he is said to have been secretary
to Sir John Puckering, keeper of the Great Seal: a path from
secrecy to a secretariatship?). He was called upon to forge let-
ters in the Essex conspiracy—but turned upon his employers,
and, if his son's testimony is to be believed, he served (after
1603?) as tutor to Prince Henry, the heir apparent. A famous
writing master, a sample of Bales's script was included in the
international anthology put together by Jodocus Hondius in
1594, *Theatrum Artis Scribendi*; but Bales was also a scrivener,
a master of a writing school in the Old Bailey in the 1580's
and 1590's, and a copyist, samples of whose script can still be
seen in the British Library. He died, it appears, destitute.
 Bales was everywhere—and nowhere, his life one of con-

tinuous displacement, circulating, like script, through a variety of locales. He was well known enough for an early scene in his life—from 1575—to be recorded in Holinshed; it is remembered over a century later by John Ayres in the preface to the reader of his 1698 *A Tutor to penmanship, or The Writing Master*, who writes that "Mr. Peter Bale a London Writing-Master, presented a Ring to Q. Elizabeth, in which was Written the Creed, Lords Prayer, Ten Commandments, a Prayer for the Queen, Day of the Month and Date of the Year; all in the Compass of a Silver Peny." Holinshed reports that the queen, aided by a magnifier invented by Bales, read the inscription "with great admiration, and commended the same to the Lords of the Council, and the Ambassadors, and did wear the same many times upon her finger" (Massey, 149). Bales finds his place in history by writing a minuscule script, almost invisible, yet displayed on the hand of the monarch. The writer's hand is worn as a jewel on the finger of the queen, his value intimately connected to illegibility, to a power that transforms itself into a mystified value (seconded and tripled in the texts of the microscopic inscriptions). The scene suggests radical disappropriation, consistent with Bales's further court services as forger and spy.

Here is another scene from Bales's life, more properly the writer's and more public: in 1595, Bales competed with another writing master, Daniel Johnson, for a prize of a golden pen worth twenty pounds; Isaac D'Israeli offers his amused summary of Bales's account (recorded in *The Originall Cause*, Harl. Ms., 675) of this "joust" (as D'Israeli terms it, turning the pen into a sword): "In this tilting-match the guerdon of caligraphy [sic] was won by the greatest of caligraphers; its *arms* were assumed by the victor, *azure, a pen or*; while the 'golden pen,' carried away in triumph, was painted with a hand over the door of the caligrapher" (D'Israeli, 5: 293–94). Bales triumphed—George Chapman is said to have been one of the judges of his skill, William Panke, the chancery clerk,

another (Heal, 10). D'Israeli remains among the scoffers of the pretenses of the writing masters; the contest, in his account, acquires the feudal trappings of an Elizabethan court event. But it is not quite that, with Panke and Chapman as the judges—fellow writers, in at least two senses of the term. And the reward here is not courtly patronage, not the presentation of an inscribed ring, but the receipt of cash and the right to display the victory publicly—on a shop sign. Bales the writer enters yet another social scene, selling his skills on the market—and this commerce might also describe the life, with its displays of skills of invisibility, ciphers, and forgeries —the life of a script that effaces itself and yet claims for itself all the ascendency of the golden pen.

In these scenes, the writer negotiates a series of places at the university, the court, and in the city; in marginal pedagogic apparatuses; in commercial spheres. He goes where perhaps his book, too, might advance. The path cut, it remains to be said, is implicated in that opening page of Bales's book on calligraphy; it starts with the knife, and the end of the path, as these scenes might suggest, cannot easily be summarized or contained. The writer begins to make his way into the world, employed and yet held back, private and public, miniaturized and self-aggrandizing. Writing is wielded as a weapon through a series of social positions. The knife works: to produce the quill, to produce the writer. The scene of writing, we could assume after Derrida, is always associated with violence; here, with the very materials of his craft, scenes of mutual violence are staged, openings and enclosures that extend and contain the activity of writing. In Vives or Bales, we can see the paths that are taken once the writer has his weapons to hand. But these scenes can be read too on the pages of the writing manuals, in their descriptions of the instruments, in their demarcations of the spheres in which the writer's hand moves. I turn to the manuals now, with the scenes from Vives and Bales as guiding (but extended, not

simply enclosing) frames for the production of the writer's hand offered in these accounts.

In a tract dated 1522 (it actually may be somewhat later), Ludovico Vicentino degli Arrighi, a copyist and Vatican scribe, published the first of the well over a hundred manuals teaching the writing of the italic hand to appear in Italy in the sixteenth and seventeenth centuries, *La Operina . . . da imparare di scrivere littera Cancellarescha*. In a version dated 1523, the manual appeared with a section of instructions for making the pen, *Il modo de temperare le Penne*; it includes an illustration of the knife used to trim the quill (Fig. 1). This is not Bales's Sheffield knife, but a more diminutive instrument, of the same size and dimensions as the quill; the two instruments are visually equated. They are, moreover, joined as they cross, tied with a flourish not unlike that produced by the hand in writing; to further the visual point, the rubrics, identifying the small knife ("*Il coltellino*") and pen, similarly wrap around the writing instruments. These instruments are (to recall the translation of Desainliens) "gathered together" by writing, by the lines that produce the images and the script. The illustration can be read beside Bales's Sheffield knife or razor, or the scenes from his life, as an idealized image of the "perfecting" of the arts of the hand—for the instruments have been suppressed, domesticated, regularized, and controlled, put in the service of the line, the work of the hand. What the tools make (the line, the quill) has been reversed in the image of the knife and quill serving the design, placed on the page. The violence of the production of the writer is (dis)placed in this ideal image. Yet not quite, for there is a story to be added to the one that can be read on the page, and it bears comparison with Bales's contest for the golden pen. It has been supposed (A. S. Osley makes the case) that Arrighi falsified the date of

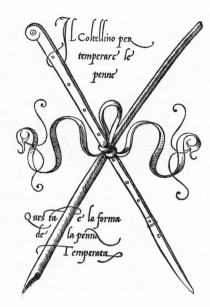

Fig. 1. Ludovico Arrighi, *La Operina di Ludovico Vicentino,* A19 recto. By courtesy of the John M. Wing Foundation, the Newberry Library, Chicago, Ill.

his manual in order that his might appear as the first book to teach the italic hand, misdating the edition to make his mark. The poised page is complicit with the forged date—or with Bales's many attempts to secure his place in Elizabethan society. The page, with its knife and quill, stages the mastery of the hand.

The violence of the tools can be seen elsewhere. Giulantonio Hercolani, in the first copperplate illustrated handwriting manuals (*Essemplare Utile Di tutte le sorti di l'tre cancellaresche correntissime* [Bologna, 1571] and *Lo Scrittor Utile, et brieve Segretario* [Bologna, 1574]), provides on the second page of his handbooks an illustration that at one and the same time displays an example of one version of the chancery hand (*cancellaresca circonflessa*) being offered to be copied by the reader, and directions for the cutting of the quill (Fig. 2). Here the knife is hardly diminutive; a "*coltello*," not Arrighi's "*coltellino*," it dominates the page with only an occasional ascender

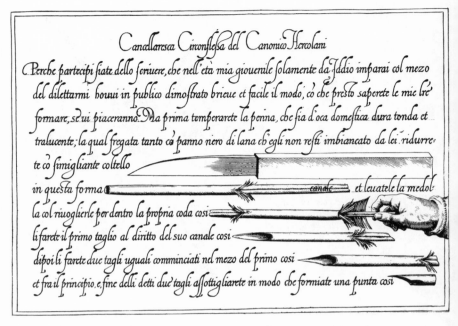

Fig. 2. Guilantonio Hercolani, *Essemplare Utile*, fol. 2. By courtesy of the John M. Wing Foundation, the Newberry Library, Chicago, Ill.

or descender of the script impinging upon it. This knife, like the one in the Plantin dialogue, makes pens speak, produces script. The quill, ever diminishing, as the various stages in its production are depicted (the written directions explain what the knife is to do to produce the quill), ends in a bladelike point, a more subtle edge but one no less sharp than that of the dominating butcher knife. Here, as in Arrighi, there is an implicit equation of quill and knife, but it is not one in which the cutting edge of these instruments has been suppressed by script. The dismembered hand in this representation, moreover, suggests at what cost the writer's hand is produced, what it means to produce the writer within these scenes, how the activities of writing implicated in the texts of Vives or Bales structure the writer's hand as an instrument.

I will turn again to the writer's hand shortly, but there is more to say about the scene of writing and its fields of violence. My comparison of the penknife to a butcher's would hardly be an overstatement were the writing surface vellum (still used in some documents in the Renaissance), whose hairy backside as well as imperfections and markings remind the writer of the slaughtered animal upon whose skin he inscribes, repeating (in however displaced a fashion) an act of violence. But, even when paper is the surface, as was more often the case, the pen point frequently is described as if it were a knife—or some other tool to work the surface, as in Vives's dialogue when the young man wonders about his inability to plough the page in a straight line—in which case the materiality of the page lends itself to a reading that writes the world. Colonial activity extends from the agricultural metaphor that extends from the writing surface.

Giovanniantonio Tagliente, the writing master Arrighi sought to upstage, offers another version of this scene. Having presented a variety of exemplary hands in *Lo presente libro Insegna La Vera arte delo Excellente scrivere* (1523), he concludes his book with instructions on how to form letters. Like Bales, he too begins with instructions on making the pen, elaborately describing the use of the knife. Then, the perfect instrument to hand, he makes this observation:

It is obvious that no competent barber can ever shave a beard well without hurting the man who is being shaved, unless he has a razor honed to a cutting edge. So note, discreet Reader, that if you want to write all the various kinds of letters and do not have the appropriate tools for the purpose, you will never be successful in the practice of the art. (*S&S*, 62; Ogg, 106)

The pen has become the sharpening tool in this metaphor, Bales's razor, and the writing surface a face to be shaved (removing signs of natural hairiness to "civilize" it, transferring the animal skin, the vellum, to the human face, the paper). On the facing page is an illustration of the tools of the art (Fig. 3).

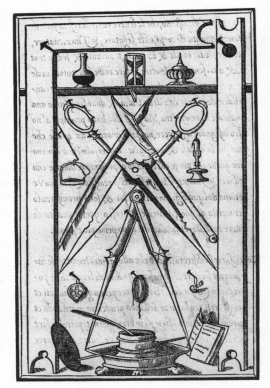

Fig. 3. Giovanniantonio
Tagliente, *Lo presente
libro insegna.* By courtesy
of the John M. Wing Founda-
tion, the Newberry Library,
Chicago, Ill.

Blade and quill cross, and the cutting edge of the knife is rep-
licated in the nib of the pen. The illustration represents the
pen as a razor's edge. Similarly, Francesco Torniello Da No-
vara describes how he forms the letters in his alphabet (1517):
"always keeping my pen square-cut and its edge as sharp as a
knife."

At a basic material level, then, writing begins with a tool
of violence, the knife or razor, and it produces the point of
the quill as another cutting edge. A material sphere is opened
by those tools, one that circulates through the violence of the
instrument, one that shapes the world, the everyday of the
dialogues for the young written by a Vives or an Erasmus,

through violence. The instructions in the manuals and the various illustrations play out the possibilities in the relationships between knife and quill: assertions of one instrument or the other, or of a balance between them, structures that are also played out in social relationships between the writer (humanist or not) and the world (court or university, marginal school or business establishment). Whether the emphasis is on the script produced by the quill, or on the quill produced by the knife, a scene of violence (or of violent suppression and displacement) can be read, as in the various scenes of mastery implicated in the texts we have been reading. These multiple relationships are transferred to the page, which acquires depth through incision; the page, as in the Arrighi illustration, can then serve to compose the instruments, to place them in the service of script.

Such too is the case on a page in the Spanish writing master Juan de Yciar's *Arte Subtilissima* (1550; D6v, Fig. 4). It brandishes a lethal weapon across the top of the illustration; a small portion of the knife's handle, however, is obscured by the feathers of a quill; the blade similarly obscures the handle of a stylus. A cartouche naming the hand displayed, "*Letra Antigua Blanca*," covers a portion of the knife and most of the stylus and quill; it also obscures the scissors that occupy a parallel position in the lower portion of the frame to the knife above. As in the illustration in Tagliente, Yciar presents the tools of the writer's craft. Rather than the symmetrical hierarchical arrangement in Tagliente, however, which organizes and contains that depiction, Yciar's woodcut plays off the manifold relationships between the tools through the covering and overlapping that give an illusory depth to the page, an effect furthered when the knife appears to have cut through the elaborate decorative border at the top of the cartouche (although that cut also allows the cartouche—the writing surface—to obscure the knife). The motif is replicated below where the quill and stylus cut through the lower border. There is no doubt at the bottom of the page that stylus and

quill have violated the broken measuring device that frames the bottom of the cartouche.

The equation of quill and stylus (an instrument for writing on wax surfaces which are incised more palpably than a piece of paper) also presents the writing surface as a historical field (like many others, including Vives, Yciar offers a summary history of writing and the "antique lettering" he claims as his "favorite" in the pages before the illustration). The depth of the page is the history of writing implements in their relationships to each other. The history of violence can be glossed with an observation made by Matthias Koope in his 1801 *Historical Account of the Substances which have been used to Describe Events, and to Convey Ideas*: "Some fescues [the *stilus graphium*] were so large, that they could be used for the same purposes as stilettos; and several authors have noticed, that in many instances they have been employed for committing murder" (35). No literal murder occurs in Yciar, of course, but the violence of writing as a way of opening distance and space is implicated on this page. The page offers tools and surfaces that insist that cutting is one with writing (and with the making of the woodblock that reproduces the tools of the writer). Yciar's page presents the tools of the trade: knife, fescue, scissor, quill, paper, letters. They are in tense and ambiguous relationships with each other, jockeying for position and priority, making counter-assertions that also are written into the sociality of script, in a story like Bales's, or in the destinations of a book like Vives's—or the destination of these writing manuals, extending the skills of literacy. Juan de Yciar dedicates his book to Philip II and expects that dedication to protect him from his detractors: "I conclude by pointing out that this book is dedicated to the Majesty of our Lord the Prince; and a work offered to so high a person should be treated with civility, however undeserving" (A4v). "However undeserving": Yciar withdraws the claim even as he makes it. The violated borders and frames, openings and

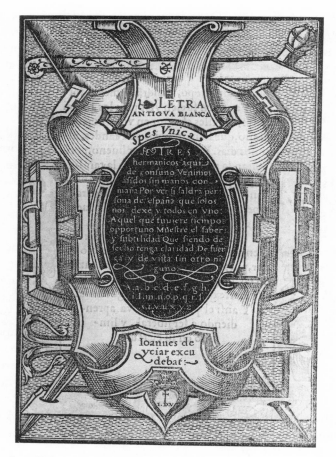

Fig. 4. Juan Yciar, *Arte Subtilissima*, sig. D6 verso. By courtesy of the Victoria and Albert Picture Library.

closures written on a surface, suggest too the trace structure of a writing into the world that starts and is reproduced in the instruments through which writing is produced.

The writer cuts into the page; the writer is produced—as script—by that cut. Numerous woodcuts of scribes writing show them with stylus in hand, marking their places while

they copy out a text. Derrida meditates on such an image in *The Post Card*, an illustration from Matthew Paris's fortune-telling book (a text about destiny and the destinations of script) depicting Socrates as a scribe, Plato dictating at his back. Socrates holds a pen in his left hand and a knife in his right. Derrida comments on this scene of inscription: "He is erasing with one hand, scratching, and with the other he is still scratching, writing" (25). The double-handed activity of marking and erasing, Derrida argues, illustrates the double-ness that constitutes the written mark as trace. It opens the field of writing as the space of protention and retention—the space that can be read on these pages or in the writers' lives that follow from them, sending them and their scripts out into the world. "Your pen-knife as stay in lefthand let rest," E. B. recommends in the verses prefacing Beau Chesne and Baildon's *A Booke Containing Divers Sortes of Hands* (1570; 1602 text cited, A2r). "Stay" suggests that the knife is the support of writing (it keeps the place, marks the line, sharpens the quill, smooths the paper: there can be no act of writing without the knife); but "stay" also suggests that the knife impedes the quill (erasure lies within its domain). As Derrida has argued, what is true of the knife is true of the quill: these are the writer's weapons for a scene in which the production of script also effaces such production to produce the writer's hand—to produce the illusory presence of writing. "Stay" re-marks the double structure of the mark, and the scriptive domain that (dis)locates the writer.

The claim to presence in script is conveyed on the title page of Juan de Yciar's *Arte Subtilissima*, showing the writing master copying a musical manuscript (Fig. 5). Comparisons between writing and musical instruments are frequent in the writing manuals, and the point is to suggest, as the Plantin dialogue did, that writing is as immediate and present as vocalization. An Elizabethan lexicon tells the same story: written music, in Elizabethan parlance, was pricksong, and writing was prick-

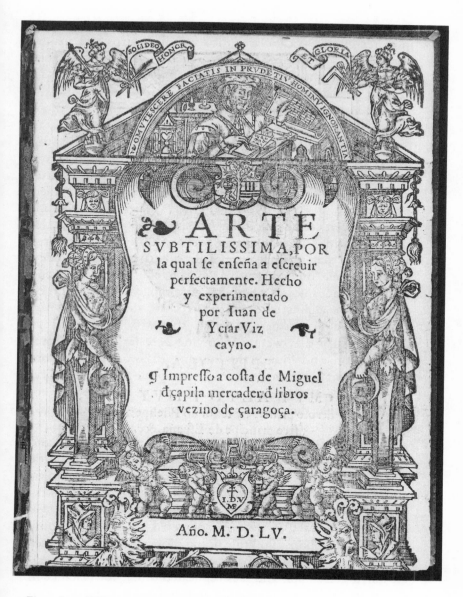

ing. Yet in this vocabulary, too, writing usurps and makes possible the "presence" of the voice. The speaking subject emerges from the depths of the page, like the interlocutors in pedagogic dialogues, as writing-effects.

The emergence of the writer can be read through these scenes of violence, as the tools of the trade are made ready, as the knife is wielded to produce the pen. The knife, ready-to-hand to sharpen the quill or mark the page, has its primary function, of course, in making the quill into a writing instrument. Here, too, lengthy instructions are regularly provided by the writing masters. First, a goose (preferably, although other winged creatures can be substituted) is deprived of the second or third feather from its left wing, or so Bales prescribes, so that its curvature will fit best the right-handed writer. "*Penna*" in Latin means wing, of course, and the scene of writing does not obscure that etymological connection or the violence against the winged creature that produces the plume, an appropriation of nature that will, in the conceptual trajectory that we are following here (as writing "civilizes" nature and founds the human), dislocate and relocate human nature within domains of scriptive instrumentality. These scenes of writing never forget nature even as they remake it social; the material world serves as writing matter.

"Then clense them well with the backe of your knife," Bales continues his instructions on the preparation of the quill, "and tourne upright the backe of the quill, and give thereon a little cutt, and with the end of the quill make the slit thereof verie cleane without raggednes or teeth" (Q2v). Arrighi's illustration of a more elaborated process (Fig. 6) presents the task in as detached a manner as he depicted the knife and quill wrapped in ribbons, no knife doing violence as in the Hercolani illustration (Fig. 2). Bales's anthropomorphic language is closer to Hercolani, and it is replicated often, for instance in the instructions on making the quill offered in Francis Clement's *The Petie Schole* (1587): "Enter a rift with the edge of

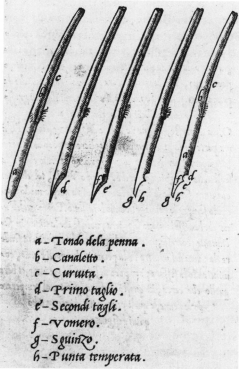

Fig. 6. Ludovico Arrighi,
La Operina di Ludovico
Vicentino, A20 verso. By
courtesy of the John M. Wing
Foundation, the Newberry
Library, Chicago, Ill.

a – Tondo dela penna .
b – Canaletto .
c – Curuuta .
d – Primo taglio .
e – Secondi tagli .
f – Vomero .
g – Sguinzo .
h – Punta temperata .

your knife even in the midbacke of your quill, then rive the
same scissure halfe an inch, into the quil, but, I say, just in
the backe, least happely it shew ragged and grinning teeth,
for then wil it never prove good" (53–54). Cut, rift, scissure,
slit: the quill is anatomized, attacked while its back is turned.

The violence in the Scottish scribe David Browne's ac-
count goes even further, transferring this scene of violence to
the writer's hand, transferring the (dis)embodied quill to the
writer's hand. In *The New Invention, Intituled Calligraphia: Or,
The Arte of Faire Writing* (St. Andrews, 1622), Browne offers an
Aristotelian exegesis of writing. The efficient causes of writ-
ing are the writer and his pen; both are instruments, "living
and deade" (***8v); the former includes the "Members of the

Writer his Bodie, as the Hand, Thombe, and Fingers." The pen is the dead instrument, and to make the pen, Browne advises first slitting the "face of the Quill" before proceeding to the back (3). The feather of the raven or goose is made into a dead instrument, yet the anthropomorphic and anatomizing language suggests a violation of life; the quill must be made dead. Can the "Members of the Writer his Bodie" remain alive once they participate in this making-dead? Have they not been anatomized too? Is not that what makes them co-efficient causes of writing?

The descriptions of making the quill pause long over a recalcitrance in the object that must be made to serve the hand, a recalcitrance that is overcome (ideally) by writing and its scriptive encroachment upon and definition of natural objects. The most elaborate descriptions pertain to the formation of the point since the varieties of hands practiced by the writer demanded, ideally, different tips (more square or rounded or pointed) to produce them properly. Equally important was the question of whether the two sides coming to the point were to be cut at the same angle, the answer depending again on which hand was in question—since the pen was (ideally) to be held in a different manner in the production of different hands. The aim, in all instances, was to *"make a pen fitt for your hand"* (Q3r), as Bales concludes his page-long description of the cutting of the point. Fitness for the hand is an ambiguous expression: which hand, the one that writes or the hand that is written, the handwriting? As the hand writing fits the handwriting, the violence against the quill necessary to make a pen fit for the hand displaces the violence that the pen wields, subjecting the hand to its demands.

This conflicted situation opens upon the reciprocal violence that structures the field of writing. The violence against the recalcitrant pen, which seems motivated by its ready capacity to fail as a writing instrument (scattering ink, losing its edge, going limp or being too stiff to manage), is expressed,

as we have seen, by treating the dead instrument as one made dead by the action of the living hand wielding the knife. Yet a potential betrayal of the pen is written into these descriptions; despite the care taken in cutting the quill, its nib may be ragged, offering a grinning (corpselike) mouth. That mouth answers the logocentric effacement of the writer's tool, insisting upon a materiality that is not quite mastered by the hand. The pen speaks against its silencing. Hence, the language in which the writing masters anatomize the dead instrument speaks within and against the logocentric plot that would make the pen a mouth. The corpse takes its revenge on the living hand or mouth.

That relationship between the mouth and the tip of the plume is written into the vocabulary of writing. As A. S. Osley notes, the description of the pen given a mouth by the knife in the Plantin dialogue puns on the fact that "the word *bec* means both 'nib' and 'mouth'" (*S&S*, 223n). Arrighi is hardly unique in *Il modo de temperare le Penne* when he compares the nib to the beak of a sparrow-hawk (*S&S*, 80): the mouth, if not corpselike, is predatory. Yciar, for another instance, says the quill is to be shaped like a hawk's beak, slit into "two equal parts or tongues" (K2v). In these images, the domestic goose has become a bird of prey. As the writing masters give instructions on how to turn the bird's feather into a tool of writing, their language continues to register the violence of the tool against the hand. It implicates, as I have suggested, the subordination of the writer's hand to his tool and to the script that is produced. For logocentric valuation, which invests the pen as a mouth, at the same time gives primacy to the handwriting—handwriting speaks; the hand of the writer could be effaced in this economy, another dead instrument like the pen. The pen, with its mouth, silences the writer— or produces script as the immediacy and living embodiment that the writer's hand lacks.

We can return now to the dismembered hand on the page

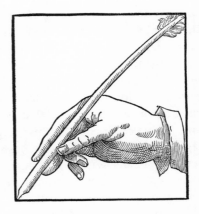

Fig. 7. Juan de la Cuesta,
Tratado y Libro, E3 verso.
By courtesy of the John M. Wing
Foundation, the Newberry
Library, Chicago, Ill.

from Hercolani (Fig. 2), a hand attached to the quill as if it
were the handle of a knife, and yet slit at the wrist, framed by
the page. Such illustrations of detached hands always depict
penhold in the writing manuals. Juan de la Cuesta's *Tratado
y Libro* (1589) presents the basic image (Fig. 7): another hand
slit at the wrist, here holding a quill. The frame of the image
looks like a sheet of paper, and the quill fits exactly along
its diagonal. The hand, however, comes short of the margin.
It has been severed. Whereas the writing manuals regularly
talk about making the quill as if an anatomical dissection were
being performed (slitting it, and so on), in this image the quill
is not menaced by the hand or knife. Rather, the hand appears
to have been separated from the body, made to serve the quill.
Both instruments, hand and quill, are placed on the page. The
page "holds" the hand—and the severed hand is put into the
destination of script, "gathered" as it is sent on that excessive
path.

These images of the hand in writing manuals (I will soon con-
sider more of them) invite comparison to the hand in Renais-
sance anatomies.[3] The striking portrait of Andreas Vesalius

that serves as a frontispiece to *De humani corporis fabrica* (1543, Fig. 8), for example, shows the anatomist holding a dissected hand and arm in his hands, the living hand of the anatomist grasping the appendages of a gigantic, statuelike corpse. The hand that has been anatomized and made visible reflects upon the anatomist's grasp; Vesalius is an anatomist by virtue of the activity of the hand. He has been made by what his hand does, as his grasp of the forearm and the delicate manipulation of the remains of the fingers suggest. The image proclaims the hand of the anatomist, against the very procedures outlined in the book, which do not start with the hand. A different order and origin is intimated in this scene of simulation in the powerful grasp of the living and dead hands. The portrait divides what is united in the self-demonstrating figures shown in the book—flayed corpses which anatomize themselves. Anatomy as a discipline is instituted by the hand (by the dissociative association of the dead and living hands), and the scene implicates the social and historical foundations of anatomy embodied in the hand of Vesalius. This is how the master is present in his art.

The illustration suggests Vesalius's relation to Galen, who devoted the first book of *On the Usefulness of the Parts of the Body* to the hand. "I put first the discourse on the hand," Galen explains in *On Anatomical Procedures*, "for that part is characteristic of man" (Bk. II, sec. 3, p. 36). In *On the Usefulness of the Parts of the Body*, the precedent for that opinion is cited from Aristotle. Nature, Galen claims, gave hands to man as a token of his intelligence: "Hands are the instruments most suitable for an intelligent animal. For it is not because he has hands that he is most intelligent, as Anaxagoras says, but because he is the most intelligent that he has hands, as Aristotle says, judging most correctly" (1: 69).

Galen alludes to Aristotle's discussion in *On the Parts of Animals* (4.10), but as Margaret Tallmadge May notes in her edition of Galen's *On the Usefulness of the Parts of the Body* (1: 71),

the Aristotelian phrase describing the hand is capable of more than one reading. "Instrument for instruments" is Aristotle's phrase for the hand as superlative instrument, capable, as is the hand of Vesalius, of grasping tightly and delicately, but the phrase can also be read as "instrument of instruments." Aristotle, attempting to refute Anaxagoras's claim that the hand is the instrument of the mind, almost reverses himself in this phrase describing the hand's privilege. The phrase could offer the hand as the originary instrument, the model for all others, and it could be read in support of Anaxagoras, as if the mind only followed upon the activity of the hand. In fact, elsewhere that seems to be Aristotle's opinion: "Man has a far more accurate sense of touch than other animals," he writes in *De anima* (421a), "for which reason he is also far more intelligent than they." Galen's praise of the hand as characteristically human seems, in fact, to lean in this other Aristotelian direction—in the direction of a materiality that (un)founds the mind, a direction we have seen before, in Mulcaster's *Elementarie*, as it described a route from the grip of the hand "to hold sure, & the mind to forese" (30), the elementary path of writing.

In the frontispiece to Vesalius, the anatomist's skill lies in his hand, and the anatomical specimen, classicized and rendered statuesque, proclaims what the hand has made. If the corpse is originary, yielding its secrets, it is also secondary, a statue made by the hand. The picture of Vesalius is odd, commentators frequently note, because of the size of Vesalius's head and because of the equally oversized anatomical specimen. Yet these are connected by the generative chain, "instrument of instruments"; what the mind makes of the anatomized body lies in what the hand does. It comes as no surprise therefore to find that the picture of Vesalius also presents him as a writer of sorts. A scrap of writing ("*De musculis digitos*," on the muscles of the fingers, it begins) lies on the table—a text that doubles the image—as does a pen in a pot of ink; a penknife

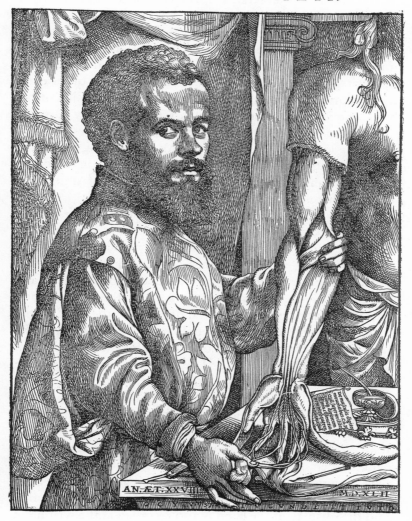

Fig. 8. Andreas Vesalius, *De humani corporis fabrica,* *6 verso. By courtesy of the Newberry Library, Chicago, Ill.

(or is it a scalpel?) lies in the foreground near the dead and living hands. The portrait is further inscribed with a motto celebrating the surgeon's speed and skill (*chirurgia* translates as "manual skill"), Vesalius's age, and the year in which the picture was made. The dexterity of the anatomist's hand communicates with the speed and sureness that Bales promised the writer. Vesalius exists—on the page—the fact of his existence represented by a hand that represents the skills of his hand. He is represented, too, by a scrap of an only partially legible text, and a text otherwise not known as Vesalius's (it may be a lost commentary on Galen); this writing is like the invisible texts Bales produced. Joining together the works of the hand—anatomy and writing—is a circuit of simulation and the (dis)placement of the hand.

Of course, Vesalius did not merely follow Galen. Indeed, in his prefatory letter to the *Fabrica* he remarks that the only time Galen anticipated him was when he used human subjects in his anatomy—and almost the only time that occurred was in discussing the hand. "Galen noticed none of the many and infinite differences between the organs of the human body and of the monkey except in the fingers and the bend of the knee, which undoubtedly he would have overlooked with the others except that they were obvious to him without human dissection" (O'Malley, 321). The hand (and knee) mark the obvious difference between the human and the animal. It was with the hand (and arm), in fact, that Vesalius began his career; his prefatory letter, urging again and again that the anatomist must lay his own hands on the corpse and dissect it himself, dramatically presents the first occasion when Vesalius did so: "The barbers having been waved aside—I attempted to display the muscles of the arms" (320). With a wave of the arm, the arm is displayed, as it is in the frontispiece to the *Fabrica*. And that display of the hand is also recorded in the writing in the picture.

Vesalius yearns for an ancient medical pedagogy, he con-

fesses in his prefatory letter, "the practice by which they trained the boys at home in the conduct of dissection just as in writing and reading" (323). The visual equivalent of that pedagogic practice is offered in the frontispiece, and Vesalius emerges onto the social scene and claims his place through the displaced hand—the hand written into a pedagogy that allows the mastery of the hand through its anatomization, through its service to what it has made, through its production as a replica of what it has produced. The philosophical question of human foundations in the hand founders on the instrumental hand; it is within the duplicities of an order of secondariness, within a logic of instrumentality, that Vesalius presents himself in the anatomical theater (assuming for the skill of his hand the hitherto despised skills of the lower class manual laborers, the barbers, laying hands on those skills in a new hierarchy of the hand) or is presented in the frontispiece to his book. The scene is like the one in Vives, as the noble lads brandish the arms of the writer, reassuring their nobility by arrogating a manual skill disseminated elsewhere, or like the writing masters, making the pen a razor and shaving the page.

The picture of Vesalius operates within the claims and counterclaims of the Aristotelian and Galenic estimations of the hand. Galen claims to follow Aristotle, yet his definition of the hand as the characteristic of humanity sides with Anaxagoras, who made human intelligence follow from the hand, as opposed to Aristotle, who subordinated the hand to the mind—or did so in an ambiguous phrase, "instrument of/for instruments." Vesalius proclaims himself a follower of Galen only in that most obvious of instances—the distinctively human hand—although the image he offers of himself in the frontispiece turns that minimal point of contact into a major statement of the arts of his hand. As commentators point out, the reason that Vesalius commented on Galen's text on the hand (the text upon which the commentary displayed

on the frontispiece is written) and first dissected the hand and arm was to show that Galen had erred in his anatomy. This is the place to start for Vesalius, for it is the founding gesture of anatomy, founded, that is, in a true knowledge of the hand and arm—true knowledge of the human. That knowledge is gathered within the logic of writing that extends to the hand, that writes the hand within a social logic of a self-aggrandizing dismemberment, the logic of an excessive pedagogy.

The writing masters similarly anatomize the hand—display it dissected, severed at the wrist or shoulder; for them too the Aristotelian phrase might sum up the ambiguous task of proclaiming the hand as distinctively human (perhaps at the expense of the mind), of proclaiming the hand holding the instrument (the pen or the knife), perhaps at the expense of the hand. All these perils attending the formation of the hand are meant to insure that the hand will function within social prescriptions, within a regulated domain of the hand "gathered" within its domain. That, at least, is the claim for a simulative logic which, as we have seen, and will again, always exceeds its framing regulations.

It comes as no surprise after the illustration from Vesalius's *Fabrica* to find that Bales's *Key of Calygraphie* proceeds from the question of the choice of the penknife and the making of the pen to instructions on "the holding of your pen, and the placing of your arme" (Q3r), extending the instrumentality of the writer's tools to the hand, instrument of/for instruments. Discussions and illustrations of penhold focus on the writer's hand, its relationship to handwriting, and its placement within a regime that organizes and socializes the body of the writer. The hand as instrument implies the problematic of the formation of the distinctively human as another work of the hand, an institutionalized foundation which posits the secondariness of the human within the simulated domains of pedagogical institutions. Discussions of penhold are situated within the terrain of the grasp of the hand and the route of an

instrumentality—from such grasping to a comprehension of a fundamental humanity—a route that still lies in the hand.

The necessity of conforming the body of the writer to the demands of the pen is recognized in Mulcaster's *Positions* (1581) when he explains why writing follows reading in the educational regime: "bycause it requireth some strength of the hand, which is not so soone staied nor so stiffe to write, as the tongue is stirring & redy to read" (32). Mulcaster divides the domains of the tongue and the hand, reading and writing; the hand requires training if it is to be made as natural as the activity of reading is supposed to be in this paradigm—if the hand is to be made into the mouth (as in the Plantin dialogue for the young), if writing is to found reading. Nature, human nature, is this artifice. Because penhold is not so immediately natural (as we have seen in the scenes of violence against the instrument and the attempts to make the pen a mouth), various training regimes are prescribed, pedagogic regimes that socialize the hand and make the hand human by inserting it within the act of writing.

Giovan Francesco Cresci (in *Il perfetto Scrittore*, 1571) echoes Quintilian in recommending that the master guide the pupil's hand: "The pupil, by feeling the movement of the master's hand, comes to appreciate more readily the details, the subtle points, and the essential shape that this letter, which he is trying to learn, should have" (*S&S*, 122). The pupil's hand is put into the master's hand; his hand is made proper (his own) by being made another's. It comes to be discriminatory and flexible, a knowing hand like the supreme instrument as described by Aristotle: "For the hand is talon, hoof, and horn, at will. So too is it spear, and sword, and whatsoever other weapon or instrument you please; for all these can it be from its power of grasping and holding them all. . . . The joints, moreover, of the fingers are well constructed for prehension and for pressure" (*Parts of Animals*, 4.10). Aristotle's description of the hand barely secures it as human. Yet the account

of the power of this supreme and violent instrument—"spear, and sword, and whatsoever other weapon or instrument you please"—glances at the human as it arises in the hand (as it does as well in Mulcaster or in the pedagogic procedures in Cresci). Here too a path is suggested, from grasping to intellectual "grasping," from "prehension" to apprehension and comprehension.

In the grasp of the hand we might recall Desainliens's translation of the office of the pen as a "gathering" together. In instructions concerning penhold, that is precisely the role of the pen; it serves as master, ushering the student into the domain of the hand, and the difficulties described in penhold involve accommodating the hand to the pen. John Brinsley, in *Ludus Literarius: Or, The Grammar Schoole* (1612), like many authors in the previous century, spells out the complexities of penhold and its vital necessity: "Cause your schollar to holde his penne right, as neere unto the nebbe as hee can, his thumbe and two fore-fingers, almost closed together, round about the neb, like unto a cats foote, as some of the Scriveners doe tearme it" (30). The hand is made to grasp like a cat's foot; so too in Aristotle, the flexibility of the hand allows it to take on the attributes of animals even as it achieves its human power. The hand is made into this grasping instrument by the pen.

On the page following E. B.'s versified rules for the writer, Beau Chesne and Baildon present an illustration: "How you ought to hold your Penne" (A3r, Fig. 9). In this illustration of penhold, as in Juan de la Cuesta, the hand, although attached to the arm, has been detached from the rest of the body, as if the body were an impediment to the writer; we see another severed arm ruled by the frame. Such detachment is necessary for the socialization of the hand and for the hand to serve as the instrument of script. Hence Beau Chesne pictures two proper hands because the pen is to be held differently, according to whether it is to produce secretarial or italic script; the

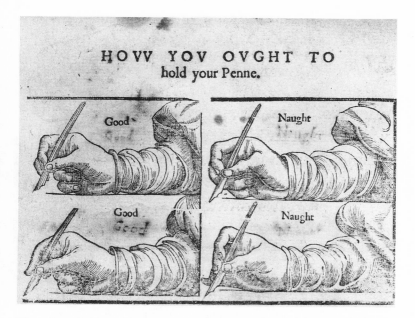

Fig. 9. Jean de Beau Chesne and John Baildon, *A Booke Containing Divers Sortes of Hands*, sig. A3 recto. By courtesy of the Bodleian Library, Oxford (Douce B 675).

privileged instrument of instruments is doubled in the illustration, as if people had two right hands, as if the two hands required of the skilled writer were the single normative hand —like the double copy in Mulcaster's *Elementarie*, two and yet one. The visual framing is doubled with the moral pronouncements "good" and "naught," absolute judgments placed on the hand. The hand either is ("good") or it is not ("naught"). Either way, its "existence" has removed it from mere bodily existence. It lives for and on the page, detached from the rest of the body. The body is replaced.

It is hard to tell from such illustrations whether the hand is a living hand. This is emphatically the case in the eerily detached hands that Hercolani depicts on a writing table (Fig.

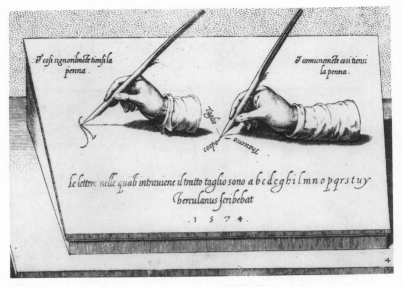

Fig. 10. Guilantonio Hercolani, *Lo Scrittor Utile,* fol. 4. By courtesy of the John M. Wing Foundation, the Newberry Library, Chicago, Ill.

10). The space around them leaves the viewer in no doubt that the hands have been detached from the body, nor is there any doubt that they have been made to serve the page or, in this case, the letters whose strokes are illustrated by the hands and realized as letters in the labels that identify the two proper penholds necessary for the production of mercantile and italic hands.

Once the pen is properly held, Brinsley's schoolboy can proceed to write: "Then let him learne to carry his pen as lightly as he can, to glide or swimme upon the paper. So hee shall write the cleanest, fayrest, and fastest, and also his pen shall last the longe" (30). Bales similarly summarizes his advice on penhold: *"Hold softlie your pen, leane lightlie thereon, / Write softlie therewith, and pause thereupon"* (Q3v). The hand is suited to the demands of the pen to make it flow properly,

overcoming the resistance of the surface, the failures incident
to the quill, the materiality of the body. These hands are being
instructed to produce documents that will not show the hand;
these hands are being trained to be hands of the state. Among
the more remarkable things in this advice is the suggestion
of strangeness in the discipline of penhold; social privilege is
being conveyed in these texts—and restrained in its very pro-
duction. How to hold a pen needs to be learned; it is not an
everyday practice. What one witnesses is the construction of
the everyday, as in the more "proper" humanistic pedagogi-
cal texts of schoolboy life. Nothing in the materials readily
suits the activity of writing. There is resistance everywhere,
in the writing implements and in the hand itself as it is made
into the writing hand, "a cats foote, as some of the Scriven-
ers doe tearme it," as if the hand once domesticated in the
task of writing had also been naturalized as a domestic ani-
mal. The illustrations of penhold suggest that the hand's ac-
commodation to handwriting, naturalization of the hand, its
realization as properly human, demands dismemberment and
decorporealization, detachment from the body. The realm of
script seems to be absolute in its demands and rigorous in
its discipline, and the hand must submit entirely to a regime
of writing that represents its claims as transcendental. Beau
Chesne's "good" or "naught" might remind us of the words
God spoke creating the world. They are applied to the sec-
ondary, doubled formation of the hand of the writer. In that
duplicity the detached hands can be made to serve a socialized
script and a socially produced human being in the hand.

These valuations, as Derrida has argued, are intent on pre-
senting themselves as unmediated, natural. Yet, as the illus-
trations and texts on penhold suggest, the natural hand must
be made and disciplined. In the images effacement is achieved
through anatomical detachment, as if the hand were made to
serve some spiritualized realm of value. It is writing, how-
ever, and writing within the social sphere of the two hands,

secretary and italic, that the hand serves. The hand is an ideological formation; the natural hand is socially produced. Logocentric idealization communicates essentially with this ideological production of and in the hand. A historical domain is thereby placed.

The descriptions attempt to renaturalize this ideological and idealizing formation, but either in animal images that work against the idealized decorporealizations or, once again, by figuring the hand as a mouth. Cresci, for example, was particularly energetic in arguing for the acquisition of a flexible hand to counter "the stiffness and resistance of the pupil's hand" (*S&S*, 262); he provides this description of the process:

> Just as a newly made earthen pot, however fine and good it looks, is easily ruined by being used, unless it is first well dried in the sun and baked in the oven, so the hand of the pupil, coming new to the discipline of writing, even though it seems to be good—unless it is then, so to speak, dried well in the sun of lengthy practice and baked in the oven of the passage of time—will, because it has only a fragile and weak grasp of the rules, easily drop back into its former bad habits and into far worse ones. (*S&S*, 262)

The hand is pictured the way Quintilian describes the pedagogic subject, as a vessel made receptive, fit for the pen. This earthen pot is not exactly an image of Adam made from the earth; it is rather the human remade as something made by hand, put out to receive the divine rays of the sun only after the hand/pot has been made artificial. It is that artificial man that is renaturalized, for, as is the pot, the hand virtually is a mouth, as it is explicitly when Cresci returns to his metaphor of the pot a page or so later in his *Avertimenti*: "When we want to fill a vessel with a narrow mouth, we cannot pour in at once all the liquid that is going into it. In the same way it is impossible to teach this art at a stroke without long and careful practice" (*S&S*, 264). Cresci's pedagogical metaphors chart the path of the hand towards its human destination, the

hand filled like a mouth, given interiority (and mind) by the external imposition of a disciplinary regime.

In Cresci's metaphor, the penman has become the pen, a receptacle for ink. In Bales or Brinsley, the management of the hand is guided to "write softlie." Too much ink will spoil the page, too much pressure will release the ink too fast. Speed and sureness here, as in Bales, confirms the writer's hand as an instrument. Worries about the hand fill the pages of writing books, especially those written towards the end of the sixteenth century in Italy when debates about penhold were rife. Cresci debated with Marcello Scalzini, who favored a more flexible hand than Cresci, one capable of elaborate flourishes. Insisting that the wrist needed training, Scalzini nonetheless asserts in *Il Secretario* that too much concentration and effort is pernicious, a sure way to lose both "health and good complexions" (*S&S*, 255). Juan de Yciar similarly counsels that "it would be less tiring to write upon [the table] if tilted slightly towards the body like a lectern or chorister's desk. This is also helpful for the eyesight which may be damaged with holding the head down" (K4r). "Your bodie upright, stoupe not with your head: / Your breast from the boord [i.e., board], if that ye be wise, / Lest that ye take hurt, when ye have well fed" is E. B.'s versified precept to preserve the body of the writer from the task of writing in Beau Chesne's manual (A2v). Bales makes similar recommendations: "*Write on a deske, least that you hurt your eyes / By stooping much; which hinders health likewise*" (Q4r). As Norbert Elias has argued, medical prescriptions tend to follow upon "civilizing" practices with their displacements of violence (turning upon the subject to found the split subject), offering a supplementary justification. The writing manuals write the body within a scriptive organization and retrospectively secure that body within the regimens of what counts for the health of the scriptively remade body.

The illustrations depicting penhold dispense with these scenes of the body by dispensing with the body. Yet both written and visual representations of penhold carry the same implications: that the body and its natural life are menaced by writing, that a different body (a socialized and civilized body) is produced by writing. Beau Chesne would have the writer be well fed before facing his task. Effort and strain lie behind the production of the swimming hand. The illustrations realize the swimming hand, none better than Hercolani's dismembered hands. They realize, that is, that the body whose care is emphasized in the written instructions is one that has been entirely accommodated to the demands of the hand. The writer is his hand; in the illustrations that is all of him that remains.

To summarize, in these discussions of penhold the violence of writing comes to produce the writer as the instrumental hand. Everywhere writing is menaced—by the quill, most notably, but once the pen is mastered, it masters the hand, literally when the pupil's hand is held, but also when the hand is suited to the pen. So suited, the hand is made docile, swimming across the page, flying like the feather/pen. Yet to do this to the hand may injure the body, and the elaborate instructions about sitting at a desk register how threatened the body is in the activity of writing, while the illustrations, by dispensing with the body, have realized that menace. Again and again, the parts of the body most threatened are the eyes. Writing depends upon and is produced within a sphere of visibility, hence the images in these texts, or the contents of the writing manuals—numerous alphabets to be eyed and copied. If the hand produced by writing is also the hand that has been detached, so too the eye is written into another order of being, a socially scripted one.

Writing, and the writing of the body within its register, opens upon a scriptive scene that also inscribes the modern

unconscious, for these scenes of writing are sexualized, gendered. The training of the boy to be a pen—and the training of the pen to be a mouth—along with the emphasis on the softness and malleability of the hand, suggests feminization even as it founds the privileged male subject. This is suggested, too, because the instrument of discipline, the pen, seems to be phallic (etymology supports a connection between pencil and penis; both words are cognate with *penes*, penetrator). To borrow a Lacanian term, but to recast it through a Derridean argument, writing (as opposed to reading/speaking) would seem to usher the child into the Symbolic register; the renaturalization of the writer rewrites a family scene: master-father, child-wife. Hands, eyes, and bodies are threatened: a castrative economy.

Much of this is explicit in the dramatization of penhold in Thomas Dekker's *Westward Ho* (?1605). Mistress Honysuckle sings the praises of a writing master and his secret skills, thereby provoking Signior Justiano to don the disguise of "*a wryting Mecanicall Pedant*" (2.1 stage direction) in order to use the writer's arts as a means of seduction. In dialogue with Master Honysuckle, the writing master describes those practices in a series of double entendres. He hopes "but to please al those that come under my fingers" and the duped husband commends "so laborious a member" (331) of the city (already, as "member," the writing master becomes his instrument, as well as the instrument of a social formation; one might compare the typical Elizabethan anatomies of the commonwealth in which various classes are described as parts of a single body). The two men turn to the edification of Mistress Honysuckle "under" the master, who fervently hopes that "shee shall fructify":

Hony. Pray sir ply her, for she is capable of any thing.
Iust. So farre as my poore tallent can stretch, It shall not be hidden from her.

Hony. Does she hold her pen well yet?
Iust. She leanes somewhat too hard upon her pen yet sir, but practise
and animadversion will breake her from that.
Hony. Then she grubs her pen.
Iust. Is but my paines to mend the neb agen. (332)

When Honysuckle's wife appears, she yearns for a new pen
to replace her old one (that is, her husband's), for it "is stark
naught, and wil cast no inck" (333).

Dekker's scene makes explicit the sexual implications in
the question of penhold that fills the copybooks. The pen ex-
tended in Mistress Honysuckle's education seems to initiate
her into polymorphous perversity; fornication, fellatio, and
masturbation can be read in this scene, as what is (in Vives's
phrase) "proper to boys" is extended to a larger social do-
main. Dekker's scene follows from writing masters' worries
about the failures of the pen; they read in much the same way,
as do their concerns about the stiffness of the hand, towards
the anxious production of the gendered subject in writing,
anxieties attendant upon the production of an ever-widening
sphere of literacy that needs to be controlled. These logocen-
tric metaphors of the child or pen as mouth are not merely
metaphors; they coincide with the lived experience produced
by writing, with the ways in which the materials of the writer
come also to be ways of inhabiting and conceptualizing the
body. David Browne, for example, recommends that the quill
be put in the mouth to keep it soft as the nib is being formed
—one "*bec*" answers another—and he also recommends that
the nib be kept wet to receive the ink properly (directions on
making the ink sometimes recommend the addition of spit—
or of urine). Only when the pen is not being used, it ought
not be put in the mouth, Browne cautions, as children are
wont to do, who "take occasion with their teeth both to en-
feeble and shorten the staulke of the pen" (*New Invention*, 11).
Here it is the living mouth (not the anatomized mouth of the
pen) that threatens the writing implement.

Elsewhere, the manuals regularly insist, the hand is produced for the pleasure of the eye; the arts of the hand are thereby giving their aesthetic justification. Scalzini, for example, says that "writing . . . should convey an impression of boldness, ease and a certain elegance that attracts and catches the eye of everyone who looks at it. The eye desires and is entitled to have its own satisfaction in all this" (*S&S*, 258). What the eye desires of itself is the regularized production of a beauty of the hand that suits the social judgments of "good" and "naught." These are inculcated through the discipline of copying that the hand is meant to serve (and which, as we will see, always exceeds its regulations by its insistent regimes of multiplication and simulation). Yet the eye, like the hand, is in danger in writing. Both participate in a similar economy. The hand produced is mastered by the mastering hand, and if the eye is threatened, it also threatens; for example, Scalzini recommends that the eye train the hand:

The pupil who wishes to learn the chancery script quickly will find it of great benefit to keep, in a part of his room that frequently catches his eye, a specimen of this style written in the size that he likes and needs. In this way he will pick up a mental picture of the image and shape of the letters by continually looking at them and will have them firmly imprinted in his mind. (*S&S*, 250)

The eye threatens to be the true hand, firmly imprinting in the mind the image that has then to be reproduced on the page. The hand, in this formulation, is a secondary effect of the mind, and the mind, in turn, is but the scene of another hand writing, perhaps a hand that has been "perfected"—decorporealized so that its place of writing is the tabula rasa. (This is the realm of interiority named memory in Vives, the place that would be secured by writing in his dialogue.) Hence, writing manuals are illustrated with alphabets (the hands) and with illustrations of the hand to install the image (a secondary effect) at the origin.

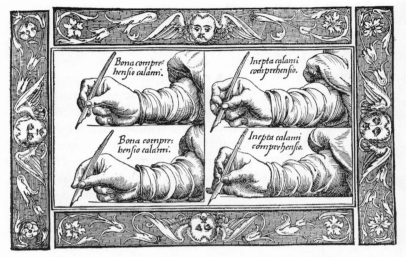

Fig. 11. Urban Wyss, *Libellus Valde Doctus*, C3 recto. By courtesy of the John M. Wing Foundation, the Newberry Library, Chicago, Ill.

These observations on what is gathered in the hand—its comprehensive order—are furthered in other illustrations. Urban Wyss labels his depictions of the proper hands *"Bona comprehensio calami"* in *Libellus Valde Doctus* (Zurich, 1549, Fig. 11), well-held, well-comprehended pens. The labels suggest themselves as images of the production of the hand and mind, the mind as the secondary effect of the hand as Aristotle did (not) say. A similar label accompanies the illustration in Gerardus Mercator's *Literarum Latinarum* (1540), the first book demonstrating the italic hand to be published in the Netherlands (Fig. 12). The labels beside hand and fingers, *"bona comprehensio calami," "bene succedentes digiti,"* are drawn from handwriting —the grasp of the hand produced by grasping the pen, the fingers that follow each other well as they follow the order of the line, letter by letter. These hands writing are written by the handwriting. *"Comprehensio"* is as ambiguous a term as the fit hand in Bales. Within the simulative logic moving from

hand to hand, the hand oversteps all boundaries even as it is well-governed by the logic of duplication; both interiority and exteriority are scriptive formations.

Bales follows Scalzini: "*Mind, hand, and eye, must all together goe*" (R1r). This comprehensive order produces the writing subject as already written, gathered "all together." Spirituality, mentality, decorporealization are exacted in corporeal terms; the materiality of writing founds and unfounds the frame. This ruined logocentrism produces the human hand, instrument of/for instruments. In Wolffgang Fugger's 1553 manual (Fig. 13), the unskilled hand makes for a slow writer,

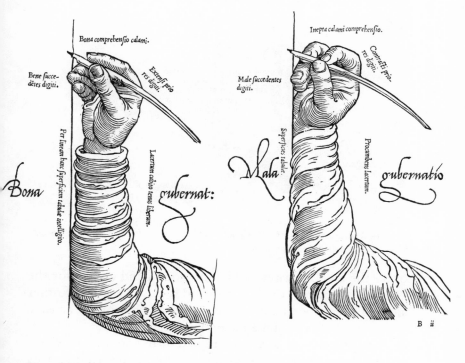

Fig. 12. Gerardus Mercator, *Literarum Latinarum*, fols. B1 verso and B2 recto. By courtesy of the Library of Congress.

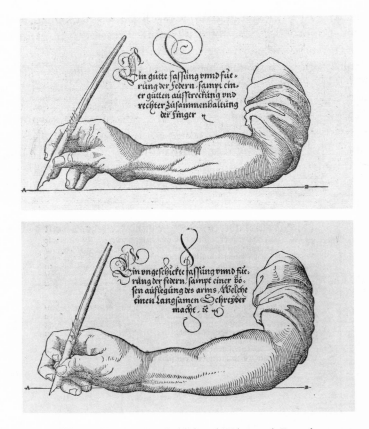

Fig. 13. Wolffgang Fugger, *Ein Ouklich und Wolgegrundt Formular.* By courtesy of the Victoria and Albert Picture Library.

or so the label declares, while the good hand allows for the "*fuerung der federn*"; the leading hand is led by and as a feather along a prescribed path of (a)destination, the comprehensive grasp in which the human hand is gathered.

Such production, as will be argued further in the next chapter, explains the ideological production of the hand and its promotion by English royalty in the Renaissance. But this

governing ideal is already visible in the illustrations of the hand, in the pedagogic judgments of "good" and "naught" for Beau Chesne's exemplary italic and secretary hands and even more explicitly in Mercator's labels "*Bona gubernatio*" and "*Mala gubernatio.*" The well-governed hand is, precisely, governed. Hence beside Hercolani's dismembered hands, the labels say "*e cosi signorilemete tiensi la penna*" and "*e comunemete cosi tiensi la penna.*" Lettering is a social practice; the two correct hands are nonetheless the common hand and the noble one. The hand is not natural but artificial, as its dismemberment suggests. It is made human. Once made it is apparently naturally socialized within the hierarchy separating the nobleman from the merchant. Either way, it is well-governed. Yet all the material resistance to this logocentric framing—the resistance of the instruments, hand and quill—argues against and informs the discourse that invests and divests (at one and the same time) the human hand. Such, then, is the violence with which the scene of writing begins.

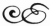

To summarize the argument thus far, this section can close with an image that will return us to the scenes from Bales's life with which we began and point our way forward to a further consideration of the place of the dismembered hand within the social production of the Elizabethan writer. Consider the frontispiece to Richard Gethinge's *Calligraphotechnia* (1619, Fig. 14). To the left is a dignified portrait of the writing master, his quills wreathed in laurel above his head, and above them the motto "*Nil Penna sed Arte,*" a declaration of the hand above the instrument (below the portrait are the more mundane tools of the trade, the travelling inkwell and pencase, which David Browne recommended should be worn on the belt as a professional emblem). The cartouche below elaborates on Gethinge's art. It is displayed on the right side of the

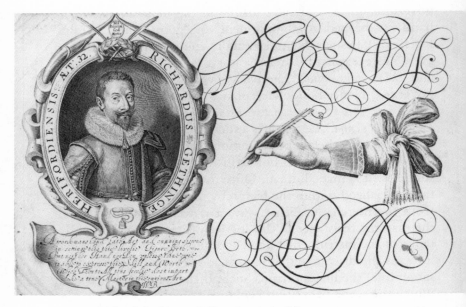

Fig. 14. Richard Gethinge, *Calligraphotechnia*, fol. 2 verso. By permission of the British Library.

page, in letters enmeshed in elaborate swirls (produced by a hand that has scarcely been lifted from the paper, the kind of display that won Bales his golden pen) spelling quill and plume. The hand produces the pen—as a word. But what produces the hand? It floats on the page between the words and terminates in swags of cloth not unlike the swirls of the hand. The hand has been disembodied to write: the final violence of the letter. Portrait, hand, writing: each suggests the production of the writer within a set of reinforcing (but nonetheless discontinuous) frames. If these produce the writer (as person, as image), his writing, and his tool, and all in highly conflicted relationships, they also produce the writer in a social setting. For the dismembered hand, as the title page of *Calligraphotechnia* announces, was (as it was for Bales and John Ayres as

well) the sign hung outside of Gethinge's place of business; the dismembered hand is a "member" of the commonwealth. (Perhaps, too, the hand illustrates mortmain, the rights in property that extend beyond the life of the owner.) Such are the rights of writing, as illustrated in John Davies of Hereford's *The Writing Schoolemaster or the Anatomie of Faire Writing* (1636, Fig. 15), where the pen and hand appear to have been produced by the text that has been written: "It is a most commendable & convenient thing to hould the pen properlie: as in this present enlish [English?] manner of example." The hand placed on the page is the hand written, not the writing hand: it is the hand as the dead instrument of the letter, mortgaged to the already-written.

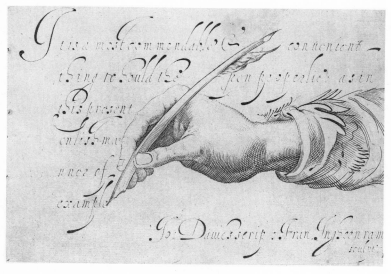

Fig. 15. John Davies, *The Writing Schoolemaster*, p. 17. By courtesy of the Victoria and Albert Picture Library.

COPIES:

INSTITUTIONS OF

THE HAND

He was the mark and glass, copy
and book,
That fashioned others.

—*2 Henry IV*, 2.3.31–32

W ITH THE instruments to hand—knife and quill, paper and ink—the instrumental hand is instructed to write. In the manuals and the pedagogic texts, to write means to copy the exemplary texts and alphabets provided to make the hand the instrument of script, to conform hands to a multiplicity of scripts. Duplication is the aim, reinscriptions that found the human and the habitual in this entirely secondary activity. The copies in the copybooks offer an ideological spectacle for the civilizing process with its "increased tightening and differentiation of controls" (Elias, 1: 223). The hand is suited again and again to differentiated scripts that mark areas of social control—that mark them as separate and that re-mark them within disciplinary confines. Copying is meant to insure the re-marking of the subject within the domains of script, yet duplication re-marks the scene of inscription, and separate spheres are opened thereby. Control of the hand is meant to insure that such extensions lie still within the domain of the hand. But the hand itself has been separated; the hands themselves are each given a page. The ideological work of the books—to make the hands conform and to regulate their activity—also licenses separate spheres of activity; allowing for duplication, the books dream of repetitions without differ-

ence even as they mark difference. In the specular and circular structure of copying there is an excessive circulation that no hand can control, the circulation figured as the dismembered hand that means to insure the hand and that, at the same time, sets it off on its separate way.

Having been re-marked within the regathering of the pen, Vives's Manricus finally does remember something from the oration on the dignity of handwriting: "He said that there was no shorter waye to learne much, Then to write faire and swifte" ("affirmabat nihil esse ad magnam eruditionem compendiosius, Quam probe ac celeriter scribere," Desainliens, 324–25). Mendoza, the other noble youth, then recalls a larger scene of forgetting: "The crowd of our nobility do not follow the precept (as to the value of writing), for they think it is a fine and becoming thing not to know how to form their letters. You would say their writing was the scratching of hens, and unless you were warned beforehand whose hand it was, you would never guess" (Watson, 67; "et nisi praemonitus sis cuius sit manus, nunquam divinaris"). Manricus continues the sentence, "And for this reason you see how thick-headed men are, how foolish, and imbued with corrupt prejudices"; Desainliens translates copiously, "And therefore thou seest how grosse men be. And her[e]of it springeth that men are so barbarous" (325).

Copying installs swift and fair writing in the hand, a celerity that overcomes distance and that functions as an overarching control—it extends humanity to those who otherwise make the marks of animals. Its swiftness and beauty is an abbreviated, "compendious" instrumentality that re-marks civilization, that makes the hand proper and noble—as it copies out the sententiae that fill the pages of copybooks. Such writing makes the writer—the hand, "manus"—recogniz-

able, and the nobility, to be noble, must be rewritten within these precepts of civilized humanity. The ideology of script does not come from the hands of the nobility but is given to them within the pedagogical apparatus that re-marks them. Nobility is the legibility taught in the regime of copying.

The specular structure of copying installs the copy before the writer. A social terrain is remapped through proprieties that rewrite what will count as noble, renegotiations that correspond to the extensions of civility beyond the court to the schoolroom, and to the pedagogization of society, extending the skills of writing and, with it, the assurance that those extensions only confirm the structures of power—so long as those with power will reconfirm those structures by submitting their hands to it. They must submit, that is, to the copying that rewrites the social structure through duplication, and that makes the nobleman's hand proper by making it indistinguishable from the copybook hand. To be legible, swift, and fair, the copy hand must claim the writer's hand. It must be disowned to be proper.

"What are your names?" the writing master asks Manricus and Mendoza:

The names themselves are evidence of noble education and generous minds. But first then, you will be truly noble if you cultivate your minds by those arts which are especially most worthy of your renowned families. How much wiser you are than that multitude of nobles who hope that they are going to be esteemed as better born in proportion as they are ignorant of the art of writing. But this is scarcely to be wondered at, since this conviction has taken hold of the stupid nobles that nothing is more mean or vile than to pursue knowledge in anything. (Watson, 69)

Indeed, the youths answer, they were just saying the same thing; having been re-marked already within the gathering of the pen, they speak its pedagogical and ideological position, subject to it and to the script that rewrites them as those who are "truly" and "properly" noble—those who have been re-

marked within the ideology of civilization that starts in the hand. The noble youths—whose noble, proper names only guarantee their true nobility because they mark them as educated—submit to the discipline of the writing master who can put into their hands the true nobility of their proper names.

Vives's text suggests how the specular structure of copying operates. It opens the domain of pedagogy, gives it power, but only insofar as it then hands that power over again to those in power. The specular structure does not simply work as a mirror in which nobles are the exemplars to be copied and imitated; they are themselves written within imitation; the re-marking of the nobility reclothes them in the dignity of the restraint of their hand, conforming it to the proper model of the copytext. The text is the pretext for the encroachments of the hand—as the controlling and gathered hand of power —which has allowed for the differentiation of hands and of social domains only to regather them within power and, at the same time, to deny overt coercion through the disciplinary function to which even the nobles submit—or, in Vives—are said to submit, in this text written by a pedagogue but for the training of a prince. The allure of the text for those to whom it is extended is that they are offered the same disciplinary submission as that to which the nobles submit—this is how aristocrats are created—placing themselves in the hands of their tutors and writing masters.

It is within such scenarios of an empowering disempowerment that humanistic pedagogy circumscribes itself so that it can inscribe the world. Consider the complaint that Erasmus makes in a 1516 letter to Guillaume Budé (#480). Although he defends his own lack of care in penmanship (arguing that pressures of work make it impossible to rewrite his letters in a fair hand and that economic exigencies prevent him from employing a staff of secretaries), he writes that Budé's letter, albeit "pure and spotless," was nonetheless illegible: "I had to write it out fair with my own fingers to make it legible . . . for

before I did that, I could hardly read it and no one else could read it at all, not so much because it was so carelessly written as that you write like no one else" (103–4). The letter Erasmus had sent to Budé needs to be excused; they are "rough notes" (103) about which its recipient complained. Budé's "pure and spotless" writing is nevertheless virtually illegible because it was not written in a recognizable hand; Erasmus's fair transcription renders Budé's letter legible by making it look like a hand that anyone trained by the copybooks might write, that anyone "literate" could read. "You write like no one else": such is the complaint. A proper letter (and Erasmus does not make that claim for his rough copy) would show no propriety. It should be, and is, after Erasmus transcribes Budé's letter, written in a model hand, an educated hand. In another's hand, his hand is his own.

The writing master in Vives makes the same complaint; the proof of the corruption of the nobility lies in their hands: "They sign their names to their letters, composed by their secretaries, in a manner that makes them impossible to be read" (Watson, 70). The master convinces the youths to take up the instruments/weapons of fine writing as a response to this situation; legible letters will result, and the youths will have employment in the households of the nobility or as arms of the state in its imperialistic ventures. The master teaches them to prepare their pens and paper and provides them with copies to reinscribe. When they present their work to him, he corrects their copies by summoning up the example of the Emperor Augustus, who did not allow words to run beyond the line. "We will gladly imitate that, as it is the example of a king," Manricus says; "You may well do so," the master replies, "For how could you otherwise satisfy yourselves that you had any connection with him?" (78). Their noble genealogy lies in their ability to reproduce the practice of a royal hand—a practice put into their hands by the writing master and his humanistic pedagogy. The noble line is a noble line.

The specular structure of pedagogy places the writing master in a differentiated position to reproduce social relations through the provision of the exemplary structure of copying in which the noble youths—or their classic forebears—are situated, in the italic hand that signifies privilege and social prestige. Domains of inscription are extended, and the pedagogue is empowered; the inflated claims of the writing masters (mocked by D'Israeli) are those of the humanists. The class that gives others the power to write as the powerful (with the noble hand of an Augustus) is nonetheless an instrument of power, an instrumentality figured in the dismembered hand; it is such a hand that is handed over to the noble youths, who are to write their "own" hand by writing the hand of the copytext—the anonymous and legible hand in which Erasmus rewrote Budé's letter. The master's hand is empowered by the hand it teaches, and disempowered as it is handed over to reinscribe the differentiated sphere which has, at one and the same time, opened a space for the writing master and insured that his instrumentality will never extend where the hands of the nobility do.

Complex social negotiations are therefore at work in the copybooks, aimed as they are at reconfirming privilege and power and yet extending it—through the exemplary hands—to those who are to serve as instruments of power. The specular circulation of copying is marked by a double inscription. Such is literally the case in numerous Italian writing books, written, at once, to two audiences. To secure the privilege of the writing master, they announce their noble or ecclesiastical patronage on their covers and in prefatory letters. Jacomo Romano, for example, in *Il Primo Libro di Scrivere* (Rome, 1589), offers a dedicatory letter to Guiliano Cesarini, the Duke of Civitanova, assuring him that writing serves the common good ("*comune utilità*"). But that common good is then extended to common hands; Romano addresses an epistle to the general reader claiming that writing is not merely useful, but

"worthy of all honorable persons" ("*degna d'ogni honorata persona*")—even though the nobility do not always display fine hands, as he explicitly says—and assuring his common readers that fine writers will never lack a position in princely courts, particularly as secretaries ("*a buoni scrittori non manca mai luogo nelle Corti di gran Signori, e nelle Secretarie specialmente*"). Writing well, they will succeed where even the nobility fail—will succeed as noble hands, but without in any way disturbing relationships of power; such, at any rate, is the promise.

Romano's promise was echoed by Guicciardini's experience; he reports in his *Ricordi* (C179) that as a young man he had scorned the skill of writing fair, but the acquisition of a fine hand opened his way to royal service (86). A. S. Osley opens *Luminario*, his study of Italian writing books, with the same supposition: the bureaucratization of the Renaissance state demanded a corps of skilled secretaries: "In the conduct of external relations the secretaries, who were originally registry clerks in charge of Court correspondence, became the principal channels of communication with foreign states. They held the ciphers, kept registers of diplomatic papers, dealt with secret intelligence, and drew up instructions for ambassadors" (2). The copytexts, even as they extend what had been a privileged, aristocratic pedagogy, further the creation of this extended bureaucratic apparatus.

What Vives or Erasmus sponsor as part of their pedagogical program is literally a notion of character formation, conforming the writer to the hand. The idealizing decorporealization of the hand and the violence attendant upon such formations are pressed into social service, not only in the lure of a career at court, but also in providing an ideological and idealizing apparatus for the state. Within the duplicative structure of re-marking, that apparatus also secures the position of the pedagogue by writing it as a state apparatus, opening thereby those scenes of rivalry between writing masters, who attempted to secure for themselves what their "own"

teaching promised, opening thereby the extensions of writing towards a more literate society, and rewriting the boundaries in order to differentiate proper from improper literacies. *"Bona gubernatio"* the label read beside Mercator's exemplary hand. Romano's double gesture assures his noble patron that skilled writers will serve the state—against the anxiety that duplication might never secure difference; Vives's dialogue or Erasmus's rewriting of Budé's letter dreams of a power transferred from the humanist's hand to the state.

In sixteenth-century England that dream was realized. Royalty supported the claims of the pedagogues by acquiring disciplined hands; Henry VIII, who loathed signing documents, nonetheless employed writing masters in the royal household. Richard Croke, a Greek scholar of notable achievement, for example, returned from successes in the German universities to teach Henry Fitzroy, the Duke of Richmond, Henry VIII's illegitimate son, and, until his death in 1536, a possible successor to the throne. Writing in 1527 to Cardinal Wolsey, Croke complains that George Cotton, the governor and comptroller of Richmond's household, had attempted to undermine his work. Croke had taught the duke to write a Roman hand, but Cotton was instructing him to write in secretary hand and to hold the Roman hand in contempt. Croke insists that the boy should not be writing to "meane persons" but only "of his owen hande . . . in Latten specially to the kyngs highenes"; the Roman hand was, for Croke, appropriate to the noble scion (Croke refers to him as the prince) and vital to his education: "He myght more fermely imprynte in his mynde both wordes and phrases of the Latten tonge, and the soner frame hym to some good stile in wrytinge, whereunto he is now very ripe" (Nichols, xliv). The schoolmaster explains the duke's education in inscription *as* inscription. Writing italic, he is to be firmly imprinted by what he prints, styled and framed (like the hands in the copybooks) by his *stilus graphicum*. This is the ideological function

of copying, a duplication here, as in Mulcaster, in which in-
teriority is reshaped by the hand. Mental imprinting begins
with the practice of copying. The duke is made princely by
such inscription. Like the boys in Vives, he fetches his lineage
from the production of the proper line, and it is to such au-
thority that he subscribes in his inscription. Thus, when the
duke wrote to the king (albeit in English—but nonetheless
conformed to the *gramme* and grammar), he displayed what
he had learned: "I do write unto the same [that is, the king]
not oonly to make a demonstration of thys my proceedinge in
writinge, but also in my moost humble and most lowly wise
to beseche youre highenes of youre dayly blessinge" (Nichols,
lii–liii). The disciplined hand conforms to its copytext models
—and pays homage to the king. The ideology of the copying
hand insists on the identity of these duplications.

Croke's career as tutor to the king's son might appear to be
a minor episode in a life of extraordinary accomplishments—
besides professorships of Greek on the continent and at Cam-
bridge, he was sent by Henry VIII as a diplomat to Italy to
consult with other scholars on behalf of Henry's divorce. Yet
it is of a piece with those events; humanism and diplomatic
service are domains of the hand. The skirmish with Cotton
over secretary and italic script plays out an ideological and
class battle. The nobility of the youth will be revealed in the
script he writes; italic is proper to his station, and what his
hand has been trained to do will also produce the kind of atti-
tude found in the letter to his father. This is the work of a
docile hand. The noble youth must write the noble script that
sets his hand off from the ordinary hand.

How much could be read in the hand is suggested in a 1546
letter of Prince Edward (MS. Harl. 5087.9; Edward VI 1: 16–
17), whose education could serve as an exemplary realization
of humanist pedagogy. He writes to the queen (Katherine
Parr) to express admiration for her Roman hand and her skill
in letters, telling her that when his tutor saw her letter he could

scarcely believe that she had penned it; only the fact that the same hand had produced the body of the letter and the signature proved conclusive. (Yet what does it prove? That Vives's scheme had been realized, but also that secretaries were more likely than royalty to have learned to produce "proper" script; that power effaces its hand and has others write for it; that when royalty come to write like secretaries that situation only furthers the ideology of effacement, an ideology complicit with the disappearance of the "instrument" of writing to insure the illusory full presence of the sovereign, guaranteed by copy.)

Edward pronounces himself as amazed as his tutor (perhaps not least because the writer is a woman—a topic to which I will return later in this chapter). Then, in good schoolboy fashion, the nine-year-old prince proceeds to the moral of the reproduction of the letter. "I have heard of your rapid progress in the Latin language and in good 'letters' " ("*bonis literis*"), Edward comments, punning, as he does throughout the letter on the fact that "*literae*" means alphabetical letters, epistles, and literary works; he puns within the duplication of the letter, the duplication of the proper copy displayed by Richmond's subservient hand, a duplication insuring the connection between humanistic teaching and the italic script. Her letters, he writes, please him, for "letters remain while all other visible things perish" ("*Literae . . . manent*"). The works of the hand (*manus*) are what remain, and yet the materiality of the letter is made to serve a transcendental remainder. Proper script (and its "proper" duplication, from letters to literature) effaces itself in this hand. Moreover, good letters (noble, Latin, antique, eternal), Edward continues, found society: "Literae etiam conducunt ad bonos mores"; the governed hand governs, leading to the formation of character and behavior. Edward slips within the letter from Latin letters to church doctrine, from the hand to the mind, "*est doctrina lux mentis*," to arrive at a neat syllogism: "All that is good comes

from God; 'literae' (letters, the holy script of doctrine) come
from God: therefore doctrine is good." Finally, he closes the
letter by quoting a dictum of Vives: " 'What you see does not
last for long.' " Edward applies the saying to the riches of the
world, but not to letters, which have been given transcenden-
tal privilege to produce the ideology of Christian humanism
and its inscription of the domains of power and privilege. The
prince reproduces the ideology of his teachers—reproduces it
as the lessons he has learned and as the authorization of his
civilized power.

Edward's letter does not say which of his tutors (Croke?
Cheke? Ascham?) had been astonished by the queen's hand.
As Ascham tells it, he was responsible for the king's "charac-
ter." In September 1552, petitioning Cecil for an appointment,
he recalls that "many times, by mine especial good, with Mr
Cheke's means, I have been called to teach the king to write,
in his privy-chamber, at which times his grace would oft most
gently promise me one day to do me good" (Giles, I: #cxl,
332). When Ascham had not received official notification of
his appointment as Latin Secretary to Queen Mary, he recalled
the same episodes in a letter of complaint to Bishop Gardiner:
"I was sent for many times to teach the king to write, and
brought him before a XI years old to write as fair a hand,
though I say it, as any child in England, as a letter of his own
hand doth declare, which I kept as a treasure for a witness
of my service" (I: #clxiv, 398). In another letter to Gardiner,
he claims that he had served as letter writer for Edward and
Henry VIII (I: #clviii, 384), and reviewing his career in a 1567
letter to Queen Elizabeth, he reiterates the claim. "Winches-
ter [that is, Bishop Gardiner] did like well the manner of my
writing," and his preferment by Henry, Edward, and Mary
was caused by only one thing: he "had done no service except
in teaching King Edward to write" (II: #lxxxvii, 154–55).
Ascham's letters reiterate that sole copytext—"I taught King
Edward to write"—as he negotiates for a position at court.

Ascham's claims about preferment under Henry VIII and Edward VI are unsubstantiated, but he did serve as Latin Secretary to Mary, and he was continued in that office under Elizabeth (Ascham's copytext, then, the one that insured him a position under any monarch, would seem to have been, "I serve the king"—*the* text within the ideology of copying). In 1548, he became tutor to Princess Elizabeth, and handwriting he certainly taught her. A letter of 1550 to Sturm praises her Greek and Roman script: "When she writes Greek or Latin nothing is more beautiful than her hand" ("Si quid Graece Latineve scribat, manu ejus nihil pulchrius," I: #xcix, 191). Twelve years later, he sent Sturm a sample of her Roman hand: "Ut ipse videas quam polite illa scribit, mitto ad te his literis inclusam schedulam, in qua habes verbum, quemadmodum, propria reginae manu conscriptum. Superius meum est, inferius reginae" (II: #xxxiv, 63–64; "So that you can see how elegantly she writes, I send you the enclosed slip of paper on which the letters of the word 'quemadmodum' are written in the queen's own hand. The upper one is mine, the lower hers"). Ascham sends Sturm a page of a copybook in which his Roman hand is imitated by the queen; the hand "properly" hers is the imitation of his hand. Apparently, what Ascham sent Sturm was a page on which the queen (then princess) practiced the first word of the dedicatory letter to Henry VIII that prefaces her translation of Queen Katherine (Parr)'s book of prayers, a copy of which, in Elizabeth's hand, survives. The royal script not only is conformed to her writing master's hand; the example Ascham sends Sturm was directed to her father.

Ascham understood his career in letters as shaped by his ability to shape hands, and not only royal ones. He confides in a letter to Cheke, for example, that he expects remuneration from the Duchess of Suffolk since he taught her son Lord Charles to write, forming his lovely hand ("dominum Carolum Graecis literis institui, et ad pulchrum manum formavi,"

I: #cviii, 222), and also from the Duke of Suffolk, whose elegant writing is indebted to Ascham's teaching ("elegantiam scribendi qua ille praestat mihi quoque debet"). As Ascham expresses it, what Suffolk possesses he owes to his teacher, and for having given him his hand, he owes money in return. The inflated claim is matched by one in a 1566 letter of complaint to the Earl of Leicester: "If I die, all my things die with me, and yet the poor service that I have done to Queen Elizabeth shall live still, and never die, so long as her noble hand and excellent learning in the Greek and Latin tongue shall be known to the world" (II: #lxxxv, 128). Ascham's letters often present himself as someone whose extraordinary services have been insufficiently rewarded; what his hand has done parallels the claims in Prince Edward's letter—it has produced a hand, a script, letters and literature that cannot die. For such transcendent gifts, secretaryships are small rewards.

These are the claims of humanistic pedagogy, and a text like Ascham's *Schoolmaster* is intent upon displays of discretion (the word recurs throughout the text), differentiating spheres of power, and re-marking them all within a pedagogy that shapes manners according to the abilities of the hand. *The Schoolmaster* opens a space for grammatical education which then extends the notion of nobility so that it coincides with the gentility conferred upon those whose hands are educated, who can negotiate the double translation that rewrites manners after the *gramme*. Elizabeth serves as the chief example in this text: "And that which is most praiseworthy of all, within the walls of her privy chamber she hath obtained that excellency of learning, to understand, speak, and write, both wittily with head and fair with hand, as scarce one or two rare wits in both the universities have in many years reached unto" (56). Yet the entire text of *The Schoolmaster* reassembles the world as the space of examples for a grammar of life that, like the text itself, always digresses as it encroaches upon social terrains to re-mark them through pedagogic propri-

eties. In this text, as in his letters, Ascham cannot be situated
since it is the mobility of duplication that his text enacts as
it attempts to place the pedagogue in relation to domains of
power rescripted within pedagogic apparatuses which claim
for themselves their discretion:

> But perchance some will say I have stepped too far out of my school
> into the commonwealth . . . yet I trust good and wise men will
> think and judge of me that my mind was not so much to be busy
> and bold with them that be great now as to give true advice to them
> that may be great hereafter. . . . Even so, whether in place or out
> of place, with my matter or beside my matter . . . I shall think my
> writing herein well employed. (59)

Ascham claims the discretion of his place by writing towards
and from a future in which everyone will be "good and wise"
in recognizing that the school—like *The Schoolmaster*—can go
everywhere, since it rewrites the commonwealth as a school
that insures the position of the great—and the mobility of the
schoolmaster, who serves to reproduce society, serves, as As-
cham did, as diplomatic correspondent for negotiations that
allow a place for his class within the domains of power.

Such is the message impressed upon another Princess Eliza-
beth's hand, the daughter of James I, by her writing master,
Jean de Beau Chesne (the same who had authored with John
Baildon the first writing manual published in England). In a
copybook for the princess in Beau Chesne's hand (Newberry
Wing MS ZW 639.B382), the writing master offers himself
and his pen for service:

> Recevez d'un bon oeil PRINCESSE, je vous prie,
> L'ouvrage e l'ouvrier de qui le coeur n'oublie
> Les tres-humbles respects qui par luy vous son deus:
> A vous donc il consacre & sa main & sa plume

The princess is asked to regard this gift of workmanship
which is her due—an eyeing of the copy that nonetheless re-
flects and reproduces her since the dedicatory poem suggests

that the gift of his hand makes manifest her nobility. If Beau Chesne is obligated to her, it is because his hand has been the means of witnessing wherein her merit lies. The dedicatory poem opens with such declarations:

> L'honneur qui se doit rendre aux merites des grands
> Donnent mille proiects a un gentil courage,
> Pour se manifester par un beau tesmoignage,
> De ce qu'il a compris dans les arts florissans.

His flourishing art, the art of his hand, returns to the princess a reflection of her merit; it is manifest in his hand. Hence, what she is to regard in his hand is herself. The dedication ends:

> Sans la plume les noms des Princes ne sont leus,
> Est le temps ravissant dans l'oubly les consume.

"Without the pen, the names of princes cannot be read, and ravaging time consumes them in oblivion." The master's hand confers immortality upon the monarch, and for its ideological gift, the princess must conform her hand to the scripts of the copybook.

That lesson is suggested in the first copytext for the princess, a French version of the sentence that opens *A Booke Containing Divers Sortes of Hands*, illustrating text hand: "All men are by nature equal, made all by one workman of like myre, & howesoever we deceave our selves as dere unto God is the poorest begger, as the moste pompous Prince living in the worlde" (B1r). In the French text, sickness and death are pronounced the common end of both princes and paupers ("*a tous deux*"), and another hand (that of the princess presumably) has copied the word "*deux*" in the margin—perhaps thereby reinscribing the word that points to the duplicative similitude in which the entire world of rich and poor are rewritten within the hand of the text. Also copied is part of the sentence in which God is said not to be a respecter of persons ("Dieu,

non; il n'a point acception de personnes"). *"Dieu non il na"* and *"point"* are written in the margins. Beau Chesne's copybook for the princess is filled (as are most copybooks) with such severe moralizing, and although the princess's hand is not visible elsewhere, the jottings suggest that she was being impressed with the master's lesson, the disciplinary negations that insure the hand of power—and guarantee power to the hand of the writing master. Beau Chesne uses his hand in the place of God, and the princess submits; the negative transcendence of divine indifference makes the princess a virtual duplicate, doubled in her hand—as can be seen, too, in a brief letter she wrote to her father, perhaps designed to show off her hand and, like Richmond's letter to Henry VIII, written to acknowledge her master; Elizabeth ends her Italian letter (written in an italic hand): "Et le bacio con reverenza l'augusta mano" (Folger MS Add 876; "I kiss with reverence your august hand"). In *his* august hand, James signed with his usual motto in 1590 in Dietrich Bevernest's autograph album (Folger MS V.a. 325): "Est nobilis inaleanis / Parcere subiectos & debellare superbos," taking Anchises's prophetic words (*Aen.*, 6.853) about the accomplishments of Augustus as his own, merciful to the conquered, conqueror of the proud. The king writes his own imperial designs in another's script, a copytext reinscribed as his motto.

In a 1603 letter to Prince Henry (BL Harl. 6986, f.67; Akrigg, 219–20), James considers his son's education as manifested in his hand: "I am glad that by your letter I may perceive that ye make some progress in learning," he opens, "although I suspect ye have rather written than indited it." "Not that I commend not a fair handwriting," he proceeds to explain, but he would have a letter "as well formed by your mind as drawn by your fingers." The anxiety here, that what should be formed by the mind may be formed only by the fingers, is also the product of the regime of copying; the accomplished hand makes the distinction between mind and hand, "write"

and "indite," difficult. James cannot tell anything about the prince's mind precisely because of the skill of his hand, which serves as a token of the mind produced by the hand. The king asks for a letter that would be "wholly yours, as well matter as form"; the well-formed copy hand frustrates that desire. The prince's hand is already wholly "his" within the duplicative anonymity of the accomplished copying hand—a hand of power and of powerful mystification that troubles the king. (Here it is worth noting that the Duke of Richmond's submissive letter to his father is matched—copied, word-for-word —by another epistle, to another recipient; only the name of the addressee is changed; see Nichols, liii.)

What James desired, he registers at the end of the letter, urging his son to consult his book, the *Basilicon Doron*, reminding him that he warns him there "to be wary with that kind of wit that may fly out at the end of your fingers." The self-citation, however, is a quotation from DuBartas, who inveighed against writers: "l'eur esprit s'en fuit au bout des doigts" (see Peacham, *The Art of Drawing*, 2), and as the king proceeds to offer further moral advice, more quotations follow, from the Bible and Virgil. James wished to insure that the prince's hand wrote properly; to be sure of that he gives him copytexts, authoritative scripts to shape the prince's hand. Matter and form will be wholly his when they are wholly his father's copytexts. However, the king's pedagogy derives from the copybooks of the writing masters; he attempts to suborn what their "proper" art taught, the well-formed, noble, anonymous hand—but only by reinscribing their teaching.

Peter Bales may have been the tutor instructing Prince Henry in the arts of the proper hand that caused his father such anxiety (since proper and duplicative, the hand reveals its inscription elsewhere and holds in reserve what James wants to know—this is the power of the hand, but also how the hand may submit to power in its duplications). John Davies

of Hereford (whose *Writing Schoolemaster or the Anatomie of Faire Writing* survives only in a posthumous 1636 edition) also has claims to the position of the prince's tutor (Grosart, xiii). Both of Davies's brothers were writing masters, and in a poem to his brother Richard, he makes the claims that worry King James, declaring that having shaped his brother's hand, he also formed his heart and mind:

> Conforme thine head and heart unto thine hand,
> Then staidly they thine actions will command;
> Thy hand I taught and partly storde thy head
> With numbers, such as stand in cyphers stead
> To make but others mount with praise undue,
> For nought but nought, which is a cypher true.
> But if thou wilt be measurde by thy gaines,
> Number not words, but number pounds with paines.
>
> ("To my brother Mr Richard Davies")

Command of hand should shape Richard's heart and mind, Davies writes, echoing the procedures of copytexts, which inscribe interiority through the hand and which display conformity in their discipline. The numbers "partly storde" in Richard's hand and head are arithmetical digits (writing manuals aim at commercial practices) and poetic numbers; like the number o (the cipher), they have the capacity of multiplication. As ciphers, they are the secret script that effaces the writer and gives value elsewhere—value, which Davies intimates, is nothing in itself and entirely the product of the duplicative hand. Yet Davies insists that real value must be returned to the writer for the value he confers, multiplying nothing into something—pounds should repay the writer's pains. Davies's poem knows the ideological work of the hand and the ways in which it is meant to survive the writer, as well as those the hand praises and serves. Thus, to his brother James, he claims that it is certain that Oxford will reward his writing skills as they deserve to be, for his writing assures the fame of the university: "so shall she as she should / Make

him, that makes her prais'd more manifold" ("To my brother Mr James Davies, Master in the Arte of Writing in Oxford"). Davies's lines are themselves "manifold," folding back upon themselves in the circulation of the procedures of copying.

Davies was, on the evidence of Epigram 215 of *The Scourge of Folly*, "Of a pen for a running hand," a rival of Peter Bales, since the writer in the poem, Clophonian, displays a hand and golden pen on his shop. In the poem, the cursive hand is literalized—Clophonian is always on the run, presumably because he is incapable of delivering the fine hand he pretends to be able to command; yet it is the "running hand" that also confers value on the writer, ciphering to greater accounts and hoping to accrue profit for his work. The ideal of a material return for the material practice is belied by the social work done by the writer, which carries no guarantee that the running hand will ever come into its own. Mystified social value does not necessarily translate into cash terms.

Fuller's account of Davies's accomplishment in the *Worthies* sums up the ideological construction of the skills of the hand:

John Davies of Hereford . . . was the greatest Master of the Pen that England in her age beheld, for 1. Fast-Writing, so incredible his expedition. 2. Fair-Writing, some minutes' Consultation being required to decide whether his lines were written or printed. 3. Close-writing, A Mysterie indeed, and too Dark for my Dimme Eyes to discover. 4. Various-writing, Secretary, Roman, Court, and Text. The Poeticall fiction of Bryareus the Gyant, who had an hundred hands, found a Moral in him, who could so cunningly and copiously disguise his aforesaid Elemental hands, that by mixing he could make them appear an hundred, and if not so many sorts, so many Degrees of Writing. (Grosart, xiii)

Unlike Bales's running hand, Davies's is said to have moved so fast as to offer a veritable example of the "leger de main" of the writing master—sleights of hand that secure the writer, the "incredible expedition" that allows the writer to be (as Ascham suggested) everywhere and nowhere at once, always

in place because every place is a domain of script. Davies's fair hand is so fair that it is not immediately apparent whether it is written by a man or produced by a machine—a realization of the ideal anonymity of the practiced hand; his microscopic hand (unless his close-writing is done in invisible ink or inscrutable ciphers) cannot be seen with the naked eye, while the variety of hands at his command, multiplied and disguised, point the moral of a monstrous myth of the power of the hand —forgeries of power. Davies's skills are those of the proper hand that has lost all propriety, the one like Prince Henry's hand which so disturbed his father, trying to separate writing and inditing, and yet was his father's model as well. In Epigram 251 ("Of Myselfe") in *The Scourge of Folly*, Davies likewise finds that he cannot puzzle out whether the person who said of him "There's none were fitter then thou to endite / If thou couldst pen as well as thou canst write" was praising him or censuring him, and that, precisely, is the point; does "endite" mean write by hand, or does "pen?" Which means to write literature, which to write letters? Which praises the hand, which the head? Is there a difference?

Martin Billingsley, tutor of the future Charles I, offers in *The Pens Excellencie or The Secretaries Delight* (1618) a summary statement of the ideological investment of writing:

And what should I say of the Excellency of this Art? Is it not one of the hands by which not only this, but all other common-wealths are upholden? The key which opens a passage to the descrying and finding out of innumerable treasures? The handmaid to memory? The Register and Recorder of all Arts? And the very mouth whereby a man familiarly conferreth with his friend, though the distance of thousands of miles be betwixt them? (C2v–C3r)

Billingsley's hand/pen displays the idealization that invests the instruments of the hand—writing and the writer. The hand that writes is metamorphosed into the hand that upholds all commonwealths. The force of the metaphor serves, for a moment, to obscure the very literality of the statement

(there is no power in the hands of illiterates), just as the gener-
ality of the statement—all commonwealths, not just England,
are upheld by the hand that writes—allows for specific social
configurations to be ignored. They emerge, however, in the
metaphors that describe writing as a key to treasures or as the
handmaid of memory, invoking thereby a technical hierarchy
inflected with class and sexual arrangements. The supporting
hand becomes a subordinate hand, an outside providing the
means of access to a more highly valued interiority, a trea-
sury that is one with the mind. The material rewards of the
secretary and royal tutor are transformed into the transcen-
dental realm, the treasury of the logos and of power. The
language reveals the conflicted nature of these claims and the
possibility of non-arrival in the ambiguity of the instrument;
it is both support and upholder, (male) key and (female) maid.
These are the contradictions that maintain the idealizing and
ideological argument, for what is inside here (and as such in-
herently valuable, spiritual) is produced by the outside. Writ-
ing, which registers and records, inscribes sociality within its
all-embracing and differentiated domains.

In the familiar logocentrism of Billingsley's paean to the
pen, mouths have become hands. Billingsley asks, "What
should I say?" and writes; he describes writing in its usual defi-
nition as the act of speaking at a distance, the "very mouth"
(sounding in its "Recorder") that is a true mouth by being in
the hand. The Recorder resounds by rewriting. The key that
opens also keeps secrets: such is the function of the secretary,
to be read in the etymological derivation of "secretary" from
"secret"—the secret of the emperor's new clothes, revealed
as the royal secretary becomes a register, as if regality were
produced by its registration, its being written. The Recorder
keeps records; it is an artificial memory that produces true
memory in the mind, the true voice in the hand. In Billings-
ley's summary statement of the prestige of the pen, sociability,
even the everyday, is produced as a sleight of hand—one that

means to insure the places of power and of the writer, and which inscribes them within the recursivity of copying.

The privilege of the secretary within this ideological domain can be seen in the device that a professional scribe, Jean-Antoine Baartwijck (he became Chief Secretary to the Imperial Chancery in 1591), entered into the album of signatures that Abraham Ortelius kept (Fig. 16). In the center of the plate, a hand holding a pen emerges from a cloud, inscribing "*Muta loquor*" (I speak silently); above, the motto "*Regumque Comes*" (companion of kings); below, "*Secreta reservo*" (I keep secrets). The plate celebrates the office of the secretary, his social standing, and the mystery of his art—the silent speech of the secret keeper, secret writer, recorder of the mysteries of logocentric and ideological mystification. The hand that writes seems to have no material support; the hand is disembodied, coming from a cloud, spiritualized. God's hand is represented this way in numerous depictions; this is the hand of the copybooks as an apparatus of pedagogical power. The words produced by the pen literally proclaim it a speaking instrument; in the depiction, the hand has just finished writing "*loquor*"—"I speak." In conjunction, the three statements are all about the hand: as royal apparatus, as silent speech. The image embodies—in its disembodied hand—writing as the apparatus of ideological imposition. The "I" who speaks here appears to be the pen. This signature device does not offer Baartwijck's name. Rather, he is produced within his secretarial function. He has become his severed hand: the noble hand prescribed in the copybooks, the hand that upholds the commonwealth and that writes the place of the secretary within it.

To summarize, the domains of the hand—English royalty and their writing masters, imperial secretaries, Italian court scribes, papal notaries, London scriveners, and court clerks —all are marked by the duplicative procedures of the copybooks, their mystified values, and the aporetic structure of

Fig. 16. Device of Jean-Antoine Baartwijck, fol. 97 recto Pembroke MS
113. Reproduced by kind permission of the Master and Fellows of Pembroke College, Cambridge.

a duplication that does not work equally in the separate domains that conform to the practices of reinscription. The writing masters and their manuals promise conformity and social regulation, and the writing masters, even within the privileged spheres of power that their hands work to maintain, are menaced by the very anonymity that their practiced hands reproduce, an anonymity which also insures the hand of power. Mystified (self-mystified) by an ideology that also re-marks the boundaries and limits of power, the pen on the move everywhere might arrive nowhere—ideological mystification works to maintain social difference, but also to allow social mobility and the lure of privilege to those who wield the pen —a privilege not inevitably realized by the writer, although maintained as the ideological truth of writing. In Italy, as A. S. Osley comments, the writing manuals were aimed at aristocratic youths and young gentlemen on the rise, hoping to find a place in one or another court or papal office (*Luminario*, 3); in an increasingly centralized national state such as England, the manuals and pedagogic treatises were aimed even more widely to include a pedagogy for children before institutionalized schooling began (if it did at all), for the middle-aged who had never been schooled, for women, who, unless they were aristocrats or members of humanistic households like those of Sir Thomas More and his offspring, were excluded from educational opportunities—the opportunity, that is, for social inscription within the widening and straitening domains of a continually renegotiated literacy.

Although like their Italian counterparts, English writing manuals recognize a double audience, and the double office that the pen performs, they glance frequently at the "extended" terrain of the literacy that is being redefined within the Tudor-Stuart state. David Browne, who claimed to be James I's official Scottish scribe, like Jacomo Romano, supposes a double audience for his *Introduction to the true understanding of the whole Arte of Expedition in teaching to write* (1638).

The prefatory letter is to Prince Charles, the other audience "those of middle age" (B1v) who, he promises, will learn to write in six hours if they know how to read already, in a month if they do not. Although there are pretenses to social advancement in Browne's claims for himself and his art, there is also, for those middle-aged readers, clear directions to find him (and to recognize his social standing): "He practiseth the most part of the day in the Terme time, and most of the after noone in the vacation, at the *Cat* and *Fiddle* in *Fleet-street*, and most of the forenoone, at his house in *S. Johns* street, next above the Unicorne, except when hee is invited to the Country at any time, especially in the long vacation" (B1v). Browne, apparently, was a law clerk, to be found in a pub when not at home and at country houses when invited there, presumably to teach a fair hand to the children of those with means enough to have a country house. Similarly, John Brinsley dedicated his pedagogical treatise, *Ludus Literarius: Or, The Grammar Schoole* (1612), to Prince Henry and Prince Charles, yet his "loving Reader" is someone who "tenderest the poore Countrey schooles" (5), and he writes for "even the meanest teachers and learners" (5v). Gethinge's *Calligraphotechnia*, as we saw earlier, announced his shop sign on the title page; the prefatory letter that follows is addressed to Francis Bacon. Edmund Coote's *English Schoole-Master*, which appeared first in 1596 and was in its forty-eighth edition a hundred years later, claims a broad demographic audience: "all . . . Schollers, of what age soever" are appealed to on the cover, "Men and Women" (A2r), indeed "Taylors, Weavers, Shop-keepers, Seamsters, and such other, as have undertaken the charge of teaching others" (A3r). With Coote's list, it appears that any place of business might have been a schoolroom in Elizabethan England.

Such an appearance is exaggerated, of course, although it witnesses how widespread the spheres of literacy were. The books produced by the writing masters also show this, for

beyond the secretary hand and the italic, which mark the domains of court business and aristocratic and humanistic hands, they offer examples of the specialized hands for various courts and their clerks, hands for merchants, fancy hands for private letters, and more. These books work to open the spheres of a highly differentiated literacy; they work towards the pedagogization of society. While there is evidence that in royal, aristocratic, or moneyed households writing masters were employed and that samples of the scripts of continental calligraphers were collected (Stephen Harvard offers a facsimile of a manuscript prepared by Bennardino Cataneo for an Englishman in 1545; ownership of such manuscripts is discussed in his introduction, as well as by Janet Backhouse and by Fairbank and Dickins), it was the printed writing manuals that more often served to instruct those without writing to acquire the skill. As the variety of hands in the books suggest, writing was not the acquisition of one's own hand for the broader populace any more than it was for the nobility or those that served as their secretaries. Any hand was to be conformed to a model hand, and certain hands were prescribed for certain offices and kinds of writing.

The printed books realize what was implicit in the writing practices prescribed in the manuals, for if the aim was to produce a hand conformed to a model, printing insured the duplication of the hand. Although the first scripts in printed books had been reproductions of individuals' hands, in the course of the sixteenth century, the process was reversed. Individuals' hands were reproductions of reproductions. The technology was no betrayal of the hand; it was its realization, as Fuller's celebration of Davies's hand as virtually indistinguishable from print suggests. Robert Williams makes the point: "As writing became standardized through the spread of printed books, there was less idiosyncracy between writing teachers, so the use of another master's copy-book made little difference to either the teacher or student" (88–89). In

the sixteenth century, the writing master appeared as a wide-spread phenomenon, no longer confined to the households of the great; that social position is concurrent with the printed writing manual that also signalled the demise of the profession, whose accomplishment wrote itself out in the printed copybooks that realized the aim of the reproduction of literacy and its values—despite the writing masters. The extensions of literacy did not guarantee extensions of privilege or power; schools of seamstresses and weavers could not claim the social prestige of humanist establishments—but neither could they simply be written off. They had been secured by copy, which secured nothing—such was its power.

The frequency with which women were expected to be readers of these manuals and pedagogic tracts may seem surprising considering the statistics about female illiteracy that historians (such as David Cressy) have produced and the rarity of sites of institutionalized pedagogy for women (Rosemary O'Day provides very few instances of grammar schools that admitted women for elementary training; see p. 185). It is no surprise, of course, to find that royal princesses were taught to write, or that Beau Chesne, for instance, dedicated his ca. 1595 manual, *La Clef de l'Escriture* (which despite its title was published in London), to Lady Mary, Elizabeth, and Althea Talbot, whose "fine and daintie pennes," the preface claims, "surmount even the best in skill" (*iir). But when David Browne continues to advertise his whereabouts in his *Introduction*, it is "where likewise *Mary Stewart* and her daughters, doe instruct young Noble and Gentlewomen in good manners, languages, writing & other qualities, by his assistance & direction" (B1v). Women, it seems, at least in such marginal institutions as the taverns and byways of Edinburgh, were being taught to write and were *doing* the teaching; as Margaret Spufford has

argued, this may have been more often the case than has been recognized, although little evidence appears to remain about these activities, and not surprisingly: much as the manuals and tracts that we have been reading sought to open spheres, the exclusion of women is as insistent as the marginalization of subaltern sites of instruction (like the shops of weavers and seamstresses). The pedagogy practiced in those locales rarely found its way into print.

Although the writing manuals scarcely seem aware of the fact that a woman might write (equally rare is the possibility that a writer might be lefthanded—there is one copy for the lefthanded writer in Beau Chesne and Baildon's manual), Ludovico Curione's *Lanotomia delle Cancellaresche corsive* (Rome, 1588) is not absolutely unique when it offers a page designated as written in and for a woman's hand (his example is a French secretarial hand, and it is labelled "*Lettre qui escrivent les dames de France*"). When Jodocus Hondius published the first anthology of hands of famous European writing masters, *Theatrum Artis Scribendi* (Amsterdam, 1594), he included hands actually written by two different women: the Dutch calligrapher Maria Strick, who published four writing manuals and ran schools in Rotterdam (in a contest for a golden pen, as Anthony R. A. Croiset van Uchelen has shown, she placed second and was commended for her special ability in italic script) and, writing two pages, his daughter Jacquemyne Hondius, both examples displaying the French hand that Curione thought of as a lady's hand.

Italic, however, was more usually regarded in England as the hand for a woman to write; Billingsley and Mulcaster, we recall, extended the "sweet Roman hand" from the university to women, as, in Billingsley's phrase, "the easiest hand that is written with *Pen*" (C4r) and therefore apt for women, who, Billingsley avers, have limited abilities to concentrate: "They (having not the patience to take any great paines, besides phantasticall and humorsome) must be taught that which

they may instantly learne" (C4r). Billingsley's paean to the pen had presented it as the handmaid to memory; women, who are regarded by him as being short of memory, are given the hand that most quickly makes memory present-to-hand. The dream of overcoming distance and installing a present "instantly" is gendered female, displaying thereby the coincidence of subjection with subject-formation in the hand. Billingsley emphasizes this point of contact between the scene of writing and gender formation early in the introduction to *The Pens Excellencie* when he argues that writing is valuable for all to learn, including women:

> And if any Art be commendable in a woman, (I speake not of their ordinary workes wrought with the needle, wherein they excell) it is this of *Writing*; whereby they, commonly having not the best memories (especially concerning matters of moment) may commit many worthy and excellent things to Writing, which may occasionally minister unto them matter of much solace. (C2r)

Women are the most recalcitrant site for the formation of memory that copying envisages. A few lines later, Billingsley adds, however, a more material reason to his ideological platform: wealthy widows (a group of women who had more than usual economic freedom) need to know how to keep accounts. There are real treasures in their hands, not merely those mystified by the pen. The aporetic structure of Billingsley's "handmaid" pen faces in the direction of social contradictions in the construction of gender that reflect back upon the circuit of copy and its reproductions of hierarchies of power. Rich and relatively independent women need the pen as part of their power; other women need to be subjected to it. Everyone should write so that everyone can be placed properly. The circuit of the pen exceeds and founds these proprieties.

Educators like Mulcaster or Vives, who recommend the education of women at least in the elementary skills—and who

commend princesses like Katherine of Aragon, Mary Tudor, or Elizabeth I for their extraordinary accomplishments (Mulcaster calls the queen the tenth worthy in *Positions*, p. 173)— never imagine that these *skills* will grant them a place or power in the world. If they are royalty they have those positions; the others are to be better wives and housewives by being literate. Theirs (as Furet and Ozouf emphasize) is an education in docility; "*Reading*," Mulcaster says, "is verie needefull for religion . . . without hindering their housewifery" (177). "When she shall be taught to read," Vives says, in *Instruction of a Christian Woman*,

> let those books be taken in hand, that may teach good manners. And when she shall learn to write, let not her examples be void verses, nor wanton or trifling songs, but some sad sentences prudent and chaste, taken out of holy scripture, or the sayings of philosophers, which by often writing she may fasten better her memory. (55)

Yet, as we have seen, the manuals prescribe docility of hand for all writers; the kinds of copytexts that Vives recommends for the woman's hand are identical to those that fill the writing manuals, and the construction of an interiority shaped by the recursivity of the hand is likewise their aim. Nonetheless, the sphere of circulation for women is limited, as is suggested by the written work of women that has appeared earlier in this chapter, even when their writers were royalty—Katherine Parr's book of prayers, for example, or Elizabeth I's translation of it into English. These are typical works of the hand of women in the period, so much so that the surprise of Edward VI at the skill of Katherine Parr's hand is a recurring trope—Sir Thomas More reports the same of his daughter Margaret Roper's hand, and even Ascham sends Sturm Elizabeth's copy because it so exceeds the expectations of what the woman's hand might do, perhaps not least by its very visibility, if only in script; and even it reveals her submission to her tutor's hand.

As the instruments of literacy are put into women's hands, the needle (the tool that defines feminity in its household sphere, as Rozsika Parker argues in *The Subversive Stitch*) is not put aside, as Billingsley indicated, or Mulcaster before him, in *Positions*: "I medle not with *nedles*, nor yet with *houswiferie*, though I thinke it, and know it, to be a principall commendation in a woman" (178); if women are to learn to draw, for example, it is because "it would helpe their nedle" (181). Vives, in fact, in his *Instruction of a Christian Woman*, devotes three pages to a history of female handicraft—skills of queens as well as commoners. But here, as with the manuals in general, training of the hand is not to disturb social relations and hierarchies, but to maintain them. When Richard Hyrde reverses the usual construction of female handicraft, in the dedicatory letter to Margaret Roper's translation of Erasmus, *A devout treatise upon the Paternoster* (1524), it is because reading and writing "occupy" the mind even more than needlecraft: "While they sit sewing and spinning with their fingers, [they] may cast and compass many peevish fancies in their minds" (in Vives, 167). Although the rhetoric of literacy and the hand suggests its instrumentality and its uses for advancement, the skilled hand is meant to confirm social relations.

In the case of women, who had little power in Elizabethan society, the contradiction between literate skills and social stasis is most acute. As Jardine and Grafton suggest in their chapter on the education of women, humanist women were again and again frustrated; although they might have the same scholarly achievements as men, they were virtually never allowed to leave the domestic sphere. As Vives insists, women should not "speak abroad"; they should not run schools; in company, a woman should "hold her tongue" (55). Hence, when Vives recommends in the section on female education in *De Ratione Studii Puerilis* (1523), dedicated to Katherine of Aragon, that dialogues be written that may be copied out and through the fingers enter the female mind, practices within

the household sphere ("those things which she requires daily
to concern herself about") are mapped "so that she may be
accustomed to name them in Latin, e.g., clothes, parts of the
house, food, divisions of time, musical instruments, house-
furniture" (143). Although this is the same practice as that
in which the young man is grammatically placed—the same
pedagogical principle—the aim is to insure insuperable, non-
negotiable differences between men and women. In both in-
stances, as Grafton and Jardine argue, the social construction
of gender is at work, but if "humanist learning provided the
male equivalent of fine needlepoint or musical skill" (57), that
"fictional identity" potentially had consequences virtually un-
imaginable in the constructed fictions of femininity.

The vast gap between pedagogic principle and the woman's
hand offers the best vantage for the aporetic structure of
the writing manuals and their institutions of copy, for they
read differently in terms of gender even when the texts are
apparently the same in their pedagogic aims: governing dif-
ferences, social construction remains the work of the hand.
In two writing manuals produced in the 1530's by Giovam-
baptista Verini, the title page shows a scene that might be
placed next to the one in *Westward Ho* that was quoted earlier,
which also suggested, through female pedagogy, the disem-
powerment that goes hand in hand with the claims of an
empowering literacy. On the title page of *La Utilissima Opera
da Imparare a Scrivere* (Fig. 17), a writing master is writing in
a secretary hand while a woman watches, gesturing to her
breast; the master is producing a lady's hand (not, in this
case, italic), and the lady's gesture suggests that it goes to
her heart. She is seduced by it, her interiority revealed and
produced in the master's inscription. In Verini's 1538 manual,
the title page has been altered somewhat (Fig. 18). The mas-
ter now writes in Roman capitals, and he and the lady stand
together on a balcony; his script can be read. It is an injunc-
tion to his female pupil to love neither too much nor too little:

LA VTILISSIMA OPERA
DA IMPARARE A SCRIVERE DI

Varie ſorti lettere di Giouambattiſta Verini
Fiorentino che inſegna al Rialto
Abbaco ey Scriuere.

Chi ha virtu è ricco bene aſſai
El mondo puo cerchare, in ogni parte,
Se non gli auanza,e non gli mancha mai.

CON GRATIA ET PRIVILEGIO.

Fig. 17. Giovambaptista Verini, *La Ultissima Opera*, title page. By courtesy of
the John M. Wing Foundation, the Newberry Library, Chicago, Ill.

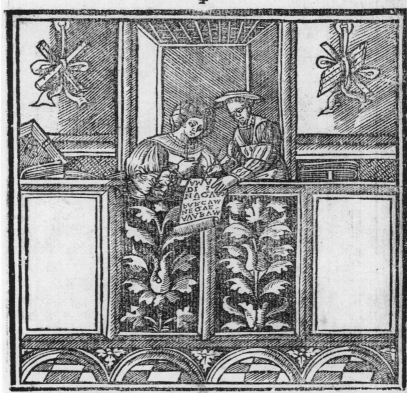

ALLA ILLVSTRA: ET ECCEL. S.
Marchesa Del Guasto. Giouanbattista Verini Fio
rentino suo dedicatissimo saruitore, che
insegna Abbacho, et de ogni
sorte littre Scriuere al
mal Cantone al se
gno del Ballone
i Milano.

CON GRATIA, ET PRIVILEGIO

Fig. 18. Giovambaptista Verini, *La Ultissima Opera*, title page. By courtesy of
the John M. Wing Foundation, the Newberry Library, Chicago, Ill.

"*AUARUM / NEQUE / PARCUM / NUMQUAM / DI S / AMA.*" The mas-
ter has just written the word *AMA* for the woman's benefit.
These title pages construct female sexuality as the work of
male inscription; they virtually illustrate the instructions of
Vives about female copying in *De Ratione Studii Puerilis*: she
is to

write down with her fingers anything the tutor may dictate. . . .
Whilst we are writing, the mind is diverted from the thought of
frivolous or improper objects. The lines which are just before the
pupil for imitation should contain some weighty little opinion which
it will be helpful to learn thoroughly, for by frequently writing out
such, they will necessarily be fixed in the mind. (141)

Verini's writing master "fixes" in the mind of woman her
constructed femininity.

If these various texts about women suggest that they have
a hand proper to them (but is it the secretary or the italic?),
that they have minds and hearts that match those hands or
that are produced by them (but is this because they are weak-
minded or wealthy?), the suppositions are those, too, that
govern copying in general. The location of these contradic-
tions on the female site exposes the contradictions in the male
hand, in the hand of power. To say this is not to deny the
vast differences between the status of men and women in the
period, but it does suggest that because ideological construc-
tions are maintained only through their contradictions, which
sustain and undermine them, the female hand makes the rifts
in the ideology more apparent, since it registers the limits
and aporias of its claims. Moreover, extension of literacy into
female hands, which did occur and increasingly so after the
Renaissance, is thinkable and possible because of the contra-
dictory nature of the ideology of the hand, because even the
differences that mean to guarantee the exclusion of women
cannot finally be stabilized in the duplicative regimes of copy.
The claims for the extension of literacy—that it will only sup-
port the status quo—has its correspondent anxiety—that it

will put power in anyone's hand. The anxiety is expressed most evidently through the woman's hand, which needs special policing. That discipline is a special version of the ordinary situation. Thus, in a few cases, it could empower women to the visible production of script, as in the dame schools or those establishments of seamstresses and weavers where, despite the injunctions of a Vives or an Erasmus, women were teachers of elementary skills. This is no great empowerment (as the place of women in elementary education in the twentieth century must remind us), but it bears comparison, too, with the marginal sites that the writing masters occupied and with the ways in which the practices of copying could open spheres beyond the regulatory dream of reinscription.

In late Elizabethan and early Jacobean England there was one accomplished female calligrapher, Esther Inglis, whose work still survives, exemplifying the possibilities in the woman's hand. She was born in a French Huguenot family and brought to Scotland in her infancy by her parents, Nicholas Langlois and Marie Presot, after the St. Bartholomew's Day massacre of 1572. They had established a French (that is, secular) school by 1578. By 1596, Esther Inglis had married Bartholomew Kello (like her mother, she did not take her husband's last name, but she anglicized Langlois to Inglis or Inglish); Kello was in charge of passports, testimonials, and letters of commendation. Presumably, Inglis had been instructed by her mother, herself an accomplished calligrapher judging by one example of her hand extant (Newberry Wing MS ZW 543.P 922), a 1574 sample that shows at least six varieties of script and closes with her signature. Presumably, too, the daughter had taught school; her husband's position gave her further opportunities to use her skill in more official capacities—she was his scribe. According to "an unproved legend," Dorothy Judd Jackson writes, she "was nurse for a time to the young Prince Henry" (3). What is certain from her some forty extant manuscripts is that Esther Inglis used

her hand to secure patronage from English royalty and aris-
tocracy. Although she lived in England from 1606 to 1615
(when she returned to Edinburgh, where she died in 1624), as
early as 1591 she had presented Queen Elizabeth with a gift of
her hand. King James was presented with her manuscripts, as
were Prince Henry and Prince Charles; members of the royal
household, such as Salisbury, divines such as Bishop Hall,
and various Sidneys and Herberts were among the recipi-
ents too. Visiting the Bodleian on July 11, 1654, John Evelyn
saw a sample of Esther Inglis's work that had been presented
to Essex, and thought it "the most exquisite imaginable" (1:
306). David Browne gives a more grudging testimonial in his
Introduction; placing Inglis first in his rolecall of contempo-
rary calligraphers, he nonetheless claims that she would never
"contend with me in the practice, let be in the art, but . . .
gave place very freely" (E2v).

The books that Esther Inglis produced are typically minia-
tures, some with pages no bigger than one inch by two inches,
written in a microscopic hand (or, rather, hands, sometimes an
extraordinary number of them), often adorned with painted
foliage. The texts are most often biblical or devotional, a qua-
train per page a not unusual format: Inglis transcribes just the
sorts of texts that Vives thought appropriate for a woman;
she is a copyist of religious texts. But she also prefaces many
of her books, and more than a dozen of them include self-
portraits. Those texts and images offer the clearest indications
of how Inglis conceived the woman's hand, and the "place"
it gave her in competition with the David Brownes of her
craft; they internalize the social construction of femininity but
also the empowerments said to lie in the hand. Enabled and
disenabled, the *"main femenine"* (Laing, 301) is put into social
circulation.

The dedications insist on the impropriety of the circula-
tion of the woman's hand, a *"hardiesse plus que feminine,"* as
Inglis puts it in a 1607 collection of pious quatrains (New-

berry Wing MS ZW 645.K292), claiming to have "transcendit the limites of shamefastnes (wherewith our sexe is commonly adorntd)" in the dedicatory letter to Lady Mary Erskine in a 1606 New Year's gift of verses from Proverbs (Newberry Wing MS ZW 645.K29). She worries that she will be "*condamnee pour temeraire*" in offering selections of the Psalms to Queen Elizabeth, since she is female and of low station ("*quoy que ie sois femme, et de petite condition*," Laing, 292); her miniaturized hand embodies this characterization. Nonetheless there *is* temerity here; a number of the prefaces indicate that the recipients were not known to Inglis—she sends her work where she might not go, but certainly with expectations of patronage in return. Inglis justifies her "shamelessness" in various ways, usually in the claim that the texts copied by her hand are of value, "*l'excellence du sujet digne d'une Roine*" (Laing, 292) as she writes to Queen Elizabeth—of value, that is, to the recipient.

Inglis thus repeats the writing masters and pedagogues in their constructions of the social value of writing, a value proclaimed by and as the art of the pen; to "Sir David Murray Knight Gent: of the Prince his Bed Chamber," she writes that her manuscript version of her husband's translation of a treatise on the Eucharist fits its recipient's beautiful soul. "That is the true beautie which can not be blotted out" (Laing, 299); the immortal soul shares the prestige of the pen. Thus, in offering her *Octonaries Upon the Vanitie and Inconstancie Of the World* to William Jeffrey in 1607, she comments on how all things fade, and one G. D. follows her remarks by praising her immortal art: "But thou (glorie of thy sexe, and mirakill to men) / Dost purches to thy selfe immortell prayse and fame / By draughts inimitable, of thy unmatched Pen" (Folger MS V.a.92). Such transcendental claims for writing she makes several times herself by drawing attention to the copiousness of her productions and the great varieties of hands that she can display, beyond the skills of other writers. These,

too, are the usual claims of writing masters; even the phrase in the letter to Elizabeth reads in this self-aggrandizing direction: "*l'excellence du sujet digne d'une Roine*" is her own value, the value of her pen to the realm.

In the *Discours de la Foy* that she presented to Queen Elizabeth in 1591 (Huntington MS HM 26068), Inglis offers a history of the reformation that leads to Elizabeth as "*instrument propre*" of divine providence, and it is that instrumentality that she claims for her own pen in offering a "portrait" of Christianity in her "*diverses sortes de lettres*" for the pleasure of the queen; it is in that presumed pleasure as well as in her resolute faith that she has been "*enhardie*" to present her book to the queen. She goes even further in the minuscule 1599 collection of Psalms written for Maurice of Nassau, for she asks that her text be his *Iliad* (he is her Alexander doing battle for the Protestant cause), and the "*hardiesse temeraire*" of her hand likens her to an Amazon queen: "Ayant quasi impudiquement chassee la crainte feminine et reprise l'esprit d'une roine des Amazones, me suis hardiment addressee a mon Alexandre, seulement pour vous supplier d'accepter de bon oeil ce petit LIVRET escrit de ma main en petit volume pour estre plus aisement porte en plusieurs sortes de caracteres" (Folger MS V.a.93). What he is to accept with his "*bon oeil*" is further specified; the variety of scripts will be a delight to his eye and mind equal to that produced by the Psalms themselves: "La varieté de l'escriture delectant la veué l'esprit soit pareillement elleve envers le grand Createur." The humble Amazon puts her hand in the place of God. Several manuscripts, including those to Lady Erskine and her first gift to Queen Elizabeth, end with a page on which two golden pens cross; above them is a crown, and the motto is "*Vive la plume*." Esther Inglis lives —beyond the confines of her sex—in her hand.

The contradictions of the woman's hand are registered as well in the self-portraits; in a volume of the Proverbs written for Essex, now, as when Evelyn saw it, in the Bodleian

(MS 990), she sits at a table writing; a page of music notation can also be seen on the writing table, as well as a lute (Fig. 19). If this offers the usual visual translation of mouth into hand, the hand that writes inscribes a version of a motto that recurs in the portraits: "Del Eternel le bien De moi le mal ou rien" ("good comes from God, from me nothing or evil"). Such is the value of her hand, a valuation, however, to be placed beside G. D.'s contrary estimation of her as the "matchles Mistresse of the golden Pen" (V.a.92), or alongside the golden pens displayed in the manuscripts. If she is not her hand—or hands—they are in the service of the transcendental, God, and the golden pen. These are the contradictions that found the instrumental hand.

What Inglis had transmitted to the "unblotted" soul of one recipient is transferred to her own interiority in the poem by the presbyterian divine Andrew Melvin that appears below the portrait in the Essex volume. Written, of course, in Esther Inglis's hand, Melvin's poem puns on the duplications running from copies to minds, and the poem equates mind and hand, and declares their inseparability. Mind and hand circulate within the recursivity of copy, founding the divided and doubled subjectivity that follows from the woman's hand and that allows Esther Inglis her limited social circulation.

In the portrait accompanying a New Year's copy (1600) of the *Octonaries*, dedicated to Prince Henry (Folger MS V.a.91; Fig. 20), the motto has been reduced to the exemplary negativity that copytexts (like those written out by Beau Chesne for Princess Elizabeth) repeat, "*de bien le bien / de moy le rien*," but the figure portrayed reads otherwise; unlike the elaborately feminine costume in the Essex manuscript, this one displays Esther Inglis sporting the masculine attire (hat and ruff) that became popular early in the seventeenth century, much to James I's displeasure; she appears in the same costume in her self-portrait in a volume of Psalms presented to Lord Ellesmere in 1606 (Houghton MS Typ 212H). These are pic-

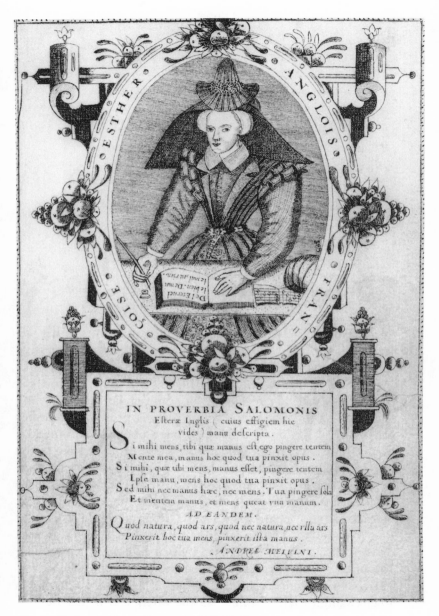

Fig. 19. Esther Inglis, self-portrait, MS. Bodley 990 p. xv. By courtesy of the
Bodleian Library, Oxford.

Fig. 20. Esther Inglis, *Octonaries Upon the Vanitie*, title page verso. By permission of the Folger Shakespeare Library (V.a.91).

tures of a humble Amazon, transcending the limits of her sex even as she retranscribes them and enters into the excessive sphere that copying opens up.

Judging by her will, Esther Inglis's attempts to find patronage allowed her to engage in commercial activities, and she died in debt. She succeeded in gaining preferment for her son, Samuel Kello, who had written a poem in commendation of James when he visited Scotland in 1617. Writing to the king in 1620, she noted that she had frequently spoken to him before and had found his favor. Now she likens her son to Daedalus, who could not escape without "the help of wings mead [made] of pennes and wax" (Laing, 308); she asks, that is, for James to write a letter of preferment ("by the wings of you Maties letter, composed by pen and waxe"). The king complied. "Your Graces humble hand-maid," she styled herself (her pen and her miniature script) to Prince Charles in 1624 (Laing, 304), wishing, as she often said in her dedica-

tions, that her handiwork might find "sum retired place in your Highnesse Cabinet." The retired place is also the subjectivity that Melvin celebrated and that allowed Inglis even within the confines of her femininity to possess the valued interiority produced by the pen. To Charles, "the onlie PHOENIX of this age" who "dazeled the eyes and amazed the minds of most men and women," she offered her script—script for which she claimed the identical property of dazzling the eye and with it the soul—the properties of a sovereign script. Upon that exchange, that identification of the subject hand and the monarch's hand, Esther Inglis depended. "*L'unique et souveraine Dame de la plume*" (Laing, 301): so Jan van den Velde, the most accomplished of Dutch calligraphers, saluted her. She was unique and sovereign—a copyist with a hand like a machine, virtually indistinguishable from print; so Esther Inglis realized the contradictions in copying, reproducing the social construction of the hand. Indeed, her hand might be compared with the neatly printed Roman capitals with which Queen Anne signed her motto in Dietrich Bevernest's *Album amicorum* in 1590 (Folger MS V.a.325): "Tout gist en la main de dieu" ("All lies in the hand of God"), Anne wrote. Into that hand Esther Inglis inserted her own.

The contradictions of the woman's hand expose the strains in the social construction of the hand: regulatory governance, on the one hand, and the opening of difference, on the other. If Esther Inglis was able to negotiate these contradictions to the limited empowerment she achieved, the regulatory functions of a disciplinary difference on the site of gender will explain why most women in the period remained unschooled, more often inscribed within the supposed docility of reading than granted access to the "docile" pen. Esther Inglis's hand makes more visible the strains inscribed everywhere in the ideological networks of the copybooks. The double audience for these, and their divided messages of empowerment and disempowerment, meet in her hand. One might (to re-

verse Billingsley and undo the ideological logic) extend its
contradictory structure to all hands. Thus, early editions of
Beau Chesne and Baildon's *Booke Containing Divers Sortes of
Hands* (1570, 1571) offer the familiar divided audience for copy.
A dedication from the publisher to Henry Fitzalan, Earl of
Arundel, hails him (in Janet Backhouse's words) as "patron of
the arts and connoisseur of calligraphy" (9); versified instruc-
tions on the regime of copying, "Rules Made by E. B. for
Children to write by" (A2r), follow in these, as in later, edi-
tions. The 1602 reprint attempts on its title page the ideologi-
cal construction that would return such elementary pedagogy
to its mystified form. On the lower corners of the title page

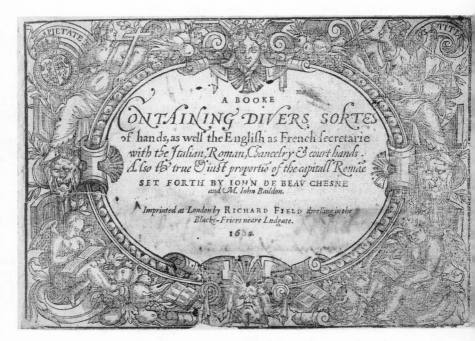

Fig. 21. Jean de Beau Chesne and John Baildon, *A Booke Containing Divers
Sortes of Hands,* title page. By courtesy of the Bodleian Library, Oxford (Douce B 675).

(Fig. 21), two cherubs write—E. B.'s "children" as angels. In the upper corners, two statuesque females are presented as the abstractions *Pietate* and *Iustitia*. Piety has a cross in her right hand and with her left arm she supports the royal coat of arms. Thanks to a female figure and to her left hand, the handmaid to memory, writing, has been translated to the skies—to the realm of divine right and divine writing.

Pedro. Good Signior Benedick, repair to Leonato's, commend me to him and tell him I will not fail him at supper; for indeed he hath made great preparation.
Ben. I have almost matter enough in me for such an embassage, and so I commit you—
Claudio. To the tuition of God. From my house—if I had it—
Pedro. The sixth of July. Your loving friend, Benedick.
Ben. Nay, mock not, mock not. —*Much Ado About Nothing*, 1.1.245–53

To summarize and deconstruct the ideological constructions of copying, consider these institutionalizing moments from the hands of the writing masters: "Rejoyce all Writers, who live by the Penne, / For your Arte with Royaltie is clad." So expostulates one I. S. in a dedicatory poem to the self-styled Scottish royal scribe David Browne's *New Invention* (**1r). To live by the pen is the life of an instrument in the service of power, yet the pen clad with royalty clothes royalty in royal letters—it performs the ideological work of the construction of a transcendental power. It also empowers the writing master. Oxford, Sir John Davies of Hereford claims, "gives me *Crownes* for my *Charactery*" (Grosart, 1: 99); as he writes further, the contradictions in this material exchange are opened: "Her *Pupils* crowne me for directing *them*, / Where like a *King* I live, without a *Realme*." His empowering is also his disempowerment—he is everywhere and nowhere within this recursive (de)situation. Mercator attempts in his *Literarum*

Latinarum (1540) to reclothe the emperor—in royal letters—
and to empower the writing master. Addressing those readers
who might think learning to write the italic hand a trivial or
merely decorative concern, he enjoins them to "reflect how
dishonest it is for a king to take off his purple and go about in
beggar's clothing unworthy of his royal station, or, again, for
a beggar to wear the royal purple. This is just what happens
when the Latin language abandons its proper characters ["*pro-
prio charactere*"] and disguises itself in Greek or gothic lettering"
(123). The royal character, as Croke impressed upon the Duke
of Richmond's hand, is the royal character. David Browne
occupies the divided subject-position to be read in Esther
Inglis, as he subscribes to and reinscribes these counterclaims:
on the one hand, he teaches calligraphy "at your Highnesse
superscribing of my former Priviledge"; on the other, he is
only "a verie meane Instrument of a verie meane Worke"
(*New Invention*, *3v). His hand and pen are in the king's hand,
which writes Browne in and out of its domain, superscribing
Browne as the addressee of a royal letter.

This recursive hand institutes the pedagogical regime,
founding it as that which founds the state and thereby writing
both apparatuses within the recursivity of the copying hand,
a simulative and duplicative order of inescapable duplicity. As
Keith Thomas argues, the school was conceived of as a minia-
ture commonwealth, "an indispensable disciplinary instru-
ment" bent on checking "youthful spontaneity" and tied to an
"ethic . . . of instinctual renunciation" (*Rule and Misrule*, 8); it
also formed the instinctual by hand—through renunciations
(those of the civilizing process) that empower the instrumental
hands of the pedagogues, even one like John Brinsley, a re-
forming schoolmaster writing for the extension of education
beyond its privileged sphere. Brinsley closes *Ludus Literarius*
(1612) by describing the school as a founding institution, a
form of "government . . . out of which, all other good and
civil societies should first proceed." In the schoolmaster, "this

authority must be maintained, as in the Magistrate, by his so
carying himselfe, as beeing a certaine living lawe, or rather as
in the place of God amongst them; I mean, as one appointed
of God" (275). The "living law" of the schoolhouse is "main-
tained," held in the hand of a pedagogue who functions "as
in the place of"—replacing—God; a God among them ap-
pointed by God, these are the king's claims of divine right,
and Brinsley's as well—all clothed in the simulations of the
royal letter—"as," "so," "in the place"—the order of copy and
its similitudes.

The "living law" that institutes the school is the one that
copying provides in its exemplary hands, model alphabets,
and copytexts for reinscription, the simulative order of the
ideological construction of the social and the individual within
the instituted domains of a recursive inscription, the replica-
tion of hands that make hands hands. To produce a perfect
copy is to reinscribe the social, to be socially inscribed; it
shows one's education into one's place within an idealized and
ideologically naturalized social order. It gives one a place by
that displaced inscription.

Education, for Brinsley, as for virtually all Renaissance
pedagogues, begins in reading—as the inscription of the letter
on the "docile" surface of the reading-subject, as its replication
in the voice that reproduces the written text. Like Mulcaster,
Brinsley expects students to enter the grammar school already
able "to reade English: as namely that they could read the
new Testament perfectly" (12). If the child has encountered a
primer before entering the schoolhouse, he will have begun
an education in religious conformity. "English," for Brinsley,
is the same thing as the text of the New Testament. School
education involves the re-reading of such "elementary" texts
as the Psalms or *The Schoole of Vertue* or *The Schoole of good
manners*: "For the second reading of any booke dooth much
encourage children, because it seemeth to bee so easie then;
and also it doth imprint it the more" (17). Re-reading *imprints*

the child within the "originary" form of social inscription
—copying. The "easiness" of reading is likewise an effect of
repetition, a simulative rewriting of the everyday. "Precepts of
civilitie" (18) are thereby naturalized. Instruction in writing,
which follows reading, repeats these "originary" principles;
Brinsley summarizes the regime of writing: "good copies,
continual eying them wel, a delight in writing" (39). That
delight, like the "easiness" of reading, is produced, in this in-
stance by seizing the hand when it is "warmest and nimblest"
(32), about one o'clock, for about an hour's worth of writ-
ing. "Good copies," like the "good" hand in Beau Chesne and
Baildon's copybook, reproduce through the eyes, within the
body, in the hand that connects and disconnects hand and eye
by founding the "good" mind and the "continuity" assured
by continual repetition.

 "Let not a day pass without a drawn line remaining"
("Nulla dies abeat quin linea ducta superfit"), the rubric reads
in the woodcut illustrating school practice in Urban Wyss's
Libellus Valde Doctus (Zurich, 1549; Fig. 22). The line drawn—
"*ducta*"—suborns nature within the regime of writing; time,
as the line, is produced by the hand. The hand is in the ser-
vice of the eye, regarding a copytext like the one that hangs
in Urban Wyss's schoolroom, a text that enforces the coinci-
dence of ordinary life with a schoolroom discipline. Brinsley
prescribes a "good" text for the exercise of the ordinary hand:
"For Secretary thus: Exercise thy selfe much in Gods booke,
with zealous and fervent prayers and requests" (31). The exer-
cise in God's book is the text reinscribed by the copying hand.

 The discipline of copying (and its related literary form,
copia) is authorized in Renaissance pedagogies by Quintilian's
Institutes:

It is in writing that eloquence has its roots and foundations, it is
writing that provides that holy of holies where the wealth of ora-
tory is stored, and whence it is produced to meet the demands of
sudden emergencies. (Illic radices, illic fundamenta sunt, illic opes

Fig. 22. Urban Wyss, *Libellus Valde Doctus*, A4 recto. By courtesy of the John M. Wing Foundation, the Newberry Library, Chicago, Ill.

velut sanctiore quodam aerario conditae, unde ad subitos quoque casus, cum res exiget, proferantur.) (*Institutio* 10.3; 4: 93)

Oratory originates in the already written, as reading does for Brinsley. And writing, as Quintilian describes it, is one with copying, for the storehouse of oratory is the "*opes*" of the already-written ready for rewriting.

Quintilian recommends that pupils be taught to write by moving their hands along a groove in the wax tablets that provided the ordinary surface for Roman inscription, the tablets which, we have seen, remain in and as the mind, as the depth of the interiority opened by the exercise of the copying hand. Quintilian's practice (leading to the handholding in Cresci) is often recommended in Renaissance pedagogy. Erasmus, for example, suggests that the master's hand should guide his pupil's; letters either should be inscribed within grooves so that the pupil's hand will be regulated, or (since writing no longer is done in wax) letters should be traced. The materials

may differ, but the point is the same: "The boy should then accustom himself to moving a stylus in the grooves until—as the philosophers tell us—the action frequently repeated generates a habit" (S&S, 35). In fact, some writing masters favor writing in grooves; Palatino, for instance, recommends that the "beginner move the end of the stylus repeatedly in the letters which have been hollowed out" (S&S, 95). Quintilian is invoked as the authority for this practice, the generation of the habitual and the everyday in the regulated movement of the hand. The grooves in the writing surface incise the depth of the subject, opening subjectivity and interiority as the space of inscription.

The hand is inserted within a practice that marks education from its commencement. The young child for Quintilian (and for writing masters like Cresci or humanist pedagogues) is like a vessel that has never been filled, or like white wool that has yet to receive a dye (1.1; 1: 21); first impressions are the ones that last—the ones produced by education as it reproduces human nature within its simulative orders. "As soon as the child has begun to know the shapes of the various letters" —and Quintilian recommends that they be made into blocks so that they can be seen and handled, a practice illustrated in Sir Hugh Platt's *The Jewell-House of Art and Nature*, a treatise on technology (45; Fig. 23)—"it will be no bad thing to have them cut as accurately as possible upon a board, so that the pen may be guided along the groove" (1.1; 1: 33–35). The child is led to this stage in his education—"*ductus*"—and he replicates his education in the grooves of the tablet—"*velut sulcos ducatur stilus*." In each case, he is guided by what has been *prescribed* ("*praescriptum*") as he pursues the traces ("*vestigia*") that mark the path of his hand confined within the margins of the letters. Education, for Quintilian, is not a drawing forth but a movement along a line, as it is in Urban Wyss's copybook; "*ductus*" names at once a course of life and a movement of the hand. This then is an education into the nature of objects and

Art and Nature. 45

with gumme water as they haue caufe to vfe it. Some
infufe the moift, and fome the drie leafe with faire
water, and fo foone as the beautiful hew of the leaues
begin to vade, they dreine away the water, and make.
an addition of frefh leaues thereunto, and fo change
their leaues often, that they may purchafe to them-
felues nothing elfe but the liuelie and bright tincture
of euerie hearbe or flower. Thofe two colours of the
Rofe, & Flower-deluce I learned of mafter Bateman
fometime the perfon of Newington a moft excellent
lymner.

43 *A readie way for children to learne their A.B.C.*

CAufe 4. large dice of bone or wood to bee made,
and vpon euerie fquare, one of the fmall letters of
the croffe row to be grauen, but in fome bigger fhape
and the child vfing to play much with them, and be-

ing alwayes tolde
what letter chaun-
ceth, wil foon gain
his Alphabet, as it
were by the way of
fport or paftime. I
haue hearde of a
pair of cards, wher-
on moft of the principall Grammer rules haue been
printed, and the fchoolmafter hath found good fport
thereat with his fcholers.

44 *To graue and inlay colours into Sol, Luna, Mars, or
Venus, to fhew in the nature of an Ammel.*

FIrft couer your mettall with a cruft of waxe, and
with a fine fharpe toole when the fame is cold, cut
out the fhape or proportion of what letters or other
H3 portrai-

Fig. 23. Sir Hugh Platt,
*The Jewell-House of Art and
Nature*, p. 45. By permission
of the Folger Shakespeare Library.

the objectivity of existence; as Derrida suggests in *Gramma-
tology*, it is a materialization of literality in (exactly) letters, a
marking out of a path of learning which is an education in do-
cility, confined within the grooves, pursuing traces. The hand
moves in language, and its movement retraces the "being" of
the individual inscribed within simulative social practices that
are lived as ordinary experience, the everyday and the habitual
produced on the retraced lines. Touching and seeing are not

immediate but mediated through the letter-blocks, sensitizing the hand and eye to a world of inscription re-inscribed in the practice of writing.

The sixteenth-century spelling reformer John Hart offers a fantasy of a landscape in which his new letters could be seen everywhere "drawn on the walles, pillers, and postes of churches, tounes and houses" (*A Methode*, A6r); his promise to extend literacy and the schoolroom to encompass the world is quickly followed with the assurance, however, that nothing in the hierarchical arrangements of society will be disturbed, for while the eyes of all are occupied with the newly written world, "their handes may be otherwyse well occupied, in working for their living" (A6r). Elyot's *Governor* is similarly a world in which walls are surfaces to be read, covered with inscriptions—the fantasy of power in the increasingly literate world of the sixteenth century. For Elyot, storing the memory with *copia* begins in copying examples and in producing the subject—the ruling subject—as an example; as the "governor" is called to govern, Elyot imagines him consulting his memory for "articles well and substantially graven" (98) in his mind. These take the form of lines by Claudian that Elyot recommends be written on a tablet, "in such a place as a governor once in a day may behold them" (99); better yet, they might be memorized, always available in their internal inscription. The lines from Claudian inscribe self-regulation, and they are inscribed as self-regulation as they usher the governor into the domains of power, governed by the civilizing process that empowers him—the mystifications of power that derive their power from the simulative economy of writing and the duplication of the letter.

The hand "occupied" in writing inscribes these ideological claims for a regulation that exceeds its bounds through the very recursivity that inscribes those bounds—as the distance between the ruler and the ruled—the ruling line that must be daily drawn, dividing and informing interiority and exteri-

ority, that founds the continuous being of the human within the simulative economies of the circulation of the letter. Peter Bales sums up the precepts of copying:

> First have an eye unto your coppie set:
> And marke it well, how everie stroake is fet:
> Then as before, goe softly with your hand,
> When in your minde the shape thereof is scand. (R1r)

The marking eye here is re-marked by what it eyes, the copy on which it is set and which situates it within a sphere of visibility; the hand likewise is "fetched" from the copy, duplicated by what it duplicates. This is how the hand is made social. The recursivity of copying, like the copytext that Brinsley prescribed for the ordinary hand, inscribes the hand within recursivity. As Quintilian recommends, the best copytexts ("*ad imitationem scribendi*") are sententiae of just this sort, for they inscribe imitation at the origin and found the subject on the line: "He will remember such aphorisms even when he is an old man, and the impressions made upon his unformed mind ('*impressa animo rudi*') will contribute to the formation of his character" (1.1; 1: 37). Hand, eye, and mind are thus mutually (in)formed. All exist within an economy of inscription: nature/practice/materiality/mind—all literally literalized, made letters.

Brinsley's copytext echoes against the moralisms strewn throughout copybooks, truisms meant to inform consciousness through the combined discipline of the eye and hand. These disciplinary texts are forever reinscribing the hand in the reinscribing hand. Thus, Francis Clement, reducing the practice of writing to the two basic hands, secretary and italic, prescribes the following copytexts in *The Petie Schole* (1587). For the secretary hand: "Of one sparke, is made a greate fire, (and of one deceitefull man is bludd increased) and an ungodlye man layeth waite for bludd, for he turneth good to ill"; for the italic: "Folowe not thy lustes, but torne the[e] from

thine owne will, for yf thou give thy soule her desire it shall make thine enemyes to laugh the[e] to scorne in thy misery." In their setting, these texts from Ecclesiastes draw upon the violence of the letter and the discipline of the hand; the will is broken by a turning and tearing ("torne"), but good can also turn to ill. The moral stance in these passages draws upon the flexibility of the wrist to form and reform words to their proper moral ends.

Equal, indeed greater flexibility is required by the more elaborate copybooks of the period with their numerous varieties of hands and texts suited to them. In a typical copybook (as Berthold Wolpe shows in his analysis of *A Newe Booke of Copies*, 1574, Clement's source for his copytexts), biblical texts account for about half the texts, and these can be written virtually in any hand. Their disciplinary force runs through all hands. Other texts, with their special uses, pencuts, and penholds, reinforce the fact that the hand that writes is inserted within the practices of inscription and is conformed to them. The individual produced by writing is not an individualized subject but one conforming to the characters inscribed —the words and the letters of the copytexts clad in royalty.

Hence, the contradictory realm of copying reduces to the aporia of empowerment of and by letters, the enabling and disenabling recursivity in which the subject of writing is written into the regulatory domains of differentiated scripts, producing the transcendental claims for the value of (written) literacy and its social regulation of that transcendental power to maintain the power of the state. It is to letters themselves that I turn in the next chapter. The ideological investment of and by letters can close this one.

The ideological importance of letters is graphically displayed in decorative initials, as Erna Auerbach illustrates in *Tudor Art-*

Fig. 24. John Foxe, *Acts and Monuments*, Preface detail C. By permission of the Folger Shakespeare Library.

ists, a study of manuscript proclamations, statutes, charters, and the like; initial capitals display portraits of Tudor monarchs, as if majuscules demanded such majesty. The monarch is displayed as the force impelling the letter, but, equally, as the depth and interiority of the letter which serves as a frame, the royal life of—and in—the letter. John Day provided an especially elaborate example for John Foxe's *Acts and Monuments* (1563; B1r; Fig. 24). The epistle dedicatory to Queen Elizabeth opens with the name Constantine and continues to

offer a history of the true church. Within the C, Elizabeth is depicted enthroned, holding her sceptre and orb, three courtiers attending her. The C writes the history of the church as the frame around Elizabeth; a putto on the left (within the curve of the initial) displays the royal arms, and another putto below tramples on a bishop (attacked as well by a snake). The embodiment of the monarch in her court is thus framed by the "lines" that inscribe the royal genealogy (just as the letter proclaimed the noble line for Vives's boys) and church history (lines like those of Esther Inglis's hand). History is seen from the eschatological frame of the "eternal" letter C; yet the C ends in a flourish of vegetation—the letter as the origin of nature. C is for Elizabeth within the providential unfolding of the letter of true religion, the materialization/ literalization within which the queen is inserted. This letter enacts the contradictions of an ideology that finds its support in a letter whose frame exceeds the domains of power.

Such is the case too in a manuscript produced by John Scottowe, an Elizabethan writing master active in Norwich (where his hand has been detected in the decorated capitals of a number of public documents). One of the two complete manuscripts of his that survives (BL Harl. 3885) offers an alphabet of decorated capitals as the demonstration of the skill of Scottowe's hand. The style of the manuscript, as Janet Backhouse comments, is old-fashioned, in the Burgundian manner favored at the court of Henry VII. That stylistic choice, however, can be understood within a political context, Gordon Kipling having demonstrated the ideological importance of the Burgundian style to Henry's legitimation. Scottowe, writing at the time of the last Tudor monarch, preserves the style of her legitimating ancestor; the style of the hand, therefore, is no mere exercise in antiquarianism nor is it a piece of provincialism. Indeed, the incorporation of such contemporary figures as the portrait of Richard Tarleton, the Shakespearian clown, with his drum, for the letter T suggests

that Scottowe was not living in a cultural backwater. Tarleton suggests more—the possibility of a subversion within the letter, as its enclosures also open beyond the domains of legitimated power, as the domains of the royal letter legitimate the widening spheres of an all-encroaching and not necessarily entirely disciplined literacy. These are clowning letters: "Love one another" the text for L begins, citing 1 John 4: 7–9; the L is being aimed at by a figure carrying a gun. "Quench Venus wanton fond delight," Q moralistically declares, belied with the figure of an infantile Bacchus astride a barrel, imbibing and displaying a prominent erection.

E, however, is for Elizabeth, and fully declares the ideology of the letter. E displays the royal arms crowned and portrays the queen herself. A scroll beneath petitions, "God save Queene Elizabeth Longe to Reigne." Two hands are displayed in the copytexts. One, proceeding from the capital, names the queen: "Elizabeth by the grace of god Queene of Englande, Fraunce and Irelande. Defender of the faith, &c." Two texts in an italic hand stand above and below, quoting (in Latin) the texts from Romans prescribed for worship on the queen's accession day, insisting on obedience:

Let every soul be subject unto the higher powers. For there is no power but of God: the powers that be are ordained by God. Whosoever therefore resisteth the power, resisteth the ordinance of God: and they that resist shall receive to themselves damnation. For rulers are not a terror to good works, but to the evil.

Wilt thou then not be afraid of the power? do that which is good, and thou shalt have praise of the same: for he is the minister of God to thee for good. But if thou do that which is evil, be afraid; for he beareth not the sword in vain: for he is the minister of God, a revenger to execute wrath upon him that doeth evil. (13: 1–4)

The violence of the letter terminates in the Pauline text threatening the sword of the divinely appointed minister. The citation, the support of monarchs, means to overcome any re-

sistance and insure the conformity of the queen's subjects. It is the ultimate justification of the moral *sententiae* scattered throughout copybooks, reinscribed countless times by Elizabethan writers. The education that began in the primers declares itself as an ideological apparatus here most transparently. Paul may have written that the letter killeth, but here it is the letter itself that upholds the state and produces the subservient hand, properly italic for the Latin letter forms, secretary for the "ordinary" English that proclaims Elizabeth as ruler and defender of the faith.

Scottowe's hand here supports the status quo that lends a hand to his. He has the place similarly occupied by the writing master William Teche in another manuscript copybook (discussed by Janet Backhouse), in which Teche is pictured offering his book to Elizabeth seated in a Petrarchan triumphal car (BL Sloane, 1832), a widely distributed image of the queen replicated in a number of contemporary woodcuts. The writing master submits his book to the imperial image, an overt representation of the disciplinary force of writing as copying/ replicating the apparatuses of state power. "The letter is the first and simplest impression in the trade of teaching" (29), Mulcaster writes in *Positions* (1581), "and now that we are returned home to our English abce" (30) education must "laie the best foundation to religion and obedience" (31). Writing and rewriting are thus ideally ideologically inscribed.

Letters themselves bear the imprint of society; thus, Timothe Bright, attempting to reduce the alphabet to shorthand, dedicates his *Characterie: An Arte of shorte, swifte, and secrete writing by Character* (1588) to Queen Elizabeth. "My Characterie dareth presume no farther, but liveth, or dieth, according to your Maiesties account, whose blessed state, as it is to all your loyall subiectes an other life, besides the naturall, so to this new sprong ympe, & to me the parent therof" (A5v). Bright fathers his characters in a natural genealogy, but the "other life, besides the naturall" of his letters lies in royal patron-

age, a support to their life and to the lives of all the queen's subjects. Letters, as Brinsley wrote, are the hands that uphold society; they exist within an order of being that "surpasses" the natural order, that replants nature within the simulative order of copy. "Writing must needes be," David Browne explains in *The New Invention*, "or else there could be litle Civile order" (**2r). Civil order is the "blessed state" of the letter C, the timeless realm that makes time and life possible, the very being of being that is, nonetheless, a supplement to nature, the generation of the habitual and the everyday on the line, reproduced in the copy. C is for copy, or for civility, or for *civilité*, the typeface named after the one used to print a French version of Erasmus's schooltext, *La Civilité Puerile*. The civility that "starts" in the recursive hand is disseminated in type, the model that overtakes the hand in its dream of a recursivity that would rewrite the world as the domain of letters themselves.

LETTERS THEMSELVES: INVENTIONS OF THE HAND

Nurse. Doth not rosemary and Romeo begin both with a letter?

Romeo. Ay, nurse; what of that? Both with an R.

Nurse. Ah, mocker! that's the dog's name. R is for the—No; I know it begins with some other letter; and she hath the prettiest sententious of it, of you and rosemary, that it would do you good to hear it.

—*Romeo and Juliet*, 2.4.195–200

T LAST, at first, letters are in the hand, the alphabet retraced. The copybooks found their practice in the reinscription of letters themselves, the foundation of writing, a scene of origin. But origin is everywhere multiplied in the two-handed scene of writing—two alphabets (at least) in the hand. And the origin of "the" alphabet? Is it too in the hand or somewhere else? In the voice? What is the relation of writing to speaking? How should words be spelled? What is a word? How can the multiplicity of hands be returned to an originary hand? Is there such a hand outside the circuit of the letter? Do the body and the mind arise from the hand? Such questions circulate in the writing manuals, in pedagogic and grammatical tracts, in books written by spelling reformers; they move within the contradictions of a logocentric argument that has, on the one hand, valued writing as an ideal and ideological reserve of power, writing as the repository of presence, and that has, on the other hand, all of the logocentric suspicion of writing, the class suspicion of manual labor, the fear of extending privilege into another hand. Insupportable arguments circulate in search of an origin, a foundation—elsewhere— that never leaves the hand.

Introducing his 1583 writing manual, the Spanish writing master Andres Brun gives a quasi-Aristotelian answer to what he represents as a Platonic claim about human nature: "Plato says that the difference which divides us humans from the animals is that we have the power of speech and they do not. I, however, say that the difference is that we know how to *write* but they do not" (*S&S*, 180). The ambiguous Aristotelian hand, "instrument of/for instruments," is pressed into the service of a defense of the privilege of writing above speaking as the origin of the definitively human—and in justification of the writing master. Although it idealizes writing, this statement also unmoors a classic definition—"man" as the speaking animal—as well as the Platonic idealization of speaking, as in the *Phaedrus*, with its attendant devaluation of writing as a secondary and pernicious effect, a devaluation which nonetheless empowers Plato's written text as a writing that conveys transcendental values. Plato's texts are not only the beginning of western philosophy; they are the first instance of the concealments upon which the values of literacy depend.

Brun's foundation of the human in writing is a familiar one in Renaissance pedagogy, an essential statement for the re-marking of the pedagogical subject in and through letters, a typical statement of a writing master advancing the claims of literacy and the skills of his hand; it is complicit with modern theories of the value of literacy. For this "essential" humanity (within the privileged sphere that it opens by extending a "proper" writing), a scene of origins—the origin of human difference—is provided by Brun, an origin troubled, however, by the very invocation of Plato and the counterarguments that could be summarized in his name—arguments that depend upon the repression of writing and its power.

Conceptually, there may be no great distance between Plato's idealism and Brun's; effectively, there is. Plato's argument reserves power to writing by strategies of denial; Brun's would empower the writer more directly, and perhaps in ways that could, by making writing the work of the hand, extend power beyond its spheres of privilege by extending the privileged forms of writing. One must not overestimate these extensions of literacy and the hand; they are regulated, idealized; nonetheless, they also cannot found themselves easily.

Such a rift within logocentrism is opened in a more elaborated version of the coincidence of human and alphabetic origination offered by Erasmus in *De recta Graeci et Latini sermonis pronunciatione* (1528). The scene is explicitly pedagogic. Ursus and Leo, the two animal speakers, discuss Ursus the bear's desire to have "one or two of my many bear-cubs brought up in such a way that they can be taken for children of human parentage" (*S&S*, 30); instructions in letter formation follow as the path to this social elevation of the selected bear-cubs. This the dialogue calls humanization. Already, in its animal fable form, the dialogue suggests that the essentially human may be no more than a simulation—that the lettered animal may not cease being an animal—that letters, which may re-mark nature, cannot provide more than a false ground; the passage from the animal to the human is one in which the animal passes for ("can be taken for") human. The human is made human through the letter. Against Theuth's claims in the *Phaedrus*, that writing would bring wisdom and improve memory, Ammon the king had pronounced his Socratic judgment—that writing would only provide the "semblance" of wisdom, "external marks" that fail to establish interiority (275a); Erasmus, in this dialogue on the true pronunciation of the ancient tongues, places the letter before speaking, and the semblance founds the human. What Ammon rejected founds the argument in favor of writing. The disseminative double-

marking to be read in "Plato's Pharmacy" underwrites the Erasmian text.

This reversal is signalled in the dialogue, for although Ursus knows that in the pedagogic regime "speaking comes first, then reading and thirdly writing" (31), he chooses to discuss writing first. Like Mulcaster, he would begin backwards—for the human, that late arrival, is founded at first in the last stage of the pedagogic process. The origin of the human lies in letters. Hence Ursus would have his bear-cub start with copying, approving a pedagogic dictate: "We should take special care to put before the pupil right from the start the most perfect model for him to reproduce" (31), for the human order is an imitative one in which the human reproduces itself in and as script. Humanistic pedagogy depends upon—and reproduces—imitations. Here, as in Vives, the human hand would be distinguished from the scratching of chickens or the paw of a bear.

The discussion proceeds to instructions in the formation of various kinds of antique letters, for this humanization process would lead the bear-cub to become a humanist, and Greek and Latin would be his languages, Greek and Latin letters in his hand. Various models are considered. "The most perfect example of majuscules," Ursus, for example, opines, "is on coins struck at the time of Augustus" (32). This is no random example, of course; this idealized script is an ideological instrument; humanization throughout is the (re)production of the "civilized" subject. The search for antique models for the hand also leads the dialogue backwards, to a foundational moment, the origin of letters—and to the origin of the human as and in letters, lettered and literate.

Erasmus offers an etiological fable for the history and origin of the alphabet, of "Cadmus being the first to import the art of writing from the Phoenicians. The matter is symbolised in the fable which depicts him sowing the teeth of a dead snake in the ground; from this seed there suddenly leapt

up two lines of men, armed with helmets and spears, who destroyed themselves by dealing each other mortal wounds" (34). Even initially in this fable, the origin of letters is elsewhere, transported by Cadmus from Phoenicia, a tale apt for the pedagogic scene of reorigination and renaturalization, for it takes the alphabet from its animal origin—the mouth of a dead snake—and replants it in a scene of sowing and human origination that is nonetheless coincident with deadly disseminative strife. The very attempt to found an origin in writing is haunted by the discussion in the *Phaedrus* (276), with its juxtaposition of false sowing (writing) and true sowing (dialectic, speech) within the soul. The human sown in the snake's tooth arises as the letter, for, as Ursus explains, the point of the fable is that the number of teeth in the mouth of a snake is equal to the number of letters that Cadmus brought to Greece; the armed warriors are letters, their ascenders and descenders their shields and helmets.

"At first the letters are at peace, being set in the alphabetical order in which they were born; then they are scattered, sown, multiplied in number and, when marshalled in various ways, come alive, burst into activity, fight" (34–35). The interpretation of the fable attempts to secure an origin—in the mouth where the letters were born, yet the only mouth in the fable is that of a dead serpent. It attempts to read the scene of sowing as productive, yet, in the fable, the armed warriors destroy each other. In the interpretation, the arms are the strokes that distinguish letters, marking human/alphabetical difference, but these strokes also produce a disseminative script incapable of stabilization.

To resecure this disseminative and anti-Socratic account, Ursus offers a quasi-Platonic definition at the close of the fable, one, at least, that relocates the origin of writing elsewhere, in speech—"what is handwriting but silent speech" (35), he opines, and Leo assents, for the justification of a discussion of handwriting in a treatise on pronunciation could

only be that the hand is to imitate the voice and that proper script must be provided for the proper language. This leads Ursus to another interpretation of the fable, another form of origin, etymology: "The Latin word for speech (*sermo*)," he comments, "comes from the word for sowing (*serendo*). Here you have the allegorical meaning of Cadmus the Sower" (*S&S*, 35). He reads the story as if it were about words— an allegory about the origin of speech—of the *word* speech —in the sowing of the alphabetical seeds. So read, "silent speech" threatens living speech, and writing precedes speaking. The practice of copying, to which the dialogue returns after the fable, resows this disseminative origin as it "plants" the habitual/the human in the movement of the hand in the grooves or furrows. The hand ploughs the page, and life and speech are its disseminative generation. Erasmus turns to the various materials upon which the ancients wrote—leaves and wood and linen, but he also would have known that writing was furrowing in the Greek script that is written in a zigzagging manner, from left to right and then from right to left, boustrophedon, named from the turning of an oxen pulling a plough. Ploughing: recall Vives's Manricus wondering "how it is inborn in me to plough out my letters so distortedly" (Watson, 68), a metaphor repeated as Mendoza comments on Manricus's skillful copies: "Have you already ploughed out two lines?" (75). The soil—the material—in which Cadmus plants the seeds is the page, as it is too in Palatino, to take an example from a writing manual, who recommends that the point of the pen should be "shaped like a ploughshare or like the beak of a sparrow-hawk" (*S&S*, 80). Ploughshare or beak: Palatino has not delivered the human hand from the animal.

Marc Antonio Rossi Romano summarizes this scene of disseminative writing in the title of his writing manual *Giardino de Scrittori* (Rome, 1598), the garden of scripts; the idealizing argument is presented in an illustration (Fig. 25), juxtaposing and equating the transcendental feather/pen blown to

Fig. 25. Antonio Romano, *Giardino de Scrittori*, second portrait frontispiece.
By courtesy of the John M. Wing Foundation, the Newberry Library, Chicago, Ill.

earth with the enclosed garden that represents script. Eras-
mian flowers of rhetoric might bloom in the garden of script
—this is where the human is cultivated—as easily, perhaps, as
flowers serve to ornament the pages of Esther Inglis's books;
flourishing hands are realized in those flowers, as Inglis indi-
cates when she refers to the work of her pen and her pencil (the
brush) as the "few blossomes" that she offers to Lady Erskine
(Newberry Wing MS ZW 645.K29). Such "flourishing" (the
term regularly used to describe the cursivity of the hand)
describes a path from writing to picturing, one that might
make painting the origin of writing, another Platonic reversal
that haunts the *Phaedrus*—or the discussion in Erasmus, which

concludes by praising Dürer and by recommending that the boy learn to write by being trained to draw. "Just as trained musicians have a superior enunciation even when they are not singing, so a man whose fingers are trained to draw lines of every shape will construct letters with greater ease and facility" (36). The analogy attempts to keep writing within the domain of the voice, but the lines of script are fetched elsewhere. Although Dürer's book, "written in German but with immense learning" (36), can be made to subscribe to an idealizing argument (its mathematics are transcendent principles), its vernacular status and the possibility that writing lies in the domain of the hand—not the spirit—will haunt discussions of the alphabet; are their lines drawn from the heavens, or from the earth?

In these scenes of an original writing, the Platonic separation of false and true sowing, of semblances and idealities, of pictures and ideas, of bodies and minds, is not read as an opposition but placed instead on a continuum—the human is planted within the alphabetical, and the seeds sowed in the soul are those that are written by hand. Contra Plato, or, rather, endorsing the speech of Theuth that Socrates would condemn, memory arises from this activity. For within the pedagogic regime, in which the human is ideally a copy, what is stored in the mind starts with the retracing of examples, and that activity begins with the making of letters. Speech in this paradigm is a secondary effect, for Renaissance pedagogy has oratory (not dialectics) as its model, and speaking and speech-making are one and the same. In an authoritative model for this pedagogy, Quintilian cites with approval Cicero's *De Oratore* (1.150), which states (as Plantin knew) that the pen is the producer and teacher of eloquence; this leads Quintilian to stress the importance of practice in writing—in a metaphor of ploughing that restates the opinion of Theuth: "For as deep ploughing makes the soil more fertile . . . so if we improve our minds by something more than mere super-

ficial study, we shall produce a richer growth of knowledge and shall retain it with greater accuracy" (10.3; 4: 91). The soil is the mind, a writing surface (a tabula rasa) inscribed by the ploughing pen; the human mind arises from the cultivation of the hand. Quintilian speaks not only of origin and growth but also of retention as the activity maintained by the hand—memory originates in writing, and the past and the future do too. If there is a present, it is that made by hand.

In summary, Erasmus's fable, by placing writing at the origin, is divided between attempts to (re)ground the alphabet and the human in the soil (thereby subordinating writing as silent speech) and an insistence on the letter as the only ground of the human. Human soil, as in Quintilian, is the mind made by the hand. The hand of Cadmus intervenes between the mouth of the snake and the ground that he sows; that intervention—between the dead snake and the disseminating letters—founds the human and the alphabet, letters themselves. Explicitly presented as a scene of origins—"the alphabetical order in which they [the letters] were born" (S&S, 34)—this beginning is a secondary formation of the human, the alphabetical, and the "order" in which they are "born." Despite attempts to originate this origin—in Phoenicia, in speech—there is nothing before this secondary state, for it founds the civilized human within the spheres that count as human. This is a foundational moment that cannot secure its foundations, haunted as it is by the logocentric devaluations of writing which it would revalue. These texts write with Plato's other hand, and attempt an idealization that always exceeds its grasp.

Logocentric arguments, as Derrida has demonstrated in "Plato's Pharmacy" or in Grammatology, are constructed along these fault lines, and these humanistic scenes are as much haunted by the Platonic denial of writing as they restate the founding speech of Theuth. Take as another example Gregory of Nyssa, who echoes Cicero in The Nature of the Gods (2.150–

52) when he defines essential humanity in aptness for speech. No sooner is the mouth named than the hand appears, second, to be sure, in both Cicero and Gregory. But as Gregory continues, the order is reversed: for man to speak, he writes, "Hands were articulated in the body . . . it was before all for language that nature added hands to our bodies" (*The Creation of Man*, 8.148d). Gregory imagines an original body language; the mouth could not speak before the addition of hands. "Hands," he adds, "are the characteristic of rational nature" (149e). The argument slides towards the position of Anaxagoras that Aristotle only ambiguously opposed. Gregory's premise about the rationality of the hand imagines a writing before speech, and not merely in the gestures of the hand: "It is, in effect, one of the marks of the presence of reason to express itself through letters" (144c). Thus, although Gregory regarded the creation of the hand as a supplementary addition that freed the mouth to speak, rationality is founded in the hand that writes, in the letters which differentiate and thereby originate meaningful sounds. The primacy of speech is retrospectively recast as the secondary effect of the rational hand. Human speech, for him, as for Aristotle and Erasmus and, as we shall see, for Renaissance grammarians, is human only when words and letters, the work of the hand, are spoken. Gregory contends, too, that writing not only precedes speaking, it maintains it; sounds fade, but writing remains (144c). That remainder "founds" presence.

Gregory and Anaxagoras are recalled explicitly by John Bulwer, in his 1644 treatises on the hand, *Chirologia: or the Naturall Language of the Hand* and *Chironomia: Or, the Art of Manuall Rhetoricke*. Like Gregory, Bulwer attempts to forge an alliance between body language and the tongue; he writes his "manuall rhetoricke" for the orator. Yet Bulwer, too, cannot efface writing: "It stands him in Hand therefore who would emblazon the armes of the Queen of the affections Eloquence, to use her owne pencill the *Hand*, of a most secret property

to quicken speech . . . the *Hand*, by whose armes and allure-
ments (as it were by main force) the ancient Orators have
so often extorted approbation" (*Chironomia*, 8–9). The ora-
tor's hand is a pencil—the painter's brush—and its gestures
originate speech, giving it a life ("quickening") manifested
as a blazon: a heraldic inscription, violent imposition. Meta-
phors of the hand compulsively enter Bulwer's writing as
what "stands" in hand (the present), or what can be effected
by "main force" (speech). These locate the "originary" vio-
lence of the letter, the "origin" of what is (what stands and is
maintained, occupying space and time) in the letter. St. Paul
may have inveighed against the letter, but as Erasmus's Leo
comments, "It is significant that the apostle Paul penned his
letter to the Galatians entirely in his own hand" (*S&S*, 29). It is
as significant, no doubt, as the double gesture of the Platonic
scripts, writing against writing—or the texts of Renaissance
pedagogy, foundering on human foundations to maintain the
ideology of literacy in the letter.

The secondariness of writing is elementary knowledge in
Renaissance grammars. Language is speech: "A Word is an
absolute & perfect voice," Francis Clement writes in *The
Petie Schole* (11), that text to make the "imperfect" perfect by
"fining" them (as Mulcaster would put it) within the ele-
ments, producing the pedagogic subject as the letter. "Voice"
in Clement translates the Latin word for "word," *voces*, as
meaningful sounds. In Quintilian, letters preserve the sounds
of words ("*custodiant voces*," 1.7; 1: 135), and Clement appar-
ently follows Quintilian in his definition: "A letter is an ele-
ment, or simple voice apt to expresse a word" (11). He gives
some examples of the "perfect" voices/words ("God, Man";
"goodnesse, towardnes") and a model sentence to show what
words are: "I see the Sunne" (11). Ideological and idealizing

examples, these words reduce script to the relationship be-
tween God and Man in the reciprocal motions of goodness
and towardness, a regaining of origins matched by the ele-
mentary sentence, in which sight/visibility is governed by
the paternal sun. These are, as Derrida has argued in "White
Mythology," the metaphors that govern philosophy (to its
undoing), and here they are meant to serve the religious and
ideological purposes of Clement's tract, forming obedient
subjects who see nothing but the sun. But the words also
open a domain of the letter and the subject, for Clement adds
one further word to his elementary list, "Imagine" (11), the
only word printed in Roman type to mark its foreign impor-
tation, the re-marking of the elementary within Latin gram-
maticality; with "imagine," interiority is opened as the space
in which "I see the sun."

The relation of letters to words/voice and of visibility to
invisibility (the human to the spiritual) is suggested further
in Robert Robinson's *The Art of Pronuntiation* (1617), divided
into two parts in the title page description, "*Vox audienda*" and
"*Vox videnda*," voice heard and voice seen; the latter are letters,
the "divers Characteres, by which every part of the voice may
be aptly known and severally distinguished." Letters serve,
Robinson argues, for "noting and charactring of the voice"
(A4r), and writing may be defined therefore as "an artificiall
framing of certaine markes and characters different in forme
and shape for every severall sound in mans voice, whereby
each simple sound having a proper mark appointed to it selfe,
may by the same be as apparently seene to the eye, as the
sound it selfe is sensibly discerned by the eares" (B9r). Let-
ters serve only the secondary function of transcribing sounds.
Sounds are natural, marks artifical.

In their terms and arguments, however, these normative
definitions are troubled by what they attempt to put sec-
ond. The secondary relationship of transparency imagined by
Robinson is an ideal he would realize through the invention of

a new system of notation, not that which supposedly phonetic script achieves. Quintilian, too, would have letters transcribe and maintain the sounds of words, but he recognizes how imperfectly this can be achieved "within the limits prescribed by usage" (1.7; 1: 145). Letters have their own history, one that diverges from a supposed originary moment when they were subordinate to sound. For Quintilian, that moment occurred in Greece, and the letters of the Latin alphabet represent a decline from the "most euphonious of the Greek letters" (12.10; 4: 465). Among his examples (and rather bafflingly, since these consonants have Greek equivalents), he adduces "the sixth letter in our alphabet . . . represented by a sound which can scarcely be called human or articulate" and Latin "M, a letter which suggests the mooing of a cow" (12.10; 4: 467). These letters, rather than founding the human, put animal sounds in the voice. Human history and usage undoes human and alphabetical origins. Quintilian's arguments will be translated in Renaissance texts; Latin letters will serve where Greek letters did for Quintilian, as the origin for the subservience of letters to sounds. To deny the historicity of letters, they must somehow be seen through to the "true" sounds occluded by false letters.

But in Clement or Robinson, as in Quintilian, letters are in the "voice," the word, from the start. It is letters that are vocalized in speech, not the other way round, as Clement makes explicit in his definition of a syllable: "A syllable is the pronouncing of one letter, or moe, with one breath" (11). Such is the case too for Robinson; there is no distinctness in the voice—no human difference—without the letter. "Noting and charactring" the voice, letters articulate the voice, making it "known and distinguished." For a word to be spoken— for a word to be a word—it must have letters. "How write you people?" John asks Robert in one of the sample dialogues in Edmund Coote's *English Schoole-Master* (1596; 1630 edition cited):

Robert. I cannot write.

John. I mean not so, but when I say Write, I meane spell; for in my meaning they are both one.

Robert. Then I answer you, p,e,o,p,l,e. (28)

Writing is spelling since the "elements" of words are letters; sounds are heard as script. Elizabethan pedagogic practice, we know, taught reading before writing (a procedure not fully abandoned until the nineteenth century), and as we have seen already reading was modelled conceptually on writing/copying. In Coote, we can see that writing literally preceded reading in the practice of spelling. Although children were taught to read without any introduction to the system of writing, that is, as if the letters were representations of the sounds of words, the oral world of reading was already constituted by writing, and letters themselves were presented as if they were naturally in the voice or in the word. This is the case, too, in Clement's definition of the letter as constitutive, rather than an artificial system to record spoken words. In this teaching, writing seems, indeed, to be the essence of speech. No wonder Ursus would have his cub start at the end. But can an origin then be secured? Will the "towardnes" of Clement's pedagogical subject ever arrive at a divine origin that has been (un)grounded in letters themselves?

These grammatical discussions exhibit the aporias of a logocentrism marshalled in support of the humanizing values of literacy. Insofar as their writers wish to regulate the domain of letters by supporting them through speech, the definitions undergo the familiar twists by which speech is only founded in the letter. Insofar as these writers wish to exalt the place of the letter and grant it primacy, their arguments move in the direction of Derridean "writing," but with a crucial difference, for they would support through letters themselves precisely what the letter will not support—transcendental value. David Browne's definition of writing in his *New Invention* points this

way: "WRITING, Is a Literall Suppliment of the Voyce, in exponing of the Minde" (***2v). Browne's supplement can be read as Derrida reads the term in Rousseau, for Browne posits writing both as a secondary addition and as something necessary to speaking, compensating for a lack in speech, as both the double meanings of "exponing" (from *exponere*—to place outside, to empty out) and the grammar of the sentence suggest. Browne's definition of writing *exposes* both mind and voice in terms that refuse the stabilization of primary versus secondary or inside versus outside.

Browne proceeds from this definition to his Aristotelian taxonomy, from the efficient cause (the living and dead instruments of the writer's body and pen, discussed earlier) to the material cause (ink) and formal cause (the shapes of letters) to arrive at the final cause of writing:

[It is the] signifying of articulate voyce, whereby the thoughts of the minde are interpreted, and the demonstrating of the minde without the voyce; for as *Aristotle* teacheth, Writs or Letters are the Symboles of Voyces or Wordes, (howsoever it may bee thought that the Voyce beeing invisible cannot be represented by anie externall Signe) the Voyces Symboles of the Conceptions of the Minde, and the Conceptions of the Minde, Images of thinges which bee outwith the Minde: and that both of Divine Writs and Humane. (****1v–2r)

Browne's chain of signification appears, at first, to be the standard and expected one: mind expressed in thoughts, thoughts in words, words in letters, a progressive exteriorization and materialization. Yet from the first, the chain is disturbed. The mind apparently has words in it from the start, "Divine Writs and Humane," and if writing exteriorizes the mind, what it presents is also what is in the mind, "demonstrating . . . the mind without the voyce." Plato's internal writing communicates essentially with writing in the ordinary sense; once again, what Plato would have separated, Browne reads on a continuum, one in which the transcendental privi-

lege of internal script lends a hand to ordinary script; the traffic between the ideal and the ordinary hands moves in two directions. "Without" in "the mind without the voyce" reads two ways, the mind lacking the voice, demonstrated (pointed out, made manifest, shown) in and by the hand. As Browne expands the Aristotelian definition, it is not sounds that are in the mind but images (Robinson's "*vox videnda*"); the mind, rather than being a locus of invisibility and internality, is made (is already) visible. "Thinges which bee outwith the Minde" are also what is within the mind. Writing manifests that relationship. The mind does not contain writing as an interiority independent of the external impingement and breaching of interiority by writing. For Browne, the violence of the letter is not merely instrumental; it is the founding of language— the founding of Clement's "imagining" subject. The origin of time and space, of memory and subjectivity, is in the letter.

It is not only a writing master like Browne or a pedagogue like Clement whose texts reveal the fault lines in the logo-centric investment in voice and debasement of writing. Such a reversal can also be found in Robinson's *Art of Pronuntia-tion*, not merely in its articulatory and differentiating system, but in acknowledging the institutional—that is, the originary —force of writing. Robinson believes in the immediate rela-tionship between voice and mind; without speech, he writes, "mans mind were but as in a dungeon, and in perpetuall thral-dome of the body" (A3r). But immediacy also represents a limit; speech does not endure. He continues: "If there were no other helpe then the voice to express the mind: man could not be the better for any thing that should be taught or spo-ken of no longer then the very words were speaking, or at the longest, but whilest our weake memories could retaine the very matter spoken of." For Robinson, as for Plato's Theuth, writing founds memory; it institutionalizes society; it marks the only beginning. Such too is Wolffgang Fugger's point in the introductory letter to his 1553 writing manual. There, the

story that Socrates tells is explicitly recalled in order to prove that even kings have erred in their estimation of the art of writing.

"How could art and knowledge exist if there were no Art of Writing?" Fugger asks, and he is echoed by numerous writing masters and pedagogues who answered the Socratic position by insisting on an alliance between letters and the mind's capacity to know and to retain knowledge: the value, in short, of literacy, as Jack Goody would have it. Although "BARE LETTERS" are his concern, Browne writes, this is no trivial matter, since writing "maintaineth al other Subjects" (**1v). "Maintenance" designates, in fact, a crucial link (visible in the etymology, "hold in hand") between the hand, memory, and temporality. Robinson's worry about the weakness of memory, its inability to "retaine the very matter spoken of" (A3r) is answered by Browne. Material retention by letters supplies what weak memory lacks. Moreover, stunningly, Browne insists that the present only exists in writing: "The worde *present* is proper onelie to Writing" (***3r). What fades (speech, memory) cannot be present; only what lasts, what is, can be, and only writing maintains the present. "The hand," Robinson grudgingly admits, "though it give a dumbe and a more dull kind of speech, yet it gives a more durable" (A3v). What is durable has duration, and immediate speech does not.

The apparatuses of literacy are marshalled for a founding moment—founding the mind and temporality in the supposed permanence of the letter. That permanence, however, is belied —in Quintilian's acknowledgment, for example, of a history of letters; it is because the letter cannot support what these idealizing accounts suggest that a writer like Robinson proposes a new alphabet since the current one so imperfectly represents sound. The search is for an alphabet that would endure, that would return to and maintain the originary moment of the alphabet—a search that continually reveals, as had Erasmus's fable, that the origin recedes and that it is only opened—as

distance, as internality—by letters that refuse the stabilizations that constitute the dream of literacy and its ideology.

Robinson's *Art of Pronuntiation* is a relatively late example of an attempt initiated by sixteenth-century Englishmen to define the relationship between the spoken and written language and to reform the spelling system to conform to the spoken language. The ideological terms of this debate are complex. Some, like Sir Thomas Smith, in *De recta et emendata Linguae Anglicae Scriptione* (1568), the first major contribution to the topic, would, as the Latin of his text suggests, reform English script so that it would have the purity of Latin—so that the letters would have a transparent relation to sound. But the vernacular texts produced in this debate (by John Hart and William Bullokar, for example) extend this privileged human- ist project in the hope of making English not only pure but also readily available. The principle remains the same—that the written language should simply reflect the spoken one —but in order to achieve this goal, there also must be the recognition that the supposedly phonetic writing system is anything but phonetic (not a particularly difficult perception in an era when there was no standard English, and most egre- gious later under James I, when the king and much of his court spoke Scots). To rewrite English means, on the one hand, to remake the language (along humanist lines) for "everyone"; it thereby attacks the privilege of those who have mastered the letter in all its waywardness. For those who defend the writing system—Mulcaster, most notably—it must be maintained in order to support a status quo, to defend against extensions that would make writing too available. Reformers also insist on the ideological purity of their work; at the conceptual level, once again, the positions are not easy to differentiate—they are forms of idealism attached to the reproduction of literacy.

Spelling reform in English, which has always been based on the dream of reducing writing to a transparency, has never succeeded, however, not merely because it is impossible, but because such a reduction also threatens the reserves of a writing system whose irregularities of spelling provide grammatical leverage in the formations of socially differentiated literacies, the maintenance of what Michael Stubbs calls "a writing community" (83), with all the privileges that entails. When English did become standardized, its spelling system was not regularized along phonetic lines; the vagaries of English spelling remained to be mastered by those who achieved "full" literacy.

The second part of Peter Bales's *Writing Schoolemaster* is a treatment of "true Orthographie" (E1r). "True" designates that ideal fit between the spoken and written language, and "Truth" is the virtue most often invoked in discussions of spelling reform, on the basis of etymology: "Orthographie is a Greeke woorde signifying true writing," John Hart explains in the epistle to his 1569 *Orthographie*. Its full title presents the entire argument, as well as the terms for its deconstruction: *An Orthographie, conteyning the due order and reason, howe to write or paint thimage of mannes voice, most like to the life or nature.* Bales's truth of spelling is something he imagines available to those who "understand the Latine tongue" (E1r); he would make spelling true by restoring it through the recasting of English along Latin models. Ideologically, this is the same justification made by those who would radically recast the alphabet, providing new letters and accent marks to make up for its unphonetic nature.

Spelling reform moves along the "civilizing" path, but whereas Bales's orthography is (like Mulcaster's) basically a dictionary that regularizes current spellings, reformers like Hart wish to extend the "civilizing" paradigm further in the dream of a script that has returned to an origin. Such reforms do not only confront the conceptual untruth (from a logocen-

tric perspective) of the writing system, but also the ideological support of that system as the maintenance of the transcendent truth of the political system. Hart thus operates at two levels at once: to return writing to its origin and to insist that such a return furthers state maintenance. Thus when Hart confronts the independence of letters from their truth function in his *Orthographie*—that one letter may serve to represent more than one sound or that more letters are used than the sound requires—he describes these lapses in political terms: "The writer is forced to usurpe one figure in two or more voyces" (14v) when the same letter serves more than one phonetic function. When more than one letter is used for one sound, he claims "writing is corrupted" and "false"; "this abuse is great" (15r). Both conditions arise from a simultaneous *lack* and *superfluity* in letters. To counteract these, Hart proposes (as we might expect) timeless laws, "the law of nature in our hearts, and commaundements of God written" (11v–12r). As in the *Phaedrus*, these eternal laws are written, not spoken, and the justification of a return to truth in writing is that it returns to such an original writing.

Hart's truth is entangled in the contradictions of the ideology of writing: "For such an abused and vicious writing, bringeth confusion and uncertaintie in the reading, and therefore is iustly to be refused, and the vicious parts therof cut away, as are the ydle or offensive members, in a politike common welth" (12r). To argue a return to an original script means to challenge the present maintained by script and its insistence that it already has achieved the ideal function of producing eternal, unchanging truth, the law of nature that is one with hierarchies of power. Hart recognizes this, most clearly in the 1551 manuscript version of his book, "The Opening of the Unreasonable Writing of Our Inglish Tongue." (It was eighteen years before the manuscript was printed, by which time Hart had been appointed Chester herald [in 1567], having served as a pursuivant before, and had been sent on official

business in the employ of Sir William Cecil, bearing money for government troops, for instance, after the suppression of the Northern rebellion in 1569. There is no question of Hart's loyalty to the crown or to the Protestant cause—his whereabouts during the reign of Queen Mary are unknown.) In the manuscript dedication to Edward VI, he notes that he has been attacked as "an inventer of troubles in a peoples long coustumes"; he aims, however, at "the amendment of their corrupted maners of lyving" (Danielsson, 1: 114) and hopes that the king will see "publyke profitt" and "reason" where others see abuse (112). The king, in short, must not allow himself to fall prey to "whatsoever use, *and* coustume hath long maintayned" (112).

Amendment of what has been maintained is to be answered by another form of maintenance, however, returning the present script to an originary one. The conservative/rebellious political stance adopted by Hart is thus an attempt to weed the commonwealth of abuses, to write a King's English that returns to the originary script of reason and the law of nature, securing by orthographic change the unchanging and transcendent reason of royal rule. As Hart announced in the preface to his *Methode or comfortable beginning for all unlearned . . . to read English* (1570), his new letters were meant to represent the language "of the Court, and London, where the flower of the English tongue is used" (A3). Weeding the garden of scripts, Hart would renaturalize writing. But what would this originary script be? Hart proposes a new alphabet, with a host of new symbols to provide a different letter for each distinct and different sound. The new script violates the supposition that the English alphabet is phonetic, and although offered in the service of state maintenance, it recasts the alphabet upon which the state stands.

Hart's difficulties are replicated in John Barrett's *An Alvearie or Quadruple Dictionarie* (1574; 1580 edition cited), although Barrett attempts to solve the problem by reforming spelling

within the ordinary (that is, "original") letters of the alphabet. "For it is best to holde us to our accustomed usages, untill authoritie shall move, and decise [sic] things to the contrary" (B1r), Barrett writes. Nonetheless, he is as vehement as Hart about the present abuses he is forced to uphold in allowing "accustomed usages" while he waits for "authoritie" to institute a new regime of letters. He is simply more wary of proposing wholesale orthographic reforms that might be met with political objections. In his dictionary, each alphabetical entry is preceded with a discussion of the letter. In those introductions Barrett repeats Hart's objections. Consider his remarks on C:

This letter troubleth me worst of all, & maketh me most to wonder howe it got this third place of honour, or how it hath so absurdely thus long usurped that dignitie. . . . If C were a proper letter, then Art and reason would it should have his proper sounde, and ever to keepe the same uniformally in speaking, not waveringly like *Proteus* or *Chamaelion*. . . . Therefore C, is either no letter at all, or else both *k*, and *s*, are like to loose not onely much of their right: but also both their names and places at length in our crosrow. (K3v)

Like Erasmus, Barrett seems to think that the order of the alphabet expresses some natural hierarchy, and like Hart, the failure of a letter to keep its proper phonetic place leads to strong moral and political language. By the time Barrett gets to E, his violence against the letter is unrestrained; he would "geld out many idle dumme *E*, *ees* . . . which signifie nothing," but once again restrains himself, looking to the "learned Universities" for amendment of abuses—that is, only "after the Prince also with the noble Councell, [have] ratified and confirmed the same, to be publikely taught and used in the Realme" (X5r). Barrett recognizes spelling reform as a politically explosive issue, which is no surprise, considering his insistent politicization of spelling. Orthography has arrived, he writes, at a state of "Cacographie" (Mm5v); one cannot tell

the vowels ("the Princes of speach," Qqɪv) from consonants: witness I/J. That such a state prevails can only be explained by current social realities; "some that wallowe in wealth, and being in some fat office of writing" (Mm5v) are quite content with the status quo. Like Hart before him, Barrett looks to the sovereign to reform such social abuses. Or, as Arthur Golding puts it in the poem to the reader that prefaces the *Alvearie*, "sound Orthographie . . . confirmed by the Sovereines will" is the means to restore "perfect order" (A5r). As with Erasmus, the alphabetical order is the "natural" social order.

The defense of custom and "the fat office of writing" can be found in the fable about the origin of writing offered in Mulcaster's *Elementarie*. Mulcaster starts from the premise of an original moment when "sound alone bare the swaie in writing" (64), but, rather than idealizing that first condition, he provides a history of writing that justifies its departure from the sway of sound. The domination of sound is read as tyranny; in this history of the "regiment in writing" (64), "sound government" under the "monarchie" of "*sounds* authoritie" was the rule of "*sound* it self being to[o] imperious" (66). The joint rule of sound and reason and custom that succeeded this original tyranny defines the present state (of the language and, transparently, of the sixteenth-century monarch-in-parliament). For Mulcaster, it is up to the present age to assure this alliance by forging a methodical art of writing, not by attempting a return to the original state. Like the writing masters, Mulcaster regards speech as transitory (67), incapable of self-identity (it is "never like to it self," 68) and variable from speaker to speaker. Replicated speech would be an unsound ruler in the literate world in which power is wielded by the pen.

Turning against the (un)sound support of writing, Mulcaster also argues against the analogy most often used to secure the secondariness of writing: writing as a picture of

speech—"*ut pictura, orthographia,*" as Sir Thomas Smith put it
(Jones, 145). Mulcaster asserts that "letters can expresse *sounds*
withall their ioynts & properties, no fuller then the pencill can
the form & lineaments of the face, whose praise is not life but
likenesse: as the letters yeld not alwaie the same, which *sound*
exactlie requireth, but allwaie the nearest, wherwith *custom*
is content" (99). Mulcaster asserts, in short, that those (like
Robinson) who would describe writing as simply the visual
depiction of sound mistake representation for presentation.
Mulcaster faults the analogy, and with it the definitions of
"truth" that support orthography. He offers, instead, another
truth, one that has the ideological support of writing. The
truth of writing is likeness, not life; artifice, not nature.

For Mulcaster, unlike Hart, this empowers letters. Whereas
Barrett would banish (indeed, castrate) E as a rebellious up-
start usurping his proper place, Mulcaster records the won-
derful capacity of E to serve in many places:

> E Besides the common difference of time and tune, is a letter of
> marvellous use in the writing of our tung, and therefor it semeth to
> be recommended unto us speciallie above anie other letter, as a chefe
> governour in the right of our writing. Which e, tho it be somtime
> idlelie writen, either of ignorance, if the writer be unlearned, and
> know not how to write, or of negligence, if he be learned, and mark
> not his hand, yet most times it is writen to great purpos, even where
> it semeth idle, before the force of it be considered, and hath a verie
> great saying in ech of the seven precepts, as shalbe declared. (111)

Correctly used by the pedagogically informed, E is "chefe
governour" of the letters and no usurper, despite its "force."
Mulcaster proceeds to methodize the various uses of E with
his "seven precepts," explaining the rules and reasons of a
writing system that is not enslaved to sound. His opposition
to any reform of spelling (beyond the errors caused by igno-
rance or neglect) aligns his pedagogy to the political order
and secures that alliance through the letter itself. E, allowed

its power but within a pedagogical domain marked by reason and custom, functions as a synecdoche for royal rule.

Mulcaster all but makes this explicit when he defines the "quintessence" of language as change of the sort exhibited by E; this is the *"prerogative"* of language: *"prerogatives* power, a great princesse in proces, and a parent to corruption, but withall intending to rase another *Phenix"* (159). E is for Eliza-beth, the phoenix princess, but unlike Scottowe's E, this one maintains itself only through change—in the mobility of re-serves that (un)ground the letter and that (de)originate it in Mulcaster's fable.

By positing process rather than the stasis of origins as his quintessence, Mulcaster secures his view of language as writ-ing for the political status quo. The contradictions in this ideological position can be noted, however. To define the essence of writing as change means to have already conceded the opponent's argument, that writing lacks the stability that sound supposedly has; change is "a parent to corruption." It means, therefore, to define the essence of writing as the non-essential and secondary, painting, not life. As picturing, writ-ing is a second-order phenomenon of representation that will never be presentation. (Writing remains copying, but without the model of sound behind it.) Mulcaster's definition of "pre-rogatives power" exhibits this contradiction: writing "rases" (it "raises" and "erases"). Letters, if they are like the phoenix, are self-begotten and self-immolating. Sui generis, they are not in nature as any other natural object is. Letters have their own "life," that of a social order that maintains itself by being on the move.

In Mulcaster, then, the idealizing of letters themselves, although offered in support of constituted power, offers no ontological security for that power, no appeal to an origi-nary moment or to the possibility that letters maintain an eternal present. This is *also* true of John Hart's position; he can scarcely mention an originary order of sound without

representing it as writing, as is further apparent when Hart makes use of the analogy from painting faulted by Mulcaster. Even to express the relationship between speech and writing as analogous runs the possibility of reversability; if writing is defined as what analogy performs (likeness, not truth), then to define by means of analogy is to make writing a master trope —the master trope that it is within the pedagogic regimes of literacy. When Hart posits a likeness between speech and writing, writing comes to be the model for speech: "As the foure Elementes are the matter and substance of all thinges that are made in bodies and shapes . . . the voyces are as Elements and the letters their markes and figures," Hart asserts (*Orthographie*, 8v–9r). Hart's analogy equates the elements that make up the natural world with the sounds that are the material support for letters. Yet the analogy undoes itself. Rather than making sounds natural, letters are naturalized as "elements"; their "markes and figures" are bodies. Rather than making "voyces" a spiritual principle, they are materialized as elements (and therefore as letters). The analogy figures voice as the bodily mark—as the letter. The entirely secondary life of the letter usurps the primacy of voice as Hart continues his analogy:

Even as every body is to be resolved into those Elements whereof it is composed, so every word is to be undone into these voices only whereof it is made. Seeing then that letters are the figures and colours wherewith the image of mans voice is painted, you are forced to graunt the writing should have so many letters as the speach hath voyces. (9r)

"Undone" indeed, if one reads "those Elements" as letters; the voice is invaded by the painted simulacrum. As it is in Plato's *Statesman* (278), glanced at in "Plato's Pharmacy," when the example of examples (as here, the analogy of analogies) is the pedagogic scene of learning letters which are there, as here, the elements of the universe, letters secure difference—

in things and in concepts. We must not be surprised, the dia-
logue says, "to find our own mind reacting in the same way
to the letters with which the universe is spelled out" (278d).
This is the elementary definition of the letter—to the ruin of
Platonic designs.

It is thus on the basic analogy between (in Robinson's
terms) "*vox audienda*" and "*vox videnda*" that the search for
truth founders and on two counts. First, *vox* means both
voice and word, hence letters enter into the voice from the
start. Second, the similitude, which makes voice visible in
letters, is already to be discovered in the definition of voice
embodied and materialized. Letters make sounds visible; the
truth and essence of sound is the visibility of the letter. Such
visibility (as we saw in Browne, for example) derives support
from the idealizing that equates ideas with images, a writ-
ing in the mind; moreover, such visibility founders on the
devaluation that attends writing as similitude and representa-
tion, the second-order phenomenon that Mulcaster elevated
to a quintessential position.

All of the lapses that we have been seeing in Hart's argu-
ment come together when he offers an "Allegorie" comparing
"the lively body of our pronunciation, which reason biddeth
the writer to paint and counterfet with letters, unto a man,
which woulde commaunde an undiscreete Painter to portraict
his figure" (27r). In Hart's allegory, sound is figured as a
man; sound is thus given a body and made visible. Although
sound orders a painter (who represents the secondary regime
of writing), he is, within the figure of the allegory, painted
himself, embodied. In the manuscript version of this alle-
gory (where it is called an "Analogie"), the man who repre-
sents speech is named "Tulli" (Danielsson, 1: 123); the printed
text calls him "Esop." Whether as grammarian or as fabulist,
these proper names do not secure the priority and primacy of
speech. Rather, as David Browne suggests, grammar is really
grammatology, for it is writing (*gramme*) that determines the

rules of speech (*New Invention*, 45–48)—or Hart's figures for speech. The letter, Browne says, is "the Key of all Learning" (47); it "pointeth foorth, or signifieth, all the rest" (50). Among the rest, a final remainder, for Browne, is the sound that the letter points to.

In Hart's allegory, the painter, left to his own devices, would not properly depict Esop, the embodiment of sound. The allegory insists on discrediting letters. Yet, to reiterate, it depends entirely on letters for its representation. It is only as representation that the equation of sound and word exists. The allegory, ostensibly exposing the secondary, lapsed, wayward, and usurping power of the letter, points, instead, to the necessity of the letter as "the lively body of our pronunciation."

The analogy of writing and painting has one further devastating effect on the logocentric argument: it is used to support the notion of an originary writing—writing before the letter—that bypasses the representation of sound entirely. Paolo Lomazzo provides a locus classicus for the analogy that haunts and ultimately deconstructs the logocentric claims for the secondary nature of writing. "If then it be true (as it cannot be denied) that the use of writing was first invented to the ende that those Artes and Sciences . . . might not be lost," Richard Haydocke Englishes Lomazzo's argument in *A Tracte Containing the Artes* (1598), this is because, he continues, "the power memorative corporall, could not containe all the similitudes and Ideas of so many things as are in the world" (2). Lomazzo argues the undeniable truth (within the idealizing of writing) that writing insures memory, maintaining and keeping present the past, securing the future. This foundation of temporality, however, is established by the retention of ideas within a Being-in-similitude, "*gl'idoli, & simolacri di tante cose*" (3), that is, by being pictures first. It follows "that Painting is an instrument under which the treasury of the memory is

contained, insomuch as writing is nothing else, but a picture of *white* and *black*."

The pedagogue William Kempe, in *The Education of Children* (1588), stumbles upon this problem. Having exalted the values of literacy, Kempe finally turns to the practice of writing, which should merely transcribe the oral teaching that begins with reading. Orthographie is "the same knowledge, but expressed by the hand, as the former is by the toong" (F3v). The "same" immediately becomes the founding difference of writing as painting: "Which expressing and skill of the hand, belongeth properly to the Arte of Painting, and not unto Grammar" (F3v). The *impropriety* of the *proper* here translates the logocentric aporias into their class spheres; grammarians are not scribes or manual workers. But here, too, the manual can be elevated, by allowing the painter a place within the grammatical regime. Aristotle offers the precedent for this, and drawing is part of Mulcaster's elementary, as it is too in Elyot's *Governor*. Writing is assimilated to drawing in Henry Peacham's *The Art of Drawing with the Pen* (1606), which similarly argues that children should learn grammar, gymnastics, and "graphice, or well handling the pen in drawing, writing faire, &c." (A3v), while William Sanderson, in *Graphice. The use of the Pen and Pensil. Or, the Most Excellent Art of Painting* (1658) adopts Lomazzo's position: "*Painting* was before *Poetry*; for Pictures were made before Letters were read" (13). "*Drawing* and *Designing* performs, what by words are impossible," Sanderson writes later, "and (to boot) perfects the hand, for all manner of writing" (28). Sanderson combines the Italian tradition (represented by Lomazzo), in which the line founds drawing and design, and the Northern tradition, in which lettering and calligraphic flourishes lead to the turned lines of the engraver's art. Nicholas Hilliard in his treatise on limning sums up the art of the hand: "The principal pte of painting or drawing after the life, consisteth in the truth of the lyne" (84).

The truth of the line, in an etymology only rejected much later, is that letters are lines; the Latin for "letters" is said to derive from "lines."

For Lomazzo, writing is a species of painting because painting "speaketh al languages" (2), and the founding instance of painting/writing is the Egyptian hieroglyph: "Whence the Egyptians, under the pictures of beasts and other living thinges, used to deliver all their sciences, and secrets, both sacred and profane" (2). Hart's allegory is an Egyptian hieroglyph of just this sort, sound embodied in the image, sound as the letter. The physical form of the letter—the lines in black on the ground of white—is the root of all signification.

The truth and reason upon which Hart insists can be read against the repeated claims of the writing masters to present the rational forms of letters. "The *Reason* of every letter must be found out," Martin Billingsley writes (D1v); "the *shape* (which giveth *life* and *spirit* to *Writing*) must be knowne also: for therein the very substance of *Writing* consisteth" (D2r). So Hart pictures speech embodied as a living spirit, in human form, but, as Billingsley says (and numerous handwriting manuals before him insist), it is the pressure of the pen that confers life on letters, and it is spacing and proportion that reveal the reason that shapes them. Examples of definitions that align truth and reason with letters could be multiplied from the Italian writing masters (or Geofroy Tory) who geometrize letters and claim to have discovered thereby the universal laws, the rational/natural laws, that letters embody. The first published writing manual, Sigismondo Fanti's *Theorica et Pratica* (Venice, 1514), in fact offered three books on the geometry of letters after an initial book on the preparation of the implements of writing. Fanti's Roman majuscules provided models of design that were only replaced late in the century by Cresci's and used, as Petrucci has shown in *La Scrittura*, for monumental inscriptions of ideological power. The supposition was that these letters revealed the most perfect

proportions, a divine geometry. These letters were meant for painters' hands (Dürer's book, praised by Erasmus, is another of these). The principle behind them, however, was extended to all forms of writing, and especially to the privileged italic hand.

"Like as the law of nature in our hearts, and commaundements of God written, doe teache us a purenesse of life to represent the nature of God, wherefore he created us: so ought the law of Reason which is in us, to turn our handes to order iustly, those figures and letters which we shal make" (11v–12r); this quotation from his *Orthographie* might be taken as Hart's founding analogy. Human nature is inscribed internally and circumscribed externally. Human existence is itself representation. Law, nature, and reason are written within the domain of the hand. Hart's founding principles for a true orthography depend upon the "truth" of letters themselves, and thereby his truth is unfounded. " 'Graphic,' " Anne Hollander has commented recently, "means 'like writing'; it now also means 'like truth' " (118); that likeness is the twinned origin of writing and the human.

The truth of letters themselves as originally painting locates the origins of the alphabet as a script without phonetic value. The justification of spelling reformers like Hart, who proposed new writing systems as a means to return to an original script, are haunted by the hieroglyph, the nonphonetic original writing; these, like the eighteenth-century examples considered in *Grammatology* (76), are limited decenterings. Similar counterclaims are also made by sixteenth-century inventors of shorthands, dreaming of a writing swift as speech—so swift that it could not be phonetic. The first book of Bales's *Writing Schoolmaster*, in fact, is devoted to "Brachygraphie," swift writing, and Bales invokes the precedent of Egyptian hieroglyphs. Like linguistic reformers later in the seventeenth century,[4] Bales hoped to provide a set of "universal characters," which, like painting for Lomazzo, would speak all languages

and which could be translated into any language; the "universal character" would immediately represent the mind by bypassing the representation of ideas in sounds. Nor was Bales alone in this. John Willis, for example, justified his "new Illiterall Characters" (F4r) in *The Art of Stenographie* (1602) on the basis of "reason," and Timothe Bright, citing the precedent of Chinese characters for his own *Characterie*, claimed that they excelled "writing by letters, and Alphabet" in their ability to communicate "meaning" immediately (A3r–v). Bales, however, claimed to go beyond the ancient hieroglyph by using *"one Alphabet of Romaine or Italian letters"* (B2v) rather than the Egyptian device of images of objects. He used the socially privileged letters of the alphabet for his shorthand, used the letters themselves, that is, without their phonetic value. The Roman alphabet is realized as an originary script, as the sheer visibility of the hieroglyph, overcoming time and space to make its durable mark.

Bales gives pride of place in *The Writing Schoolemaster* to his shorthand, and with good reason. The idealization of handwriting is attached to the Roman hand; the idealization of letters is attached to nonphonetic script. Bales combines the two in his Roman hieroglyphs. If they immediately transform the mind into a set of scripted representations, they also serve to idealize the power of letters as the permanent repository of learning. But the invention of the universal character imagines more, a global communication that would allow any language to be translated into this one, a dream of power like the one to be found in John Florio's Italian-English dictionary, *A Worlde of Wordes* (1598), and not just in its title. Explaining why his dictionary featured more English than Italian examples, Florio instanced "the copie and varietie of our sweete-mother-toong" exemplified by "this most Excellent well-speaking Princesse or Ladie of the world" (a5r), Queen Elizabeth; Florio's world of words is an imperialistic projection, even more explicitly so in the second edition when it was retitled *Queen Anna's New World of Words.*

It is worth recalling in this context Mercator's book on the italic hand, or Hondius's collection of scripts, for both Mercator and Hondius were mapmakers, and their letters produce worlds too: in the names on maps; in the lines of maps, delimiting territories; in the pictures on maps, depicting the world. Britain entered the "world of words" in the sixteenth century when italic, *"Regina d'ogn'altro carattere"* ("the queen of all scripts") as Marcello Scalzini termed it in his *Secretario* (55; *S&S*, 247), was adopted as the hand of power. When Peter Bales devised his universal character in a Roman hand, he realized the power of the script. To make Roman script a cipher, that is the dream: a script whose very immediacy is that of an illegible letter, storing the secret reserves in a script that no longer communicates with sound, one that has mastered all the world by rewriting it as writing.

Which of you (grave Patrons of all knowledge) may not (if you please) drawe profite from hence: seeing that by this readie helpe, you maie supplie your memories, perfect your readings, publish your conceites, and profite your schollers: Which of you (yong Students) either in Divinitie, Physicke, Law, or Philosophie, shall not gather great commoditie from hence? (B3r)

Thus Bales recommends his swift writing, a shorthand of profit to the mind "supplied" by the hand, valuable to the pedagogy that trains the professional classes, and beyond them, to those "men of state" (such as Hatton and Walsingham) who need to *"swiftlie and secreatlie decipher your intelligences"* (B3r). This is a spy service written in the name of "reason," Bales writes, a reason which is one with reasons of state and with the reasons of writing, of letters themselves, that with *"a tittle or twaine, and . . . a couple of accents"* (B2v) return the ancient scripts to a scriptive and nonphonetic origin. These are letters that may cover space and time within their ruling and differentiated domains.

This then is an ideology of literacy shared by all who participate in the debate over spelling reform, to be found justify-

ing new alphabets (which aim at legibility) and secret scripts alike. It is the alliance of secrecy and the italic that marks off the sphere of power, however. Were there no writing, Robert Robinson opines, "Princes in every age (though in one and the same kingdome) would have a different kind of ruling, the subiects a different course of living, both the Princes and people a different and new course of religion" (A3r). States could not "stand" without writing, David Browne comments, "seeing it not only keepeth constant memories of Promises, Rightes, and Dueties, betwixt man and man, from Generation to Generation; but likewise goeth in Ambassage from Nation to Nation in all effaires, expressing mens Mindes whose persons bee absent, as if they were present" (*New Invention*, **2r–v). "If thou looke for any favour or preferment in our Court, nay if thou looke for any seate or resting place in the Court of heaven," William Kempe counsels in *The Education of Children*, "seeke for it by learning" (E1v), by which he means literacy. The divine court and the human court are one for Kempe, a sleight of hand made possible by putting these words in the mouth of a resurrected King Alfred, the "speaker" of the treatise's section on the utility of learning. Such mystified idealization represents (literally—in the ghostly marks of King Alfred) the force of writing as a permanent repository of law and order, as the link between generations and the nexus of all human relations (historical and social as well as the relations between the mind or memory and the body). In these formulations, once again, writing surpasses (and establishes) human nature—as biology, as space, and as time. Letters are idealized as the origin of the human. The letters so privileged are nonetheless the ordinary letters that store their reserves, not the invented alphabet of a John Hart, which might realize the extensions of literacy to empower spheres that need to be kept in their places.

Hart's orthographic reforms were as doomed to failure as the secretary hand, in which he wrote his manuscript, or as

the blackletter type in which his book was set, replicating his hand; these mark the paths that would have extended his "reasonable" script, an immediacy (imagined through phonetic replication) that would have rewritten the language in ways that violated hierarchies of power maintained by the privileged hand and by the vagaries of the English spelling system, unmoored from a transcendental origin. The ordinary English hand was replaced by the rounded and flourished italic hand that Scalzini had proclaimed as the queen of all scripts, but not, for him, it might be noted, in the name of some transcendental principle. To such arguments, Scalzini replied: "It would indeed be ridiculous to assert and foolishly naive to believe that these letters were based on mathematics and geometry" (*S&S*, 257). Rather, Hart's bugbear, custom, was Scalzini's explanation for letters:

Just as a language is based simply on the authority of those who speak it and is modified and changed by the passage of time during which the idioms formerly used later become obsolete, so the beauty of a script depends upon the practice, custom and accepted choice of those who write it. In this art there are no fixed unchanging rules handed down by men like Bartoli and Euclid. This is plain and clear as daylight. (*S&S*, 257)

Scalzini demystifies what Mulcaster had idealized as the quintessence of language—change and history. Is it merely chance that Mulcaster's *Elementarie* was printed in Roman type? Might not his principles of truth, which have no founding principle, be the truth of the ascendant hand? This "truth" equates letters themselves with the "essence" of "being" and the "spirit" of "life" within the ideological sphere marked by the "queen of scripts."

Those who provided new scripts as ciphers had too to justify themselves by claiming an ideal origin, a necessity at

once conceptual and ideological. On the title page of Edmond Willis's *An Abreviation of Writing by Character* (1618; Fig. 26), idealizing claims are made for his newly invented shorthand. "All that thine hand shall finde to doe, doe it quicklie for there is neither Art, Invention, Knowledge nor Wisedome in the grave whither thou goest," reads the verse from Ecclesiastes (9: 10), giving divine sanction to the new script. The frontispiece presents a visual argument for this new script and its relationship to the phonetic alphabet. On the top of the page, to the left, a figure is depicted inscribing the new characters; on the right, another figure reads an illegible alphabetical script. In the scenes below, the process is reversed. The figure on the left eyes an alphabetical text that is partly legible ("Jesus Christ is the beginning," it opens), while the figure on the right inscribes the new characters. Reading the scenes from left to right, alphabetical notation is bracketed by the writing of the new characters, which appears as the beginning and end of the process. The new characters have the authority of the origin and the virtue of permanence; they remain. The emblems at the top and bottom centers of the page reinforce the point. "*Sol Lux Mundi*" appears above, granting the new characters a privileged visibility and a divine origin; in the beginning was analphabetical script. "*Ex Fonte Flumina*" appears below: the new script derives from an origin (*fons* means source) and continues it indefinitely. Willis invokes scriptural authority for his characters, asking "in all Christian love . . . what profit is there in a *treasure that is hid?*" (A4v). What he reveals is an origin for writing that puts reading/speaking and the phonetic alphabet in a secondary position.

An analogous supposition is entertained at the conclusion of the history of the alphabet offered in a 1628 writing manual, *Caracters and Diversitie of Letters*, an English version of a manual that had appeared as *Alphabeta et Characteres* in Frankfurt in 1596. Its plates were cut by Theodore de Bry, who had also done the engravings after John White's drawings in Harriot's

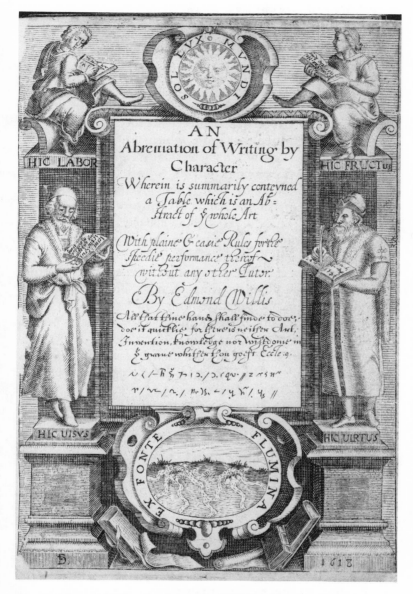

Fig. 26. Edmond Willis, *An Abreviation of Writing*, title page. By permission of the British Library.

Report of the New Found Land of Virginia, part of his vast project of New World depictions—print as a medium of colonization. This introduction glimpses the multiplicity of systems of script and attempts to write a history that recognizes the historicity of writing, a history whose origins cannot be known. Turning to modern scripts, a precedent for ancient practices is found: "We still see that those which teach short writing, can and doe devise new Characters daily . . . that others ordaine Cyphres or Characters only knowne to those the Author shall impart the skill unto" (10). These inventions of the hand point to the historicity of hands as a history of the "Arts of concealment": "These diversified ad *libitum*, as any intends to impound or pale his secrets or mysteries of State, or Art; some of which perhaps in processe of time have beene made vulgar and ordinary Letters" (10). The history of writing, the history that scandalizes William Warburton in his *Divine Legations*, as Derrida argues in "Scribble (writing-power)"—of the alphabet—is one of occulted origins allied to the hands of power, analphabetic scripts that, in time, become legible, to be replaced with other scripts that keep their reserves of illegibility in the service of the state. Phonetic scripts ("ordinary Letters") are but the vulgar remainder of those occulted hands.

This is an extraordinary conclusion—an extraordinary account of the origin of the alphabet which is more usually naturalized, as in Erasmus's account of Cadmus and the snake, or divinized, as in Willis's appropriation of the Bible for his shorthand. Yet it is a conclusion that follows from a history of the alphabet read through the prospect of the present, through the divided hands of contemporary practice, through the shorthands and ciphers newly invented. The English experience of multiple scripts (and it was not unique, of course; B. P. J. Broos summarizes the situation in the Netherlands in the late sixteenth century in the opening pages of an essay on Rembrandt) begins to denaturalize the relationship between scripts and sounds; the occulted scripts used in the courts fur-

ther the recognition of the origin of script. "As the *Egyptians* had two sorts of Letters, one sacred and hieroglyphicall, the other vulgar: and as with us the writing proper to the publike Courts in Court and Cancerie hands differ from the common writing: so the *Hebrewes* also might have a two fold writing" (8). The evidence is everywhere—in the past, in the present: "And both all Records of old, and the divers Courts of this Kingdome, yea every Copy-booke, and each Writing Masters Masterpiece hanged forth to publike view, easily manifest the passed and present varietie of Letters in common use ad [sic] the same time" (11). How to account for this situation, how to provide a unitary origin for such diversity: to such questions we turn now, for, as Derrida suggests, considering eighteenth-century recoveries of the history and multiplicity of scripts, these could not quite arrive at a grammatology because of "speculative prejudice and ideological presumption" (*Gram*, 75). The 1628 manual exhibits, despite its deconstructive potential, a full-scale logocentrism and an endorsement of the power that it has revealed; "want of Letters," it notes, "hath made some so seely as to thinke the Letter it selfe could speake" (6). Those so ignorant as to have a naive phonology and not recognize the true power of script are—once again— the Amerindians: "so much did the *Americans* herein admire the *Spaniards*, seeming in comparison of the other as speaking Apes" (6).

Although most Renaissance writing manuals devote their pages to exemplary scripts suited to a variety of occasions, they have, from the first, another project: the illustration of the history and origin of writing. Arrighi's 1523 manual, although the first handbook of italic cursive, also follows the example of Sigismondo Fanti by offering an alphabet in Roman capitals, not for the use of secretaries but on the sup-

position that those letters reveal divine proportions and have therefore some time-transcending originary (and ideological) value. Tagliente's 1530 writing book, besides offering a wide variety of nonitalic scripts, also includes Greek and Hebrew alphabets, as well as an example of African script. Palatino's 1540 manual makes explicit on its title page that it offers "all sorts of letters, ancient and modern, of every nation" (Ogg, 123: "*ogni sorte lettera, Antica, & Moderna, di qualunque natione*"); among them are ciphers and rebuses, Chaldean, ancient Hebrew, Egyptian, Arabic, and Saracen alphabets. In his prefatory letter to Cardinal di Carpi, Palatino glances at the justification for the inclusion of these scripts: "Veramente senza questo singular dono, di poco sarebbe il vivere nostro da quello dei Bruti differente, si come credo io, che in quei primi secoli, avanti che i Caldei et gli Egittii cominciassero a trovare i Carateri" (A3r–v; Ogg, 127–28; "truly, without this singular gift [that is, of writing], our life would differ little from that of the beasts of those first centuries before the Chaldeans and the Egyptians, as I believe, began to find out letters"). The gift of writing is "singular," a divine dispensation; it founds the human, as it had done for Erasmus. Yet the singular gift is represented by a multitude of scripts, and the originary scripts mentioned by Palatino are nonphonetic. Indeed, Palatino also offers a long essay on ciphers and their relationship to an original script, and his book features several rebuses, combining pictures and letters (Fig. 27), indications that for him letters originally were pictures.

The impetus of the earliest published manuals continues to Luca Orphei's ca. 1600 *De Caracterum et Litterarum Inventoribus*, which presents a historical series of alphabetical plates, each labelled with the names of their inventors beginning with Jesus as author of doctrine (1) and Adam as "*primus scientiarum et litterarum inventor*" (2) and on to Moses, Abraham, Esdras, Evander, Hermes Trismegistus, Cadmus, and so on. Putting Jesus first, Orphei attempts to secure origins in the divine

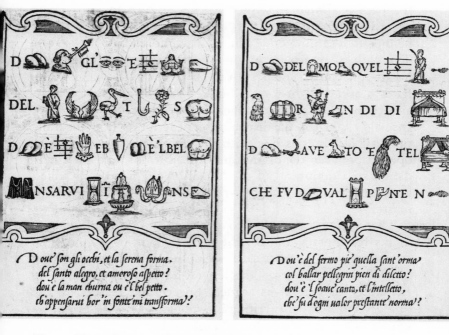

Fig. 27. Giovambattista Palatino, *Libro Nuovo*, K2 verso and K3 recto. By courtesy of the John M. Wing Foundation, the Newberry Library, Chicago, Ill.

originary Word become Script; a multiplicity of alphabetical origins is nonetheless suggested as well. Another manual with similar aims is Pierre Hamon's *Alphabet de l'invention des lettres en diverses ecritures* (1561), which offers as its copytexts a narrative of the history of the alphabet. De Bry's 1596 manual and its 1628 reprinting offer examples ranging from Chaldaic to the double Hebrew and Egyptian scripts to versions of Greek and ancient Roman letters; more than two dozen plates occur before a modern hand is delivered.

In these historical handwriting manuals, alphabetical origins are multiplied, even as divine origins and sanctions are insisted upon. Palatino, for example, states that "it is by means of sacred letters that God is known, and it is by them that

the path is shown by which we may return to him" ("per mezzo delle sacre lettere ci fa conoscere Iddio, et che insieme ne mostra il camino onde a lui ci possiamo ricondurre," A3v). The path of return by means of script elevates the writer's hand—or hands. This return to an origin in the hand negotiates a series of historical firsts always at a distance from an origin. It is far from clear whether phonetic script has a special privilege in the dispensation of script, or how the multiplicity of hands is one with the divine hand. A breach is opened between the divine and human hands, and the foundation of a definition of the human in the hand is troubled by the multiplicity that the writing of the present attempts to master.

That mastery is attached to idealizing and ideological arguments for literacy and for the value of writing. In "A Discourse of the Diversity of Letters," the preface to *Caracters and Diversitie of Letters*, "the letteral advantage" (*3/5)—the advantage of letters—is argued. Speech and reason are the first gifts to man, but writing is a supplementary addition, by which men not only "exceed" animals but also one another: "God hath added herein a further grace, that as Men by the former [speech] exceed Beasts, so hereby one man may excell another; and amongst Men, some are accounted Civill, and more both Sociable and Religious, by the Use of *letters* and Writing" (*3/5). The advantage of letters is compared to speech:

By speech we utter our minds once, at the present, to the present, as present occasions move (and perhaps unadvisedly transport) us: but by writing Man seemes immortall, conferreth and consulteth with the Patriarkes, Prophets, Apostles, Fathers, Philosophers, Historians, and learnes the wisdome of the Sages which have beene in all times before him; yea by translations or learning the Languages, in all places and Regions of the World: and lastly, by his owne writings surviveth, himself, remaines (*litera scripta manet*) thorow all ages. (*3/5–6)

Writing is granted an immortality that any moment lacks; it has the ability to transcend time and space, and that transcendental privilege is literalized in script as that which remains. In this account, the writer survives himself by writing; the life he has in script is the afterlife of what remains—in script. That remainder is, as it is in Browne, what the hand maintains. The past is made present, distance is overcome, the mind is maintained. A unity is posited in the activity of the master hand. Those without this "leterall advantage"—this literal advantage—are "esteemed Brutish, Savage, Barbarous" (*3/5).

The civilizing function of the letter is put to pedagogic purposes in Kempe's *The Education of Children* (1588) in its opening chapter, "The Dignitie of Schooling," which is, in fact, a history of writing, literally: a history of the alphabet. His narrative follows Josephus in *Antiquities* I.ii, originating writing in Genesis; according to Josephus, Seth, having been warned by a prophecy of Adam's about future devastations, undertook to preserve his knowledge of the world by writing it down. Kempe translates the passage in Josephus:

When they understoode that the world should bee twice destroyed, once with water, and agayne with fire, they engraved their learning in two pillers; the one of bricke, the other of stone, that if the bricke piller should be dasht in peeces with the flood, the stone piller might remayne; and if the stone piller should bee consumed with the fire, the bricke piller might remayne to teach men this ancient knowledge. (B1v)

Josephus's account of alphabetical origins is repeated in other Renaissance texts including Browne's *New Invention*, where it is said to show "that Literature hath beene from the beginning" (**4r). In the preface to *Caracters and Diversitie of Letters*, it too appears as the first instance of writing (6), and it plays the same part in Billingsley's *Pens Excellencie*, although Billingsley, aware of ancient scholiasts, refuses to decide whether Josephus's account is really about Seth or Enoch: "Howso-

ever, if it were but as ancient as the Law, it carries with it age enough" (C1r). Age enough: the originary account is multiplied; either a moment before the flood or one well afterwards institutes writing. Billingsley insists on the eternal remainder of this indeterminate origin: "What worthy and notable acts were heretofore done by any, either Divine, Morall, Legall or Martiall, but were reserved to after-ages by the meanes of *Writing*?" he exclaims, adding, "And I wonder how we should ever have attained to any kind of learning, had we not had the scrols of our learned fore-fathers to peruse and looke into, as also the holy Scriptures" (C1v). "Notable acts" are those that have been noted, and education follows the prescribed grooves of the already written. Josephus's account of the pillars of Seth ends by stating that they are yet extant; they are, in writing of them.

If this alphabetical origin is already multiple (Seth or Enoch, and the repetitions of the original writing), it is also an origin at some distance from the biblical original. Alphabetical origin does not coincide with the creation of man; it is a secondary invention caused by the threat of the flood and the ultimate effacement of nature at the end of the world. Writing is founded in Adam's prophetic forecast of future annihilation and as a way of surviving loss; it maintains a life in script impossible in life itself. These scripted foundations —pillars of the world of writing—are haunted, then, by the usual devaluations of writing as secondary and compensatory.

Not surprisingly, then, an originary moment before writing is also posited. For Kempe, the patriarchs were the first pedagogues, and they were, he claims, analphabetic: "They did conceive and keepe in minde without the helpe of letters a great deale better than the ages following could do" (B2r). Yet Kempe returns immediately to the authority of Josephus. "We see that they had the use of letters even before the flood." Within the space of a sentence, the excellence of "their letterlesse and unwritten doctrine" is coupled to their

literacy. They may not have needed letters, but they did not lack them. The idealizing of writing as the origin of civilization makes it virtually impossible to conceive of a letterless excellency.

The origin of the alphabet is pushed back even farther by William Bullokar, who versifies human history in the prologue to *The Amendment of Orthographie for English Speech* (1580). For him, it is the Fall, not the flood, that ushers in writing. In the prelapsarian state, the original couple had speech to "shew their minde." This is, of course, the expected story of speech before writing; writing is one with mortality: "But men changing this mortall life, by picture leaves in minde, / the speciall gifts of God most high, to them that bide behinde" (C1r). The origin of writing here is picturing, a remainder that preserves the mind and assures the future and its continuity with the past. It opens history, and it would seem that Bullokar attaches prelapsarian orality to an impermeable Edenic situation. Yet this is not quite the case. Speech, even at first, is also a kind of picturing: it shows the mind. What writing leaves "behind" (which also means ahead) is this original "oral" state, and that oral condition is less perfect than what letters preserve: "Letters, which for picture true, of speech, were first devizd, / in all time guiding man aright, when speech is halffe disgizd." Letters, a consequence of the Fall and a secondary attempt to picture speech, are, in these lines, accorded abilities that speech lacks: preservation ("in all time"), pedagogical leadership ("guiding man aright"), a truth lacking in "disgizd" speech. As Bullokar tells it, history after the Fall is that of a lapsed speech, and only letters recall the Edenic state. (It is not too much to say that only because of letters could there have been an Edenic state—it "is" and "was" only because of its retrospective record.) Bullokar's project in the *Amendment* is spelling reform, and like others, he would return writing to an originary truth (its proper phonetic function). Yet his argument, like Hart's, establishes instead an originary

writing/picturing that is simultaneously undermined by the logocentric devaluation of lapsed writing and maintained by the idealization of writing.

The way to make both arguments at once is by assigning a divine origin for script, and Bullokar does so, although much later in the *Amendment*. He revises his account of history; in this second telling, neither speech nor writing is original to human creation. Both, instead, are regarded as acts of divine violence. Both were "forced by God unto man," and of the two, Bullokar continues, writing is "to be preferred, for that it may longest continue in his [its] perfectnes, and used both in absence and presence: which use, speech (of it selfe) can no wise have, without the helpe of letters" (40). For Bullokar, as for Browne, the supplement supplants the origin, and the secondary "helpe of letters" maintains the voice, and with it achieves an ideal "present" composed of both absence and presence, past and futurity. Like Kempe, Bullokar cannot, finally, imagine human origins as letterless. The cataclysms of the Fall and the flood are replaced by an originary violence founding speech and writing at once.

"God was the first Author of letters," Joseph Hall announces in a commendatory preface to Brinsley's *Ludus Literarius*, dividing that "first" immediately into a multitude of hands, "whether by the hand of Moses; as Clement of Alexandria reports from Eupolemus: or rather of the ancienter Progeny of Seth in the first world; as Iosephus" (1). Is divine authorship here writing? By the hand of God or by the hands of his scribes? And in which hand is this original script written? Hall conjures up two scenes of origin, but there were more, as we know, and not simply from the Bible. There was the Egyptian story in the *Phaedrus*. Cadmus or the Phoenicians also had claims, thanks to the account in Pliny's *Natural History* VII.lvi, which supposes various Middle Eastern origins for script and briefly entertains the possibility that Mercury invented it. For Pliny, origins are multiple and undecidable,

and the history he offers is one of continued human invention. Rather than a single originary script, Pliny recounts a history of the alphabet (it is repeated by Kempe, among others): Cadmus brings sixteen Phoenician letters to Greece; Palamedes, at the time of the Trojan War, adds four more letters; Simonides adds another four. That is, Pliny adds, unless the history of the alphabet should be told according to Aristotle, in which case the original alphabet had eighteen characters. Other Greeks figure in the account of additional inventions; perhaps Anticlides also should be credited when he claims Egypt as the source of the alphabet, or perhaps Epigenes, who opts for Babylonia.

With such multiplicity, with so many "original" hands, the attempt continually made in Renaissance tracts is to maintain divine authorship of all scripts. The title page of *Theatrum Artis Scribendi* (Amsterdam, 1594; Fig. 28), Jodocus Hondius's anthology of pages from sixteenth-century copybooks, provides a summary image for this project. The history of the alphabet is rehearsed in the images of a series of exemplary classical inventors: Anaxagoras, presumably because of his estimation of the hand as the origin of the mind; an Egyptian Mercurius (identifying pyramids are in the background); Hermes Trismegistus, thanks to Plato and Renaissance neoplatonists; Palamedes (with the Trojan horse) and Cadmus (with the serpent), thanks to Livy and his elaborators, including Erasmus. At the top and bottom centers of the title page, the Christian idealization of the origin of script in the hand of God is represented; the divine hand is severed, emerging from a cloud, the image of secretarial skill, to inscribe the tablets of the law and the warning on the wall.

Hondius's title page confronts the problem raised by the history of the alphabet, the difficulty of assembling the multiple human inventions of script alongside the affirmation that script comes from the hand of God, but one can see how insupportable this logocentrism is, how difficult it is to

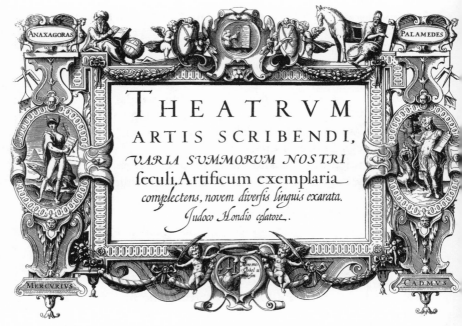

Fig. 28. Jodocus Hondius, *Theatrum Artis Scribendi*, title page. By courtesy of the John M. Wing Foundation, the Newberry Library, Chicago, Ill.

maintain. The double representation of God writing, while it certainly emphasizes the divine hand, also multiplies that supposed originary event; the tablets from Exodus and the handwriting from Daniel are, moreover, historically late examples from the Bible, nor is it certain that they are supposed to precede the human inventions of the alphabet, or even the contribution of the divine Hermes, who was often credited with the Egyptian wisdom that Moses learned before he led the Jews into the wilderness (Kempe makes them contemporaries).

If the multiplicity of origins troubles the ascription of writing to the hand of God, it also elevates the human hand, and the hand of the writing master. It reveals, once again, that

these idealizations are always also ideological arguments that may exceed what they mean to regulate. Pedro Madariaga in the fifth dialogue of the first part of his *Libro Subtilissimo intitulado Honra de Escrivanos* (1565), for example, works from a defense of the fair writing appropriate to gentlemen to a declaration that its place among the liberal arts is supreme, "close to Theology":

The sciences which seem to me to be "inspired" and "supreme" are those that were not invented by mankind, but were revealed to us by God. Read in the seventh book of Pliny where he says that the "pen is eternal" [VII: lvi, translated by Philemon Holland as "letters were alwaies in use, time out of mind," 158]. That which is eternal does not originate in this world of ours. Look at the Apocalypse of St. John, and you will see that he relates that he saw in heaven a book written on both inside and outside. . . . Consider the twenty-fourth chapter of Exodus, and you will see how God called to Moses and gave him the Tablets of the Law written in his own hand. . . . And St. John says in his eighth chapter [8: 6] that Christ wrote on earth. Because of all this, and for many other reasons and authorities which I omit for the sake of brevity, I take it as an ascertained truth that this accomplishment was not invented by humans. (*S&S*, 155)

None of these examples will support the idealization of script as readily as Madariaga supposed: each is written within a devaluation of writing. The book in Revelation 5: 1 is sealed shut, to be opened only by the Lamb; God's inscription of the tablets occurs twice in Exodus—the idolatrous episode of the golden calf intervenes—and each time it is far from clear whether God writes or Moses does; Jesus does write on the ground (it is the single time he is depicted writing), but only to mock the Pharisees and their appeal to the written laws of Moses. Even Willis's Old Testament quotation on the title page of his *Abreviation of Writing* (see Fig. 26) finds a most uncomfortable echo in the words of Christ to Judas: "That thou doest, do quickly" (John 13: 27).

All accounts of the divine origination of the alphabet are troubled: by the multiplicity of human hands originating a variety of "first" scripts and by logocentric devaluations of writing as a fallen mark. The hand of God cannot secure the human hand, much as the effort is made, for it is not clear that God ever writes. Browne, for example, invokes the example of God writing the tablets of the law "with His owne Sacred Hand," only to add the parenthetical "(spoken so for our capacitie)" (*New Invention*, **1v). The "letteral advantage" is denied literality. Moreover, when Browne instances the example of Jesus writing, it is a sign of his humiliation that he "bowed Himselfe in the Temple of Hierusalem, and wrote on the ground" (**2r). Browne can find only one literal instance of divine inscription: "GOD Himselfe, who is the Author of all Goodnesse, first devised and ordained it, as a thing good also of it selfe: and that eyther immediatelie as hee marked *Kaine*, with some hieroglyphicall or aenigmaticall letters . . . or mediatelie by enduing others with the rare gift" (**4v). The original script in the hand of God is not the alphabet but the "hieroglyphicall or aenigmaticall letters" that mark the brow of Cain, the first murderer; nonphonetic "Egyptian" hieroglyph or cipher, God's hand inscribes an originary violence as the lapsed origin of the human. Yet Browne presents this as the way to idealize the origins of script and the foundation of the "letteral advantage" of humankind. We have seen the logic that leads him to this originary mark, for the hieroglyph or cipher bypasses the connection between writing and speaking; these are visible scripts that reproduce the (scripted) images of the mind.

Rosaline. O, he hath drawn my picture in his letter!
Princess. Anything like?
Rosaline. Much in the letters, nothing in the praise.

Princess. Beauteous as ink—a good conclusion.
Katharine. Fair as a text B in a copy-book.

<div align="right">—Love's Labor's Lost, 5.2.38–42</div>

"*Make ruled lines, the way more plaine to showe,*" Peter Bales
enjoins, giving instructions on the formation of letters (R2r).
"For as yong children before they can goe, must of necessi-
tie be led at the first, to make them goe straight and upright;
even so, whosoever shall learne to ioyne his letters and wordes
even together, must needs at his beginning bee directed by
ruled lines" (R1v). The lines at the beginning of the alpha-
bet were a cross—the alphabet was the cross-row, yet the
lines that make letters are those of the ruled hand. The ruled
line (an origin of letters always seeking to ground itself in
divine origination—but, even with the cross, arriving at an
illiteral mark) is where sovereign authority and the rules of
nature meet and have their founding principle. It is on the line
that life is produced—human life, and the life of letters. Beau
Chesne's E. B. would "rule a good Scholler" (a schoolboy)—
and the rule: "Marke, your selfe well to ease, / That none but
best hands may alwayes best please" (A2v). The success of
the penman, in this formulation, lies in his own re-marking,
so that he is produced as he produces his lines. The rules of
Bales or Beau Chesne go back to Quintilian and his grooves,
original scenes of multiple reinscriptions. E. B.'s rules em-
body the writer as writing and imagine the world as script.
This, too, can be found in Quintilian when he recommends
a procedure for learning the letters: "It will be best therefore
for children to begin by learning their [the letters'] appearance
and names just as they do with men" ("Qua propter optime
sicum hominem pariter et habitus et nomina edocebuntur,"
1.1; 1: 33). One learns letters as one learns the world—as
named bodies, figures like those in Hart's "Allegorie," aptly
hieroglyphical as the 1628 manual remarks of the Chester her-
ald's craft: "And our Heralds Art keepeth records of pedigrees

in a kind of Hieroglyphikes" (12). Despite his fulminations against the painted word, that was the herald's occupation.

These scripted foundations, lines of life, are lines of death: "Give the letter a little of a certain movement which is called the 'dead line'" (*linea morta*), Sigismondo Fanti advises in his 1514 writing book (*S&S*, 51). "It is with this line that the link is made with other letters." The joining of letters—the cursivity that gives them life and makes them words—takes place along the dead line which is the life of script, the present maintained by hand. Such is the argument displayed on the frontispiece to John Davies's posthumous *Writing Schoolemaster* (1636, Fig. 29). The writing master is presented in a "lively portraiture"; the image grants him the visibility of writing/painting. He is crowned with laurel, and his hand, brandishing a quill, rests upon a skull. The image is also an effigy,

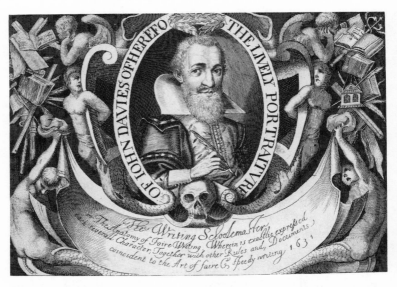

Fig. 29. John Davies, *Writing Schoolemaster*, title page. By courtesy of the Victoria and Albert Picture Library.

the living portrait of a dead man. It displays the life of letters; through the dead line, life(likeness) is conferred by writing, the "being" of the "present." As in the frontispiece to Gethinge's *Calligraphotechnia* (see Fig. 14), the portrait displays the hand, or, as the 1664 reprinting of *Gething Redivivus* explains: "We cannot out of Honour to his Name and Memory, who hath so eminently deserved the best of our modern Masters, but write on his Dust some grateful Characters which rude envy shall not dare to deface" (A2r). The writer's hand remains and founds with it his name, his memory, a future linked to a past in the present instance of a posthumously scripted being.

If the "letteral advantage," that overgoing of origin in which human civilization arises as the work of the hand, is the material embodiment of life on the page, this is the place where the human body has its alphabetical origin and reflection. For, as the manuals repeatedly insist, letters have the material form of bodies. If in the illustration of penhold in Hercolani (see Fig. 10) the writer's hand has been detached from the body, the strokes of his hand (the hand that he writes and that writes him) are embodied—they are labeled "*traverso*," "*corpo*," and "*taglio*." The basic stroke of the line becomes a letter as the letter is embodied with head and tail. These bodily terms are found again and again in the writing manuals, a corporeal investment in letters that have bodies, heads, bellies, legs, feet, and tails. Letters are inscribed within nature, *and they inscribe nature, the human, and the social/ideological within their domain.*

This multiple origin in the letter is affirmed by the first entry in Barrett's *Alvearie*. He describes the letter A:

Howsoever the reast of the letters were driven to this order, it is of many supposed that nature hath taught *A*. to stande in the first place, as wee may easilye perceyve by the first voyce or confuse crying of young infants, which soundeth in the eare most like to *A*. being also the first letter in the name of our great graundfather *Adam*, as *Abba*

signifying Father, which woorde children gladly heare and learne. (B1r)

The first letter in the mouth is the first letter; the child's first word is the cry A. A is for the first man, and A is for father, the first patriarch and the model for all rulers since. The alphabetical order authorizes the hierarchical authority of society. Writing properly, in order, on the line, founds the embodied social world. Wolffgang Fugger, having given his rules for the forms of the German hand, concludes: "I have made them [the letters] as the pen, in a rightful manner, shapes them." He then continues, in a heavily ironic passage, to affirm the importance of this "rightful manner": "Whoever is able to write them well may, hereafter, if he so desires, bend them, twist them, break them on a wheel, hang them, behead them, make them walk on stilts—in short—do with them what he likes. But I leave it to you to judge what good that will do them."

David Browne picks up where Fugger leaves off: "Let neyther the head nor tayle of anie letter of one line, doe harme to the bodie, head, nor tayle of anie letter of another line" (*New Invention*, 38), he admonishes. Letters have their natural places on the line; their order is the human (natural/sociopolitical) order. Even John Hart (not surprisingly, considering his analogy of voice and body/letter) agrees, explaining the function of punctuation marks. A colon is "the space, or the bone, fleshe and skinne betwixt two ioyntes" (like that between the ankle and the knee), whereas a comma "doth but in maner devide the small parts (betwixt the ioynts) of the hands and feete" (40v). Descriptions of bodies, or descriptions of letters? At the least, these are founding definitions of life, rule, authority, nature, order, reason, and truth: all in the letter.

Hence we have those decorative initials of Holbein and his followers in which the letters serve as playgrounds in a populated landscape, putti swinging from their bars, reclining in their curves, hiding behind them. A world is formed from let-

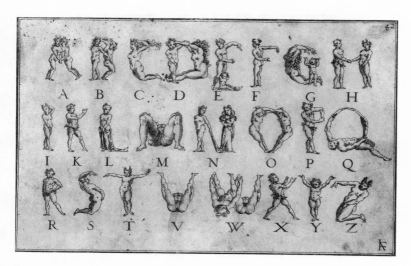

Fig. 30. Giacomo Franco, *Del Franco Modo di Scrivere*, p. 42. By courtesy of the Victoria and Albert Picture Library.

ters, grounded in them. More outrageously, the alphabet that Giacomo Franco provided in his *Modo di Scrivere Cancellaresco moderno* (Venice, 1596), in which the letters are bodies, posing, joining, and unabashedly displaying an insistent corporeality and sexuality (Fig. 30), reveals that corporeality and sexuality are, within the domains of literacy, scriptive phenomena. In this alphabet, as in a similar one in De Bry's *Alphabeta et Caracteres* of the same year (Fig. 31), as well as in the 1628 reprint, the letters are human, social in their relationships. An origin of the human and the alphabetical is depicted at once, and the letters are simultaneously pictures and characters (in the several meanings of the word). Life originates in these lines. The historical anthology of scripts realizes itself in these embodied letters. The human is the alphabetical, as it was in Erasmus's fable of the original letters as armed men—their arms the ascenders and descenders, the limbs of the embodied letters.

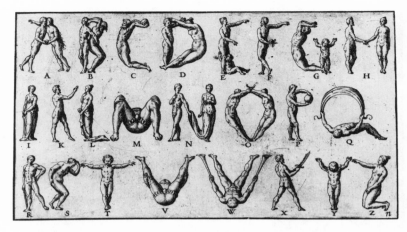

Fig. 31. Theodore De Bry, *Alphebeta et characteres*, N1 recto. By courtesy of the John M. Wing Foundation, the Newberry Library, Chicago, Ill.

A page before, Erasmus comments that some letters "cannot bear to be joined, others enjoy being close together, and others embrace one another tightly" (*S&S*, 33). These are not unique remarks. Some combinations of letters, according to Mercator, "are pure, as when one letter is joined organically to another like a living creature. Others are impure" (163). The scene from Dekker's *Westward Ho* that we cited earlier is played out in Renaissance writing manuals and their embodied letters. "There are some letters so unforthcoming that they refuse to enter into any sort of friendship or conversation with others," writes Juan de Yciar (K6r); "other letters," he continues, "are naturally amiable and of good concord and do not deny their intimacy to any other letter." Yet, oddly, "there are some letters which in themselves are capable and possess the means of joining up, but which never in fact are joined because they cannot meet in the context of common speech" (K6v). Letters themselves, which ground the world, are not grounded in speech; the materiality of letters themselves and

the literal investment of materiality grounds "being" in the hand.

And what letters *naturally* like to join? Tagliente offers, merely as an offhand example, the word *magnifico* (*S&S*, 68). It just *happens* to be a princely superscription (nature is an ideological inscription). Augustino da Siena, on the other hand, offers as a model word *Augustinus* (*S&S*, 108). It just happens to come to hand—as his august signature.

SIGNATURES, LETTERS, SECRETARIES: INDIVIDUALS OF THE HAND

You know the character to
be your brother's?

—*King Lear*, 1.2.61

HE LETTERS of a signature arrive in the writer's hand—or, more accurately, the hand arises from the letters, and the signature is an effect of the possibilities of letters to join to write the name, the person, the human—the individual marked by a proper name whose propriety lies in the letter. The trajectory from letters to letters—from vowels and consonants to epistles—follows the same route, one in which the propriety of the signature is established only through its location in the writing of the proper hand that may be no one's property, and yet one's own. This is a hand whose skill is secretarial and whose secret is that of the individual self, the self undivided from the scriptive origins of the writer whose letters also might be called literature.

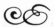

Reiterating the complaints of the elite schoolboys Mendoza and Manricus about the chicken scratchings that pass as the noble hand, Vives's writing master fastens on their signatures: "And therefore it is to be seen that they sign their names to their letters, composed by their secretaries, in a manner that makes them impossible to be read; nor do you know from

whom the letter is sent to you, if it is not first told you by the letter-carrier, or unless you know the seal" (Watson, 69–70).

That a proper hand would authenticate the nobility as a class we have already seen; to this claim, the writing master appears to add another: that a legible signature also would be self-authenticating, that the being of the writer—the name of the writer—only can be delivered in his (proper) hand. Yet, even as that claim seems to be implicit in the complaint of the writing master about the illegibility of the signature, other modes of authentication—to which I will turn shortly—also are invoked: the testimony of the letter carrier; the seal on the letter. Within the space of the missive, the noble writer is offered only a signature as the place of self-authentication. It is assumed that the letter is written, composed, by another hand, that of the secretary. Thus, the claim for the signature needs to be read in conjunction with this other hand and with these other modes of authentication.

It must be emphasized first, however, that even within the system of re-marking that Vives's writing master represents, the proper, legible, and noble signature is already, from the start, written with another hand. This is the possibility that Augustino da Siena recognized when he offered his signature as an example—that the hand (writing) arises from the hand (written), that the signature has its origins not in the writer but in the script that re-marks the writer within its socially differentiated and discriminatory strata. "The influence of social stratification is here a fact of life," François Furet and Jacques Ozouf argue in their study of literacy from the Reformation to the opening of the modern era, *Reading and Writing*; "only the socio-occupational structure appears to correlate constantly with the ability to sign one's name" (149).

The signature proper to the noble hand, we know, was to be written in italic. Hence, increasingly in the sixteenth century and invariably with James I, English royalty wrote their

private correspondence in an italic hand. Their letters were marked as written in their own hands by displaying hands modelled in the copybook italic of the writing masters. The hand of such a letter, whether written by Elizabeth or by Ascham, was also, at least from the middle of the century on, the one preferred by signers making claims to "full" and high literacy. As Samuel Tannenbaum summarizes: "By the middle of the sixteenth century the Italic hand . . . had made itself sufficiently felt in England for professional scriveners and the well-educated there to learn to write it, even if only for ceremonious and formal epistles and for signatures in documents and letters written in secretary" (14–15). Confirming this, Anthony Petti explains that Surrey's secretary signature of 1545 is the last example he presents in his collection, *English Literary Hands*, since the nobility invariably signed in italic after that date, although their secretaries went on writing their letters in secretary hand. "It is clear that the nobility followed the example of royalty in learning the *italic* hand, and in their wake came the gentry and the rising middle class by the end of the century" (Petti, 19).

Petti's historic scheme (shared by Furet and Ozouf) needs, of course, to be modified. It was the place of the writing master to inculcate the "proper" hand; complicated class negotiations are involved that move in more than a one-way direction, although the thesis articulated by Furet and Ozouf remains pertinent: "The literacy process is quite simply the story of how an elitist cultural model penetrated throughout society" (149). In this structure of re-marking, the noble hand is properly civilized by a pedagogy; it is proper, moreover, by not being a native hand. The italic hand aspires to a civilization with pretenses to universality, a network linking England to the continent, and the present to an idealized past. In all these ways, what is being authenticated by the italic signature is a great deal more than the individual, if it can be said in

fact that an individual in the modern post-Cartesian sense is produced in this highly regulated and socialized system of the proper hand.

In the scene from Vives, it is not clear whether the nobility is expected to be able to produce more script than the authenticating mark of the signature. What is being demanded is that, at the very least, the proper name be written in the proper hand. The signature is not imagined as the same hand as that which writes the letter, because it will be written by a secretary and in secretary hand. No part of the letter, the signature's authenticity derives from elsewhere—from the system of the re-marking of the writer within the privileges of the italic hand. Within that system, the signature gains legibility by its conformity to the exemplary models of the copybooks and writing masters. In these ways too the hand produced as proper is derived from elsewhere. Within the letter, its space is only a closing line, which is not part of the letter and which marks itself in its difference from the rest of the letter. Yet it also marks itself as self-differentiated; fetched from elsewhere, to be legible it must subscribe to norms that establish and authenticate it as the mark of authentication. To be legible, moreover, it must be repeatable. From the discipline of copy, then, the authentic signature takes its cue: it is inscribed within domains of repetition that (de)situate the hand.

This, as Derrida has argued, is the "normal" situation for any signature. "In order to function, that is, in order to be legible, a signature must have a repeatable, iterable, imitable form: it must be able to detach itself from the present and the singular intention of its production. It is its sameness which, in altering its identity and singularity, divides the seal" ("Signature Event Context," 328–29). The self-sameness of the italic signature lies in its ability to simulate first the copy, and then the copier, who reinscribes identity through self-duplication. The usual detachment of the signature suffers here a further

detachment, one that we have seen in many images of sev-
ered arms and hands, for the noble (or aspiring) writer writes
the proper hand fetched from elsewhere; the signature is pro-
duced as the detached mark attached to a letter written by
another hand. Derrida's point is that the signature does not
secure an individual or intentionality (subjectivity or subjec-
tive volition). Rather, it is attached (by being detached) to an
order of writing. Within the system that we have been ex-
amining, that order can be specified and delimited, since the
signature is entered within the register of the italic, and the
claims for self-ownership can only be made through the mul-
tiple submissions and duplications demanded by copy. The
individual is authenticated within a system in which he copies
himself within the simulative order of divided practices of
writing. Rather than being self-identical, the mark is divided,
and self-re-marking inscribes the signature within an order
of differance, the protentions and retentions of a privileged
mark that includes the signature within its domain and that
empowers the writer within a sphere of (dis)empowerment
that cannot be regulated by that which regulates the hand.

We might take the title page of Eustachio Cellebrino's *Il
modo d Imparare di Scrivere* (1525) as an illustration of this pro-
duction of the writer (Fig. 32). The title and claims of the
book are made in the hand that the book teaches; below them
is a picture of the writing master at his desk; on a sheet of
paper he writes his name, signs in the hand that has written
the title of the book. In this self-portrait, Cellebrino is his
hand, so much so that the representation allows the viewer to
see the hand—it might be an example of how to hold the pen,
just as the signature might show how to form and connect
letters—the hand, the arm, but not the face. This individual
writer cannot be identified through the usual conventions of
self-portraiture, but through the system that produces him
—without individual identity marks—in his perfected hand.
Cellebrino's self-portrait is fetched from the illustration of

Fig. 32. Eustachio Celle-
brino, *Il modo d Imparare
di Scrivere*, title page.
By permission of the Folger
Shakespeare Library.

penhold in Sigismondo Fanti's *Theorica et Pratica* (Venice, 1514;
Fig. 33), the first printed writing manual; its authority derives
from its simulation, and it differs from the image it copies by
adding the signature that also further identifies the writer as
"his" hand.

Derrida's assault on the modern investment in the hand,
the contemporary notion (attested by handwritten signatures
on typed letters, for instance) of an authenticity guaranteed
by the hand, has the support of the historical system that we
have been investigating. In this system, rather than delivering
an individual by writing in the proper hand, the proper hand
delivers the individual within the socially marked spheres

that differentiations in handwriting signify. It is nonetheless also true that the regularization fostered by training the hand produces a legible and recognizable signature; thus, within that disciplined regularity, the repeatable signature serves as a mark of the person, as differentiated, repeatable, and therefore self-identical. The space of such an individual is suggested, moreover, by the image of the detached hand. The signature is written within that structure of detachment and has its place on the page in much the same way; the separated self is produced by these structures of detachment and reiteration. They found the subject of writing. There is a route, too, from literacy to literature.

Within this system of re-marking, an italic signature would indicate class or class aspiration, the trammels of "civilization" —the high culture of the writer. Suited to certain documents, and above all to the *personal* or *familiar* letter, it was by no means the only hand that a fully literate person could write or in which a signature would be produced. As Petti goes on to note: "It is very likely that most educated men in the period were able to write both scripts [italic and secretary] with equal facility, as in the Spenser, Ascham and Chettle illustrations, in which Ascham and Chettle show that they signed their names in either script" (19). Petti's example of Spenser's hand shows that he could write a document in secretary—the former stu-

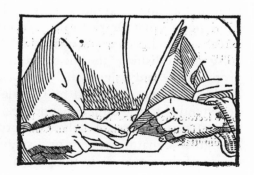

Fig. 33. Sigismondo Fanti,
Theorica et Pratica, *8 verso.
By courtesy of the John M. Wing
Foundation, the Newberry
Library, Chicago, Ill.

dent at Mulcaster's Merchant Taylors' School *was* a secretary
—and attach an italic signature to it. Ascham's italic and sec-
retary signatures subscribe to their documents: an italic sig-
nature to sign a Latin text, secretary for an English one. Petti
comments: "Ascham seems to have observed consistently the
convention of employing *italic* for Latin and *secretary* for the
vernacular in correspondence, even with his signature" (73).
This "convention" startles any supposition that one might
have a single proper and self-owned signature. Moreover, in
suiting his signature to the document, Ascham is doing noth-
ing more than what is implicit in the noble production of the
italic hand for the signature; the mark of self-ownership has
been textually regulated. In the example that Petti provides, a
further propriety, perhaps, also is registered by Ascham's sec-
retary signature (not a single letter of which corresponds to
the italic signature displayed on the same page), for he writes
a letter to Sir William Cecil, and may thereby inscribe social
distance through his secretarial hand.

The Chettle example is equally stunning: writing a receipt
to Philip Henslowe on December 19, 1599, Chettle cites his
name in the receipt and also signs. For the cited name, Chettle
provides italic capitals, but all the letters in his signature are in
secretary. The divided hand divides the proper name; Chettle
claims less for his own in his signature than he does for his
name written in another's account. With his own hand(s),
he re-marks himself doubly. This double writing of Chettle's
name poses what Derrida calls "redoubtable problems" even
in the most elementary structure of the signature, the diffi-
culty of establishing "the line between the autography of one's
proper name and a signature" (*Signsponge*, 54). The system of
double marking employed by Chettle (but the example can
be extended to the double-handedness of any "fully" literate
writer) also, in a sense, solves the problem by its refusal of
a singular signature system or a singular notion of the pro-
priety of the signature to the person. Insofar as a hand came

to be regulated and regularized (and as Petti remarks this is neither fully the case for Ascham nor for Chettle, both of whom vary their signatures a good deal), it could reproduce, through a structure of self-imitation, a self-duplicating person —though the different hand in different situations (including the situations of signing and of self-citing) would remain different.

When *properly* employed, there is no propriety in the hand that signs; the propriety of the hand is regulated by the situation in which the name is inscribed. This is abundantly clear in Petti's collection of signatures, or the earlier gathering in W. W. Greg's *English Literary Autographs*, which similarly displays authors who write their names in italic and sign in secretary, and those who write their names in the body of a text in secretary and sign the same text in italic. These are writers whose sense of the propriety of their names allows them to sign themselves Philip or Philippe (Sidney), Fulke or Foulke (Greville), Rauley or Ralegh. "Rauley" appears at the end of a letter "written in a secretary hand wholly unlike Ralegh's usual script," Greg comments (3: 75)—and yet, he claims, authentic. Nor is that particularly unusual; for example, "Dekker wrote two, or really three, distinct hands" (3: 9)—ordinarily. These "literary" hands also exemplify the nature of high literacy by the close of the Elizabethan period; they suggest further that literary production cannot be divorced from the production of the individual hands.

What's in a name when the proper name has no propriety? This Shakespearian question resonates in the face of the six indisputable Shakespeare autographs, each with a different spelling of the name, each with wide divergencies in their letter forms. These hands are authentically Shakespeare's only because their documentary location insures and authenticates them; they have never been convincingly attached to other instances of the writing of Shakespeare's name nor to Hand D of the Sir Thomas More play; it is possible that Shakespeare

could have written an italic signature, too, but there would be no route from his secretary hand to that other hand, as is clear from the instances that survive of the hands of Sidney or Spenser. If the name that guarantees high literariness (and with it the production of the individual) in modern estimations is to be attached to Shakespeare's hand, it is only to raise further the question of the path from literacy to literature in the Elizabethan period, for the modern estimation of Shakespeare's hand is of a piece with the posthumous re-marking of script that a modern system of literacy reads in literary production.

What does a signature authenticate when a person can produce multiple versions of the signature in different hands and spellings? This is a question raised by John Hart, who noted that many of his countrymen could not spell their names because the letters of the proper name failed to coincide with what Hart took to be their orthographic function, phonetic truth: "Many a man doth scantlye know how the writing of his owne name should be sounded" (*Orthographie*, 5r). Hence (scandalously, from Hart's perspective), the proper name is a purely *literal* marker, divorced from sound, produced only by the hand. In *Literacy and the Social Order*, David Cressy quotes Hart, as well as the complaint that "our English proper names are written as it pleaseth the painter"—the proper name as simulation and similitude. Cressy explains the aberrance of the spelling of the signature through pedagogical principles: "Instead of teaching a standard orthography for personal names and encouraging their writing at school, Coote and the others concentrated on writing with a more universal application. Children who were just learning to write might have more success writing 'people' [as in Coote's dialogue] than their own individual signature" (25). In the pedagogic system, in which learning to write was deferred—reserved for a select number of (usually male) students—the signature was not taught. Hence (as Cressy knows), statistics about

literacy (including his own) that depend on counting signatures err; moreover, as was emphasized earlier, they reproduce the more modern notion of what constitutes literacy —the ability to sign the name and thereby to produce the individual. Modern literacy counts in this respect are complicit with the re-marking of the subject—as in Mulcaster's *Elementarie*. Retrospectively, they reinforce the new discriminations that determine a "proper" literacy—and a "proper" individual.

In the concluding pages of their study, Furet and Ozouf detail what such an individual is—someone who can produce the authenticating mark of the individual in order to enter into contractual and commercial relations, in order to be a citizen of a state that has fostered the production of the individual (through the signature as the privileged mark of that individuality) as an item in a political calculus. Although Furet and Ozouf write out of the strong bias of an "older" orality rooted in a communal situation of the face-to-face, which they see suborned by the state and its production of a mystified notion of the discrete individual—a historic argument that needs to be questioned for its logocentric mythology—they do point towards the signature system that follows upon the one revealed by the multiplicity of hands and proper names in the sixteenth century. It is the system realized in nineteenth-century "universal" literacy that allows for the demarcations that retrospectively count for high literacy in the Elizabethan period, that determine what is literary in that culture—and that continues to be reflected by modern literacy studies that tally signatures as if they alone count as literacy in the earlier period, reinforcing the sense that past literacies can be reduced to their modern counterparts.

Modern regularization of the "individual" hand follows from that earlier system of (in Tannenbaum's phrase) "highly educated" multiplicity that places the signature in relationship to the document and the handwriting; it inserts the individual

writer within a system that denies the writer any propriety over the name. To regulate the signature, as the increasing use of the italic signature by any writer did, only further conforms it. The seventeenth-century reduction of the multiplicity of hands to the normative single rounded hand continues this regularization, a production of the individual with one hand or one spelling of the name that only furthers the apparatuses of control and the authenticating of the individual who guarantees and is guaranteed by the mark.

The signature in the sixteenth century, regulated by the document and the hand, is not clearly an individual mark, although that is the direction that the history of signatures takes. It is, rather, a mark that remains distrusted, for its role in the production of a new form of high literacy is not fully consistent with earlier modes of such re-marking (and with differences within earlier notions of what constitutes literacy). Michael Clanchy demonstrates this in his study of literacy in England from 1066 to 1307, and although his historical trajectory is also from the oral to the written (evident in the title, *From Memory to Written Record*), he nonetheless demonstrates a movement from one kind of writing to another, for example when he shows how the signature began to take over functions of authentication previously conveyed by seals and witnesses. These, as the passage from Vives suggests, remain to authenticate the letter in the sixteenth century. Although one can (as Clanchy does) treat these as oral structures, it is important to recognize that they too depend upon repetition and self-simulation, that they are structures of writing in the broad (Derridean) meaning of the term. As Clanchy himself suggests, the prototype for moveable type may more easily be seen in the seal than in the mark that served as a signature (260), for the seal is capable of exact duplication. Seals continue (into the nineteenth century, in fact) to authenticate state papers.

The distrust of the signature can be seen when Juan de Yciar excuses himself for signing every page of his book:

I have been blamed by some for putting my name in each plate; they attribute it to boastfulness, which it truly was not, but rather inadvertence and oversight, in that I followed in the footsteps of those excellent Italian authors who have written on this subject, namely, Ludovico Vicentino [that is, Arrighi], Antonio Tagliente and Juan Baptista Palatino, very skilled men who all put their names on each plate in their treatises. (A3r)

Yciar claims to have produced his signature only within the "inadvertence" of copying his models. Such too was the practice of Richard Gethinge, who signs in a regularized and rounded, self-duplicating signature on each of the exemplary copytexts—and commercial and legal forms—in his *Calligraphotechnia*; Maria Strick does likewise in her *Tooneel der Leflijcke Schrijfpen* (Delft, 1607), signing in a variety of italic hands and spelling her name Stricke, Strick, and Stric. The examples could be multiplied, and they would show that although there was no formal training in the writing of the signature, the copybooks nonetheless display signatures over and over again. But rather than serving clearly as signs of self-ownership, they serve as Augustino da Siena's signature had, to show the hand producing the signature within the disciplines of the hand—hence the multiplicity of spelling and letter forms—or they show the *same* hand subscribing to any document, insuring it through the regularization of the hand. From Stricke/Strick/Stric to Gethinge, one traverses the path of the regularization of the hand, a path also marked when one notes that the flourishing word "Quell" for quill that appears on the frontispiece to Gethinge's book (Fig. 14) is itself a copy—hence the spelling—of an identical hand in Jan van den Velde's *Thresor Literaire*. The authentic movement of the hand retraces another hand.

That such regulation (as in Gethinge's signature) could raise

worries about the authenticity of the mark is acknowledged by David Browne in his *New Invention*, for he says that it has been objected that were his pedagogy to succeed, everyone would have the same hand, which would "make the Subscription of Evidence doubtfull" (188). Browne relies on "naturall disparitie," the intrusion of bodily difference in the ability to control the hand, to insure the difference from one hand to another; moreover he, like Vives, assumes that further modes of authentication will be possible—seals and witnesses once again. The authenticity of the signature is thereby allied to prior modes of authentication; there is an implicit recognition that the pedagogy of copy produces the self-imitating individual and that it does not guarantee individual difference. (This is not to suppose that seals and witnesses do that— rather, what counts as the individual is always subject to systems of re-marking; there is a history of these conditions that goes hand in hand with the shifting notions of literacy, registered, for example, by Clanchy in his discussion of changes in the meaning of the opposing pairs literate/illiterate, cleric/ layperson.)

In fact, what guarantees a signature is the possibility of its production: the possibility, on the one hand, that the signer can make the mark that counts for the writing situation in which it is being written and the possibility, on the other hand, that to be writing in such a situation means that the individual writer has been produced as someone who could be writing in that circumstance. In the highly differentiated spheres of sixteenth-century script, many writers may not have been able to produce a signature, or may have clung to older modes of self-authentication (like a mark devoid of phonetic pretense, but signifying class or trade more pictorially) even if they could; they would have hands proper to the keeping of accounts. It is only in the highly literate spheres that are documented by the anthologies of Petti and Greg that one encounters the fulfillment of the writing program—the

multiplicity of self-reproductions that betoken social mobility and power but that lead nonetheless, with the ascendency of the italic, to the self-reproduction of the self-identical mark that guarantees the individual only through the documentary status of the signature. "Who signs, and with what so-called proper name, the declarative act that founds an institution?"; Derrida's question about the signatures on the Declaration of Independence (*Otobiographies*, 16) ramifies to all documents—and to the institutions that a later age will call high literacy, literature, humanist pedagogy, and the production of the civilized "human." "Who signs all these authorizations to sign?" (31). The self-guaranteed mark must be guaranteed by the situation in which one signs, a situation that is reinscribed through the complex negotiations that regulated handwriting in the sixteenth century and that leads to the regulated system in which the self-duplicating individual is produced.

In fact, what differentiates one italic signature from another is more often a paraph, a flourish, than the letter itself; seventeenth-century writing manuals, like those produced by Edward Cocker, are famous for their flourishes, for a cursivity that seems to have taken off beyond the letter, a mark that displays the movement of the hand. Elizabeth I's signature is distinctive in much the same way, notable for the tail of the z that trails well below her name in loops and zigzags that extend the letter in a series of decorative simulations that are less to be read as z's and more as the distinctive movement of the royal hand. The signature in this way is exceeded by a mark that recalls the preliterate mark, by a recursivity of the hand that writes itself beside the letter. If such a mark guarantees Browne's "naturall disparitie" and bodily difference, it does so by writing the "older" (oral/communal) body within the domains of a script whose regularity testifies to the mechanism and detachment required of the hand. Even such "illiterate" marks (that is, marks that appear not to be letters) function within the domains of literacy (this is true as much

in the medieval period as in the Renaissance; the boundaries of what counts as literate are always on the move) only by being themselves regulated and repeated. A stray mark, or a different mark each time, will not guarantee a signature—unless the document does beforehand. But if authenticity is thus always a matter of self-forgery, it is always therefore open to the possibility of unauthorized forgery. It will always be *where* the signature is, more than what it looks like, that serves to authenticate it.

In Vives's account, the bottom line of the letter is the place reserved for the nobleman's italic self-re-marking. This is a writing situation that needs some further thought on two counts: first, to investigate the relationship between it and the body of the letter written in another hand; second, to consider whether a system that authenticates a letter through two hands (of two writers) is not also capable of forgery through the two hands of the skilled writer—the secretary—and to see that such forgery also serves as a mode of authentication, however much it too would violate a modern system of the signature. Secretaries were not only able to forge their master's hands—they were permitted and even expected to do so, as Paul Saenger notes in a comment on the role of royal secretaries in early modern France, where the assumption that the royal hand would autograph certain state missives was met when "Louis XI empowered his secretaries to imitate his hand in order to speed the flow of letters" ("Silent Reading," 406n). Sir Hilary Jenkinson claims that the same was true in England, where it is not uncommon to find letters signed by secretaries in a different hand from the one in which they wrote the body of the letter ("Elizabethan Handwriting," 31); here, one must abandon "modern ideas of morality with regard to the signature: a clerk, for example, copying a signed letter, will give artistic verisimilitude to his rendering of the signature and think no harm" (*Later Court Hands*, 85). It is that exchange of hands, performed by the secretary, that is

handed over to Vives's nobleman, that exchange that Pierre Hamon, "Escrivain du Roy & Secretaire de sa Chambre," as he is named on the title page of his *Alphabet de plusieurs sortes de Lettres* (1566), depended on, as he claimed that his pen had been given to him by the king and as he used it to forge the royal signature. After all, as Cresci indicated (but it is a commonplace observation), hands suit occasions; there is an ordinary hand for "routine letters to gentlemen and persons of quality" and another, more legible hand, for "writing to Lords and Princes" (*Essemplare*, 34). That is how a proper hand is made authentic and a letter is authored.

Vives's writing master focuses on the letter as the space for the production of the signature, and it is worth asking why. What is a letter? The question is answered in Erasmian terms by any number of manuals (modelled on Erasmus's *De Conscribendis Epistolis*) that appeared in England from the mid-sixteenth century on. Here, for instance, is William Fulwood, in *The Enemy of Idlenesse*, the first of these books, which appeared in 1568: "An Epistle . . . or letter is nothing else, but a declaration, by Writing of the mindes of such as bee absent, one of them to another, even as though they were present" (1621 ed., 1–2). The space of the letter is determined here (as in Derrida's theoretical remarks in "Signature Event Context") by structures of absence: the physical absence of writer and receiver from each other, replaced by the presence of the letter to reconstruct that physical space; the absence of the writer, substituted for by the letter (alphabetic marks as well as the epistle); the absence of the receiver, constituted by the marks that are received; the absence of interiority (the mind), recreated (an original simulation) in the space of the letter. The letter thereby is also a mode of presence—"even as though they were present"—a fiction of presence that is constituted solely on the basis of absence. To take this further, one would have to argue that the "original" that the letter replaces (bodily presence of the face-to-face and the oral; mental

intuition and intention) is also structured as the letter is, since such proximities are always already distanced by the letter (in its linguistic definition). Letters, which cover distance, also function in the gap that divides any moment, and their space and modes of presence are how presence is constituted.

Such theoretical concerns are also rendered more fully specific within the letter manuals, not merely in their typical definition, but in the very form that the manuals take. Like the copybooks, these also offer copytexts, form letters meant to serve any occasion; whether divided along Ciceronian lines, to present either "Doctrine," "Mirth," or "Gravity" (Fulwood, 12), or organized by such (Erasmian) rhetorical categories as the deliberative, suasive, or judicial letter, they are presented to the reader to serve as models for the writing of any occasion. (As Katherine Gee Hornbeak has detailed, the model letters in these manuals are culled from ancient collections, notably those of Cicero, and modern examples, like the letters of Erasmus or Poliziano.)

Abraham Flemming represents such letters as arms for the task of writing in *A Panoplie of Epistles, Or, a looking Glasse for the Unlearned* (1576). Just as no soldier would enter the battlefield without weapons, he writes (recalling the violence of the instruments of writing), "so it is not for any man, to tye the use of his penne, to the vanities of his owne imagination, which commonly be preposterous & carelesse in keeping order" (5r). The letter, then, expresses the mind, but only when the mind has been formed by the letter; to this end, Flemming offers letters "drawne out of the most pure and cleare founteines of the finest and eloquentest Rhetoricians, that have lived and flourished in all ages" (5v). The origin that the letter replaces is to be found in these antique and humanist pretexts, and the source—the "founteines"—of the letter lies in other hands.

The letter to which Vives's writing master would have the nobleman set his hand is one written within these dictates; it is composed by a secretary, presumably from such a storehouse

as those that Fulwood or Flemming provided for English writers, "glasses" for the unlearned who could reproduce the learned letter as part of a warfare, to gain a place in the realms of high rhetorical literacy. Such is clearly the aim, announced in its title, of Angel Day's frequently reprinted and ever expanding *The English Secretorie* (which appeared first in 1586), *In which is layd forth a Path-waye, so apt, plaine and easie, to any learners capacity*. That edition opens with a version of the usual definition of the letter: "A Letter . . . is that wherein is expreslye conveied in writing, the intent and meaning of one man, immediately to passe and be directed to an other, and for the certaine respects thereof, is termed the messenger and familiar speeche of the absent" (1). Immediacy is mediated, and the letter stands in the place of the face-to-face communication of the messenger, writing structured as the familiarity of speech. One man and another function as bordering absences that meet in the letter.

Day repeats and modifies this opening definition several times in his manual, wrestling with the problems involved. "Letters are onely messengers of each mans intendments" (5), he goes on to say, yet the insistence upon intentionality is belied by the rhetorical and copying aim of the manual; individual intention is no more within the scope of the art of the secretary than it is in Flemming's armed writer. Day's summary sentence follows from a discussion of the necessary "discretion" of the letter, its fitness "to the time place and presence" (4) of the receiver to which the writer must be shaped. "I see no reason, but he that can frame him selfe to the varietie of these [the conditions that must be met to form a "discrete" letter], may with greater facilitie reache unto the reste, the better to enhable him selfe hereafter if advauncement draw him to it to become a Secretorie" (5). Such is the sentence just before the one defining the letter as a structure of intention; intention here is, then, that to which the writer frames himself, into which the writer is inserted, as he

chooses the "proper" letter to suit the occasion. Rather than his own intention, it is shaped to suit the situation of writing.

Some pages later, the initial definition is again restated: "Letters also are but a formall kinde of mutuall talke, both speach and writing, serving onely to declare a mans meaning" (17); letters here seem to be a secondary, formalized version of speaking, and both speech and writing stand in a secondary relationship to the primacy of a meaning that would seem to have no need of a formal means of expression. The definition, however, appears in a parenthesis, inside this sentence: "It shall behoove each one in framing his Letters (seeing Letters also are . . .) to indevor according to the waight or lightnes of the cause to contrive his actions, that they be such as wherein this *decorum* both in person and matter may be imbraced." Meaning thus lies within the domains of a formal contrivance, and the possibility of the legibility of a meaning lies in its decorous relationship to the cause, the person, and the matter. Thus, when, on the next page, Day once again defines the letter, this time in its most intimate terms (translating Erasmus) as "the familiar and mutuall talke of one absent friend to an other" (18), he immediately continues by delimiting the genre of the familiar letter, and the stylistic traits necessary to produce familiarity and the scripted intimacy of absent friends, going on to the stylistic features that would constitute other letters and other social relationships.

Meaning, familiarity, intention, and the like—all that would constitute presence—are constructed in the letter along rhetorical lines, inscribing the social rhetoric that also writes the domain of presence as and in the letter. Writing begins with an awareness of the person, not as an individual but rather as a social category: "In accompt of the person, is to be respected, first the estate and reputation of the partie, as whether hee be our better, our equal, or inferiour, next the lightnesse or gravitie, as whether he be old, young, learned, unskilfull, pleasaunt, sage, stately, gentle, sequestred from

affayres, busied" (13). As Day states, writing is a form of "behaviour" judged like all other behavior on the basis of its "comelinesse or beseeming" (13). The letter is the space of a beseeming seeming, the simulations of a rhetorical culture that writes all forms of behavior. Although Day eventually moves to classify letters according to their genres and offers his anthology in terms of genre—letters categorized as "descriptorie," "laudatorie and vituperatorie," "hortatorie," "swasorie," "conciliatorie," "commendatorie," "consaltorie," "monitorie," and "amatorie"—he first devotes several chapters to the format of letters. These take up the forms of greeting and farewell, of superscription and subscription; providing the proper titles for writers and recipients, they offer nothing less than the fine discriminations of a hierarchized society matched by the forms by which the letter is to open and close. For if the content of the letter is entirely a matter of genre, the frame of the letter is the social space that makes genre legible, and literally so. As Day prescribes, in "writing to anye personne of accompt, by how much the more excellent hee is in calling from him in whose behalfe the Letter is framed, by so muche the lower, shall the Subscription thereunto belonging, in any wise be placed" (27). When Vives's nobleman subscribes in the allotted place, the very location of that place for his signature has already signified, and the writer has been written into the letter by his secretary, who manages the space of writing as the index of social relations.

Day's notion of the space of the letter is hardly unique; elaborate rules of decorum are spelled out, for instance, in Jean Puget de La Serre's *The Secretary in Fashion*, as in this example (from the sixth edition of 1683): "There must be as great a distance between the first and second line, because the further they are distant, the greater respect they signifie. . . . When we write to persons of quality, we use to leave a great distance between the body of the Letter and the Subscription" (B7r, B8r). While the letter manuals provide the forms, writing manuals

often reproduce them too, their pages simulating letters, exhibiting the proper modes of address: Salvadore Gagliardelli's *Soprascritte di Lettere in Forma Cancellaresca Corsiva, Appartenanti ad ogni grado di persona* (Florence, 1583) is entirely devoted to such forms of address. As Puget insists, the proper letter must insure its visibility through the fairness of the hand that writes it: "Your letters must be written fair and without any blots, upon fine perfumed and guilded Papers (if you please) and with large Margins. For, what Action is in a Speech, the same is Writing in a Letter. It should not tire the Readers eyes, but be written so fair that it may delight the sight" (C1v).

It is within the simulative space of the letter that the proper signature is located, but through a series of dislocations that write sociality, presence, the person, intention, and meaning within the scripted domains of a rhetoric in the hands of the simulating secretary. It would seem, as Derrida insists in *The Post Card*, that the letter is inescapably related to literariness, that the writer must be and enter into a fiction: the fiction of presence in the handwritten letter (written by another hand, and doubly so—the hand of the secretary; the hand taught by the writing manuals and reproduced as the socially significant hand); the fictions defined by the generic classifications that embrace the social domain (in its class hierarchies, its ages and types that read like the characters from a Roman comedy or from a Roman rhetoric) and by the kinds of epistles, which write occasions and persons according to their dictates and frame them within the highly coded openings and closings (in which, to this day, one registers familiarity with "dear" and signs oneself "sincerely yours," "yours truly").

Claudio Guillén has surveyed "the Renaissance awareness of the letter" (73), its intimate connections to fiction and to autobiography, to the making public of the private. Connected, as he notes, to the rise in literacy, the letter manuals serve to instruct on the socially countenanced modes for a

self-production that can never be separated from the fictive simulations that structure the real. Perhaps in no area is this clearer than in the case of gender; Day's writer is invariably male. When he comes to provide examples of amatory epistles (232 ff.), however, a narrative frame is introduced; B. L.'s love letters appear, but his lady's answers are merely reported. The lady does not write, except indirectly, but soon there would appear manuals like Ierome Hainhofer's 1638 translation of Du Bosque's *The Secretary of Ladies*, compiling women's letters, or Dutch paintings, like those Svetlana Alpers discusses in *The Art of Describing*, in which women receive and write letters; soon, too, would appear epistolary novels that take their cue from such sixteenth-century letter collections as those provided by Nicholas Breton. The "intimacy" of the letter will produce female subjectivity as the most circumscribed and delimited space within the artifices of the letter. Hence, on the cover of a collection of epistles titled *Cupids Messenger* (?1638), Cupid aims an arrow tipped with a book at a man and a woman embracing (Fig. 34). Woman will be constructed as the repository of privacy.

The social construction of such interiority in the sixteenth century is less a matter of gender oppositions (since women are scarcely conceived of as having a place within the domains of literacy—of the letter) than, more visibly, a matter of class. As Day's manual suggests, it provides instructions for a secretary whose literate skills (the sort to be had at the hands of a writing master or copybook) equip him to rise into aristocratic employment, to write the sorts of letters Vives's nobleman will sign. The proliferation of secretarial manuals, then, must be read within the context of the expansion of literacy and the places provided within a widening bureaucratic network for those skilled in penmanship. Thus, Gervase Markham offers his letter manual, *Conceyted Letters, Newly Layde Open* (1618), by insisting on the importance of letters

CVPIDS

MESSENGER·

OR,

A trufty Friend ftored with fundry forts of ferious, witty,
pleafant, amorous, and delightfull Letters.

What Cupid *blufhes to difcover,* Thus to write he learnes the Lover.

Newly Written.

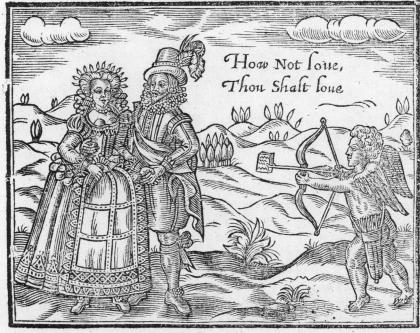

How Not foue,
Thou Shalt foue

LONDON,

Printed by MILesFLESHER.

Fig. 34. *Cupids Messenger,* title page. By permission of the Folger Shakespeare Library.

(script) in transparently ideological terms: "Writings be the verie soules and external substances of Time," and especially letters (epistles)

> by which even the whole state of the world is sustained For . . . how shall Kings know and communicate their great actions, enlarge their bounds, redresse their peoples iniuries, how shal the noble, know intelligence to serve his Countrie, the Merchant trade . . . or any or all sorts of people speake at a farre distance, but by the helpe of Letters only. (A3)

Markham's terms recall the elementary definition of writing as that which makes absence present and the particular form in which that work is accomplished, within the expanding nation-states of the Renaissance, with their commercial and colonial activities and with their increasing corps of state servants, wielding the pen. This situation, which further explains why it is a letter that Vives's nobleman writes, can be specified even further, for it is in the sixteenth century in England (and somewhat before that on the continent) that the secretaryship—the principal secretary—becomes the office of paramount importance in state administration. If, as I have been arguing, the production of the individual is something accomplished through writing within its differentiated domains, it remains to be seen how, too, the history of the secretaryship participates in this social formation.

That history is a complex terrain, for the narrative provided by G. R. Elton's *The Tudor Revolution in Government* (a modification of the story told in Florence M. Greir Evans's *The Principal Secretary of State: A Survey of the Office from 1558 to 1680*) has in the past several years frequently been called into question, most notably in a collection of essays edited by Christopher Coleman and David Starkey, *Revolution Reassessed*, where the revolution in question is the one argued by Elton, and the reassessment takes the form of a series of specific forays that undermine the grand narrative that is the attraction—and distortion—of Elton's account. Nonetheless, there are some

things that seem possible to say within the context of this investigation of the roles of letters and letter writing. There is, first of all, the continued pertinence of an observation made by Sir Hilary Jenkinson in "The Teaching and Practice of Handwriting in England": that with the transformation of the secretary as keeper of the King's Seal into the executive authority of the Secretary of State "went the rise of a new administrative instrument—the informal letter in English" (215). It is clear, whatever the route of this transformation (less likely to be the sole creation of Thomas Cromwell, as Elton argues, but equally unlikely to be merely the reassertion in the sixteenth century of a lapsed fifteenth-century office, as Starkey would have it—although he does argue strongly for the importance of the resituation of the secretaryship in relation to the Privy Council in "Court and Government," 55), that among the most powerful men in sixteenth-century England were those who held the office of principal secretary: Stephen Gardiner, Thomas Cromwell, William Cecil, Francis Walsingham, Robert Cecil. "From 1534 [the date Cromwell assumed the secretaryship] onwards," Elton writes, "every aspect of the government of England is reflected in the correspondence of the king's principal secretary" (*Tudor Revolution,* 299).

Whatever its medieval origins and precedents, the office was represented in the sixteenth century as the sphere of individual power and genius; serving as go-between among the king, his council, parliament, and petitioners, the limits of the office were nowhere prescribed, and the granting of the position, at least early on, was done by fiat, not by any letters patent detailing what was involved. So Robert Cecil reports in his brief account, "The State and Dignity of a Secretary of State's Place, with the Care and Peril Thereof." According to him, the office lacked "prescribed authority": "Only a secretary hath no warrant or commission, no, not in matters of his own greatest particulars, but the virtue and word of his

sovereign" (166–67). Hence, the office was a matter of trust: "As long as any matter, of what weight soever, is handled only between the Prince and the Secretary, these counsels are compared to the mutual affections of two lovers, undiscovered to their friends" (167). Cecil's emphasis on the personal is endorsed by both Evans and Elton in their accounts. Yet what must be said is that the notion of the personal here is constructed in a relationship of empowerment that is capable of further (and of an institutional) reading; moreover, this mystification of the personal relationship between secretary and royal master also obscures the very route that lies behind Cecil's rise to power, following his father, whose road to high office began with a secretaryship (in the more limited sense of the office) to Somerset. It ignores, too, the class of the Cecils or Walsingham, immensely powerful men who were not aristocrats but the "new men" of Elizabethan administration, country gentry educated in the humanistic paradigms of service to their nation.

This institutionalization within the chains of an expanding bureaucracy can be read, for example, in a document written by one of Walsingham's secretaries in 1592, a couple of years after Walsingham's death, Nicholas Faunt's "Discourse touching the Office of Principal Secretary of Estate." Faunt details the office of the secretary to the principal secretary in terms that echo against Cecil's description, for it is within the precariousness and peril of the unprescribed office that he describes the need for a secretary in whom "secrecie and faithfulnes bee cheifly required" (501) for the "dispatch" of dispatches. "The Secre: must use one as his owne penne, his mouth, his eye, his eare, and keeper of his most secrett Cabinett" (501). The embodiment of the person (the private secretary) makes him another's pen, and the place of dispatch, of letters covering distance, is the intimate sphere shared and replicated from hand to hand, circulations of power that are also always in another hand.

The ascendency of the secretariat, as Starkey demonstrates, is tied to shifts within institutional power, as the royal signature, the sign manual, came to be the mark of authority (as opposed to the signet, the seal usually associated with the king's command, which moved into areas of secretarial control). As the personal royal letter bypassed older administrative routes and the signature came to be the authoritative mark, different administrative relationships were developed, both to handle these forms of power and to interact with the older ones (beyond the signet—the seal initiating documents from the monarch's hand—were the Privy Seal and Great Seal, affixed in regulated ways to documents as they passed from one administrative or judicial office to another). The secretarial corps increased in size and importance, and the principal secretary became the hand through which the king's correspondence passed. What is "personal" in this situation, then, has to do with the passage of the signature, with the office of writing the king's letters, and with the correspondence carried on in the principal secretary's hand, or by his secretaries.

Of the secretariat, Elton provides a description that also ramifies in the direction of the principal secretary and even of the royal signature:

> The correspondence through which Cromwell so largely governed was written and received, endorsed, classified, and filed away by his private clerks. Their handwritings are quite familiar, though as they are clerical hands they too often lack very distinctive features; but where we know a name we cannot assign a hand, and familiar hands have no known owners. (*Tudor Revolution*, 304)

The privileges and privations that mark the office of the principal secretaryship participate in this situation of the authorized and anonymous hand, whose instrumentality is tied to the detachment that also opens up the sphere of "personal" power as the power of the hand. "The secretaries acted simply

as clerks and as mouthpieces for the king," Elton remarks (57) —and as a letter from Richard Pace, chief secretary from 1516 to 1526, to Cardinal Wolsey, that Elton prints in *The Tudor Constitution* (120–21), shows, it was on their clerkly nature that secretaries depended, insisting that their letters were merely written at the dictates of the monarch. Elton's sentence continues: "There cannot be any doubt that they were deep in all the secrets of policy, knew what went on as well as Henry who rarely read and even more rarely wrote a letter himself, and must have had some gain in personal importance from all this" (57–58). One "gain" was precisely the gain of the personal through this secretarial, secret-sharing office, whose intimacy, as Elton's description reveals, involved acting in the king's name, or even through his signature.

The king, like Vives's nobleman, loathed writing and was hardpressed to sign "his own" unread letters; this has been understood, by Starkey among others, as a matter of personal disinclination: "He would sign only when the mood took him" (50). Nonetheless, the sign manual passed eventually into the control of the principal secretary. "Inflamed by illness and old age, Henry's reluctance to sign became an aversion. Eventually he freed himself by setting up the machinery of the 'dry stamp'" (Starkey, 55). This was in 1545–46, but Starkey continues:

There had long been a "wet stamp," used to rubber (or rather, wooden) stamp circulars. The dry stamp was quite different. It left an uninked impression on the paper which was gone over in pen-and-ink by an expert clerk. The result was a near perfect facsimile, that was used henceforward to authenticate all documents to which the sign manual would ordinarily have been applied. And the dry stamp was firmly in the hands of the Privy Chamber. (55)

"Firmly in the hands": the signature of the king became a form of mechanical reproduction, and authorized forgery passed into the hands of the secretarial corps. It is such hands—such

forgeries—that have personal power, and it was because the signature, even in one's own hand, participated in this structure of duplication that it was resisted by the king, even as it was claimed as the mark of secretarial power.

That Henry's aversions were not idiosyncratic is suggested by another of Walsingham's secretaries, Robert Beale, who also provided an account of the principal office in 1592. "When her highnes signeth, it shalbe good to entertaine her w[i]th some relac[i]on or speech whereat shee may take some pleasure" (Read, 1: 438). The queen withheld her signature—as was proved against Principal Secretary Davison to his downfall over the death of Mary Stuart—and Beale insists both on amusing the queen and on trying to get letters from her before anything is undertaken: "If you be com[m]anded to wright anie matter of importance, doe what you can to procure that the same may be done by a speciall l[ett]re from her Ma[jes]tie herselfe" (438). The secretary was empowered to write in the queen's name, while the queen withheld her script and signature. These transfers of power, like those between the queen and her writing master, open and foreclose spheres of empowerment that circulate through the disowned and yet proper hand.

In the administrative reforms of the sixteenth-century secretariat, procedures were worked out for the passage of documents along prescribed routes, through proper hands, and towards the attachment of necessary signatures and seals to authenticate the sign manual and the royal hand and to guard against forgery. The authorizing hand in the hand of others required countersignatures to countersign the authentic counterfeit. Beale and Faunt each detail these procedures (pages of Faunt's "Discourse" list all the sorts of books of record that the principal secretary required to administer the country). These are to serve, Faunt writes, as "a generall memoriall Booke" (503), and Beale emphasizes the same point: "You shall do well to have a memoriall in wrightinge of things to

be done, least your memorie deceive you" (424). Recording receipts of letters and their passage and securing signatures and seals, the secretary's writings are a locus of memory, the secretarial counterpart of the humanistic memory stored with *copia*, ready to hand for rhetorical operations. These store-houses, too, are to serve a corps of letter writers who write in the king's name. "Thus," Faunt concludes his account of the office of the secretary, "I have in some sorte discovered my poore conceipt touchinge the necessarie servants and Bookes that the Secr: is to provide as instrumentall meanes for the better dischardginge of his waightie office" (508). Secretaries (to secretaries)—or books: the pairing suggests their equivalence, and the personal and private, the secret of the individual, must be connected to (in Furet and Ozouf's terms) "engendering the individual in his social context" (314), the private scriptive and scripted individual.

Instrumental means: the secretaries are the hands of a power that has inserted itself into other hands, disowned to serve as their marks, granted personal scope and individuality to secure the hands of those in whose hands they wrote. This is Norbert Elias's civilizing process—in which *restraints* serve those in power. Among the corps was the office of the Latin Secretary, Ascham's position; it was in the hands of the principal secretary. "The Latin secretary's duties were bureaucratic, not political," Evans writes (171), going on to remark the existence of Ascham's letter book, which "begins with a table of epistolary styles; it is written mainly in his own hand." One passes here from the more mystified copying that defines the spheres of political and personal power to the more mundane copies of Ascham's letter book, a collection of epistolary forms, like those provided by Angel Day. These routes of the instrumental hand pass through such provisions as the 1590 letters patent for the "due and orderly writing and engrossing of bills and warrants to be passed under the royal sign manual" issued into the hands of J. D. and P. B. (Evans, 199);

John Davies and Peter Bales? Writing masters (and cipherers for Walsingham) and humanist pedagogues (royal tutors): they are instruments of the hand and of the letter. They meet in the picture of intelligence-gathering provided by Faunt, who imagines that when the principal secretary is known to require masses of paper, opening every corner of the realm, there will be those who will respond to the call of such "vertuous imployment," having been "liberally brought up" to "freely bestowe" their papers and their services (508), to be the book-men who used their hands as hands for letters of state.

How such hands are made by the king's hand is recorded in a final anecdote by Beale:

> It is reported of K[ing] Hen[ry] 8 that when S[i]r William Peter, at the first time that he was Secretarie, seemed to be dismaied for that the K[ing] crossed and blotted out manye thinges in a wrightinge w[hi]ch he had made, the K[ing] willed him not to take it in evill parte, for it is I, sayd he, that made both Crumwell, Wriotheslie and Pagett good Secretaries and so must I doe to thee. The Princes themselves knowe best their owne meaninge and ther must be time and experience to acquainte them w[i]th their humours before a man can does anie acceptable service. (Read, 1: 439)

The story is no doubt a fiction, putting (in this telling) authority back into the king's hand, who writes only to strike out what has been written; it is the inverse of the account offered here, in which the sign manual is the manipulable signature placed into the secretary's hand in an act of deauthenticating authentication that allows the circulation of power always to be in another hand.

It has its parallel in a claim that Stephen Gardiner, the first undeniably powerful principal secretary in the sixteenth century, made some twenty years after he held that position. Writing in 1547, he insisted that the forms of letters were of no importance:

As for paper, inke, perchemente, stones, wood, bones, A.B. of the chancery hande, and a.b. of the secretary hand, or a letter of Germany fasshion, of any other forme [they] be all of one estimation, and may be of man [either] enclining to the devel, [and] used for falshod; or, applying to God's gracious calling, [and] used to set forth truth. (Quoted in Morrison, *Selected Essays*, 280)

Even as he demystifies the tools, Bishop Gardiner remystifies the hand, transcendentalizing the differences in forms and materials so that what matters is a divine truth indifferently available to any hand. This denial of the hand offers the religious equivalent to the state apparatus of a secretarial corps whose empowerment, though often great, nonetheless remains regulated by the hand that refuses to sign or that signs with a mechanical copy. It passes on the disowned mark of the signature, the forms of letters and their management; these are, at one and the same time, how individuals are formed and how the individual, even in his secret innermost recesses, is the index of the interiority of an other, an artificial limb and mind. The secretary is a living pen.

What characterizes the secretarial corps in government circles is no less the case in the household situation imagined in Vives's dialogue. This position is detailed in one of the additions to the 1599 edition of Day's *English Secretorie*, "Of the partes, place and Office *of a Secretorie*," a description fetched in many instances from a discussion in the first of the Italian manuals, Francesco Sansovino's *Secretario* (1565). Day's manual also includes a full section of devices ("*Tropes, Figures, and Schemes*") requisite for the letter writer. If this points quite directly to the humanistic/rhetorical nature of his manual (and if it also formally aligns the letter manual with a rhetoric and a poetics), such is also the case with the 30 pages on the office of the secretary. Here, too, the ideals of a rhetorical culture are displayed and embodied in the secretary, who is presented as an ideal type, like Castiglione's courtier, with whom he

shares many points of resemblance. Like him, he is a counsellor to be trusted for the honesty of his word; insistently, he is a gentleman; and his education includes the full Latin curriculum that humanism prescribed. Day ends his description by declaring, much as Castiglione had done, that "The *Secretorie* is nowe accomplished" (132). This marks not only the conclusion of the discussion but also the "accomplishment" of the secretary, "framed" (the word recurs) by Day within the spheres of perfection; "how much needful it is to that place more then ordinarilie to bee learned, yea with the greatest abilitie and perfection (if it were possible) to bee also everie waie adorned" (129).

For Day, at least at first, the office of the secretary cannot be reduced to the hand: "So then am I not of opinion of the multitude, who holde that the praiseable endevour or abilitie of well writing or ordering the pen, is the matter that maketh the *Secretorie*" (102). This is to be understood in terms of the "more than ordinary" requirements of the office, because the secretary is "so speciall a beeing" (102). The "being" of the secretary is fetched from all the requirements of humanistic, courtly gentleness and civilization; it extends from proper birth through high rhetorical education to include even a well-formed body and face (Day devotes some time to showing that there is an art to read the mind in the face). The main office of the secretary, as Robert Cecil also emphasized, lies in the "*trust* and *fidelitie*" (102) of the relationship of the secretary to his lord and master, an office that can be read and understood in its very name, etymologically construed, secretary from secret; a secretary is "a keeper or conserver of the secret unto him committed" (102–3).

One of these secrets is conveyed by Day's initial refusal to make the secretary into a hand, for the secret sharing that he imagines derives from a master whose hand, like that of Vives's nobleman or like the hand of Henry VIII or Eliza-

beth I, is notable for its invisibility. For Day, the secretary is so fully the hand (and more) of his master that he cannot be reduced to that role. If the secretary is the one in whom trust is reposed in the form of the master's secret, he is also thereby endowed with a secret that is not exactly his own, but the one proper to his office, which is mystified through the descriptions of the person who is to hold it—the perfect gentleman —in the place of his master.

What Day's discussion does, then, is to open up the sphere of the private secretary—the sphere of individualized privacy —within an institutionalized setting. It is not merely that suggested by the place of the discussion within Day's book, with its letter forms and rhetorical schema, and not merely in the place of the secretary within a humanist pedagogy of "civilized" (rhetorical) behavior: Day describes the secretary who becomes his office, quite literally. Just as a house has its most secret place, the closet, "a roome proper and peculiar to our selves" (103), so the lord and master has his secretary.

The *Closet* in everie house, as it is a reposement of *secrets*, so is it onelie . . . at the owners, and no others commaundement: The *Secretorie*, as hee is a *keeper and conserver of secrets*, so is hee by his Lorde or Maister, and by none other to bee directed. To a *Closet*, there belongeth properlie, a *doore*, a *locke*, and a *key*: to a *Secretorie*, there appertaineth incidentlie, *Honestie*, *Care*, and *Fidelitie*. (103)

In this analogy, the secretary is his lord's closet, the place to which he retires to deposit secrets. The interiority of the master, which replicates the structure of his abode, is replicated in the interiority of the secretary. In Day's discussion, what is "proper" to the closet and "proper" to the secretary is interrupted by their being the property of the lord and master. The secretary is given the simulation of a self-ownership in the propriety of his rhetorically inscribed behavior, in the institutionalized space of the closet, in conserving the other's secret, and in having private recesses through that acquisition.

The room in which he has to maneuver is another's; the place into which the lord retires to be alone with his secrets is also the place in which the secretary is.

The structure that Day summarizes here is one in which interiority and exteriority are inextricably entwined, one in which repetition and difference circulate in this duplicating relationship. Day handles this aporetic structure by delineating the office of the secretary on a double basis. The secretary is at once both a servant and a friend: "Hee is in one degree in place of a *servant*, so is he in another degree in place of a *friend*" (106). If the secretary is not defined as the hand or pen (or not so defined at first), these descriptions of the office define the secretary as the letter. It was, in Day's earlier definition, after Erasmus, the friendly go-between, the absent presence in which that friendship was reconstituted over an otherwise uncrossable distance. Here, between the secretary and his lord, there is the distance of the master-servant relationship and the proximity of friendship; nothing could be closer than the intimate space into which the lord retires, and yet even that intimate space is separated as a special privy chamber, the space in which one can be alone (in other rooms one is not). The secretary serves in two rooms, present and absent at once; he is, exactly, "in place of" friend and servant, structured by and as a replacement for his lord, as the space of his lord's secret.

In this structure of secret sharing, a double grammar writes lord and secretary into each other's place:

Much is the felicitie that the maister or Lord receiveth evermore of such a servant, in the chary affection and regard of whom affying himselfe assuredlie, he findeth he is not alone a commander of his outward actions, but the disposer of his verie thoughts, yea he is the Soveraigne of all his desires, in whose bosome hee holdeth the repose of his safety to be far more precious, then either estate, living, or advancement, whereof men earthly minded are for the most part desirous. (115)

In these mystified exchanges, the lord receives his life from the one to whom he gives life; they are in each other's bosoms, in each other's minds and thoughts. The secret they share is the divided life that the letter replicates, repetitions with a difference that open distance; as here, the distance between life and death.

Day offers several stories to suggest how extraordinary the secretary must be; one is of a boy who laid down his life for his master (106–7), the other of a secretary who took his own life rather than betray his master by going over to the enemy's side (108–10). These are extraordinary stories, not for their point that the self that the secretary acquires is founded in an institutionalized selflessness (the privacy and privation that define the structure of the secret shared, that neither is without the other, and that the secretary must be that necessary absence in which the lord has presence), but for Day's insistence that what the boy did was foolish (for laying down his life he was nonetheless unable to save his master) and for a complication in the story of the secretary; although he would not be a traitor, he had used his hand traitorously. The latter story Day instances as an example of the "linke of Vertue" (110) that ties secretary and master. It is a link forged even by a betraying hand. The secretary remains without being "spotted" (110) even though he has used his hand against his master. The stories, then, true to the initial definition of the secretary as more than his hand, indicate that the more that is involved is, on the one hand (in the story of the boy), the necessity that makes the life of the secretary valuable only insofar as it saves the life of his lord and, on the other hand, that makes the virtuous life of the secretary necessarily separate from the betrayals of his hand. If the person and the personal arise in these exemplary tales, it is through the structure of the detachment of the hand, or the detachment of the secretary from his hand.

The specialness of the secretary, his separateness, is thus

inextricably part of his attachment to his lord and master. Day emphasizes that as a servant, his relationship goes further than the natural attachment of parent and child, for the child has a duty to survive that the secretary cannot claim. If parents give life to a child, children do not give life to their parents. The excessive special nature of the lord-servant relationship lies in the fact of a mutual circulation, one that pushes beyond nature: "So is *Nature* in this action of *parentes* and *children*, which running forwards from issue to issue, hath mighty operation, but when it should be returned backwarde, hath seldome anie power at all" (105). The forward/backward motion that ties lord and secretary, like the protention and retention of the mark, anchors them both in an excessive sphere of simulation and exchange, the circulations of a secret life and a mutuality that moves the relationship from the hierarchical servant-master relationship into the domains of an exalted and mystified virtue that falls under the more equal category of friendship, the space of a mutual meeting.

This opens "greater scope and efficacie" (111) to the secretary, producing a "residue" (111) that surpasses limits, the equalities defined by the spheres of high literacy and its attendant virtues in which the secretary operates. But it is here that two forms of annihilation meet: the mystified absence of the lord and master (who is present only in the secretary) and the secret special being of the secretary (who takes life from the similitude). A structure of resemblance still insists on difference: "and so each *vertue* kindled by the others *Grace*, maketh at last a coniunction, which by the multitude of favors rising from the one, and a thankfull compensation alwayes procured in the other, groweth in the end to a *simpathie* unseparable, and therby by all intendment concludeth a most perfect uniting" (113). Yet resemblance, as we have seen again and again in these economies of writing, always threatens— here, to give the secretary scope and power, which are being guarded against in all the ways in which humanist "gentling"

and "civilizing" attempted. All of this may "accomplish" in the secretary something that goes beyond the very limits prescribed.

That excess might lie, in fact, in the hand that Day at first excludes but that insists upon itself in the final pages of the discussion when Day admits that all the equipment for life that the secretary has may yet not serve if he cannot write fair, for this, in a structure of exceeding that works in a direction opposite to the idealizing strategies of the discourse, no pedagogy may quite serve:

Now is it a matter often seene, and in common use almost to be found, that a great many of men otherwise discreete, learned, experienced, and for their several callings questionlesse of very good deliverie, and every way to be deemed sufficient, some also that in the *Greeke* and *Latine* tongues are verie well studied, and are also with the use of forraine languages laudablie indued, that notwithstanding have not in themselves the facultie and use of well writing. (127)

To explain this, Day falls back on a mystified notion of "a meere instinct of Nature" (128) to account for the skill of the hand that the secretary as writer must possess. Here the art itself is nature, for as Day insists, the writer has so fully "repressed" (it is Day's word; see p. 129) the body, so entirely framed it, that it becomes another nature, precisely that "excessive" form that the rigors of a training in the rhetoric of civilization may produce—a being who is the perfect duplicate of the one he stands in place of. The secretary is himself imprinted with the eye of the Other (126); a duplicate made through copy and made as a copyist, what he simulates finally is the secret of a lord that is otherwise unavailable.

For, at last, the secretary is embodied as "the perfection of his hand," a perfection in which his own hand is not his own—"he is utterlie to relinquish anie affectation to his own doings." As "a zealous imitator in all thinges," he knows his

lord's style ("unto what forme and maner of writing he is spe-
ciallie addicted," 130); it is that his hand (re)produces. He acts
as his lord, as his representative, writing his hand, but also
handling suitors in the name of his retired lord:

His office is likewise to entertaine all maner of suters unto his Lord,
to conceive and understand of their severall occasions, and how
much or how little, they or anie of them do import, to answer the
dispatch of the greatest with as much facilitie as he may, and those
of lesse moment with discretion to remoove, and put backe, to the
ende the walkes and passages of his Lorde be not with the vaine and
frivolous demeanors of fond people too often encumbred. (131)

With the lord retired to his cabinet, or walking his private
paths, the cabinet comes into the open in the duplicate marks
of the secretary's missives. As Day insists, the secretary is "to
be alwaies at hand" (131), ever ready to dispatch. He is the
speed of the letter covering distance. He writes as his lord, "in
his owne person to answere" (131) the letters he delivers, the
suits he reports; he functions as the attached/detached hand.
Entirely his office, he is that into which his lord retires—and
in whose hand he may be lost. In that threatened and coun-
tenanced forgery, a "self" is forged in the secret-sharing of
lord and secretary, that differential and differentiated equation
upon which literate individuality depends and which extends
well beyond the secretaryship to a modern notion of what
constitutes individuality, and which is (re)produced (from the
start) in the letter.

 I think we do know the sweet Roman hand.
 —*Twelfth Night*, 3.4.26

Scenes from the life of the master('s) script. Jean de Beau
Chesne addresses a letter to François de Mandelot, Seigneur
de Passy, prefacing *Le Tresor d'escriture* (Lyon, 1580); he assures
him of his qualifications—of his *personal experiences*; having
desired *true* knowledge about what was necessary for the mas-

tery of his art, he has traveled to Italy to find the "Temple of Writers." Overcoming distance, and the difficulty of the route, he has arrived there:

Ainsi donc comme i'ay tousiours esté curieux de parvenir a la vraye science de l'escriture, pour former divers carracteres, i'ay tousiours cherché l'occasion de trouver hommes qui me fussent escorte & guide, pour estre conduict au Temple des Escrivains: & n'ayant eu esgard à distance de lieu, difficulté de chemin, ny à peine aucun, ie me suis elongné de mon naturel pays, pour voir la plus grande partie d'Italie. (*3)

The trajectory he has followed—the path from his natural country—is that of the letter, literally. Beau Chesne's own words for his own experience in script are another's. Literally. Here is Conretto da Monte Regale's letter to Vincentio Gonzaga di Mantoa, prefacing *Un novo et facil modo d'Imparar'a Scrivere* (Venice, 1576):

Per tanto io che sempre fui vago e desideroso di pervenir alla vera cognitione del scrivere diversi caratteri, cercai sempre occasione di ritrovar huomini che mi fussero scorta & guida per condurmi al Tempio de' Scrittori, & non havendo riguardo a distanza di camino ne a fatica veruna m'allontanai dalla natia patria cercando la maggior parte d'Italia. (A2r)

Self-forgery.

London, 1594. John Gerard, Catholic priest, is caught by the spy system. A paper full of accusations is presented to him, and he decides to answer its "lies," to the delight of his jailor, the notorious Topcliffe, "in writing": "He was hoping to trip me up in what I wrote, or at least to get a sample of my handwriting. If he had this he could prove that certain papers found in the search of the houses belonged to me. I saw the trap and wrote in a feigned hand" (96). Arrested again, a blank piece

of paper is presented to him, one that had passed through Gerard's hands:

He showed me the piece of white paper which I had given to the boys and asked me whether I recognized it.

"No," I answered.

It was true, for I had no idea that the boys had been captured. Then he put the paper into a basin of water and the writing appeared on it with my full signature at the bottom. When I saw it I said:

"I don't admit that the writing is mine. My hand is an easy one to forge and my signature may well be faked." (121)

His own signature might well be faked even were it in his own hand.

The 1604 edition of the master Dutch calligrapher Jan van den Velde's *Spieghel der Schrijfkonste* literally displays a mirror of the art of writing the signature (Fig. 35). At the bottom

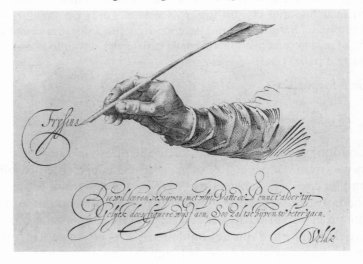

Fig. 35. Jan van den Velde, *Spieghel der Schrijfkonste*, signature plate. By courtesy of the Victoria and Albert Picture Library.

of the page, a text in the exemplary hand, signed by Velde. At the top, the hand itself, detached, formed from the same strokes that make the letter—a picture of the detached hand of Jan van den Velde. And it signs itself Frysius—the name of the engraver of the plate. The mirror is a mobius strip in this exchange of hands and names, signatures in a singular double hand.

The final page of Peter Bales's *The Writing Schoolemaster*:

> Swift, true, and faire, (good Reader) I present;
> Art, penne, and hand, have plaid their parts in me;
> Minde, wit, and eye, doo yeeld their free consent;
> Skill, rule, and grace, give all their gaines to thee:
> Swift art, true pen, faire hand, together meete;
> Minde, wit, and eye, skill, rule, & grace to greete.
> (R3r)

Who says "I" here and in what present? A speaking book, *The Booke to the Reader*, set within the fictionalized circularity of literate, secretarial exchanges: Bales in this (self) ciphering hand. In the sliding parataxis of these lines, there are "parts" everywhere, exchanges between the instruments of writing and the writing and writer/reader produced. Mind, wit, and eye are "freely" subjected; the subject of writing gains and loses in this endless give and take of materiality (hand and pen) and immateriality (of mind, of truth)—the transcendentalizing ideology of the severed (detached and attached) hand in a social scene of meeting and greeting. Overcoming and re-inscribing distance, the speed of these letters and proto-poetic lines is the speed of the letter to the reader, handing over the skills of literacy—to the socialized, well-formed reader on the line, who might sign within these authenticating exchanges, and have a part and place within their excessive regulations and regularity, ruled and framed on the endless line.

The frontispiece to Martin Billingsley's *The Pens Excellencie or The Secretaries Delight* (1618; Fig. 36) portrays the writer, one hand visible, having just put the final touch on the date, making him present in the picture. Below, the cartouche in his hand proclaims the perfection the writer has arrived at, present perfection. Within that moment of writing, protended and retained, as the frame around the image of the writer, right now before our eyes, there, a single, and endlessly decipherable, reversible sentence:

Lingua, Penna: Mentis Muta.

1. The pen is the mute tongue of the mind.
2. The tongue is the mute pen of the mind.
3. The mute pen is the tongue of the mind.
4. The mute tongue is the pen of the mind.
5. The tongue of the mind is a mute pen.
6. The pen of the mind is a mute tongue.

Circulations within language; on the feather. The writer's foundation in the pen; the mind's foundation. This subject, pictured, fully inscribed, has no name or signature. The secretary's delight: to be a severed hand.

Erasmus's Leo, who will soon teach Ursus's cubs how to simulate the human hand—the italic—impresses upon him the importance of writing *in one's own hand*:

To be brief: a letter that is a product of someone else's fingers hardly deserves the name. For secretaries import a great deal of their own. If you dictate verbatim, then it is goodbye to your privacy; and so you disguise some things and suppress others in order to avoid having an unwanted confidant. Hence, quite apart from the problem of the genuineness of the text, no open conversation with a friend

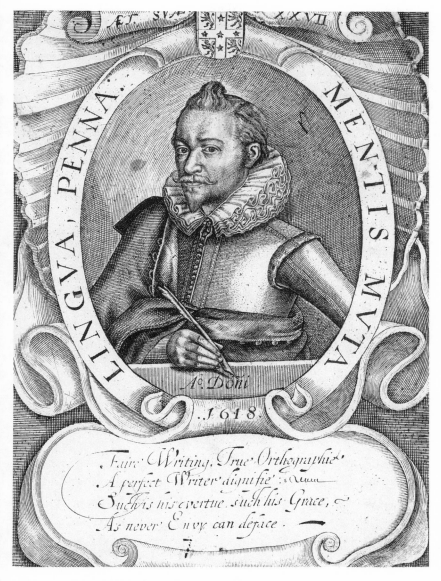

AET. SVÆ XXVII

LINGVA, PENNA

MENTIS MVTA

A⁰ Dñi

.1618.

Faire Writing, True Orthographie,
A perfect Writer dignifie:
Such is his vertue, such his Grace,
As never Envy can deface.

Fig. 36. Martin Billingsley, *The Pens Excellencie*, frontispiece. By courtesy of
the Bodleian Library, Oxford (70.b.60).

is possible here. It is very easy to forge a signature but very diffi-
cult to forge a complete letter. A man's handwriting, like his voice,
has a special, individual quality. (*De recta Graeci et Latini sermonis
pronunciatione*, *S&S*, 30)

The open conversation in a letter to one's friends—the re-
moval of the secretary to open the secret of one's own proper
self—in writing in the proper hand: modern subjectivity is
born in that ever circulating, entirely mystified relationship.

THE HAND
IN THEORY

The great epoch (whose
technology is marked by paper,
pen, the envelope, the individual
subject addressee, etc.) and which
goes shall we say from Socrates
to Freud and Heidegger . . .

—Jacques Derrida, *The Post Card*

*L*IVING, as Derrida noted almost a quarter of a century ago (in the opening pages of *De la Grammatologie*, announcing its *"programme,"* 15), in an age in which writing has begun to replace and to *comprehend* language—"A tous les sens de ce mot, l'écriture *comprendrait* le langage" (16)—it is from that vantage point that *Writing Matter* has been written; to open, in a re-reading of the material conditions of writing in the Elizabethan age, a path towards the closure of modernity. The legibility of that path, and the possibility of this deconstructive reading, has been enabled thanks to the Derridean critique. It gave this study its "program." To mark finally the "comprehensive" grasp of the hand, and its relinquishment in the writing of a post-modernity, I reflect in these pages on discourses—literary, philosophical, psychoanalytic, materialist—that communicate essentially, and therefore doubly, with the modern history of the hand writing and its deconstructive re-marking.

On September 27, 1973, an interview with Roland Barthes conducted by Jean-Louis de Rambures appeared in *Le Monde* as

part of a series called "how writers work." Others interviewed may well have given in to the lure of that rubric, for the writer to mythologize (to idealize and dematerialize) the activity of writing. Barthes, however (and not surprisingly, considering his relentless unveiling of the mythologies of the modern world), refused such a gambit. Declining to talk about methodology in any metaphysical way, Barthes insisted upon the practices of writing—such things as the instruments he used, his schedule, the layout of his desk. Sounding very much like someone heeding the Derridean call for a new graphology, recognizing that his style could not be separated from his stylus, Barthes decried the lack of concern with practices of writing at their "most material level" (*Grain*, 177). Registering the mythological scene of the interview, he describes this material approach to the question of "how writers work" as "an anti-mythological action: it contributes to the overturning of that old myth which continues to present language as the instrument of thought, inwardness, passion, or whatever, and consequently presents writing as a simple instrumental practice" (177). The "old myth" is logocentrism; in its reversal, inside and outside change places, and the material practice of writing determines thought and language.

Rather than a "simple instrumental practice," Barthes confesses that his relationship to the scene of writing exhibits "un rapport presque maniaque avec les instruments graphiques," "an almost obsessive relation to writing instruments" (178). Barthes was obsessed by pens. It is this obsession that I want to analyze. For however wittily aware he was of his own graphic investment (an element that could lead to a "psychoanalytic graphology") and however brilliantly he analyzes such investments in others, Barthes nonetheless does not quite recognize what accompanies his response to the lure of the pen—and of the hand writing—the logocentric complicity that we have seen already in the graphic investment of Elizabethan writing practices.

Barthes's obsession occurs within a hierarchized scheme of types of writing instruments. Testifying to an uncontrollable urge to try all sorts of fountain pens, including those with felt-tipped points, Barthes draws the line at the ballpoint. The Bic is evidence, perhaps, of the Americanization of France, a making-commercial of writing that is epitomized, however, in the typewriter. Barthes explains that although he uses a typewriter to transcribe what has first been written by hand, he doubts that he ever will compose on a typewriter. Nonetheless, he reports that he has been practicing his typing technique, partly at the instigation of Philippe Sollers, who has assured him that "writing directly at the typewriter creates a kind of unique spontaneity which has its own beauty" (179). Still, he continues, it is not likely that this new regime will replace his old habit of writing by hand, "outmoded and eccentric [*"passéiste et individualiste"*] though that may be" (179).

The hierarchy in which the fountain pen holds the supreme position thus is historicized: the investment in the pen is old-fashioned. It is anti-technological, and it carries with it an investment in "individualism." Perhaps there is no surprise in finding that a theorist who was obsessed with nineteenth-century texts seems to have been equally at home with nineteenth-century modes of textual production. Indeed, Barthes's willingness to use the typewriter at all only came from the fact that he occasionally needed to make use of a typist to transcribe his handwritten texts; doing so, he found himself in a position that elicited (as he describes it) another scene from the nineteenth century: "an alienated social relationship: a person, the typist, is confined by the master in an activity I would almost call an enslavement, when writing is precisely a field of liberty and desire!" (179). Barthes's terms of analysis seem to be those of Marx and Hegel but juxtaposed with an idealist account of writing as "a field of liberty and desire." Indeed, ascribing to Sollers the notion that the typewriter (it is, in fact, an electric typewriter that is in ques-

tion) carries with it "its own beauty" is yet another sign of the idealizing aestheticism of Barthes's encounter with the instruments of writing. While he may appear to heed Derrida's strictures about the *"becoming-literary of the literal"* ("Freud and the Scene," 230), that is, recognizing that the instrument is not merely indifferent to the production of the text but implicated in it, the sign of literariness for Barthes is beauty, a term that seems to efface material production and to supply some transcendental measuring device. This is not entirely surprising; when Barthes summarizes the argument of *Grammatology* in "Erté, or A la lettre," he says it "sets in opposition to speech a *being of writing*: the letter, in its graphic materiality, then becomes an irreducible ideality, linked to the deepest experiences of humanity" (*Responsibility*, 116).

Barthes's summary is slippery; while it may mean to reduce ideality to materiality and while its "deepest experiences" may also attempt to resituate a definition of "humanity," the formulation slides in the opposite direction to recoup idealism and humanism in the name of materiality. Much the same could also be said of the rather easy Marxism of Barthes's analysis of the exploitation of the typist. It appears to allow him to turn his obsession with writing instruments into a seemingly unproblematic (and delighted) form of bourgeois acquisitiveness: "I have far too many pens—I don't know what to do with all of them! And yet, as soon as I see a new one, I start craving it. I cannot keep myself from buying them" (*Grain*, 178). This unembarrassed celebration of the joys of surplus-value is joined to equally suspect alignments of his writing practices: to the "almost religious asceticism" (178) with which Chinese scribes faced the task of writing, or to the habits of monks in medieval monasteries, meditating for a day before they began their task of copying. Evoking such practices, Barthes attempts to purify his urge to acquire new pens and also to elide the very differences in writing practices that these nonwestern and medieval scenes of writing

evoke. For one thing, of course, the monks were copyists, yet precisely because the typewriter is only a machine for making copies, Barthes cannot see himself composing on it. Moreover, the invocation of the monks smacks of the medieval revival of the nineteenth century, and the Chinese example, of ethnocentrism.

These would all seem to follow from the way in which Barthes reads Derrida, or from an inescapable logocentrism that can as readily invest itself in writing as in speaking. In the interview in *Le Monde*, one can see lapses of the pen, slips in writing in which Barthes betrays his bourgeois individualism even as he consciously speaks against the bourgeois scene in which he speaks. (To grant an interview in the newspaper is, of course, to commit oneself to being copied beyond the capacities of any typewriter.) Indeed, there is an unconscious writing in this text, one, in fact, that the illustrator for *Le Monde* had no difficulty discerning (perhaps because he read the mythological Barthes of his own desire). Accompanying the interview is a picture of Barthes at the typewriter (Fig. 37). He is all head atop an atrophied body; his miniature torso ends in an exaggerated pair of hands, the two fingers which Barthes claimed to use at the keyboard poised in action. The head, however, looks straight forward. It is the head of Michelangelo's Moses, but instead of horns, Barthes sprouts pens. Tucked behind his ears, beneath his hair, these pens seem to come from, or, at the very least, to interpenetrate his skull. The illustration thus makes visible the metaphysical and psychic investment of the pen, instruments of the mind and of desire. The desire for the pen is a logocentric desire; writing by hand betrays its essentialism; it puts the hand in mind; it transforms the hand into the mind.

This analysis stands, I think, despite places in the interview where Barthes seems virtually to be citing Derrida, for such citations, as I have been suggesting, depend upon a reading of Derrida that has reidealized *Grammatology*, one that has

Fig. 37. Zoran Orlic,
Roland Barthes, from
Le Monde, September
27, 1973. By courtesy of
the artist.

granted originary value to writing. Barthes's insistence on the
material practice of writing is admirable, of course; nonethe-
less it hovers constantly on the brink of a de-originated origin
and an origin that has been reinvested metaphysically. When
he tells the interviewer that he prefers to the notion of method
the word "protocol," since it derives its etymology from the
scene of writing in which a page is glued onto the beginning
of a manuscript, he insists on the scriptive origin of his own
vocabulary and refuses to trace an origin for writing in the
mind; nonetheless, this is a return to an origin, not the de-
originated origin of the Derridean trace. When he says that
writing begins for him with a calligraphic urge and "desire is
invested in a graphic impulse" (*Grain*, 179)—this perhaps ac-

counts for much in Barthes's characteristically aphoristic style
—the hand would appear to have been invested in a writing
that precedes the individual act of inscription, or that cannot
locate the "individual" except in the pressures of the hand. It
is this that Barthes admires, and describes so well, in his essay
"Masson's Semiography," for instance, or his pieces on Cy
Twombly, in which he follows *"in the hand's footsteps"* (*Respon-
sibility*, 171), or in "Requichot and His Body," which delivers
a staggering definition of the nexus of writing, a certain illegi-
bility and the text, all arising from the hand as "the truth of
painting" (*Responsibility*, 213): "What constitutes writing, ulti-
mately, is not the sign (analytic abstraction), but, much more
paradoxically, *the cursivity of the discontinuous* Make a loop:
you produce a sign; but shift it forward, your hand still resting
there on the receptive surface; you generate a writing" (219).
The description answers, too, to Barthes's own writing, and
he is brilliant in his ability to show the effects of the stylus on
style.

Yet, in the interview in *Le Monde*, there is a desire behind or
beneath the graphic impulse; the hand-in-writing is attached
to the body and its desires, and these do not seem to origi-
nate in writing but to find themselves realized there. Scenes
of writing seem to require some originary impulse that is not
reducible to a calligraphic urge, but to an ideality and a hu-
manity that would appear to precede the act of inscription, or
to be generated from it. Hence, the sign insists upon itself,
and writing practice is reduced to an idealized semiotics. If the
aim in the interview is to focus on what might be regarded as
insignificant—the protocols of writing—it is, Barthes insists,
because they signify: "Insignificance is the locus of true sig-
nificance. This should never be forgotten" (*Grain*, 177). Here
Barthes sounds like Freud. But, if so, his sentences bear wit-
ness, as does Freud's *Psychopathology of Everyday Life* (a text to
which I will turn shortly), to the forgetting of writing in the
very act of making writing significant. It is remarkable, as

Derrida notes at the close of "Freud and the Scene of Writing," how inattentive Freud is when he writes about slips of the pen. For what slips from discussion is, precisely, writing.

With Barthes, it is in the very attention to the movement of the hand and the slips of the pen that writing is elided and reinvested in directions that Barthes would, at least at times, not appear to want to go. In *Roland Barthes*, in a section on "*fautes de frappe*," typos, Barthes writes of the *lapsus calami*—but not of slips of the pen, rather typing mistakes. Here, too, the program seems Derridean, following the argument in "Freud and the Scene of Writing" that it is as a writing machine that Freud represents the relationships between the unconscious and consciousness. "Through the machine," Barthes writes, "the unconscious writes much more surely than natural script does, and one can conceive of a *graphanalysis*, much more pertinent than our insipid graphology" (*Barthes*, 97). But one must notice the part the pen plays in these remarks, as the guarantee of a "natural script"—as if the pen were not itself a machine too. "Manuscript particularities," as Barthes refers to them in this passage, alone would seem able to retain their ability to be "*individualiste*," while typing would appear to have a privileged relation to the unconscious, as if, one supposes, the unconscious, being itself a machine, would speak more directly and without an intermediary, when the keys of the typewriter were (mis)struck. Yet even that possibility is denied as Barthes proceeds, for it is only his own unconscious that could be revealed in a typo. The enslaved secretary, the transcriber of the master's text, puts in another appearance. "It is true," Barthes concludes the section on typos, "a good secretary does not make mistakes: she has no unconscious!" (97).

Barthes here not only repeats the scene that his interview is willing to scrutinize, however banal the terms of his Marxist analysis may be there, but now the copyist is also inscribed in another dialectic; not only do we have writer versus copy-

ist, master versus slave; here, it is man versus woman, which is not, perhaps, surprising, considering Barthes's obsession with pens. The scene of bourgeois acquisition of numerous pens also becomes a kind of scene of homosexual cruising. "I've tried everything," Barthes confesses. "When felt-tipped pens first appeared in the stores, I bought a lot of them. (The fact that they were originally from Japan was not, I admit, displeasing to me.) Since then I've gotten tired of them, because the point flattens out too quickly" (*Grain*, 178). It is the only admission of disappointment in the Japanese text/culture that elsewhere in *Roland Barthes* he claims to be his one entirely successful piece of writing, *The Empire of Signs*, a success that is one of writing and of sexuality; "a happy sexuality doubtless finds its corresponding discourse quite naturally . . . : *in what he writes, each protects his own sexuality*" (*Barthes*, 156). Protects, not projects? (Is that, perhaps, a typo? Not literally; the French reads *"dans ce qu'il écrit, chacun défend sa sexualité,"* 159. Nonetheless, to regard the writing surface as a defensive structure is at once to protect and to project sexuality onto writing.) Should we recall those Chinese scribes and Christian monks to discover a happy—and *castrated*—sexuality?

It is something like a happy sexuality that Barthes encounters in "Stationery Store" in *The Empire of Signs*. Invidious comparisons are drawn between Western (American and French) and Japanese stationers. The first two are emporia for commerce where "the user experiences no need to invest himself in his writing," and where the quintessential patrons would be "the eternal copyists, Bouvard and Pecuchet" (*Empire*, 85). The Japanese stationery store is otherwise, a place where the numerous papers display their "fibrous origin" and the brush gestures like fingers: "It has the carnal, lubrified flexibility of the hand" (86). The hand invested in (Japanese) writing is a hand playing with itself; felt-tip pens that flatten too easily perhaps allegorize the relationship between West and East. At the origin, which is what Japanese—oriental—

writing would seem to signify for Barthes, the pen apparently never is exhausted. Indeed, for Barthes, even the Japanese typewriter is not, as the machine is in the West, a producer of copies transforming writing "into a mercantile product" (87). For in Japanese typewriters, characters are not lined up in the row that represents the logocentric tyranny of the line; rather they are rolled on a drum, and to strike the key, Barthes contends, would extend the graphic pulsion of the free hand at play on the page.

If this is Barthes in the guise of Pierre Loti (an author Barthes rescues for modernity in his 1971 essay "Pierre Loti: *Aziyadé*"), perhaps the only difference in his orientalism (I use the term advisedly) is its coding of homosexuality. Yet the sexual terms, despite that inversion, are recognizably phallogocentric, and the investment of desire in Japan conforms to the classism of much late-nineteenth-century homosexuality (Gide, the "intertext" that Barthes credits in *Barthes*, 145, as the origin of his desire to write might be cited as an example), while the coding of the text on pens as an erotic text also conforms to the oriental genre of such writing (it can be found, in fact, as early as Byron, as Jerome Christensen has shown in a brilliant essay). To make my point perversely: the investment in the pen for Barthes produces such forms of desire. The ethnocentrism, sexism, and classism go unremarked by Barthes. Yet they follow, or so I am arguing, from the direction that Barthes's investment in the hand takes: from materialism to an idealism.

The slips of the pen in these passages from Barthes succumb to the terms of analysis that Derrida suggests at the end of "Freud and the Scene of Writing," for whatever Barthes's conscious program in these passages, they betray unconsciously their logocentric bias. In so doing, they write a small episode in the history of writing (marked by the pen/typewriter antithesis) and offer an instance for "a new *psychoanalytic graphology*," not least because Barthes so recognizably rewrites

Rousseau's dangerous supplement—the alliance of writing and masturbation. In short, Barthes's texts reveal, as Derrida suggests must always be the case, the inextricability of western metaphysics even from a deconstructive text. Attempting to follow Derrida, Barthes instead rewrites what Derrida deconstructs, caught within the closure of metaphysics.

The scenario that I have begun to read in Barthes can be found in another set of texts, this time by Heidegger, and indeed, the legibility of the problematic of the hand that I read there is indebted to Derrida's work on Heidegger, in particular two essays, "Geschlecht: Sexual Difference, Ontological Difference," and especially "*Geschlecht* II: Heidegger's Hand." In the pages that follow, I can do little more than explicate texts in a manner to which Derrida has pointed, extending the argument a bit and focusing on the issues most pertinent to *Writing Matter*.[5]

Heidegger shares a distrust of the typewriter with Barthes, and there are no Japanese exceptions for him. In his 1942–43 lectures on Parmenides, Heidegger inveighs against the typewriter; for him, as for Barthes, it is a copying-machine and not a writing-machine. "Die Maschinenschrift . . . die Handschrift und damit den Charakter verbirgt. In der Maschinenschrift sehen alle Menschen gleich aus" (*Parmenides*, 119). Type hides the hand and all men appear the same in type, Heidegger claims; the sexist marker "*Menschen*" is worth remarking here, for, as with Barthes, the scene of writing is one that betrays phallic desire, although Heidegger does not invest that desire homoerotically; he writes, we might say, after Eve Kosofsky Sedgwick, the homosocial script of western culture, inflected here, as elsewhere, with the abstractions that would seem to guarantee the equation of universality with masculinity. As Derrida comments in "Geschlecht: sexual dif-

ference, ontological difference," Heidegger's neutralization of questions of sexual difference seems always to be implicated in the binarism that it apparently suppresses. Moreover, as Derrida comments, pursuing the multiplicities of the neutral "*Geschlecht*," (a word that means genus, sex, and race), Western culture for Heidegger inevitably has a Germanic cast, as much in his hand as the *Fraktur* that he wrote. "Typewriting . . . hides handwriting and, thereby, character": character, here, may mean both masculinity and national character. Yet, as the word "*Charakter*" cannot help but remind us, character is, precisely, a scriptive formation. Heidegger does not mark these multiple sexual and national meanings, and in his very silence he attempts to make character mean the human character; the scriptive duplication of terms also goes unremarked, despite the fact that the typewriter/handwriting contrast is how Heidegger writes a "history" of writing (" 'Geschichte' der Art des Schreibens," *Parmenides*, 119); for him, as for Barthes, the handmade mark betrays a nostalgia for the individual. It bears a nostalgia, too, for a style of German transcendental philosophy (and Romantic poetry)—for the human here, as in "Letter on Humanism," is essentialized (Heideggerian essentialism is, of course, an enormously complicated question, and I will want to move further than this blanket statement). The typewriter is the machine of a modernity that Heidegger repudiates.

More than nostalgia, as with Barthes's nineteenth-century attachments, is in question; indeed, the investment in the hand in Heidegger carries with it (despite itself) metaphysical and logocentric assumptions. Heidegger proclaims as essentially human the possession of the hand. Whereas for Barthes, the hand is continually invested as natural, and writing as material practice derives its materiality from the body, the hand for Heidegger is, at once, denaturalized and nonetheless quintessentially human. As he puts it in *Parmenides*:

Die Hand ist in einem mit dem Wort die Wesensauszeichnung des Menschen. Nur das Seiende, das wie der Mensch das Wort 'hat,' kann auch und muss 'die Hand' haben Kein Tier hat eine Hand Der Mench 'hat' nicht Hände, sondern die Hand hat das Wesen des Menschen inne, weil das Wort als der Wesensbereich der Hand der Wesensgrund des Menschen ist. [The hand is, along with the word, the essential mark of mankind. Only the being that, like man, 'has' the word, can and also must have 'the hand' No animal has a hand Man 'has' not hands, rather the hand holds [has] the essence of man within, since the word, as the essential domain of the hand, is the essential ground of man.] (118–19)

The denaturalization of the hand is a deconstructive gesture, and it is one that speaks powerfully against the "graphic impulse" in Barthes which seems to come from some notion of the naturalness of the pen and paper.

On the other hand, the attempt to define the human against the animal runs the risk of inscribing a transcendental difference in man and the activity of the hand, a biologistic determinism which, as Derrida implies, relates to Heidegger's nationalism ("*Geschlecht* II," 173; Heidegger "knows" this in "Letter on Humanism": "Every nationalism is metaphysically an anthropologism, and as such subjectivism," 221. As Derrida says, one must recognize that Heidegger's text is written with at least two hands, and not with the one hand that he proclaims). It runs that risk, moreover, since the passage, which makes language and the hand the marks of humanity, effaces the scene of writing implicit in this equation. A powerful repression of writing is at work.

The problematic in these sentences from the lectures on Parmenides can be glossed further with some remarks that appear early in *Was Heisst Denken?*:

The hand's essence can never be determined, or explained, by its being an organ which can grasp. Apes, too, have organs that can grasp, but they do not have hands. . . . Only a being who can speak,

that is, think, can have hands and can be handy in achieving works of handicraft. . . . The hand's gestures run everywhere through language, in their most perfect purity precisely when man speaks by being silent. . . . Every motion of the hand in every one of its works carries itself through the element of thinking. . . . All the work of the hand is rooted in thinking. (16)

This passage is not immediately elucidatory, although it seems clear that Heidegger's gestures here are, once again, antimetaphysical and yet nonetheless metaphysical. They are most significantly materialistic in their association of an essential humanity with the activity of the hand and sound a bit like Engels in his brief, exploratory essay, "The Part Played by Labour in the Transition from Ape to Man." There Engels argues that the hand played that crucial role in the evolution of primates and that speaking and thinking only followed the activity instituted by the hand (I will return to Engels; Heidegger's wary relationship to Marxism can be read in "Letter on Humanism"; for example, "The essence of materialism is concealed in the essence of technology," 220). Heidegger does not situate the material investment of the hand in the history of labor—he regards that history as entangled with Hegelian metaphysics, but within a philosophical conception.

What he means by "works of handicraft" can be understood, I think, by the discourse of the hand that appears in *Being and Time* (the Parmenides lectures explicitly recall the passages to which I will turn). Frank Lentricchia (in a discussion in *After the New Criticism*, 85–88, which mine frequently parallels) has applauded passages from that work precisely for the way in which whatever is meant by mind is rooted in the hand and in handiwork, and in the world defined as a workshop, which suggests the antimetaphysical and materialistic investment that is carried by the Heideggerian hand. Indeed, the hand is fundamental to the vocabulary of *Being and Time*, so much so that questions of being and temporality are con-

stituted through the crucial terms that run through the text, ready-to-hand (*zuhanden*) and its pair, present-to-hand (*vorhanden*). It is in the relationship between these two terms that the hand of the Parmenides lectures and *Was Heisst Denken?* is clarified.

Present-to-hand would seem to mean an ordinary mode of being in the world, an unthinking everydayness in which objects seem simply to be there as objects. Present-to-hand thus names the object within the dualisms of a Cartesian universe. Heidegger argues, on the contrary, that the mere objective existence of things is a derivative effect, following upon a failure of the ready-to-hand. That is, it is only in the refusal of things simply to be ready-to-hand, whether in their opacity or their unavailability, that an object seems simply to be there, present-to-hand. It arises, that is, in the failure of the ready-to-hand, a failure we might want to consider as a slip of the pen. For when Heidegger exemplifies the tools of handiwork, his random list opens upon the scene of writing: "In our dealings we come across equipment for writing, sewing, working, transportation, measurement. The kind of Being which equipment possesses must be exhibited" (*Being*, 97). And, further down the page: "Equipment—in accordance with its equipmentality—always is *in terms of [aus]* its belonging to other equipment: ink-stand, pen, ink, paper, blotting pad, table, lamp, furniture, windows, doors, room." "The kind of Being which equipment possesses" is revealed by connectedness, and by failures of connection, for connectedness does not lie in some mastering hand.

What arises at such moments of failure, Heidegger insists, is what is precisely ungraspable, a revelation not of the essential being of the object as divorced from the hand, but that the object is only when it is in hand. But that in-handedness of the ready-to-hand is not a function of the hand's ability to grasp. Unlike Hegel, as Derrida observes, Heidegger does not read the hand's grasp and conceptual grasping as on a continuum.

"If there is a thought of the hand or a hand of thought, as Heidegger gives us to think, it is not of the order of conceptual grasping" ("*Geschlecht* II," 173). As opposed to the Cartesian hand—and to the hand of technology—the Heideggerian hand is not the property of the subject who can master the object. In the double movements of the ready/unready-to-hand, the unveiling and veiling of the object within its essence occurs. Typewriting, and the typewriter, would seem to line up with the present-to-hand, a technological misconstrual that Heidegger labors to rewrite in "The Question Concerning Technology." In the Parmenides lectures, the typewriter is said to destroy language on two counts: by removing the hand from script, thereby objectifying writing and splitting it off from the subject, and by producing letters that are themselves unconnected from each other, thereby destroying a relatedness that defines the Heideggerian notion of essence. This is a scriptive essence, defined by the connections of the cursive hand.

"The hand is a peculiar thing," Heidegger remarks, in the passage I quoted above from *Was Heisst Denken?* (16). "In the common view, the hand is part of our bodily organism." But, as he goes on to say, the hand (and I am assuming that the "peculiar" hand is to be associated with the ready-to-hand) is, however bodily, not organic. Here, then, we can see a sharp contrast with Barthes, who invests strongly in physicality and nature, as if those were not constructed. If Heidegger demystifies the everyday and recognizes the constructedness of existence ("Perhaps thinking, too, is just something like building a cabinet," he remarks earlier in this passage), the hand that has been detached from nature and is distinguished from "paws, claws, or fangs" is denied its definition in the ability to grasp. And that which is ungraspable is the ready-to-hand, grasped perhaps most readily in moments of unreadiness; indeed, another name for it is thought, for, as Heidegger says throughout *Was Heisst Denken?*, we are not yet

thinking, and thinking would seem to lie elsewhere. It is the need for that elsewhere, however much it has been invested materially, which remains metaphysical, even if what is beyond the physical somehow arises from it or is still imagined through it or as it.

But not quite as an it. From the unready-to-hand to the ready-to-hand it is still the hand and the discourse of the hand that carries Heidegger's discourse, and if the hand cannot grasp being and if its present is always slipping away, the hand is nonetheless what is "had," and being lies in the hand if not present-to-hand. The contrast between the typewriter and the pen thus continues to speak to the contrast between the ready-to-hand and present-to-hand. If the typewriter facilitates, its facility would seem to stifle thought; it offers the illusion of communication and transparency, opening the entire public sphere that Heidegger relentlessly denounces for its inauthenticity. Yet Heidegger claims that typing *hides* the hand and obscures character; if so, its readiness-to-hand would also seem to have the qualities of unreadiness-to-hand that Heidegger claims to be necessary if one is to have a genuine relationship to the tool: "The peculiarity of what is proximally ready-to-hand is that, in its readiness-to-hand, it must, as it were, withdraw in order to be ready-to-hand quite authentically" (*Being*, 99). Heidegger designates three modes of unavailability that make the ready-to-hand unready and, therefore, able to read the derivativeness of mere presence-to-hand. "The modes of conspicuousness, obtrusiveness, and obstinacy all have the function of bringing to the fore the characteristic of presence-to-hand in what is ready-to-hand" (*Being*, 104). The typewriter, especially in its definition as that which hides the hand, would seem capable of making the break that Heidegger considers necessary if one is to pass from the present-to-hand to the ready-to-hand. The refusal to grant this capacity to the typewriter thus speaks to ways in which the natural—the hand—remains a metaphysical term in Heidegger. (Much the

same could be said about the arguments in "The Question Concerning Technology," in which the attempt to define the essence of technology refuses to locate a technological essence; technology is displaced as techne, techne rewritten as poetry. Once again, language and nature stand against the machine, yet this also means that within the Heideggerian discourse there should be no *essential* reason for devaluing the type-writer.) If, then, the typewriter must be denied for the sake of the hand, and the human, and the essential, it is nonetheless true that Heidegger's own analysis cannot provide terms for that break. For insofar as Heidegger's analysis is also aimed at a denaturalization, the typewriter might serve as an image for the hand on the other side of the break, though perhaps in putting it that way we are still caught choosing between ideas of the thing and the thing itself, a choice between idealism and empirical objects which is no choice at all, since they are the same.

And yet what is pertinent to this discussion is the fact that what lies on the other side of the break, the hand that holds human being within it, is insistently a hand and not, beyond that abstraction, an abstraction, not a Platonic idea (perhaps nothing like an idea at all). Being and writing are twined, and in ways that deny the metaphysical break that nonetheless seems to function in Heidegger. They meet in language. "The hand's gestures run everywhere through language," Heidegger continues in *Was Heisst Denken?*, "in their most perfect purity precisely when man speaks by being silent." Yet, a page later, Heidegger proclaims Socrates "the purest thinker of the West. . . . He wrote nothing" (17). Once again, as Derrida points out in "*Geschlecht* II" (179–81), Heidegger's text is riddled with double gestures. The hand in language, language that is not speech, could define language as writing, yet the hand cannot, on the other hand, be writing, or, at least, such is the explicit force of this example of Socrates, and there are numerous other passages in *Was Heisst Denken?* that

carry on a typical logocentric devaluation of the nonessenti-
ality of writing. Yet the materiality that Heidegger ascribes
to the ready-to-hand participates in writing; what else is the
path that withdraws and draws? A "long maneuver," as Der-
rida writes, "that makes the *path of thinking* and of the question
of the sense of Being a long and continuous meditation *of/on*
the hand" ("*Geschlecht* II," 177).

This inextricable relationship between Being and writing is
seen most easily in the explication of a sentence from Parmeni-
des that occupies the second half of *Was Heisst Denken?* Being-
in-the-hand is, almost exactly, Heidegger's formulation there,
for the master-sentence of Parmenides is " 'One should both
say and think that Being is' " (178), and, as Heidegger charac-
teristically pauses over every term in the sentence, he finds the
hand everywhere. "One should" means "needful"—it desig-
nates a mode of using—and the Greek word, Heidegger says,
derives its etymology from the hand (186); the hand of "one
should," however, is the hand that leaves alone: "So under-
stood, use itself is the summons which demands that a thing
be admitted to its own essence and nature, and that the use
keep to it" (187). This corresponds to the attitude towards
equipment in *Being and Time*: "Letting something be involved
is implied in the simplest handling of an item of equipment"
(404). One should therefore put one's hand into the hand that
holds the human within it. If the hand is characteristically
human, its humanity is a derivative quality; its essence thus
lies elsewhere in the hand that calls (that calls for thinking and
for the thoughtful handling that lets things lie). "The hand
designs and signs, presumably because man is a sign" (16);
the hand therefore points to the essence that points to it, the
circulation of the sign. (This is "*die Wesensauszeichnung*" of the
Parmenides lectures; it is important to recall too that the dis-
cussion of readiness-to-hand and equipment leads, in *Being
and Time*, to a consideration of the "sign" as equipment in
section 17.)

From "one should" in the sentence of Parmenides being ex-
plicated in *Was Heisst Denken?*, Heidegger proceeds to "say,"
finding that the Greek word here is the cognate of Latin *legere*
(198), a word that means both lay and read. For what lies be-
fore us to be gathered is, in both senses of the word, relation—
connection and tale-telling. Man is a sign that is already writ-
ten, his character lies at hand, to be gathered like the letters of
the alphabet (208), whose collation constitutes an act of read-
ing that is not simply phonetic transcription. It is more like the
cursivity of a script. Meaning is not in the sound but silent.
This "originary" script, then, is not phonetic. Gathering is
the act of thinking, yet what thinking thinks is the duality be-
tween Being and beings, a split, then, in the tautology "Being
is."

The duality in tautology is a primordial quality of lan-
guage for Heidegger, and language, at least in *Was Heisst
Denken?*, and despite all disclaimers, is written language, a
sentence from Parmenides, glossed, as often as not, by lines
of Hölderlin. Heidegger's etymological drive, at least in *Was
Heisst Denken?*, arrives repeatedly at scriptive origins, being-
in-the-hand. We seem, in other words, to be, once again, in
the nineteenth century, as Heidegger (like Victorian classi-
cists) seeks a moment—for Heidegger it is even before Aris-
totle and Plato—the originary moment of culture from which
the West has strayed.

Although Heidegger and Barthes may not seem ultimately
comparable, their attitudes towards the typewriter and their
attachment to the handwritten imply similar investments in
the hand, similar investments in logocentrism. Both are anti-
technological; the typewriter is opposed for the sake of the
human. Individual difference cannot be maintained if the hand
is not extended by the pen, if the marks are made by the intru-
sive machine. Yet, as I have been arguing, much in Heidegger
should recognize the machine, and the same could be said for
Barthes. For them, then, a logocentric atavism is to be found

in their attitude towards the typewriter and in their insistence on the hand. Heidegger, early in *Was Heisst Denken?*, writes explicitly that the search for thought is also the search for the essence of technology (14), but he cannot locate its essence elsewhere than in Being. Nor, finally, can Barthes. "The machine is dead. It is death" (227), Derrida writes in "Freud and the Scene of Writing," describing finally the mystic writing pad. It is death "not because we risk death in playing with machines" [which could be a way of saying what Heidegger and Barthes fear, the death of man] "but because the origin of machines is the relation to death." That origin, Derrida goes on to argue, is not other than the origin Freud himself ascribed to life in *Beyond the Pleasure Principle*. Life originates in death; the "being" of the machine (call it the typewriter) is the production of copies, not of originals; the typewritten page is not the product of the hand, and in its distance from life and nature it occupies a reproductive position. It is, in a word, the space of re-presentations. It intimates the secondariness of all origins, including the origin of life. "The machine—and, consequently, representation—is death and finitude *within* the psyche" (228), Derrida concludes.

Barthes would only put two fingers on it, refusing to allow his hands to be at the service of the machine. Heidegger would not use it at all. For him, the hand is so singular, and so essential, that it is, almost without exception, but one hand. Heidegger's insistence on the singularity of the hand is a mark of its abstract essence. As Derrida has commented, virtually the only time that Heidegger mentions the fact that man has two hands, it is to see them locked together in prayer ("*Geschlecht* II," 182). Nowhere does Heidegger consider the hand embracing another's hand. Nowhere is the abstract hand gendered save as the hand of man. Yet, the hand, in languages which do gender their nouns, is marked as feminine: *die Hand, la main, la mano, manus*. As the last two designations might suggest, the gendering of the hand is complex. In Latin and Italian,

the hand appears, by its ending, to be marked as male, yet it is female in gender. Is this a sign that confirms Heidegger in regarding the hand as primordial, virtually present in all language? Of the neutralization of sexual difference? Or a sign of difference which Heidegger cannot afford to recognize?

Here, with such questions, we seem to pass to psychoanalytic graphology from these brief attempts to locate Heidegger in the history of writing (the history of logocentrism and, in Barthes as well as Heidegger, the attempts, however baffled, to think beyond the closure of Western metaphysics). Freud's unpromising text on slips of the hand might therefore call for attention now, if only because it too repeats the problematic of the hand. Like Barthes and Heidegger, Freud's text registers attempts to think beyond the closure; indeed, it offers Derrida terms for his deconstructive strategies. These terms, however, must always be scrutinized since they can succumb to metaphysics—it is for that reason that Derrida borrows the notion of repression from Freud to describe the place of writing in Western philosophy, but cannot simply repeat the Freudian term since it represses writing too. Repression "contains an interior representation" ("Freud and the Scene," 196), Derrida writes, for what is repressed is neither forgotten nor remembered. It exists in and as writing, the writing of the machine that at once retraces; repressed memories are remembered, but one must emphasize the "re," both to account for the "original" and always unavailable writing (which is also and always its simultaneous effacement) as well as for the return to consciousness of the repressed. For consciousness "re-members" by a further act of reinscription. It does not unearth the repressed. It rewrites it. "Press" in repression is etymologically one with "press" in impression— or in the printing press; repression, even as a word, implicates the scene of writing, and the holding back of the "re" is, at the same time, the duplication of what is inscribed along the facilitating and blocked paths of the memory.

All of this, Derrida contends, can be read in Freud, yet what also can be read is the supposed truth beneath these scenes of inscription—the primal scene, to go no further. When Freud passes to readings of such sexual scenes, he bypasses the scene of writing which would keep one from ever arriving at the Freudian truth. This, as I mentioned earlier, is precisely the case in *The Psychopathology of Everyday Life*. Whereas texts contemporary with the first edition of that book had begun to regard the unconscious as a rebus (*The Interpretation of Dreams* is the most notable example), and thus to move towards the originary secondary script that Freud finally conceptualizes through the mystic writing pad, the book on parapraxes, rewritten over and again through the same time period, is curiously silent about this development. In each edition subsequent to the first in 1901, chapter 6 on slips of the hand swelled with new examples. Yet these are never taken to demonstrate anything that might not also be found in a slip of the tongue or in an instance of the forgetting of names. The chapter only comes after those parapraxes have been explored, and slips of the hand even take second place in the chapter the topic shares with mistakes in reading. Thus, although the terms of analysis are important ones for Freud (condensation, displacement among others), slips of the hand seem only to repeat what has been discovered in the analysis of slips of the tongue; writing would appear to be entirely secondary and instrumental, and the chapter operates in a fairly perfunctory manner, repeating solutions of a type that by then have become standard in the book. However the unconscious is manifest through them— for the slips allow for lapses in repressive mechanisms—the unconscious that is revealed in these slips is, on the whole, remarkably uninteresting, or, at the least, uninteresting to Freud as the site for any further revelations. What is, for the purposes of this inquiry, most remarkable is the failure of the scene of writing to intrude itself upon these slips in any overt fashion.

There is apparently no specific graphic discourse. Unlike Barthes or Heidegger, no invidious comparisons between pen and typewriter organize the observations of written slips of the hand. Freud's examples come from handwritten letters, but also from newspapers, books, and telegrams. The unconscious considered can be that of the writer or of the copyist, or even the compositor; no explicit distinctions are made at the level of nationality, class, or gender (although the examples do line up in quite remarkable—and unremarked—ways in terms of gender, and matters of class and nationality also do figure). Still, there is then no sense that any particular instrument intrudes itself more readily or speaks more naturally to or for the unconscious. These categorical absences at the theoretical level bespeak a powerful universalizing and totalizing tendency (and indeed the history of accretions to the text offers a local version of that since it gathers together the testimony of colleagues and even occasional anonymous readers, who confirm the truth of the text), and the failure to privilege or hierarchize suggests how endemic slips of the hand are, although nothing marks such slips as distinct from others or in any way originary. The unconscious, it would appear, is dehistoricized, dematerialized; although Freud recognizes that political conditions of censorship might occasion slips of the pen, these too can only be explained by the unconscious. Any writing practice, in any situation, can reveal its operations. Nonetheless, it is worth pointing out that Freud does not join Barthes and Heidegger in a polemic against technology, and that essential humanity has no fear of the machine as some inhuman domain.

Despite such ecumenism, *The Psychopathology of Everyday Life* is a powerfully repressed text. Thus, although Freud endorses Wundt's dictum "that we make slips of the pen more readily than slips of the tongue" (*Psychopathology*, 131), he does not follow Wundt in his claim that writing, as a mechanical activity less subject to conscious control, is thereby a less

inhibited activity than speaking. Rather, confirming the direction of his thought towards the writing-machine, Freud instead insists that conscious attention has nothing to do with the production of parapraxes; rather "a *disturbance* of attention by an alien thought" (132) explains all lapses, whether of the tongue or of the hand. That alienation, it seems fair to say, although Freud does not, has to do with the materiality of the signifier. Having insisted on the unconscious, the letter is repressed.

Similarly, when Freud offers personal examples in chapter 6, what they reveal about him seems to have almost nothing to do with lapses of the pen per se; his pen slips, writing October 20 instead of September 20 (116)—he desires a female patient to come a month sooner than her next appointment, and the slip is made while he keeps accounts. Elsewhere, there is another slip in writing a number when money has to be withdrawn for an ailing relative. Even if Freud does not go very far in analyzing these scenes, what seems possible to say about them would appear to have little to do with writing, and even as personal revelations they seem quite banal. So, too, does the scene of professional rivalry that dictates the mangling of the name of someone who had written an unfavorable review; perhaps the substitution occurred more readily because it took cover under the identical name of a gynecologist. And when a telegraphist mistranscribes a telegram from his publisher so that it seems to be about the body (rather than about books)—the message falls prey to "the telegraphist's hunger-complex" (129)—the unconscious explanation manages to ignore economic and class difference. Such readings of Freud's errors lead, then, to revelations of the sort we have uncovered in Barthes or Heidegger. But do they show his hand? What difference does it make that he writes O instead of S, that in withdrawing money he cuts off o when he meant to cut off 4, that in explaining the writing of *Buckrhard* (117) he cites in a footnote the murder of Cinna the poet, for his

name, in *Julius Caesar*? What is the place of the letter, or the literary, in these scenes of self-writing?

An analysis of Freud that goes beyond what he offers is, of course, possible. Autobiography may extend beyond the examples offered as his own. Mistakes made by other physicians may also be Freud's; "the doctor's relation to his mother must have been of decisive importance" (124), written about an anecdote offered by Hitschmann (whose name is elsewhere mangled as Hintschmann), surely reflects upon Freud himself, and the belladonna story is told at great length, communicating perhaps with the bungled action in chapter 8, when Freud puts morphine in an old woman's eyes. The worries about ailing relatives, women who don't come when they are wanted: perhaps these are stories about Freud's mother. Perhaps, too, the interweaving of episodes from various hands are rewritten in Freud's hand, and the panoply of others, named or anonymous, are still retracing the Freudian text. In "My Chances," Derrida raises such possibilities reading *The Psychopathology of Everyday Life*, suggesting that there may be unconscious communications in the text, unconscious representations (22). A primal scene of writing?

To read these stories about Freud as Freud would read them, we would arrive at Oedipus. The chapter on slips of the pen arrives, however, at another literary text, a passage from a Galsworthy novel (supplied by Dr. Hanns Sachs) in which the protagonist fails to sign a check as a way of extricating himself from a romance—and of getting his penurious male friend to arrive instead. No doubt the character's self-reflection, "you don't want to part with your money, that's all" (*Psychopathology*, 133), reflects on autobiographical revelations in the chapter, and goes beyond them. Money is never, we can be sure, all that such denials are about. But, again, it would seem that sexuality will explain everything. Will it explain the literary trajectory of the chapter, however? The choice of a text in which the hero states, as he "forgets" to

sign and refuses " 'a helping hand,' " that " 'the line must be drawn!' " (133)? What would it mean not to read Freud himself in these instances, but to read Freud's repressed signature, or to trace the lines, written and rewritten, in the chapter?

We would still be reading along Freudian lines, but in the direction of the *nachträglich*, of the rewriting, the supplementary postscript that constitutes the originary and primal scene. Chapter 4 in *The Psychopathology of Everyday Life* leads there, "Childhood Memories and Screen Memories." Its topic might seem out of place in a book on parapraxes, yet it is there, and not in the chapter on slips of the pen, that one encounters the question of psychoanalytic graphology, in a form, moreover, that might elucidate the question of why the only thing the unconscious seems to have on its mind is sexuality. The episode recounted there intimates (this is, of course, no surprise) that writing may be equated with textually determinate forms of sexuality. Explaining why a chapter on screen memories is not out of place in the book, Freud elaborates theories of substitution, repression, and re-impression that are also textual theories. Both forgetting and misremembering, effacement and replacement, come about in the same way, Freud claims, "by means of displacement along a superficial association," a "tendentious factor" (45). Here, that "alien effect" is a "verbal bridge" (49) or, more exactly, a slip of the hand, a transposition of the letter. As Freud insists, the quality of screen memories is their combination of an intense visual component coupled to a seemingly indifferent content. They have, he remarks, a "plastic form, comparable only to representations on stage" (47). If the drama is *Oedipus Rex*, it is the script of the play that is played as the screen memory. What it offers is "not the genuine memory-trace but a later revision of it" (47–48). Such second editions and replays are as close to primordiality as one ever comes.

Because screen memories are so deeply imbedded in the revisionary rewritings that dictate the subject, they are, Freud

says, difficult to extract from context. He has, however, one "good example" that can be lifted whole:

A man of twenty-four has preserved the following picture from his fifth year. He is sitting in the garden of a summer villa, on a small chair beside his aunt, who is trying to teach him the letters of the alphabet. He is in difficulties over the difference between *m* and *n* and he asks his aunt to tell him how to know one from the other. His aunt points out to him that the *m* has a whole piece more than the *n*—the third stroke. (48)

It is a lesson in sexual difference in which masculinity is equivalent to a supplementary stroke of the pen, a lesson in sexual difference, then, that depends upon the instrument of writing. "For just as at that time he wanted to know the difference between *m* and *n*, so later he was anxious to find out the difference between boys and girls" (48). It might suggest then, even if Freud is not this little boy, that he writes with a pen—and thus inscribes and reinscribes sexual difference as determinant. (The chapter ends with a long autobiographical moment, the screen memory of the child Freud screaming that his much older half-brother has locked his mother in a cabinet, and William Beatty Warner has examined the textual filiations of that screen memory for all the ways in which the oedipal reduction forecloses the endlessly revisionary quality of the "labyrinth of primal scenes," 97.)

The point about this exemplary scene I would argue is simply that sexual difference arises from the instrument of writing. The unconscious is an historical phenomenon. If it is written, it is, within Freud, or Heidegger, or Barthes, written by hand. The instrument held in the hand is all too easily phallic. Indeed penis and pencil are etymologically related. The scene that is inscribed on the psyche—the primal scene —is the scene of writing by hand. No wonder, then, that Derrida concludes "Freud and the Scene of Writing" by producing the primal scene in Freud's textual metaphors of the machine as male genitals, the paper as the body of the mother,

and the pathbreaking, breaching, violence, and resistance by which traces are produced as coitus (229).

Such, too, is the lesson Melanie Klein reads in her 1923 essay, "The Role of the School in the Libidinal Development of the Child," which Derrida cites with approval in the closing paragraphs of "Freud and the Scene of Writing," and immediately after his outline of a new graphology in *Of Grammatology*. With her patient Fritz, I and E play the role of M and N; Fritz has different explanations of the production of the Latin alphabet and German *Fraktur*; in Latin minuscules, " 'i' and 'e' are the same, only in the middle 'i' has a little stroke and the 'e' has a little hole"; in *Fraktur*, however, "e" has a "box" rather than a hole (64). These letters are male and female genitalia. But might not Fritz's box communicate with the cabinet in which Freud fears his mother has been locked? Six-year-old Ernst with his " 'I' box" (65)—an explicitly theatrical setting —may point in this direction too (male genitals trapped in female genitalia) and may help explain Freud's slips with O and o, just as Fritz's speculations on the letter S may explain why Freud wrote O instead of S. "In general he regarded the small letters as the children of the capital letters. The capital S he looked upon as the emperor of the long German s's; it had two hooks at the end of it to distinguish it from the empress, the terminal s, which had only one hook" ("Early Analysis," 100).

Klein reads in these childhood scenes anxiety about castration, an anxiety perhaps manifest when Freud has to clip the numbers and starts at the end of the line ("the line must be drawn"), rather than at the beginning. But everywhere too Klein reads ordinary life, walking on roads, riding on scooters, sailing on lakes, as scenes that are sexually invested because they are graphically invested: "For Fritz, when he was *writing*, the lines meant roads and the letters rode on motorbicycles—on the pen—upon them" ("Role of the School," 64). "For in his phantasies the lines in his exercise book were

roads, the book itself was the whole world and the letters rode into it on motor bicycles, *i.e.* on the pen. Again, the pen was a boat and the exercise book a lake" ("Early Analysis," 100). The pen, for Fritz, is, at once, a writing-*machine* and the phallus. Might his journeys by hand or on foot relate to Freud's preoccupations with travel? Or might Fritz's road be put next to Heidegger's text, not to reveal that sexuality is the truth of the path we are said to tread on the way to Being—a journey whose end will never come—but because the sexual way is also, and always already, graphic? We can perhaps only generalize the scriptive formation of Freud's text on slips of the hand because we do not know the encryptment of letters in his unconscious, but, at the least, Klein's text reveals that the unconscious (which she thinks is sexual) is rather graphic. For her, speech has a libidinal cathexis, and so too does all motor activity; in her young patients, these motor activities find their symbolic site in the hand, and even speech appears to be a derivative effect of this more generalized scripting of (human) being. For Fritz, as Klein reports in "Early Analysis," "we discovered that the spoken word was to him identical with the written. The word stood for the penis or the child, while the movement of the tongue and the pen stood for coitus" (100). She sums up: "Speech and pleasure in motion have always a libidinal cathexis which is also of a genital-symbolic nature. This is effected by means of the early identification of the penis with foot, hand, tongue, head and body, whence it proceeds to the activities of these members, which thus acquire the significance of coitus" (104).

But Klein's terms of analysis also lead in another direction: to a primal scene of (re)writing in which the body and the world is scripted. It is for this reason that Derrida suggests that "a certain privilege should be given to research of the psychoanalytic type. In as much as it touches the originary constitution of objectivity and of the value of the object. . ." (*Gram*, 88). The object is as "originary" here as it is in Hei-

degger's scene of handiwork and the ready-to-hand of the pen and paper, the lamp and the room. Or, as Klein suggests, everything starts with the letter I, up and down, in and out, subject and object, and even the I Klein regards as derivative from a nonphonetic originary script: the writing of the unconscious ("Role of the School," 66). The "privilege" of a psychoanalytic graphology, therefore, does not privilege the psyche or the discipline of psychoanalysis. It leads, rather, to a recognition of the ways in which being (human, material) is scripted. Within the logocentric script of the West, it leads to the hand.

It is the hand, as noted earlier, that Engels, in "The Part Played by Labour in the Transition from Ape to Man," situates in his evolutionary scheme as the site of humanity. "Engels's speculation," Elaine Scarry comments in *The Body in Pain*, "that the crucial location of the transition from ape to man had been in the hand, the organ of making, rather than in the skull, the attendant of the organ of thinking, has after many years been confirmed by the discoveries of anthropologists" (252). It is confirmed, too, by André Leroi-Gourhan in *Le Geste et la Parole*, whose argument Derrida summarizes: "the slow transformation of manual motricity which frees the audio-phonic system for speech, and the glance and the hand for writing" (*Gram*, 84). For Engels, primate evolution first separates the foot and the hand (a separation that psychoanalytic graphology rejoins); the hand, then, evolves from an organ for the "collection and grasping of food"—and as the wielder of "clubs to defend themselves against enemies"—to the hand that makes. "No simian hand has ever fashioned even the crudest of stone knives." It is in the handmade that the hand is made human. The artifactual lends itself to the hand, and the hand is thereby liberated: *"the hand had become free."* Through the labor of its making, it is made: "Thus the hand is not only the organ of labour, *it is also the product of labour"* (Engels, 2: 81).

This evolutionary scenario locates a primordial hand that bears comparison with the Heideggerian hand; its investment in materiality also marks a separation from the merely organic paw of the ape. But what returns to the hand in the circle of labor is not, as it is for Heidegger, an essential connection with relatedness to being; it is rather the artifactual that extends the hand into matter and that is returned to the hand as its materiality. Engels's point is, of course, related to Marx's speculations about an originary scene: of man and the land. At a number of points in the *Grundrisse*, that relationship, although posited as an originary Cartesian dualism of subject and object, is transformed by labor. And in labor, it is not only the land that is changed (appropriated, made human property), but the laborer as well: "However great the obstacles the land may put in the way of those who till it and really appropriate it, it is not difficult to establish a relationship with it as the inorganic nature of the living individual, as his workshop, his means of labour, the object of his labour and the means of subsistence of the subject" (Marx, 71). Nature, Marx writes, lies "to hand" (85), yet the primordial connection between the laborer and the land is an inorganic one (a unity of the "objective" nature of the land and the "objective," that is, inorganic, nature of the subject). Thus, in *Capital*, Marx endorses the definition of man as a tool-making animal. The originary human is the laborer, engaged in re-production through the inorganic, material reproduction—of objects and of the subject-as-object, original duplication.

Engels indulges in a Lamarckian fantasy of the evolutionary inheritance of acquired manual dexterity; what needs to be said instead is that human evolution, from the point of the emergence of the human-in-the-hand, has taken place through the labor of the hand, through the extension of the hand into the world through the instrument, the tool, the machine. Engels's essay allows one to think that the origin of the human hand is one with the machine. It is when the

stone becomes a knife in the hand that the human arises, and, although Engels does not pursue this point in the direction that I would now, it is important to recall that graphesis and incision are etymologically one. From the knife to the implement of writing, one travels a short distance, the distance, for Leroi-Gourhan, that marks the arrival of the human. "The emergence of the graphic symbol at the end of the paleo-anthropic era implies the establishment of new relationships between the two operative poles [of the hand/tool and the face/language], relationships exclusively characteristic of humanity in the narrow sense of the term" (1: 262). Animals, Leroi-Gourhan goes on to say, have tools and language, but this particular connection in written marks denotes the elementary difference: "rien de comparable au tracé et à la lecture des symboles n'existe jusqu'à l'aube de l'*homo sapiens*."

This is, of course, not the direction that Engels follows, since it would make alienated labor coincide with primordial humanity; as Gayatri Chakravorty Spivak also has argued, it would found the human in an "essential" displacement, reading on a continuum from primordial economies to capitalism "the disturbingly graphic concept of the severing of the worker from his own extended body," as Scarry puts it (250), in a phrase that I would read literally. Yet, labor, as Engels (or Scarry, for that matter) describes it is thereby essentialized through fantasies of unity with nature (Scarry insists on "sharability") that are in fact broken by the activity of the hand, rendering thereby the distinction between use-value and surplus-value problematic as well. If humanity begins in reproduction, there is excess at the start. Were one to align the Heideggerian displacement of the human with Engels's materialism, one could perhaps arrive at the "essential" hand deprived of metaphysical investment. Indeed, much in Engels's essay reads in that direction, not least by making the development of the brain a secondary phenomenon, and by granting no privilege to speech in the formation of the

human. "In short, men in the making arrived at the point where *they had something to say* to one another" (Engels, 83). Speech is a derivative effect of the labor of the hand, through which primitive community is founded; speech, shared with the parrot, is no primordial mark of humanity. The materialist foundation of the human here, as in *The German Ideology*, lies in its insistence that intellectual constructions follow from material ones. Engels insists that the activity of the mind follows the hand, that "that idealistic outlook on the world" (87) represents the effacement of materiality. He insists, too, that one recognize the production of cultural objects as the work of the hand. "Only by labour . . . has the human hand attained the high degree of perfection that has enabled it to conjure into being the paintings of a Raphael, the statues of a Thorwaldsen, the music of a Paganini" (81–82).

These are aspects of what Derrida calls "graphic power" (*Gram*, 92), the inseparability of writing and power and its ideologies. Thus, if Marxist materialism cannot be reduced immediately to the deconstructive project, since that materialism (as in the primordial fantasies about the hand in Engels or in Marx's pastoralism in *Capital*) can easily be accused of essentialist sentimentality, deconstruction cannot be lined up in solidarity with a merely philosophical/intellectual critique. Rather, Marxist materialism can communicate with deconstructive protocols once the hand of Engels is relocated within a graphic discourse—not, it should be added, the direction that Scarry takes when she seizes upon the pencil "endowing the hand with a voice that has more permanence than the speaking voice, and relieving communication of the requirement that speaker and listener be physically present in the same space" (254).

Scarry partially counters any sentimental reading of the human hand when she insists that nothing of humanity is lost as "artificial hearts, hips, wombs, eyes, grafts, immunization systems" (253), products of the hand, return to the human:

"The presence of such man-made implants and mechanisms within the body does not compromise or 'dehumanize' a creature who has always located his or her humanity in self-artifice" (253–54). Yet this leads Scarry to a phenomenology that is more than a bit related to Barthes's scenes of bourgeois acquisitiveness. To prove that the world at hand is the hand-made world, Scarry lists those objects of bourgeois comfort that make the world human. The argument, I think, needs to be turned around. "The socialization of sentience" (255), as Scarry terms it, the artifactual nature of human experience, is not an immediate confirmation of the phenomenological world; it is just the opposite. As Marx comments in the *Grundrisse*, although the land may stand as "an *objective mode of existence . . . antecedent* to his activity, . . . as much a precondition of his activity as his skin, his senses . . . what immediately mediates this attitude is the more or less naturally evolved, more or less historically evolved and modified existence of the individual as *a member of a community*" (81). Immediate mediation like originary reproduction also must resituate the originary scene of subject and object; activity and life, being, begin in those duplications. There is no world out there, no inhabited body, before them. This non-originary origin has the structure that Derrida calls writing, the structure that Leroi-Gourhan identifies as an originary duplication. Like the Freudian primal scene, the Marxist originary moment reads *nachträglich*, towards an impossible arrival at a singular moment that has always already been divided by the intrusive gesture of the hand, the link and the break, the writing and the erasure of an essential humanity. The impossible task of a new graphology, Derrida describes: "We must attempt to recapture the unity of gesture and speech, of body and language, of tool and thought, before the originality of the one and the other is articulated" (*Gram*, 85). This is the unity of the *gramme*, and it shatters every metaphysical preconception.

Thus, Engels's withering remarks on idealism need to be

read against Scarry's phenomenology, to reroot it in the social/material, but Engels (or Marx) must also be read against themselves when their materialism is idealistically invested in notions of primordial community, essential labor; this is not, I would hasten to add, to argue against the materialist point of view, but to resituate it. To reveal the hand in all its investments, including the investment in the hand as primordial humanity and materiality, need not be to deny the insights of Marxism, but to extend them beyond their situation within an inescapable Hegelianism, or within the teleological evolutionary scheme writ large in Engels's essay.

Engels's essay, like *Grammatology*, allows us to think that investments in writing by hand have a history that may be as long as the west. The terms of the Freudian unconscious, for example, are perhaps first available when writing by hand becomes a more general phenomenon in the Renaissance, when writing is not simply the privilege of monks and scribes. Even Lacan, in the closing pages of "The Agency of the Letter," summons up the name of Erasmus to indicate the beginning of a shift in the nature of the unconscious allied to changes in the practice of writing: "The slightest alteration in the relationship between man and the signifier, in this case in the procedures of exegesis, changes the whole course of history by modifying the moorings that anchor his being" (*Ecrits*, 174). Erasmus is a well-chosen name, for were we to return now to the fable offered about the origin of the alphabet in *De recta Graeci et Latini sermonis pronunciatione*, it would be to remember who was born in the line of those alphabetic teeth of Cadmus—mythical founder of Thebes, Cadmus sowed that line with those teeth: Oedipus was among his progeny.

Our program here might close instead with another confession of Roland Barthes, one that (re)writes these primordial

scenes of writing. It is a parenthesis in "*faute de frappes*": "In what I write by hand, I always make only one mistake, though a frequent one: I write *n* for *m*, amputating one leg—I want letters with two legs, not three" (*Barthes*, 97). It is with M that Barthes closes his essay on Erté, "the inhuman letter" (*Responsibility*, 128), connected with "love and death (at least in our Latin languages)"—and with man in Germanic tongues; connected, either way, with castration. Not anthropomorphized in Erté's alphabet, and therefore, not *feminized* (what else is the body for Barthes?), M is, Barthes concludes, "the loveliest object imaginable: a script." And when the hand writes N for M? We return to the mirror with "N, the specular letter par excellence" (*Responsibility*, 125), N the truth of M. Ready-to-hand in the writing implement par excellence, the pen: "In the end," Barthes tells his interviewer in *Le Monde*, "I always return to fine fountain pens. The essential thing is that they can produce that soft, smooth writing [*cette écriture douce*] I absolutely require [*à laquelle je tiens absolument*]" (*Grain*, 178). Barthes holds—absolutely—his being in his hand; he rewrites the screen memory of sexual difference.

What it would mean to write otherwise, we hardly yet know. "Now, a certain form of support is in the course of disappearing, and the unconscious will have to get used to this, and this is already in progress" (*Post Card*, 105). It is reported that Derrida has only now just begun to compose his texts on a word-processor. What form will a psychoanalytic graphology take when texts are no longer produced by phallic instruments, when it is no longer the flow of liquid onto the page that produces traces? It is—as the examples considered in this chapter would seem to suggest—too soon to be able to answer such questions except in a speculative mode. But, when one thinks about *these* pages, with their insistent gestures (note that word), posing questions on the one hand (note that), desiring to arrive at a point (note that, too) on the other (to get a second hand in here), one sees that the play-

ful supports of this piece of writing—and they are already no more than that—might someday no longer be a recognizable structure.

It has been a long time now since I wrote by hand. For many years, I wrote at the typewriter. The fantasy was that language was there in the keys and that striking them would release the text (Michelangelo's fantasy about the stone that contained the statue, transferred to the machine, but still a logocentric fantasy). But now the fantasy is that somewhere there is (or someday there will be) a program, and rather than having to write oneself, the machine will be able to do it. Considering the opprobrium that so-called "computer prose" has already elicited, it is clear that, for some, that day has arrived. Perhaps it is here. A machine wrote this.

REFERENCE

MATTER

1. There is no lack of books for anyone needing basic orientation in Renaissance paleography—texts teaching techniques of decipherment, like those of Dawson and Kennedy-Skipton or Tannenbaum; anthologies of scripts like Fairbank's *A Book of Scripts* or his and Wolpe's *Renaissance Handwriting*; the collections of literary hands assembled by Greg or Petti; histories of developments, often geared to Italy, as in Osley's *Luminario*; others to specific developments in England, like Fairbank and Dickins, *The Italic Hand in Tudor Cambridge*, or Heal's book on English writing masters, or Jenkinson's survey of the system of hands used in documents. Among the most useful of these books are those by Joyce Whalley, as well as the catalogue she edited with Vera C. Kaden, and the equally informative catalogue, *Two Thousand Years of Calligraphy. Scribes and Sources (S&S* throughout the text), ed. A. S. Osley, is an indispensable source of information and provides translations from a large number of continental manuals (it also has an informative section on England, edited by B. Wolpe). I have relied on it throughout.

Much of the work in twentieth-century paleography owes its impulse to the revival of italic in modern times, a program with a fairly transparent ideological agenda. Fairbank gives a brief history starting with William Morris's imitations of Arrighi in "Cursive Handwriting," in *The Calligrapher's Handbook*, and Renaissance models are favored in Fairbank's *A Handwriting Manual* for their legibility and beauty—and as social and moral discipline: "Some teachers have re-

marked upon the improved morale of a class when handwriting has been taught with understanding. As the act of writing legibly imposes control and self-discipline it is not surprising that there should be some overlap" (16). Fairbank echoes claims made, for instance, by Edward Johnston, perhaps the most important modern figure in the revival of Renaissance hands; Priscilla Johnston quotes her father in the introduction to his papers, *Formal Penmanship*: "Our aim should be, I think, to make letters live . . . that men themselves may have more life" (9), sentiments reproduced in Osley's introduction to *Scribes and Sources*, who reports that with the instruments of writing to hand "the gates of the inexhaustible treasure-house of the Western alphabet—perhaps the most far-reaching and attractive device of the human mind to appear in the interval that separates the inventions of the wheel and the printing-press—lie open" (13), open, Osley insists, to all: a "democratic" art for those whose ruled hands subscribe to the treasures of the alphabet.

The alphabetic prejudice has been most successfully countered by Roy Harris in *The Origin of Writing*, a book that recognizes some of the implications of Derrida's critique. Among more conventional paleographers, Stanley Morrison's *Politics and Script* comes closest to the aims of *Writing Matter* and to the work of Armando Petrucci. Morrison details the thesis that "for a script to have authority it must be imposed by authority" (144), charting, in particular, the history of Roman capitals through the twentieth century and the ideological functions they have served (evident most recently in Nazi Germany). Morrison attempts to correlate, perhaps a little too insistently, the ideological function of scriptive elements, such as the use of serifs; he discusses how the humanist "revival" of antique letters succeeded through the authority of the church and state in Renaissance Italy, and the diffusion of such authority to "attendant chanceries and corps of intellectuals, poets, litterateurs" (263). For Morrison, the decisive shift towards humanist hands, and the empowering of humanists, is connected to the emerging authority of the state and, in particular, to Cosimo de Medici's patronage of Poggio Bracciolini and Niccolo di Niccoli.

2. Goody's views were first developed in "The Consequences of Literacy," co-authored with Ian Watt. Here, literacy is causative, and true literacy is associated with the Greeks and the alphabet (as

opposed to the writing systems of the Egyptians, for example); the alphabet brings with it history, rationality, democracy, and the individual. Throughout the essay, too, there is a strong nostalgia for the lost face-to-face sociality of the oral. In *The Domestication of the Savage Mind*, Goody engaged some of the criticism that can be leveled at this earlier essay, noting the ethnographic bias in its celebration of Greek literacy to the exclusion of other kinds of literacies and recognizing that writing cannot be separated from social institutions. Yet these recognitions do not go far, and within the space of a paragraph one finds Goody writing "I am not attempting to put forward a simple, technologically determined sequence of cause and effect" (10) and "The significance of technological factors has to be judged independently of such ideological considerations" (11), which frees him to repeat most of the arguments made in the earlier essay. Thus, although he does "not mean to imply that pre-literate societies are without history, mathematics, individuals or administrative organisations" (19), that remains his argument. "The specific proposition is that writing, and more especially alphabetic literacy, made it possible to scrutinise discourse in a different kind of way by giving oral communication a semi-permanent form; this scrutiny favoured the increase in scope of critical activity, and hence of rationality, scepticism, and logic" (37). In *The Logic of Writing and the Organization of Society*, Goody once again tries to modify his earlier position, this time by emphasizing the forms of society that relate to the existence of writing. In fact, the ethnographic bias is even stronger; the written religions of the Judeo-Christian tradition now become the repositories of a permanent and universal truth (11); with religion, as with economics, law, and government, ideological effects are treated as inherent in writing and used to explain the rise of states or advanced economic systems. Goody's most recent book, *The Interface Between the Written and the Oral*, opens with a chapter narrating the triumph of the alphabet, and closes: "Cognitively as well as sociologically, writing underpins 'civilization,' the culture of cities" (300), scare quotes only going so far to register the ideology of Goody's literacy.

Although written from the perspective of an unexamined notion of "consciousness," Robert Pattison's *On Literacy* does argue, from a historically informed position, against the most excessive claims

of a theoretician like Goody. The Greek biases in the definitions of true (alphabetic) literacy in Goody or Havelock are effectively answered in an essay by Anna Murpurgo Davies that shows that every claim made for alphabetic script can also be found in Sumerian inscriptions.

3. In the discussion of Vesalius, I draw upon two recent essays, by Glenn Harcourt and Luke Wilson, that appeared in *Representations* 17. I follow Harcourt's conclusion that the antique statuesque illustrations in the *Fabrica* answer to "Vesalius's rhetorical attempt to establish the *opera manus* . . . as the pristine philosophical ground of medicine in general" (52), although Harcourt's assertion of an evasive quality in the visual representation of the violated body needs, I think, to be countered through an argument like the one that Devon Hodges makes in *Renaissance Fictions of Anatomy*, which is more alert to the violence of representation. So, too, Wilson's reading of the frontispiece to the *Fabrica* too easily dissolves the textual into the corporeal, although I depend upon his account of the economies relating the living and dead members, as well as his reading of the social scene of class difference in the performance of the anatomist. More to the point seems to me Francis Barker's reading of Rembrandt's *Anatomy of Dr. Nicolaas Tulp* and the analysis of that painting by William Heckscher that stands behind it. Heckscher argues for the pertinence of the Vesalius frontispiece to the Rembrandt and characterizes Vesalius as "a veritable cultist of the hand" (73; an assertion easily verified by reading his prefatory letter to Charles V, translated in C. D. O'Malley's biography); Heckscher continues: "Vesalius was proudly conscious of having paved the way for his revolution in anatomy when, as an undergraduate, he performed a feat hitherto unattempted: the dissection of the muscles of the human hand" (73). Thus, as Heckscher argues, anatomical procedures do not begin with the hand (66), but Vesalian anatomy, in a certain respect, does.

The relationship between the anatomical hand and the hand writing is suggested, too, by Richard Haydocke's prefatory remarks in his translation of Lomazzo's *Trattato del l'Arte de la Pittura* (1584). Haydocke was a "student in physik," as is announced on the title page of *A Tracte Containing the Artes* (1598), and he excuses his work of the hand—translating Lomazzo—and its work of the hand (paint-

ing, which, in Lomazzo's definition, is the essence of handwriting—
"non essendo le scritture altro che pittura di chiaro & d'oscuro," 3)
—by arguing for the "preservative" value of works of art; the lines
of painting outlive the line of death (iiir). Haydocke's surgical/ana-
tomical/artistic hand thus operates within the sphere of the hand in
Vesalius. The Aristotelian text, and its further elaborations (for ex-
ample, by Cicero in *The Nature of the Gods* II. 150–52), are part of this
system too. The Aristotelian definition of the quintessential hand
is repeated frequently in anatomies; in *L'Edificio del Corpo Humano*
(1550), Francesco Sansovino defines the hand as "instrumento di
tutti gli altri instrumenti" (37) and cites the opinion of Anaxago-
ras; Colombo's *De Re Anatomica* (1559), an enormously influential
text, similarly defines the hand as "organum . . . organorum" (156),
crediting Galen and Aristotle; John Banister's *The Historie of Man*
(1578), derived from Colombo, adds Vesalius to the company of
authorities for his definition of the hand as "the organ of organes"
(108). The definition also appears in Thomas Tomkis's play about
the battle of the senses, *Lingua: Or The Combat of the Tongue* (1607), in
which Tactus announces himself through the hand, "the instrument
of instruments" (I2v).

As their titles suggest, the various *Blasons anatomiques* published
during the sixteenth century share in this discourse of the hand.
These books, as Nancy J. Vickers's forthcoming study will make
clear, dismember bodies in the service of gender economies. In
them, "good" and "bad" members (like the hands in handwriting
manuals) are displayed (some are illustrated in Alison Saunders's
The Sixteenth-Century Blason Poétique); as Vickers has observed to me,
the *same* illustration depicts both the good and bad member. This
is not quite the case in the illustrations in the handwriting manu-
als (although the differences are not all that apparent), yet there are
points worth comparing: first, dismemberment; second, doubling
(the handwriting manuals often depict two "good" hands—those
for the italic and the secretary). These representational strategies,
which violate the body in order to represent it and which disem-
power the hand in order to empower it in its "own" sphere, are
especially legible when the hand (or any other member) is gendered
female, a point to which I will return below.

4. The epistemological shifts entailed in the charting of the uni-

versal character are studied in Murray Cohen, *Sensible Words*, which demonstrates the ways in which empiricism and idealism are joined through a "development of the typographic technology used to represent linguistic thought in England" (34), charts of the sort anticipated in Bales's lists, which reduce the world of sensible objects to their universal categories and assign them their unifying marks. Some of the intellectual history and political situation of these universal language schemes are sketched in Vivian Salmon's *The Study of Language in 17th-Century England*, while an extraordinary reading of later developments in the joint projects of stenography, history writing, and the "democratization" of knowledge is offered by Linda Orr in "The Blind Spot of History: Logography."

5. Derrida has extended his arguments in *De l'esprit*, which recalls the "Geschlecht" essays on pp. 27 ff., in order to situate them within the problematic of "*Geist*" in Heidegger and the complicities of metaphysics with Nazism. One route that Derrida follows involves pursuing the argument that contrasts the human with the animal and that endows the human with spirit, unlike the animal (see chapter 6 passim); the arrival along this path is in a "humanist teleology" (87), which, however much it may seek to oppose the biologism and racism of Nazism, reinstates it within a metaphysics of the hand. As Derrida shows, the Heideggerian path from *Being and Time* through the Rectorate's address is one that finds its "leader" (that is, *Führer*) and a destiny and destination that has been "imprinted" with the "German character" (57–58).

Heidegger's situation of the typewriter is endorsed and historicized in Friedrich Kittler's "Gramophone, Film, Typewriter," a frequently brilliant exploration of the ways in which the "human" has been technologically constructed through the abilities of storage and retrieval that differently mark the tools of writing, hearing, and seeing: "What we take for our sense perception has to be fabricated first" (103). Kittler's focus is on the nineteenth-century transformations, from handwriting to writing machines; he does not sentimentalize the hand, recognizing the fantasmatic "individual" produced by script: "Typewriters do not store an individual, their letters do not transmit a beyond which could be hallucinated by perfect alphabets as meaning" (113). Nonetheless, his resolute opposition to all technologies—which he sees heading towards the final

nuclear apocalypse—does not seem to be founded in a recognition of what is being endorsed through these blanket oppositions; the approval of Heidegger's anti-technologism is one sign of this. Kittler is quite provocative when he aligns the Lacanian psychotopology of the Imaginary and the Symbolic to technological instruments and their production of lived bodily and psychic experience.

Far less interesting, except as one more instance of the sentimental endorsement of the hand/writing and its anti-technological "humanism," is Reginald Gibbons's "Writing at the Computer."

PRINTED WORKS CITED

Throughout the text, *S&S* refers to A. S. Osley's invaluable *Scribes and Sources*.

Akrigg, G. P. V., ed. *Letters of King James VI & I*. Berkeley: Univ. of California Press, 1984.

Alpers, Svetlana. *The Art of Describing*. Chicago: Univ. of Chicago Press, 1983.

Alphabeta et Characteres. Frankfurt, 1596.

Aristotle. *On the Parts of Animals*. Trans. W. Ogle. London: Kegan Paul, French & Co., 1882.

Arrighi, Ludovico. *La Operina* (1523). Facsimile in Ogg, q.v.

Ascham, Roger. *The Schoolmaster*. Ed. Lawrence V. Ryan. Ithaca: Cornell Univ. Press, 1967.

Auerbach, Erna. *Tudor Artists*. London: Univ. of London, The Athlone Press, 1954.

Ayres, John. *A Tutor to penmanship, or The Writing Master*. London, 1698.

Backhouse, Janet. *John Scottowe's Alphabet Books*. Menston: Scolar, 1974.

Bales, Peter. *The Writing Schoolmaster* (1590). Facsimile. New York: Da Capo Press, 1969.

Banister, John. *The Historie of Man*. London, 1578.

Barker, Francis. *The Tremulous Private Body*. London: Methuen, 1984.

Barrett, John. *An Alvearie or Quadruple Dictionarie*. London, 1580.

Barthes, Roland. *The Empire of Signs*. Trans. Richard Howard. New York: Hill & Wang, 1982.

————. *The Grain of the Voice*. Trans. Linda Coverdale. New York: Hill & Wang, 1985.

————. *The Responsibility of Forms*. Trans. Richard Howard. New York: Hill & Wang, 1985.

————. *Roland Barthes*. Paris: Seuil, 1975. Trans. Richard Howard. New York: Hill & Wang, 1977.

Beale, Robert. *A Treatise of the Office of a Councellor and Principall Secretarie to her Majestie*. In Read, q.v.

De Beau Chesne, Jean. *La Clef de l'Escriture*. London, ?1595.

————. *Le Tresor d'escriture*. Lyon, 1580.

De Beau Chesne, John, and John Baildon. *A Booke Containing Divers Sortes of Hands* (1570; facsimile ed. 1602). Norwood, N.J.: Walter J. Johnson, 1977.

Bec, Christian. *Les Marchands Ecrivains: Affaires et Humanisme à Florence 1375–1434*. The Hague: Mouton, 1967.

Billingsley, Martin. *The Pens Excellencie or The Secretaries Delight*. London, 1618.

Bourdieu, Pierre, and Jean-Claude Passeron. *The Inheritors: French Students and Their Relation to Culture*. Trans. Richard Nice. Chicago: Univ. of Chicago Press, 1979.

————. *Reproduction in Education, Society, and Culture*. Trans. Richard Nice. London: Sage, 1977.

Breton, Nicholas. *A Poste with a madde Packet of Letters*. London, 1602. Rev. ed. 1605.

Bright, Timothe. *Characterie: An Arte of shorte, swifte, and secrete writing by Character*. London, 1588.

Brinsley, John. *Ludus Literarius: Or, The Grammar Schoole*. London, 1612.

Broos, B. P. J. "The 'O' of Rembrandt." *Simiolus* 4 (1970): 150–84.

Brown[e], David. *The Introduction to the true understanding of the whole Arte of Expedition in teaching to write*. 1638.

————. *The New Invention, Intituled Calligraphia: Or, The Arte of Faire Writing*. St. Andrews, 1622.

Bullokar, William. *The Amendment of Orthographie for English Speech*. London, 1580.

Bulwer, John. *Chirologia: or the Naturall Language of the Hand . . . [and] Chironomia: Or, the Art of Manuall Rhetoricke.* London, 1644.

Burke, Peter. "The Uses of Literacy in Early Modern Italy." In *The Social History of Language,* ed. Peter Burke and Roy Porter. Cambridge: Cambridge Univ. Press, 1987.

Caracters and Diversitie of Letters Used by Divers Nations in the World. Frankfurt, 1628.

Cecil, Robert. "The State and Dignity of a Secretary of State's Place, with the Care and Peril Thereof." *Harleian Miscellany* 5 (1810): 166–68.

Cellebrino, Eustachio. *Il modo d Imparare di Scrivere lettera merchantescha* (1525). Facsimile. Ed. Stanley Morrison. Paris: Pegasus Press, 1929.

Chalmers, Alexander. *General Biographical Dictionary.* London, 1812.

Christensen, Jerome. "Setting Byron Straight: Class, Sexuality, and the Poet." In *Literature and the Body,* ed. Elaine Scarry. Baltimore: Johns Hopkins Univ. Press, 1988.

Cicero. *The Nature of the Gods.* Trans. H. C. P. McGregor. Baltimore: Penguin, 1972.

Clanchy, M. T. *From Memory to Written Record: England, 1066–1307.* Cambridge, Mass.: Harvard Univ. Press, 1979.

Clement, Francis. *The Petie Schole* (1587). Facsimile in Robert Pepper, *Four Tudor Books on Education.* Gainesville, Fla.: Scholars' Facsimiles & Reprints, 1966.

Clifford, James, and George E. Marcus, eds. *Writing Culture: The Poetics and Politics of Ethnography.* Berkeley: Univ. of California Press, 1986.

Cohen, Murray. *Sensible Words: Linguistic Practice in England 1640–1785.* Baltimore: Johns Hopkins Univ. Press, 1977.

Coleman, Christopher, and David Starkey, eds. *Revolution Reassessed.* Oxford: Clarendon Press, 1986.

Colombo, Renaldo. *De Re Anatomica.* Venice, 1559.

Conretto da Monte Regale. *Un novo et facil modo d'Imparar'a Scrivere.* Venice, 1576.

Coote, Edmund. *The English Schoole-Master.* London, 1596.

Cresci, Giovan Francesco. *Essemplare di piu sorti lettere.* Ed. A. S. Osley. London: Nattali & Maunce Ltd., 1968.

————. *Il perfetto Scrittore*. Rome, 1571.

Cressy, David. *Literacy and the Social Order: Reading and Writing in Tudor and Stuart England*. Cambridge: Cambridge Univ. Press, 1980.

Cupids Messenger. London, ?1638.

Curione, Ludovico. *Lanotomia delle Cancellaresche corsive*. Rome, 1588.

Danielsson, Bror, ed. *John Hart's Works*. 2 vols. Stockholm: Almqvist & Wiksell, 1955, 1963.

Davies, Anna Murpurgo. "Forms of Writing in the Ancient Mediterranean World." In *The Written Word: Literacy in Transition*, ed. Gerd Baumann. Oxford: Clarendon Press, 1986.

Davies of Hereford, John. *The Writing Schoolemaster or the Anatomie of Faire Writing*. London, 1636.

Dawson, Giles E., and Laetitia Kennedy-Skipton. *Elizabethan Handwriting 1500–1650*. New York: W. W. Norton, 1966.

Day, Angel. *The English Secretary* (1599). Facsimile. Ed. Robert O. Evans. Gainesville, Fla.: Scholars' Facsimiles & Reprints, 1967.

————. *The English Secretorie* (1586). Facsimile. Menston: Scolar Press, 1967.

Dekker, Thomas. *Westward Ho*. In *The Dramatic Works of Thomas Dekker*, ed. Fredson Bowers. Vol. 2. Cambridge: Cambridge Univ. Press, 1955.

Derrida, Jacques. *De l'esprit: Heidegger et la question*. Paris: Galilée, 1987.

————. "Freud and the Scene of Writing." In *Writing and Difference*, trans. Alan Bass. Chicago: Univ. of Chicago Press, 1978.

————. "Geschlecht: Sexual Difference, Ontological Difference." *Research in Phenomenology* 13 (1983): 65–83.

————. "*Geschlecht* II: Heidegger's Hand." In *Deconstruction and Philosophy*, ed. John Sallis. Chicago: Univ. of Chicago Press, 1987.

————. *De la grammatologie*. Paris: Minuit, 1967.

————. *Of Grammatology*. Trans. Gayatri Chakravorty Spivak. Baltimore: Johns Hopkins Univ. Press, 1976.

————. *Limited Inc*. Evanston: Northwestern Univ. Press, 1988.

————. "My Chances/*Mes Chances*: A Rendezvous with Some Epicurean Stereophonies." In *Taking Chances: Derrida, Psychoanalysis, and Literature*, ed. Joseph H. Smith and William Kerrigan. Baltimore: Johns Hopkins Univ. Press, 1984.

————. *Otobiographies*. Paris: Galilée, 1984.

————. "Plato's Pharmacy." In *Dissemination*, trans. Barbara Johnson. Chicago: Univ. of Chicago Press, 1981.

————. *The Post Card*. Trans. Alan Bass. Chicago: Univ. of Chicago Press, 1987.

————. "The Principle of Reason: The University in the Eyes of Its Pupils." *Diacritics* 13 (1983): 3–20.

————. "Racism's Last Word." *Critical Inquiry* 12 (1985): 290–99.

————. "Scribble (writing-power)." *Yale French Studies* 58 (1979): 117–47.

————. "Signature Event Context." In *Margins of Philosophy*, trans. Alan Bass. Chicago: Univ. of Chicago Press, 1982.

————. *Signéponge/Signsponge*. Trans. Richard Rand. New York: Columbia Univ. Press, 1984.

————. "White Mythology." In *Margins of Philosophy*, trans. Alan Bass. Chicago: Univ. of Chicago Press, 1982.

Desainliens, Claudius. *Campo di Fior*. London, 1583.

D'Israeli, Isaac. "The History of Writing Masters." In *Curiosities of Literature*. 6 vols. London: Edward Moxon, 1834.

Dürer, Albrecht. *On the Just Shaping of Letters*. Trans. R. T. Nichol. New York: Dover, 1965.

Edward VI. *Literary Remains*. Ed. J. G. Nichols. London: Nichols, 1857. Reprint. 2 vols. New York: Burt Franklin, 1963.

Eisenstein, Elizabeth L. *The Printing Press as an Agent of Change*. Cambridge: Cambridge Univ. Press, 1979.

Elias, Norbert. *The Civilizing Process: 1. The History of Manners; 2. Power and Civility*. Trans. Edmund Jephcott. New York: Pantheon Books, 1978, 1982.

Elton, G. R. *The Tudor Revolution in Government*. Cambridge: Cambridge Univ. Press, 1959.

————, ed. *The Tudor Constitution*. Cambridge: Cambridge Univ. Press, 1982.

Elyot, Sir Thomas. *The Book Named The Governor*. Ed. S. E. Lehmberg. London: Dent, 1962.

Engels, Frederick. "The Part Played by Labour in the Transition from Ape to Man." In *Selected Works*, by Karl Marx and Frederick Engels. 2 vols. Moscow: Foreign Language Publishing House, 1962.

Erasmus, Desiderius. *The Correspondence of Erasmus*. Trans. R. A. B. Mynors and D. F. S. Thomson. Vol. 4. Toronto: Univ. of Toronto Press, 1974.

Evans, Florence M. Greir. *The Principal Secretary of State*. Manchester: Manchester Univ. Press, 1923.

Evelyn, John. *Diary and Correspondence*. Ed. William Bray. 4 vols. London: George Bell, 1883.

Fairbank, Alfred. *A Book of Scripts*. London: Faber & Faber, 1977.

————. "Cursive Handwriting." In *The Calligrapher's Handbook*, ed. C. M. Lamb. New York: Pentalic, 1956.

————. *A Handwriting Manual*. London: Faber & Faber, 1954.

Fairbank, Alfred, and Bruce Dickins. *The Italic Hand in Tudor Cambridge*. London: Bowes & Bowes, 1962.

Fairbank, Alfred, and Berthold Wolpe. *Renaissance Handwriting: An Anthology of Italic Scripts*. London: Faber & Faber, 1960.

Fanti, Sigismondo. *Theorica et Pratica*. Venice, 1514.

Faunt, Nicholas. "Nicholas Faunt's Discourse touching the Office of Principal Secretary of Estate, &c. 1592." Ed. Charles Hughes. *English Historical Review* 20 (1905): 499–508.

Fisher, John H. "Chancery and the Emergence of Standard Written English in the Fifteenth Century." *Speculum* 52 (1977): 870–99.

Flemming, Abraham. *A Panoplie of Epistles, Or, a Looking Glasse for the Unlearned*. London, 1576.

Florio, John. *A Worlde of Wordes*. London, 1598.

Foxe, John. *Acts and Monuments*. London, 1563.

Franco, Giacomo. *Del Franco Modo di Scrivere Cancellaresco moderno*. Venice, 1596.

Freud, Sigmund. *The Psychopathology of Everyday Life*. Trans. Alan Tyson. New York: W. W. Norton, 1965.

Fried, Michael. *Realism, Writing, Disfiguration*. Chicago: Univ. of Chicago Press, 1987.

Fugger, Wolffgang. *Handwriting Manual*. Trans. Frederick Plaat. London: Oxford Univ. Press, 1960.

Fulwood, William. *The Enemy of Idlenesse*. London, 1621.

Furet, François, and Jacques Ozouf. *Reading and Writing: Literacy in France from Calvin to Jules Ferry*. Cambridge: Cambridge Univ. Press, 1982.

Gagliardelli, Salvadore. *Soprascritte di Lettere in Forma Cancellaresca Corsiva, Appartenanti ad ogni grado di persona*. Florence, 1583.

Galen. *On Anatomical Procedures*. Trans. Charles Singer. London: Oxford Univ. Press, 1956.

————. *On the Usefulness of the Parts of the Body*. Trans. Margaret Tallmadge May. 2 vols. Ithaca: Cornell Univ. Press, 1968.

Garber, Marjorie. *Shakespeare's Ghost Writers*. London: Methuen, 1987.

Gerard, John. *The Autobiography of a Hunted Priest*. Trans. Philip Caraman. Garden City, N.Y.: Image Books, 1955.

Gethinge, Richard. *Calligraphotechnia*. London, 1619.

————. *Gething Redivivus*. London, 1664.

Gibbons, Reginald. "Writing at the Computer." *Raritan* 7 (1988): 122–50.

Giles, J. A. *Life and Letters of Roger Ascham*. 2 vols. London: J. R. Smith, 1865.

Goody, Jack. *The Domestication of the Savage Mind*. Cambridge: Cambridge Univ. Press, 1977.

————. *The Interface Between the Written and the Oral*. Cambridge: Cambridge Univ. Press, 1987.

————. *The Logic of Writing and the Organization of Society*. Cambridge: Cambridge Univ. Press, 1986.

Goody, Jack, and Ian Watt. "The Consequences of Literacy." In *Literacy in Traditional Societies*, ed. Jack Goody. Cambridge: Cambridge Univ. Press, 1968.

Grafton, Anthony, and Lisa Jardine. *From Humanism to the Humanities*. Cambridge, Mass.: Harvard Univ. Press, 1986.

Gramsci, Antonio. *Selections from the Prison Notebooks*. Ed. and trans. Quinton Hoare and Geoffrey Nowell Smith. New York: International Publishers, 1971.

Greg, W. W. *English Literary Autographs*. 3 vols. Oxford: Oxford Univ. Press, 1932.

Gregory of Nyssa. *La Création de l'Homme*. Trans. Jean Laplace. Paris: Editions du Cerf, 1943.

Grosart, Alexander, ed. *Complete Works of John Davies of Hereford*. 2 vols. Edinburgh: Edinburgh Univ. Press, 1878.

Guicciardini, Francesco. *Maxims and Reflections*. Trans. Mario Domandi. Philadelphia: Univ. of Pennsylvania Press, 1965.

Guillén, Claudio. "Notes Toward the Study of the Renaissance Letter." In *Renaissance Genres*, ed. Barbara Kiefer Lewalski. Cambridge, Mass.: Harvard Univ. Press, 1986.

Guillory, John. "Canonical and Non-canonical: A Critique of the Current Debate." *ELH* 54 (1987): 483–527.

Hainhofer, Ierome. *The Secretary of Ladies*. London, ?1638.

Hamon, Pierre. *Alphabet de plusieurs sortes de Lettres*. 1566.

Haraway, Donna. "A Manifesto for Cyborgs: Science, Technology, and Socialist Feminism in the 1980s." *Socialist Review* 15, no. 2 (1985): 65–107.

Harcourt, Glenn. "Andreas Vesalius and the Anatomy of Antique Sculpture." *Representations* 17 (1987): 28–61.

Harris, Roy. *The Origin of Writing*. La Salle, Ill.: Open Court, 1986.

Hart, John. *A Methode or comfortable beginning for all unlearned . . . to read English*. London, 1570.

———. *An Orthographie, conteyning the due order and reason, howe to write or paint thimage of mannes voice, most like to the life or nature*. London, 1569.

Harvard, Stephen. *An Italic Copybook: The Cataneo Manuscript*. New York: Taplinger, 1981.

Havelock, Eric A. *The Muse Learns to Write*. New Haven: Yale Univ. Press, 1986.

Heal, Ambrose. *The English Writing-Masters and Their Copy-Books 1570–1800*. Cambridge: Cambridge Univ. Press, 1931.

Heckscher, William S. *Rembrandt's Anatomy of Dr. Nicolaas Tulp*. New York: New York Univ. Press, 1958.

Heidegger, Martin. *Being and Time*. Trans. John Macquarrie and Edward Robinson. New York: Harper & Row, 1962.

———. "Letter on Humanism." In *Basic Writings*, ed. David Farrell Krell. New York: Harper & Row, 1977.

———. *Parmenides*. Frankfurt am Main: Vittorio Klostermann, 1982.

———. "The Question Concerning Technology." In *Basic Writings*, ed. David Farrell Krell. New York: Harper & Row, 1977.

———. *Was Heisst Denken?*. Trans. Fred D. Wieck and J. Glenn Gray as *What Is Called Thinking*. New York: Harper & Row, 1972.

Hercolani, Guilantonio. *Essemplare Utile Di tutte le sorti di l're cancellaresche correntissime*. Bologna, 1571.

———. *Lo Scrittor Utile, et brieve Segretario*. Bologna, 1574.

Hilliard, Nicholas. *A Treatise Concerning the Arte of Limning*. Ed. R. K. R. Thornton and T. G. S. Cain. Manchester: Mid Northumberland Arts Group & Carcanet New Press, 1981.

Hodges, Devon. *Renaissance Fictions of Anatomy*. Amherst: Univ. of Massachusetts Press, 1985.

Hollander, Anne. "The Unacknowledged Brothel of Art." *Grand Street* 6 (1987): 118–40.

Hondius, Jodocus. *Theatrum Artis Scribendi*. Amsterdam, 1594.

Hornbeak, Katherine Gee. "The Complete Letter Writer in English, 1568–1800." *Smith College Studies in Modern Languages* 15 (1934): i–xii, 1–150.

Jackson, Dorothy Judd. *Esther Inglis Calligrapher 1571–1624*. New York: Spiral Press, 1937.

Jed, Stephanie. *Chaste Thinking: The Rape of Lucretia and the Birth of Humanism*. Bloomington: Indiana Univ. Press, 1989.

Jenkinson, Hilary. "Elizabethan Handwriting: A Preliminary Sketch." *The Library*, 4th series, 3 (1922): 1–35.

———. *The Later Court Hands in England*. Cambridge: Cambridge Univ. Press, 1927.

———. "The Teaching and Practice of Handwriting in England." *History* 11 (1926): 130–38, 211–18.

Johnston, Edward. *Formal Penmanship*. Ed. Heather Child. New York: Taplinger, 1971.

Jones, Richard Foster. *The Triumph of the English Language*. Stanford: Stanford Univ. Press, 1953.

Kempe, William. *The Education of Children in Learning* (1588). Facsimile in Robert Pepper, *Four Tudor Books on Education*. Gainesville, Fla.: Scholars' Facsimiles & Reprints, 1966.

Kipling, Gordon. *The Triumph of Honour: Burgundian Origins of the Elizabethan Renaissance*. The Hague: Leiden Univ. Press, 1977.

Kittler, Friedrich. "Gramophone, Film, Typewriter." *October* 41 (1987): 101–18.

Klein, Melanie. "Early Analysis" and "The Role of the School in Libidinal Development." In *Love, Guilt and Reparation & Other Works, 1921–1945*. New York: Delta, 1975.

Koope, Matthias. *Historical Account of the Substances which have been used to Describe Events, and to Convey Ideas*. London, 1801.

Lacan, Jacques. *Ecrits*. Trans. Alan Sheridan. New York: W. W. Norton, 1977.

Laclau, Ernesto, and Chantal Mouffe. *Hegemony and Socialist Strategy*. London: Verso, 1985.

Laing, David. "Notes Relating to Mrs Esther (Langlois or) Inglis." *Proceedings of the Society of Antiquaries of Scotland* 6 (1865): 284–309.

Lentricchia, Frank. *After the New Criticism*. Chicago: Univ. of Chicago Press, 1980.

Leroi-Gourhan, André. *Le Geste et la Parole*. 2 vols. Paris: Albin Michel, 1964.

Lévi-Strauss, Claude. *Tristes Tropiques*. Trans. John and Doreen Weightman. New York: Atheneum, 1974.

Lomazzo, Paolo. *A Tracte Containing the Artes*. Trans. Richard Haydocke. London, 1598.

——. *Trattato del l'Arte de la Pittura*. Milan, 1584.

Markham, Gervase. *Conceyted Letters, Newly Layde Open*. London, 1618.

Marx, Karl. *Pre-Capitalist Economic Formations*. Portions of the *Grundrisse* trans. F. Cohen. New York: International Publications, 1965.

Massey, William. *The Origin and Progress of Letters*. London: J. Johnson, 1763.

Mercator, Gerardus. *Literarum Latinarum* (1540). Facsimile and translation in A. S. Osley, *Mercator*. London: Faber & Faber, 1969.

Morrison, Stanley. *Politics and Script: Aspects of Authority and Freedom in the Development of Graeco-Latin Scripts from the Sixth Century B.C. to the Twentieth Century A.D.* Oxford: Clarendon Press, 1972.

——. *Selected Essays on the History of Letter Forms in Manuscript and Print*. Ed. David McKitterick. 2 vols. Cambridge: Cambridge Univ. Press, 1981.

Mulcaster, Richard. *The First Part of the Elementarie* (1582). Facsimile. Menston: Scolar Press, 1970.

——. *Positions* (1581). Facsimile in *The Training Up of Children*. New York: Da Capo Press, 1971.

Nancy, Jean-Luc. "Dum Scribo." *Oxford Literary Review* 3 (1978): 6–20.

Nash, Ray. *The Plantin Dialogue on Calligraphy and Printing*. Antwerp: Plantin-Moretus Museum, 1964.

A Newe Booke of Copies (1574). Facsimile. Ed. Berthold Wolpe. London: Oxford Univ. Press, 1962.

Nichols, J. G. "Inventories of Henry Fitzroy." *Camden Miscellany* 3 (1855): i–c, 1–55.

O'Day, Rosemary. *Education and Society 1500–1800*. London: Longman, 1982.

Ogg, Oscar. *Three Classics of Italian Calligraphy*. New York: Dover, 1953.

O'Malley, C. D. *Andreas Vesalius of Brussels 1514–1564*. Berkeley: Univ. of California Press, 1964.

Ong, Walter J. *Orality and Literacy: The Technologizing of the Word*. London: Methuen, 1982.

Orphei, Luca. *De Caracterum et Litterarum Inventoribus*. Rome, ?1600.

Orr, Linda. "The Blind Spot of History: Logography." *Yale French Studies* 73 (1987): 190–214.

Ortelius, Abraham. *Album Amicorum Abraham Ortelius*. Ed. Jean Puraye. Amsterdam: A. L. Van Gendt, 1969.

Osley, A. S. *Luminario: An Introduction to the Italian Writing-Books of the Sixteenth and Seventeenth Centuries*. Nieuwkoop: Miland, 1972.

———. *Scribes and Sources: Handbook of the Chancery Hand in the Sixteenth Century*. Boston: David R. Godine, 1980.

Palatino, Giovambattista. *Libro Nuovo* (1561). In Ogg, q.v.

Pank[e], William. *A Most breefe, easie and plaine receite for faire writing*. London, 1591.

Parker, Rozsika. *The Subversive Stitch: Embroidery and the Making of the Feminine*. London: The Women's Press, 1984.

Pattison, Robert. *On Literacy*. New York: Oxford Univ. Press, 1982.

Peacham, Henry. *The Art of Drawing with the Pen*. London, 1606.

Petrucci, Armando. "Libri e Scrittura in Francesco Petrarca." In *Libri, scrittura e pubblico nel Rinascimento*, ed. A. Petrucci. Rome: Laterza, 1979.

———. "Il libro manoscritto" and "La scrittura del testo." In *Letteratura Italiana*, ed. Alberto Asor Rosa. Turin: Einaudi, 1983.

———. "Scrittura, alfabetismo ed educazione grafica nella Roma del primo Cinquecento." *Scrittura e Civilta* 2 (1978): 163–207.

———. *Scrittura e Popolo nella Roma Barocca 1585–1721*. Rome: Quasar, 1982.

———. *La Scrittura: Ideologia e Rappresentazione*. Turin: Einaudi, 1980. Rev. ed. 1986.

Petti, Anthony G. *English Literary Hands from Chaucer to Dryden*. Cambridge, Mass.: Harvard Univ. Press, 1977.

Plato. *Collected Dialogues*. Ed. Edith Hamilton and Huntington Cairns. New York: Pantheon, 1961.

Platt, Sir Hugh. *The Jewell-House of Art and Nature*. London, 1594.

Pliny. *The Historie of the World*. Trans. Philemon Holland. London, 1601.

Quintilian. *Institutio Oratoria*. Trans. H. E. Butler. 4 vols. London: William Heinemann, 1921.

Read, Conyers. *Mr Secretary Walsingham and the Policy of Queen Elizabeth*. 3 vols. Cambridge, Mass.: Harvard Univ. Press, 1925.

Robinson, Robert. *The Art of Pronuntiation*. London, 1617.

Romano, Jacomo. *Il Primo Libro di Scrivere*. Rome, 1589.

Romano, Marc Antonio Rossi. *Giardino de Scrittori*. Rome, 1598.

Saenger, Paul. "Silent Reading: Its Impact on Late Medieval Script and Society." *Viator* 13 (1982): 367–414.

Salmon, Vivian. *The Study of Language in 17th-Century England*. Amsterdam: John Benjamin, 1979.

Sanderson, William. *Graphice. The Use of the Pen and Pensil. Or, the Most Excellent Art of Painting*. London, 1658.

Sansovino, Francesco. *L'Edificio del Corpo Humano*. Venice, 1550.

———. *Del Secretario*. Venice, 1565.

Saunders, Alison. *The Sixteenth-Century Blason Poétique*. Bern: Peter Lang, 1981.

Scalzini, Marcello. *Il Secretario*. Venice, 1587.

Scarry, Elaine. *The Body in Pain*. New York: Oxford Univ. Press, 1985.

Schulz, Herbert C. "The Teaching of Handwriting in Tudor and Stuart Times." *Huntington Library Quarterly* 6 (1943): 381–425.

Sedgwick, Eve Kosofsky. *Between Men: English Literature and Male Homosocial Desire*. New York: Columbia Univ. Press, 1985.

De La Serre, Jean Puget. *The Secretary in Fashion*. London, 1683.

Simon, Joan. *Education and Society in Tudor England*. Cambridge: Cambridge Univ. Press, 1966.

Spivak, Gayatri Chakravorty. "Marx after Derrida." In *Philosophical Approaches to Literature*, ed. William E. Cain. Lewisburg: Bucknell Univ. Press, 1984.

Spufford, Margaret. "First Steps in Literacy: The Reading and Writing Experiences of the Humblest Seventeenth-Century Spiritual

Autobiographers." In *Literacy and Social Development in the West*, ed. Harvey J. Graff. Cambridge: Cambridge Univ. Press, 1981.

Starkey, David. "Court and Government." In *Revolution Reassessed*, ed. Christopher Coleman and David Starkey. Oxford: Clarendon Press, 1986.

Stone, Lawrence. "The Educational Revolution in England, 1560–1640." *Past and Present* 28 (1964): 41–80.

Street, Brian V. *Literacy in Theory and Practice*. Cambridge: Cambridge Univ. Press, 1984.

Strick, Maria. *Tooneel der Leflijcke Schrijfpen*. Delft, 1607.

Stubbs, Michael. *Language and Literacy: The Sociolinguistics of Reading and Writing*. London: Routledge & Kegan Paul, 1980.

Tagliente, Giovanniantonio. *Lo presente libro* (1530; first published 1523). In Ogg, q.v.

Tannenbaum, Samuel A. *The Handwriting of the Renaissance*. New York: Columbia Univ. Press, 1930.

Thomas, Keith. "The Meaning of Literacy in Early Modern England." In *The Written Word: Literacy in Transition*, ed. Gerd Baumann. Oxford: Clarendon Press, 1986.

———. *Rule and Misrule in the Schools of Early Modern England*. Reading: Univ. of Reading, 1976.

Tomkis, Thomas. *Lingua: Or the Combat of the Tongue*. London, 1607.

Torniello Da Novara, Francesco. *The Alphabet* (1517). Ed. Giovanni Mardersteig, trans. Betty Radice. Verona: Officina Bodoni, 1971.

Tory, Geofroy. *Champ Fleury*. Trans. George B. Ives. New York: Dover, 1967.

Two Thousand Years of Calligraphy. New York: Taplinger, 1965.

Van den Velde, Jan. *Spieghel der Schrijfkonste*. 1604.

———. *Thresor Literaire* (1621). Facsimile. Nieuwkoop: Miland, 1970.

Van Uchelen, Anthony R. A. Croiset. "Dutch Writing-Masters and the 'Prix de la Plume Couronnée.'" *Quaerendo* 6 (1976): 319–46.

Verini, Giovambaptista. *La Utilissima Opera da Imparare a Scrivere*. ?1530's. Rev. ed. Milan, 1538.

Vives, Juan. *Instruction of a Christian Woman*. Trans. Richard Hyrde (1540). In *Vives and the Renascence Education of Woman*, ed. Foster Watson. New York: Longmans, Green & Co., 1912.

Warner, Michael. *The Letters of the Republic: Publication and the Public Sphere in Eighteenth-Century America*. Cambridge, Mass.: Harvard Univ. Press, forthcoming.

Warner, William Beatty. *Chance and the Text of Experience*. Ithaca: Cornell Univ. Press, 1986.

Watson, Foster. *Tudor School-Boy Life, the Dialogues of Juan Luis Vives*. London: J. M. Dent, 1908.

Whalley, Joyce Irene. *The Pen's Excellencie: A Pictorial History of Western Calligraphy*. New York: Taplinger, 1982.

———. *The Student's Guide to Western Calligraphy*. Boulder and London: Shambhala, 1984.

Whalley, Joyce Irene, and Vera C. Kaden. *The Universal Penman*. London: Her Majesty's Stationery Office, 1980.

Williams, Raymond. *Writing in Society*. London: Verso, 1974.

Williams, Robert. "A Moon to Their Sun: Writing Mistresses of the Sixteenth and Seventeenth Centuries." *Fine Print* 11, no. 2 (1985): 88–98.

Willis, Edmond. *An Abreviation of Writing by Character*. London, 1618.

Willis, John. *The Art of Stenographie*. London, 1602.

Wilson, Luke. "William Harvey's *Prelectiones*: The Performance of the Body in the Renaissance Theater of Anatomy." *Representations* 17 (1987): 62–95.

Wyss, Urban. *Libellus Valde Doctus elegans, & utilis, multa & varia scribendarum literarum*. Zurich, 1549.

Yciar, Juan de. *Arte Subtilissima* (1550). Facsimile. Ed. and trans. Evelyn Shuckburgh. London: Oxford Univ. Press, 1960.

Library of Congress Cataloging-in-Publication Data

Goldberg, Jonathan.
 Writing matter : from the hands of the English Renaissance /
Jonathan Goldberg.
 p. cm.
 ISBN 0-8047-1743-5 (cloth) : ISBN 0-8047-1958-6 (pbk.)
 1. Paleography, English. 2. Penmanship—Copy-books—History.
3. Manuscripts, Renaissance—England—History. 4. Renaissance—
England. 5. Writing—History. I. Title.
Z115.E5G64 1990 89-36949
745.6′1′0924209024—dc20 CIP

 ∞ This book is printed on acid-free paper